Yale Publications in the History of Art, 23

Vincent Scully, Editor

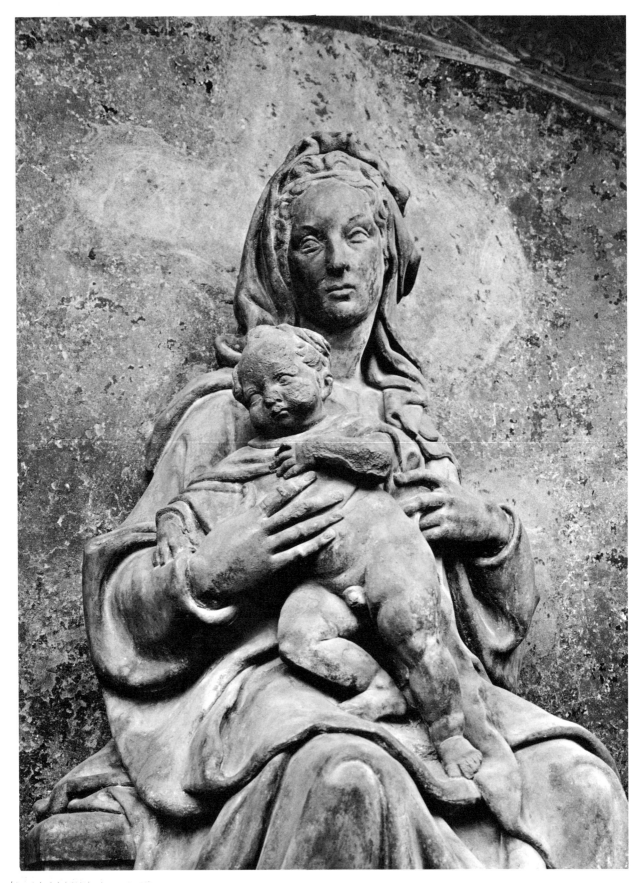

Porta Magna, lunette, San Petronio, Bologna. Madonna and Child

Jacopo della Quercia

SCULPTOR

by Charles Seymour, Jr.

New Haven and London, Yale University Press

1973

Copyright © 1973 by Yale University.
All rights reserved. This book may not be
reproduced, in whole or in part, in any form
(except by reviewers for the public press),
without written permission from the publishers.
Library of Congress catalog card number: 72–75208
International standard book number: 0–300–01529–1

Designed by John O. C. McCrillis
and set in Palatino type.
Printed in the United States of America by
Connecticut Printers, Incorporated, Hartford, Connecticut.

Published in Great Britain, Europe, and Africa by
Yale University Press, Ltd., London.
Distributed in Canada by McGill-Queen's University
Press, Montreal; in Latin America by Kaiman & Polon,
Inc., New York City; in Australasia and Southeast
Asia by John Wiley & Sons Australasia Pty. Ltd.,
Sydney; in India by UBS Publishers' Distributors Pvt.,
Ltd., Delhi; in Japan by John Weatherhill, Inc., Tokyo.

Dedicated to

J. H. B., A. C. H., J. T. P.

Contents

List of Illustrations

The sources of the photographs selected for reproduction are given below for each individual illustration. Where the words *Soprintendenza, Florence* appear, they refer to the Soprintendenza alle Gallerie in Florence. The word *Croci* refers to the aging collection of Croci negatives now held by the University of Bologna. The abbreviation I.D.E.A. refers to the enlarged Alinari holdings at this writing in Via Nazionale in Florence, which now include Brogi and Anderson negatives; these are in each case indicated, to facilitate their location for reference or order, as "Brogi" or "Anderson" ("I.D.E.A." implied). The regular line of catalogued Alinari photographs are indicated simply as "Alinari." The numerous photographs (still uncatalogued) taken especially for my use by the late Signor Malenotti of the Brogi firm are indicated by the rubric "Seymour-I.D.E.A." These last photographs had been restricted in their sale up to the time of this publication but are now available to the public. I am indebted to the firm of Alinari, which acquired the negatives, for maintaining my rights to their use, earlier established with Brogi.

Text Figures

Plates

Early Period, 1395–ca. 1410

Middle Period, 1409–1425

Figures

Preface

Over the past fifty years, the documentary basis for the study of the art of Jacopo della Quercia has significantly broadened and deepened. The archival research of I. G. Supino in Bologna at the beginning of the twentieth century (Bibliog., no. 14) was supplemented by Peleo Bacci in Siena in the 1920s and early 1930s (Bibliog., nos. 3, 4). The Lucchese documents were reexplored in the 1920s by Lazzareschi (Bibliog., no. 12). However, the huge task of reviewing and collating for ultimate publication as a unit the hundreds of documents from all the various archives was only a relatively short time ago quite obviously uncompleted; and it is still not entirely completed today.

In order to make headway on so large a project of basic research it would appear realistic to attack it piecemeal, dealing with component parts that correspond to the major programs on which Jacopo della Quercia was employed. A few years ago, three gifted American art historians began that work. They assumed responsibility—in the first instance as topics for doctoral dissertations at Bryn Mawr, Columbia, and Yale—for the full documentation of the major programs of the Fonte Gaia and the Baptistery Font in Siena and the Porta Magna of San Petronio in Bologna. Of these studies, one, Anne Coffin Hanson's *Jacopo della Quercia's Fonte Gaia*, has already been published in England (Bibliog., no. 9). The second, James H. Beck's documentary history and iconographic analysis of the Porta Magna of San Petronio, Bologna, has just been published in Italy under the title *Jacopo della Quercia e la portale di San Petronio* (Bibliog., no. 6). The third, by John T. Paoletti, on the Siena Baptistery Font, to which Quercia made major contributions, has been prepared for publication in book form. Thus, over the past decade a comprehensive structure of documentary evidence collected and reviewed according to modern methods has been building steadily and modifying the findings of the past.

Meanwhile, in addition to sections in surveys of Italian sculpture, new findings and opinions on Quercia problems have been appearing in print or in lectures. One thinks immediately of Enzo Carli's important article of 1949 on the Siena Madonna (Bibliog., no. 79). More recently, Cesare Gnudi's researches into the young Quercia's possible activity in Venice, which we have yet to see in print, has opened up new perspectives for discussion. Still more recently, Manfred Wundram has suggested a hitherto

unrecorded statue in wood as being from Jacopo's own hand in his early period (Bibliog., no. 107). At the other end of the chronological spectrum, a whole new survey of the Porta Magna in Bologna has been published in a small book by Anna Maria Matteucci (Bibliog., no. 55), a pupil of the late Stefano Bottari of Bologna. Her critical and historical conclusions, however, must be carefully checked against Beck's more recent findings. In 1962, Ottavio Morisani issued, in the small format of the well-known Rizzoli series, *Tutta la Scultura di Jacopo della Quercia* (Bibliog., no. 56); in 1965 Aldo Bertini's concise *L'Opera de Jacopo della Quercia* appeared (Bibliog., no. 49). Quercia's art is to some extent discussed in the most recent survey of Sienese Quattrocento sculpture by Carlo del Bravo (Bibliog., no. 110), the early style by Claudia Freytag (Bibliog., no. 51a).

None of these studies, despite some of their titles, can be called definitive. But they bear eloquent witness to the fact that Quercia's art has recently been far from neglected. There is quite clearly more than ever a need for, first, a comprehensive, and second, an up-to-date study of Jacopo and his art in English. The time has not yet come when a large-scale "definitive" and "complete" monograph can conscientiously be presented to the public. But a reexamined estimate of Jacopo's achievement as a sculptor is as feasible as it is desirable.

The plan of this book has grown naturally, though only after several revisions, from this situation. Today length of text creates problems in publication. Accordingly, I have held critical generalities to a minimum; opinions expressed in older secondary works have been much reduced, although a systematically presented bibliography will in theory provide access to secondary works in a convenient form. Summaries of the hard, factual information provided by the documents have, on the contrary, been stressed. The patterns of fact supplied by the documents appear in a second section (part 2) so as not to interfere with the flow of the narrative and the critical portions of the text, and also to make the consulting of references easier.

The general reader will probably be more drawn to part 1 where, after a brief introduction, he will find a survey of the artist's career, with a résumé of known information as well as some indication of what we do not know about it but would like to know if we could. Then follows a discussion of the major divisions of his life work. Treated are: (1) the controversial early period up to 1409, whose earlier definition and virtually very existence has recently been questioned by Beck; (2) the work at Lucca of approximately 1412–22 and the Fonte Gaia in Siena, the latter finished only in 1419 though commissioned in 1408; (3) the last period, which

covers Jacopo's part in the beautiful font of the Baptistery of Siena between 1427 and 1434, the Porta Magna of San Petronio in Bologna, on which he worked between 1425 and 1438, and such secondary but nonetheless important programs as the Vari-Bentivoglio Monument in San Giacomo Maggiore (begun about 1433–35 but not finished by Jacopo), the Casini Altar (about 1435) in the Siena Duomo (now dismantled), and the Loggia of San Paolo (also called Loggia della Mercanzia), for which Jacopo may well have supplied designs in the mid-1430s but was never able to make much more than a slight beginning on the program of figural sculpture before his death in 1438. The concluding chapter of part 1 is in the form of a broad summary intended to bring together the various units of Jacopo's achievement treated programmatically in earlier chapters.

Finally, in an appendix I have placed material of interest to specialized students: texts of a number of relevant documents, without translations but with modernized punctuation. The texts have been reviewed for accuracy and carefully selected to cover the general range of the artist's career, including such major programs as the Fonte Gaia, the Baptistery Font, and the San Petronio portal. All of them have been published at one time or another, but some are readily available today only in digest form. In short, the intention of this book is to provide an interim publication, but nevertheless one of sufficient scope to fill the gap on library shelves that a full-scale monograph (with apparatus of catalogue raisonné, solid notes, and the full panoply of documentary texts) may one day fill more satisfactorily.

Particularly important for the kind of book I have attempted to write is the element of illustration. Photographic records not only supply indispensable clues to the quality and range of the documented Quercia sculpture as a whole, but should bring clearly to the reader the visual basis for the points raised seriatim in the text. These two functions of illustration do not always coincide; in fact their nature and sequence often conflict. In this book, as in others of the same type, a solution to the problem is sought by dividing the illustrative material into two parts. The first part presents in larger size, photographs of Jacopo's sculpture in a series of some 135 plates. The second part consists of 115 smaller figures, some of attributed work, some of comparative material by other artists from the Renaissance, the Middle Ages, and Greco-Roman antiquity. I have thought of the second section of illustrations as a collection of "visual footnotes" to the "visual text" represented by the plates.

It would be impossible to list all the sources of assistance I have received over the years that have gone into study and preparation of the text; I

would hardly know where to begin. But if a choice must be made, I would like to thank first of all Anne Hanson, James Beck, and John Paoletti, on whose archival research and on whose opinions I have drawn fully and, thanks to their friendship, freely; their assistance of a moral as well as of a purely intellectual nature is recognized on the dedication page. I should also like particularly to acknowledge help from Ulrich Middeldorf, Enzo Carli, Cesare Gnudi, and Fiorella Superbi in Italy; from Mary Shideler, H. W. Janson, Richard Krautheimer, Hanns Swarzenski, Helmut Wohl, and Frederick Cooper in America; and in Germany, from Ursula Schlegel, Heinrich Klotz, and Manfred Wundram. I thank members of patient classes at Yale University, the University of Colorado, and the University of Pittsburgh, who helped me formulate conclusions; also, for generous help over several years, the staffs of the art libraries at Yale University, I Tatti, the Kunsthistorisches Institut in Florence, and the University of Pittsburgh.

My gratitude goes to the Simon Guggenheim Memorial Foundation and to Yale University for fellowships enabling me to work abroad on this topic; to Charles Mitchell of Bryn Mawr for courtesies in connection with an earlier submission of my manuscript; to my colleague George Kubler of Yale who read the manuscript in semifinished form and made a number of valuable suggestions to improve it, and to C. Douglas Lewis, Curator of Sculpture at the National Gallery of Art, for his time and conscientiousness in reading still another version of the manuscript; and to Wendy Stedman Sheard, Robin Bledsoe, and Barbara Folsom for their parts in editing the final version. I would like to thank Mrs. Philip Baxter, Mig Carlson, and Mrs. Robert Schotta for their skill and patience in typing and retyping the manuscript. To my wife goes my appreciation for her companionship on study-trips abroad and for encouragement and help in measurements, writing, and revision. Finally I thank John O. C. McCrillis for his care in all matters pertaining to the design and production of the volume itself.

New Haven, Connecticut C. S., Jr.
May, 1971

List of Abbreviations

Bacci, *Quercia* P. Bacci, *Jacopo della Quercia* (Siena, 1929).

Bacci, *Valdambrino* P. Bacci, *Francesco di Valdambrino, emulo del Ghiberti e collaboratore di Jacopo della Quercia* (Siena, 1936).

B.-B. S. Borghesi and L. Banchi, *Nuovi Documenti per la storia dell'arte senese* (Siena, 1898).

Beck J. H. Beck, *Jacopo della Quercia e il portale di San Petronio a Bologna* (Bologna, 1970).

B.-P. F. Bargagli-Petrucci, *Le Fonti di Siena e i loro aquedotti* (Siena, 1906).

Carli E. Carli, *La Scultura lignea senese* (Milan-Florence, 1954).

Del Bravo C. Del Bravo, *Scultura senese del quattrocento* (Florence, 1970).

Della Valle G. Della Valle, *Lettere sanesi del padre Guglielmo Della Valle, minore conventuale, socio dell'Accademia di Fossano etc., sopra le belle arti*, vol. 2 (Rome, 1785).

Gatti A. Gatti, *La Fabbrica di San Petronio* (Bologna, 1889).

Hanson A. C. Hanson, *Jacopo della Quercia's Fonte Gaia* (Oxford, 1965).

Janson H. W. Janson, *The Sculpture of Donatello*, 2 vols. (Princeton, 1957). Reissued in one volume, 1963.

Krautheimer R. Krautheimer and T. Krautheimer-Hess, *Lorenzo Ghiberti* (Princeton, 1956). Reissued, 1971.

Lazzareschi E. Lazzareschi, "La Dimora a Lucca di Jacopo della Guercia e di Giovanni da Imola," *Bullettino senese di storia patria* 32 (1925): 63–97.

Milanesi

Milanesi, G., *Documenti per la storia dell'arte senese*, 2 vols. (Siena, 1854–56).

Morisani

Tutta la Scultura di Jacopo della Quercia (Milan, 1962).

Paoletti

J. T. Paoletti, "The Baptistery Font in Siena" (Ph.D. diss., Yale University, 1967). To be published in 1973–74.

Pope-Hennessy

J. Pope-Hennessy, *Introduction to Italian Sculpture*, vol. 1, *Italian Gothic Sculpture* (London-New York, 1955; rev. ed., 1971).

Supino

I. B. Supino, *Le Sculture delle porte di S. Petronio in Bologna* (Florence, 1914).

Vasari 1

Le Vite de' più eccelenti [sic] architetti, pittori et scultori italiani da Cimabue insino a' tempi nostri: descritte in lingua toscana da Giorgio Vasari pittore Aretino. Con una sua utile e necessaria introduzione a le arti loro (Florence: Torrentino, 1550).

Vasari 2

Le Vite de' più eccellenti pittori, scultori e architettori scritte da M. Giorgio Vasari pittore et architetto Aretino, di nuovo del medesimo riviste et ampliate, con i ritratti loro et con l'aggiunta delle Vite de' vivi et de' morti dall'anno 1550 insino al 1567. (Florence: Giunti, 1568; ed. G. Milanesi, Florence, 1878–85). All references are to vol. 2 of the Milanesi edition.

JACOPO DELLA QUERCIA
Sculptor

Introduction

The piazza stretching in a southerly direction from the Porta del Perdono of the Duomo in Siena, and occupying the area that was once intended for the nave of the enlarged cathedral planned in the fourteenth century but never finished, bears the name of Jacopo della Quercia. It is not often that so large and importantly situated an urban space is named for a sculptor. Rarer still is to find such a space defined by the unbuilt nave of a church that has remained, in the hugeness of its scale as planned, an unrealized, impossible dream.

Something of the ambiguity of that architectural phantasm colors the modern view of Jacopo's place in art. Not too long ago, in 1938, a commemorative inscription composed by an art historian was put up at the entrance to the Piazza Jacopo della Quercia. The words are Adolfo Venturi's, and their meaning, in a brief paraphrase, is that Jacopo's memory will be honored as the link in the chain of genius between Giovanni Pisano and Michelangelo, who, like Jacopo, worked for the Duomo in Siena. One should perhaps welcome the attempt to summarize so briefly a subject of art history as difficult as Jacopo della Quercia. To be frank, the role of "link" is not overly complimentary, but there should be no dishonor, either intended or implicit, in placing Jacopo between two such distinguished artists of two such outstanding eras.

There is, however, a danger in conceiving of Jacopo merely as a transitional figure rather vaguely situated between two greater "periods" of art instead of within the span of his own life. There is also a tendency evident in recent critical writing to place Jacopo somewhere in the indeterminate area of "Gothic" art in Italy, at times modified to the term *Tardo-Gotico*. This last category stems from the kind of thinking that might justify the term *transitional*. Actually, all history can be shown, as we know, to be transitional, since any break in the flow of events in time will sooner or later be revealed as artificial at best, or at worst as arbitrary or deceptive. In Tuscany in or about the year 1420, the line between *Gothic* and *Renaissance* is particularly hard to draw. Varieties of both "styles" existed side by side, and it is certain that this dualistic terminology was not in the minds of artists and patrons of the time. The wisest course today is to avoid where possible the confrontation implied in the normal usage of those terms.

Nonetheless, there can be no question that Jacopo spent his childhood and youth in a Siena that looked more to its glorious medieval past than to a dubious future. He also drew for support more on the sober thirteenth-century art of Nicola Pisano than on that of Nicola's more "Gothic" son, Giovanni. This stylistic distinction between two artists of the same family implies in the long run not so much a difference in period styles as in personal styles. And it is the personal tradition of Nicola Pisano and his immediate followers (for example, Arnolfo di Cambio), as revived in Tuscany about 1400, that we probably should acknowledge as a model for Jacopo's beginnings as a sculptor in marble, rather than some broader stylistic abstraction. By the same token, Jacopo's role as a force in art beyond the time of his death does not appear to depend on a "style-cycle" (whether Renaissance or Gothic) so much as on the personal appeal that his own rather idiosyncratic kind of sculpture held for later artists, who may have been drawn to it because they were similarly idiosyncratic vision-makers themselves. This seems to have been the case in the remarkable phenomenon of sympathetic relationship between Jacopo's sculpture in Bologna and Siena and the art of the young Michelangelo, certainly up through his composition of the Genesis scenes of the Sistine Ceiling.

In the breadth of his design schemata, particularly in Bologna, Jacopo broke away from the formulae of the more elaborate—some might say more learned—relief styles of his greatest contemporaries, Donatello and Ghiberti. Ultimately, there was no essential sacrifice on his part. The scale of Jacopo's later work seems to have grown preternaturally; his statements in stone took on increasing moral as well as physical weight. One thinks of Dante's terza rima—so direct, at times apparently quite simple, yet so subtle and also so monumental. Elsewhere I have described this phase of Jacopo's art as representative of an epic style in Quattrocento sculpture.

Possibly it was the characteristic of broad simplicity of presentation with minimum detail to clutter the background, thus putting maximum emphasis on the large-scale heroic figures of the foreground, that basically appealed to Michelangelo when he was contemplating a similarly epic style in painting for the Sistine Ceiling. Michelangelo could have studied Jacopo's sculpture in Lucca on trips into the neighboring marble quarries close to Pietrasanta and Carrara. He would have had ample opportunity to look attentively and repeatedly at the Fonte Gaia and at the Font in San Giovanni on journeys to Siena in connection with the Piccolomini Altar commission, or when passing through Siena on later journeys between Rome and Florence. There is clear internal evidence in Michelangelo's own

work that he closely studied Jacopo's Porta Magna of San Petronio in Bologna both in 1494–96 and 1507–08, when he was working on statuary for the Shrine of St. Dominic and on the ill-fated bronze statue of Pope Julius II that was placed in 1508 on the façade of San Petronio, directly above Quercia's portal. The decision to replace the main portal precisely as Jacopo had left it when the façade of the church was moved outward in connection with the installation of the pope's statue, appears very possibly to have been the result of Michelangelo's personal intervention and influence. Note well that these contacts all occurred outside Florence.

Distinguished Italian writers, beginning with Giorgio Vasari in the middle of the sixteenth century, have from time to time been attracted to the idea that Jacopo may actually have worked in Florence.[1] But the fact is that he is known to have had only one serious, and probably rather fleeting, professional contact with Florence, and that was as an unsuccessful contestant in 1401–03 in the competition for the Baptistery Doors. In this he, with four others, was eliminated before the finals, which were contested between Ghiberti and Brunelleschi. Jacopo della Quercia was not much beholden to Florence, though undoubtedly well aware of developments in Florentine sculpture and painting up to 1430.

Essentially, we may now consider Jacopo, in the wake of the nineteenth century, an "Independent." The origins of his own art are so obscure that his emergence, quite unheralded, into the forefront of the art of Western Europe about 1400 seems today to have something of the drama and mystery of Géricault's explosive entry onto the European stage of art four hundred years later. Over Jacopo's subsequent career as an artist, as deeply involved with central events in art history as Géricault's, has continued to radiate an aura of Romantic adventure and restless striving. In this respect he offers an image that is a perfect foil to the "classical," consistently contained, Florentine Ghiberti. Perhaps Jacopo's image as an artist came closer in temperament to Donatello's, whose work he seems to have admired and paralleled, at least to some degree. In other ways, particularly in his strong sense of three-dimensional form and in the fusing of Antique influences with International Gothic trends, he also had a good deal in common with Nanni di Banco—so much so that Vasari was twice tempted to confuse Nanni's work with that of Quercia's own hand.

It is hardly to be expected that so intriguing a proto-Romantic, Inde-

1. Vasari 2:115–16. A "Florentine period" was suggested for Jacopo by Brunetti (in *Belle Arti* 2 [1951]:3–17) and more recently in Morisani, passim. Against this thesis see C. Seymour, Jr., in *Art Bulletin* 41 (1959):1–17.

pendent, and forerunner of Michelangelo would have been allowed to sink back into the shadows of the past. As indicated above, Vasari, staunch apologist for "fiorentismo" though he was, was in the mid-sixteenth century drawn to Quercia—so irresistibly in fact that he used Jacopo's biography to introduce what he termed the second phase of "modern" art. In this he bypassed, surprisingly, both Donatello and Masaccio. He justified this choice with the statement that Quercia was the first of his generation to show that art might once more, after a barbaric "Gothic" interlude, equal Nature herself, thus giving courage to his contemporaries to open the gates to an exciting new period—successor to the Age of Giotto and immediate predecessor to that climax of all art history which Vasari unabashedly proclaimed the Age of Michelangelo—and which, incidentally, in good part coincided with his own.[2]

Thus, a major part of the impact of Jacopo's art went to the future rather than to his own present, though for a long period between 1600 and 1900 his sculpture enjoyed only local fame. For example, literature in English on the whole has not been particularly attentive to Jacopo's art (in contrast, for instance, to the interest in Donatello exhibited in Hawthorne's *The Marble Faun* and his Italian notebooks). The signal exception is Jacopo's Ilaria Monument in the Duomo in Lucca (pls. 10–18). In our own century, Charles Morgan's description of the Ilaria Monument as a central focal point for the novel *Sparkenbroke* hardly requires pointing out; and one of his most sensitive pages elsewhere discriminates between the nature of "serenity," which he sees as exemplified in the figure of Ilaria, and mere "calmness."[3] Those passages need not take a rearward place, for the psychological overtones that Morgan was able to capture and to project may well appear today to be of a subtler caliber than John Ruskin's reactions to the same piece of sculpture.

John Ruskin's words about Ilaria and her image are nonetheless most important for English letters. They are also crucial for his own autobiography as a critic. His remarks are moving and deserve to be recalled. He wrote.

> From Genoa I went . . . in that spring of 1845, to Lucca where the tomb of Ilaria di Caretto [*sic*] at once altered the course of my life for me . . . and from that day I left the upholsterer's business in art to those who trade in it.

2. Vasari 2:109; also Vasari (Milanesi ed.) 4:13–14.

3. C. Morgan, *The Writer and His World* (posthumously published series of lectures and essays; London, 1960), pp. 47–50.

I began my true study of Italian, and all other art,—here, beside the statue of Ilaria di Caretto, recumbent on her tomb. . . . It turned me from the study of landscape to that of life.[4]

Ruskin reported more clearly than any other critic on record the paradox that the art of Jacopo seems to have posed to observers for more than five centuries. This was the power of the artificial image as much as nature to evoke reality, somewhat along the lines Vasari may have had in mind when he wrote that Jacopo was the first of his generation to show that Nature herself might be emulated by artists. Of Ilaria, Ruskin wrote further in that vein:

She wears her dress of every day, clasped at her throat, girdled at her waist, the hem of it drooping over her feet. No disturbance of its folds by pain of sickness, no binding, no shrouding of her sweet form, in death more than in life. As a soft, low wave of summer sea, her breast rises no more: the rippled gathering of its close mantle droops to the belt, then sweeps to her feet, straight as drifting snow.[5]

He moved even deeper to the heart of the matter in his evocation of an artistic vision that transcends the natural fact and its imagery, and sets up a higher order of experience and existence. That Jacopo should have sensed the possibilities of that new order is not only possible, but, in the company of his great contemporaries, eminently probable. It is almost certainly because we can unconsciously sense this probability that we continue to return over and over again to his work, which never wearies the eye nor clogs the imagination. Ruskin wrote, finally, in his occasional schoolmaster's tone, of Ilaria:

You are to note that with all the certain rightness of its material fact, this sculpture still is the sculpture of a dream. . . . Those straight folds, straightly laid as a snowdrift, are impossible; known by the Master to be so—chiselled with a hand as steady as an iron beam, and as true as a ray of light—in defiance of your law of gravity to the earth. *That* law prevailed on her shroud, and prevails on her dust: but not on herself, nor on the vision of her.[6]

The words are still fresh and still carry lightly their weight of a great

4. E. T. Cook and A. Wedderburn, eds., *The Works of John Ruskin*, Library Edition (London, 1903–12), 11:239 and 28:146.
 5. Ibid., 34:171.
 6. Ibid., 34:172.

deal of truth and visual experience. It is a pity that Ruskin did not write, in 1845, of the Fonte Gaia when it was in its original site in the Piazza del Campo in Siena, or of the Madonna and the Genesis reliefs of the Porta Magna of San Petronio in Bologna, then far less surface-bitten than we have seen them in our own time.

Today, though we know more about the artist and the Quattrocento in general, we cannot see Jacopo della Quercia's art as clearly as Ruskin could, and for a tragic reason. The conditions of sullied atmosphere in our culture of the automobile and the factory have done their damage, along with the wind and rain. The danger from the first-named causes of destruction seems the greater. There is no more urgent task before us than to urge the removal of those carvings that are still in the open–those in the upper loggia of the Palazzo Pubblico in Siena as well as those of the façade of San Petronio in Bologna—and to place them behind doors and windows where they will be safe against the real and present threats of what we are pleased to call our civilization.[7] Otherwise we shall most certainly have pitifully less in the future on which to base the foundations of what Ruskin called our "vision" of Jacopo, and of other sculptors too, who belonged to those greatly gifted and, to use a modern phrase, unpolluted times.

Although it has indeed suffered much from both weather and lately from the chemically affected atmosphere, Jacopo's existing sculpture adds up to a large and impressive oeuvre whose interest since 1900 has become more and more widely recognized. Next to nothing that is documented is missing altogether, even though damaged. Jacopo's sculpture hardly needs an introduction, particularly in view of Ruskin's words quoted above. But his lifework is still not nearly as well known in detail as it deserves to be. In current estimates of Italian sculptors of the early Quattrocento, who in fact revolutionized the style of European sculpture as a whole, Jacopo della Quercia evidently holds a pivotal place. His name is rarely omitted in textbooks from the charmed circle of the "Big Four" of the first generation of Quattrocento Tuscan sculptors: Donatello, Ghiberti, Nanni di Banco, and Quercia.

The first-named three artists were thoroughly and undeniably Florentine by birth and by artistic culture, whatever differences may have separated their personal styles. Jacopo, on the contrary, was born not only outside of Florence but in the neighboring, and traditionally archrival,

7. See the report on the effects of polluted atmosphere in Bologna in E. Riccomini, ed., *Sculture all'aperto. Degredazione dei materiali e problemi conservativi* (Ferrara-Bologna, 1969), pp. 53–67.

republic of Siena. His career drew him not merely to his native city, as might be expected, but to Lucca, another rival to Florence among the fifteenth-century Italian republics or city-states, and also to Ferrara and Bologna. Recently some scholars even see evidence in Venice for the formation of his style; others point to Milan. Both those "Gothic" centers were even further removed geographically and spiritually than Siena from the Florentine vortex of developing "Renaissance" style.

Thus, in addition to the inherent difficulty of classifying Jacopo's art by period-style (such as "Gothic" or "Renaissance"), there is also a problem of placing his art according to geographical school, as Early Italian art is normally still classified. Though he is usually linked with the Sienese School, it is quite evident that his art does not conveniently fit so restrictive a classification. That older art-historical meaning of *school* simply breaks down in his case. Instead, for Jacopo we must take into consideration a constellation of centers of activity, each one with its own set of specific programs and each with its own structure of tradition and aims. The Siena of the Fonte Gaia was not the Lucca of Lorenzo Trenta or Paolo Guinigi—nor is either place the Bologna of Martin V or Eugenius IV. Into each of these centers we find introduced the creative personality of a strongly individualistic artist at different points in his career.

Even the older notion of a single personal "style" must now, at least in considerable part, be abandoned. For in Jacopo's case we have to deal not with one style but several styles, each seemingly the result of a deliberate choice for a specific program. At the same time it is possible to trace a development in breadth and power of expression from his early work to his last. One can, though only with great difficulty, speak of his art in terms of periods—early, middle, mature, for example. Ultimately, one must leave the comfortable platitudes of conventional art history, of school, style, and period, and come face to face with the phenomenon of an individual—an unpredictable creator, a master dependent on no teacher, with no firm allegiance except to his belief in his own genius and to his own restless search for a new art. A definition of that individual and of that search is the subject of the chapters that follow.

PART 1

1 Sketch for a Biography

It would appear that Jacopo's life was shaped more by the demands of his art, by the shifts and turnings of the programs he undertook, by the pulls and shoves of circumstances springing directly from his work, than by any succession of external events. His biography was a product of his art rather than the reverse. So the biographical framework we must look for is not the conventional one of the "life and times" formula; it must be sought in the chronology of his known work.

The fact is that we know very little about Jacopo as a person. We do not know what he looked like, nor do we know exactly when or exactly where he was born.[1] We have no firm information about his apprenticeship and only rather dubious sources for speculation on his earliest work. Moreover, there are two distinct versions of Jacopo's life by his earliest biographer, the Florentine Giorgio Vasari. Between the two versions written by Vasari there are many discrepancies, not only in factual detail but, perhaps even more importantly, in emphasis.

What hard data we do have come from archival documents rather than from the verbal tradition Vasari was able to pick up and pass along. Nevertheless, although his double account is hopelessly confused in chronology and flawed by many omissions, Vasari still performed an invaluable service in transmitting the rudiments of the record of our sculptor's personal achievement and the remains of an actual, historical reputation. The Tuscan antiquarians of the seventeenth and eighteenth centuries could hardly have performed their various surveys of documents and objects without Vasari as a guide. And, in their turn, the more recent praiseworthy delvers into local archives, beginning with Gaetano Milanesi, editor of Vasari's *Vite*, could hardly have progressed as far as they have, without Vasari as both a constant referent and butt, as potential aide and unresisting opponent, in their fluctuating efforts to reach a truer view.

1. Vasari claimed to have had a likeness of Quercia in the form of a drawing which he had directly from the sixteenth-century Sienese painter, Beccafumi. This apparently was the basis for the woodcut published by Vasari in the 1568 edition of the *Vite* (reproduced as the frontispiece of Bacci, *Quercia*). Though Bacci accepted it as a bonafide likeness of Jacopo, without supporting evidence it can hardly be so considered today. More recently, Beck, in a lecture (1971), questioned Vasari's evidence for the birthdate and suggested that Jacopo was born some years, possibly a decade or more, later. His position today is less extreme and approaches mine, I am glad to find, more closely.

It is reasonable, therefore, to begin with Vasari's biography—or rather biographies—of Quercia. On comparison one can easily see that the 1568 version is longer and fuller than that of 1550. It would appear that in the interim between the two the author had probably returned to Siena to gather more material. He must also have either gone again to Lucca or been in touch with a close associate who was on the scene. Vasari evidently returned to Bologna where he was able to study anew the great portal of the façade of San Petronio in the light of the experience of his idol, Michelangelo.

The additions or changes may be summarized fairly succinctly. In the edition of 1568 Vasari added a long sentence about Quercia's part in the Siena Baptistery Font, which in the 1550 edition he had failed to mention entirely. He also added a long passage on a memorial equestrian statue in perishable materials for the funeral service of the Sienese general Giovanni d'Azzo Ubaldini; this was done, according to Milanesi's estimate, in or about 1390.[2] Vasari inserted a passage on Jacopo's participation in the Florentine Baptistery competition of 1401–03 (omitted entirely in the 1550 edition).[3] In the new interpretation Quercia's competition piece is favorably compared with those of both Brunelleschi and Donatello (sic).[4] The apocryphal interlude of Jacopo's four-year stay in Florence, which included, according to Vasari in the 1550 edition, the authorship by Jacopo of the crowning relief of the Porta della Mandorla of the Duomo, is retained, though in changed form.[5] The disparaging remarks about the recorded artist, Nanni di Banco, are omitted; instead we find a more honorable echo, not unfavorable to Jacopo, of the earlier rivalry at the time of the Baptistery Doors competition, with Donatello, Brunelleschi, and Ghiberti.[6]

A number of explanations for the variants in the text of the second Vasari version of Quercia's vita might be offered. But the one that seems to fit best of all the principal changes in emphasis is the hypothesis that Vasari had been directly in touch with Michelangelo after 1550 and had received from the aging Florentine "master of masters" the major impetus toward making the revisions in the Quercia vita published in 1568.

The revisions in Vasari's life of Michelangelo must have come from much the same kind of personal motivation, since the 1568 version includes liberal interpolation of material taken from Condivi's biography of 1553, many sections of which competent students today consider to

2. Vasari 2:110. 5. Ibid., p. 115.
3. Ibid., p. 112–13. 6. Ibid., pp. 115–16.
4. Ibid., p. 335.

have been virtually dictated by Michelangelo himself. Similarly, the new emphasis on Quercia as a sculptor great enough to rival the Florentine trio of Donatello, Brunelleschi, and Ghiberti is a striking shift in terms of appreciation, and most likely came from Michelangelo's favorable estimate of Quercia's importance—indicated by the famous remark in Vasari's 1568 version that Quercia was the first sculptor of his generation to "inspire others with the courage and belief that it would be possible in some way to equal Nature herself."[7] This succinct statement, so rich in possibilities for Renaissance theory, replaces the earlier, characteristically Vasarian introduction to the vita of 1550, which states platitudes about the worth of modesty and the just deserts of "merit" as opposed to "good fortune." In the 1568 version the appreciative remarks about Quercia's deservedly receiving the plaudits of his fellow-townsmen are appropriately placed at the end, where they logically follow the account of events of a lifetime. Incidentally, they make an interesting equivalent to the virtual apotheosis of Michelangelo by his fellow Florentines at his death in 1564. Of course, Vasari's enthusiasm is no substitute for knowledge. His chronology of Quercia's work is admittedly out of kilter. Also, he tries to ennoble Jacopo *avant la lettre* by suggesting as his birthplace a castellated town in Sienese territory that has since been tentatively identified by modern historians as Quercegrossa.[8]

The fact is that we do not know how or when the "della Quercia" came into being as part of the name by which we know Jacopo today. For a time he was called "della Guercia" from the reading, perhaps erroneous, of an older source.[9] The documents up to and including the period of the Fonte Gaia usually refer to him as "Jacopo di Maestro Piero"; after the comple-

7. Vasari 2:109–10: "Fu . . . il primo, dopo Andrea Pisano, l'Orcagna e gli altri di sopra nominati, che, operando nella scultura con maggiore studio e diligenza, cominciasse a mostrare che si poteva appressare alla natura, ed il primo che desse animo e speranza agli altri di poterla in un certo modo pareggiare."

8. See, for the most recent example, Morisani, p. 7. Here the Quercegrossa place-of-origin is implied not for Jacopo so much as for his father. Vasari, on the other hand, implies that Jacopo came from there too. Quercegrossa (Querciagrossa) is easily accessible to Siena by road. A castle, or the remains of one, are not in evidence to the interested visitor today; however, remains of what could once have been a sizable oak forest are very close by.

9. The cognomen "della Guercia" was used for Jacopo by C. F. Carpellini in 1868–69 and was discussed sympathetically by Cornelius in 1896 (C. Cornelius, *Jacopo della Quercia*, Halle, 1896, pp. 10–11). In the Lucchese documents edited by Lazzareschi "della Guercia" appears as a corruption of "della Quercia"; it is now out of favor. The usage of *guercia* in older Italian denoted a worker in underground projects such as mines, drains, or pipes (for example, pipes or *bottini* needed to supply water to fountains such as the Fonte Gaia). However, when Jacopo was given a cognomen in Siena in connection with his work on the Fonte Gaia, it was not "della Guercia," but "della Fonte" (see below).

tion of the Fonte Gaia he was sometimes called "Jacopo della Fonte" (in analogy, for example, to the later usage of "Niccolò dell'Arca" for Niccolò d'Apulia in Bologna).[10] Conceivably, the cognomen Quercia, with its overtones of oaklike natural strength and the Renaissance symbolism of power, would attract a writer like Vasari who, with Ghiberti, is most responsible for the version of the artist's name we use familiarly today. It is entirely possible, one must admit, that the Quercia part of the name may have been inherited from his grandfather or his great-grandfather, who were Sieneseborn as far as we know. There is a record of a Quercia or "oak-tree" placename for a former *contrada*, or ward, in the city of Siena; it might well have been the origin of the usage as part of a personal name. But though not unreasonable, this notion is still far from certain in Jacopo's case. The best policy to observe is one of watchful skepticism. The position to avoid is even so much as a hint of the Vasarian theory of origin, with its overtones of noble, or at least knightly, background outside the bourgeois confines of the city proper.

The marriage of Jacopo's parents is recorded in Siena as of 21 April 1370. In view of no opposing evidence, it is to be assumed that Jacopo was their eldest child and that he was born in Siena; he was followed by a sister, of whom, as we know from the documents, Jacopo was fond. A full brother, Priamo, who became a painter, was born in Siena still a little later. On the basis of the Vasari *Vite* of 1568 two birthdates have been adduced for Jacopo. One is from the mysterious Ubaldini equestrian statue of 1390 (?) which, according to Vasari, Jacopo made when he was nineteen years old. This event would provide a birthdate of 1371, the year following the marriage of his parents. Another date emerges from Vasari's statement, again in the 1568 *Vite*, that Jacopo "died at the age of sixty-four" (*morì finalmente di anni sessantaquattro*).[11] Since it is known from documentary sources that Jacopo died in Siena on 20 October 1438, this would place his birthdate approximately in 1374.

We do not know Vasari's sources. Probably one was a Sienese artist, very possibly the Mannerist Beccafumi, whose name appears in the Vasarian text immediately preceding the sentence about Jacopo's death.[12] Beccafumi could have had the tradition as handed down in the circle of artists in Siena. The time lag, to be sure, is a full century or even more. Nonetheless, the chances are that the figure given by Vasari for Quercia's age at his

10. Hanson, pp. 9, 111. 12. Ibid.
11. Vasari 2:119.

death is correct, particularly because he also could have obtained it from Jacopo's tomb-marker before 1550, as mentioned at the end of this chapter. If so, the more conservative date of 1374 would be the preferred supposed birthdate. We would perhaps be on still safer ground by rounding out the lustrum to 1375, perhaps even a year or two beyond. This would place Jacopo squarely in the artistic generation of Brunelleschi and Ghiberti, with whom he competed in Florence in 1401–03. On the other hand, he could have been as much as eight or ten years older than Donatello, who survived Jacopo by no less than twenty-eight years and was apparently too young to have competed for the Baptistery Doors in Florence.

The first firmly fixed, dated, and attested event in Quercia's career is his participation in the Florentine Baptistery Doors competition of 1401–03.[13] It is felt possible that, following the Malavolti uprising in Siena in 1391, when the city-state was pushed into the camp of the Visconti of Milan, Jacopo may have left Siena in the company of his father, Piero d'Angelo della Quercia.[14] The latter is known to have been in Lucca in 1394.[15] Whether Jacopo was with him is not known. The best openings at this time for an incipient carver of stone like Jacopo, were not in Lucca but in Milan or Bologna. Given the temporary Sienese-Milanese political alliance, Jacopo might well have found employment in the ranks of stone sculptors who were then being drawn from most of Europe to the workshops of the Milanese Duomo. The Milanese records of the period, which are relatively complete, do not list him, however. Bologna, the next likely spot, had one of the largest single programs in sculpture of the 1390s, the High Altar of San Francesco (fig. 1).

There is a possibility that Jacopo worked in Bologna for a time before 1400. More certainly he was also active in Siena. Vasari states that Quercia did some marble figures of rather small size for the façade of the Duomo in Siena.[16] Those "façade figures" appear to be apocryphal. But they may have been confused by Vasari's time with a commission for an altar inside the Duomo from which an early Madonna, now on the Piccolomini Altar (pls. 1–4), to be treated in the next chapter, represents the sole survivor.

By 1401, when he took part in the Florentine Baptistery Doors competi-

13. The oldest source is in the autobiography included in Ghiberti's own *Commentarii*. Vasari stated in his edition of 1550 that Jacopo stayed in Florence four years on the occasion of the Baptistery Doors competition, but did not so specify in the edition of 1568. For further discussion see pp. 24, 30–31.

14. Bacci, *Valdambrino*, pp. 49–50.

15. Ibid., p. 84, doc. iii.

16. Vasari 2:111.

tion, Quercia must have been well known not only in Siena but also to the
Florentines, as well as already possessing some reputation in northern
Italy. After the close of the competition in 1403, Jacopo went to Ferrara,
where he received from the bishop the important commission of the Sil-
vestri Altar.[17] The superb marble Madonna (pls. 5–9), still preserved in
the Duomo, was finished by 1408. In the interim, that is, after he had be-
gun the Silvestri Madonna but before the final approval of his work and
payment for it, Jacopo appears to have returned to Lucca. The purpose of
that journey was to execute, probably with assistance from his Sienese
contemporary, Francesco di Domenico Valdambrino, the famous monu-
ment of Ilaria del Carretto-Guinigi (pls. 10–18). This was done by the
commission of wealthy Paolo Guinigi, the early Quattrocento Lucchese
equivalent of a Medici in Florence.[18]

After the payment in 1408 for the Silvestri Madonna in Ferrara, Quer-
cia was once again drawn back to Tuscany. We find him early in 1409
engaged by the Commune of Siena to carve and construct a new marble
fountain, the so-called Fonte Gaia (pls. 37–55), for the Piazza del Campo
in the heart of the city. Work was often interrupted and dragged on until
1419. It should not be forgotten that Quercia, in this middle period of his
career, was also deeply involved with at least two major commissions, and
possibly a third, in Lucca. The first was for what appears to have been a
series of the Apostles, at larger than life scale, for the buttresses of the
nave of the cathedral (see pl. 21). It is also possible that at this time he may
have worked, with assistance, on part of an interesting series of heads that
decorate the nave windows of the Lucca cathedral (figs. 26–27). Then, in
or about the spring of 1412, he was commissioned by the wealthy Lucchese
merchant, Lorenzo Trenta, to do the sculpture for a chapel dedicated to
St. Richard the King, St. Ursula, and St. Jerome in the church of San
Frediano, which was to become the funerary chapel of the Trenta family
(pls. 28–36).

Late in 1413 he became involved in the tragicomedy of an amorous affair
with the wife of a wealthy Lucchese merchant-citizen. The lady appar-
ently made her assignations in the Trenta Chapel itself. Jacopo, together
with his assistant, was accused of no less than three simultaneous crimes:

17. The question of the dating of the Ferrara Madonna is complex and has recently been
renewed with fresh evidence, which will be discussed in the next chapter.

18. The question of possible collaboration between Francesco di Domenico Valdambrino
and Jacopo, according to the stylistic evidence of the early Quattrocento statuary, will be dis-
cussed in the next chapter; see pp. 34–35.

theft, rape, and sodomy.[19] It is unusual, even for the fifteenth century, to find these three accusations leveled all at one time.

What this rather flamboyant incident in Lucca reveals of Jacopo's character is altogether uncertain. Whether it was he or his assistant at the time, Giovanni da Imola, who was the recipient of the lady's attentions is not clear from the record, nor do we know which of the two was guilty of theft. It is also not certain at whom the charge of sodomy was directed; in any case, Jacopo, or Giovanni, or both, would not be the only artists of Renaissance Italy to be accused of homosexual practices. Later, in 1424, about a decade after the incident in Lucca, Jacopo evidently did seriously consider marriage; the bride's dowry of 350 florins was even reportedly delivered to him.[20] But there is no record of a wedding. No wife or issue is mentioned in his will of 1438. The marriage contract must have fallen through for reasons we do not know today, nor are ever likely to know.

Indeed, the personal and private side of Jacopo's life remains elusive. The documents offer only tantalizing hints. For example, one gains the general impression of a willful personality, but one also generous and thoughtful of the feelings of others, particularly those close to him in his family and in professional working relationships. Jacopo is recorded as standing more than once as godfather to children of his colleagues or assistants, and this in an age when the responsibility was far from nominal. His will reveals consideration not only for his sister and brother but for his shop assistants.[21]

He was more than once nominated for public office or for public duty in Siena. A number of times he was elected, but it must also be said that on several occasions he was turned down. He was elected to the City Council of Siena in 1418 and to be prior from his district in 1420. In 1423 he went on an official inspection tour of fortified places in Sienese territory. In 1435 he was again elected to the City Council of Siena, and in February 1435 he presided over the Consistoro, or chief governing committee of the city. These evidences of public trust must however, be balanced by the fact that his nominations for rector of the Scala hospital (1435) and envoy to Milan (1438) were unsuccessful.

19. E. Ridolfi, *L'Arte in Lucca studiata nella sua cattedrale* (Lucca, 1882), p. 116; Lazzareschi, p. 66–71. For fuller references see pp. 38–44.

20. Bacci, *Valdambrino*, pp. 391–92. Not mentioned by Cornelius, though included by Morisani in his basic chronology (p. 51).

21. See Appendix, p. 126.

Temperamentally, he may have been overly ambitious and desirous to please; why otherwise do we see him time and again accepting concurrent commissions–and finding it impossible to carry out any one of them—thus inevitably inviting serious and disagreeable warnings on the part of the impatient patrons when he failed to deliver on schedule? He was eager for accomplishment, and when the time for delivery approached he was a prodigious worker. But there must also have been long intervening periods of dreaming and delay. We have every reason to suspect that he was a poor manager of money, for when he died, apparently the family had some trouble clearing up irregularities of his stewardship of funds for the Duomo in Siena. But, conversely, it was the Sienese who made him overseer, or *operaio*, of the Duomo, and with that responsible office came the dignity of knighthood, possibly a device to save him from the clutches of the Bolognese, who in 1425 had succeeded in luring Quercia into the onerous commission for the façade sculpture of their great civic church of San Petronio (pl. 79).

The Bolognese made available to Jacopo a house and certain privileges of a citizen; but Jacopo's relations with the authorities were far from unruffled.[22] The Sienese tried to keep him at home with still another local commission for the Baptistery Font, of which he was to be in charge from 1428 on (pl. 61).[23] Then came the commission for the Casini Altar in the Siena cathedral, as of about 1430 (pls. 130–33),[24] and at about the same time a commission for the sculpture of the important monumental public loggia at the back of the Piazza del Campo—sometimes called the Loggia San Paolo, sometimes the Loggia della Mercanzia (pl. 134).[25] Meanwhile new demands were being made on the bottega (workshop) in Bologna by the Vari family of Ferrara, with the commission of an impressive funeral monument (pl. 128), later to be taken over by the Bentivoglio (now in San Giacomo Maggiore, Bologna). Quercia evidently planned the monument, which was originally intended for Ferrara, not Bologna. He probably began some part of the statuary before he died late in October 1438. He was buried in the cloister of Sant'Agostino in Siena.[26]

22. J. H. Beck, "An Important New Document for Jacopo della Quercia in Bologna," *Arte antica e moderna* 18 (1962): 206–07.

23. The documentation for Quercia's work on the Font has recently been completely reviewed and amplified beyond earlier research by J. T. Paoletti (soon to be published). See also Bacci, *Quercia*, pp. 77–148.

24. Bacci, *Quercia*, pp. 279–328.

25. The documentary evidence up to now is rather scattered and almost certainly incompletely published. See in any case Bacci, *Quercia*, pp. 301, 308–09, 313–16.

26. Cornelius, *Quercia*, pp. 51–52.

He left little estate, but he was certainly far from destitute, as we can gather from his will and the inventory of his bottega, both reprinted in the appendix to this volume. The makeup of the personnel of his shop is difficult even to guess at. A number of names are transmitted by the documents, but so far there is no way of being sure what the personal styles of his assistants were. At least we can be sure that there was no successor to carry on after his death. The nearest to a viable disciple was Antonio Federighi, his junior, it now seems clear, by many years and an artist whose oeuvre is still in some doubt.[27]

In summary, Jacopo had a busy life, a career of distinction, and numerous commissions concerned with important programs in a circle around, but never in, Florence. His memory was quite certainly revered in Siena, though to his contemporaries he may well have been something of an enigma. However, to return to the guiding thought at the beginning of this chapter, the Cinquecento clearly found him a key figure in the development of post-Gothic art in Italy. The early Quattrocento apparently recognized his genius and inventiveness but hardly knew what to do with him. It was in the full bloom of the Renaissance that he was acclaimed a prophet. Vasari's two versions of his biography may not give us the facts we should like to know, but they do indicate clearly that, to the Age of Michelangelo, Jacopo was a rather special hero. Subsequent ages lost track not only of his Renaissance reputation but of the physical reminders of his existence, even to the location of his grave. It is necessary to go to the first version of Vasari's *Vite* of 1550 to find the only surviving transcript of his epitaph. Besides the work he left behind him, the sonorous Latin phrases, taken without change from Vasari's printed text, constitute Jacopo's most worthy memorial:

IACOBO QUERCIO SENENSI, EQUITI CLARISSIMO, STATUARIAEQUE ARTIS PERITISS. AMANTISSIMOQUE: UTPOTE QUI ILLAM PRIMUS ILLUSTRAVERIT: TENEBRISQUE ANTEA IMMERSAM, IN LUCEM ERUERIT, AMICI PIETATIS ERGO, NON SINE LACHRYMIS P. [. . .][28]

Rather appropriately, the text breaks off before the end. Like the artist's

27. See J. T. Paoletti, "Quercia and Federighi," *Art Bulletin* 50 (1968):281–84.
28. Vasari 1:238–39. Roughly translated as:

To Jacopo della Quercia of Siena, eminent knight,
Most skilled and admired practitioner of the art of sculpture
Which he first had shown to have emerged into the light of day
From the shadows where it earlier was obscured.
His loyal friends, therefore, in grief . . .

own career, it is irretrievably incomplete. It has remained for the more
sympathetic mid-twentieth century to try once more to redress past in-
difference and to set straight the record.[29]

29. In her long summary of the artist's achievement, published in the 1961 *Enciclopedia Universale dell'Arte* (trans. *Encyclopedia of World Art*), Nicco Fasola well expressed a feeling that many have rather instinctively felt. Writing in 1960 she stated: "Particolarmente negli ultimi decenni, con l'indirizzo critico portato a valorizzare le espressioni d'arte libere ed eccezionali, le forti personalità, Jacopo della Quercia ha preso un posto di primo piano." A little further on she notes: "L'arte di Jacopo appare oggi altrettanto moderna, nel suo tempo, di quella di Donatello."

2　Emergence of an Artistic Personality

In his *Republic* Plato makes a statement to the effect that "the beginning is the most important part of the work." Somewhat later, still in the *Republic*, he has Socrates say that "Youth is the time for any extraordinary toil" (Jowett's rendering). A more modern version (Cornford's translation) gives another twist to the meaning: "Youth is the time for hard work of all sorts." On purely nonphilological grounds, I prefer to apply the first of these translations to the beginnings of Jacopo della Quercia's career. His early achievement, as it has come down to us, reveals a good deal more than simply hard work. It is in every respect extraordinary. It leaps out from the pattern of the times, revealing a subtle and original combination of both tradition and experiment. Whether we call it late Gothic, Transitional, or Early Renaissance, it remains a notable phenomenon in the annals of creativity.

It is not easy to put a date on the beginning of this early period. Recently, as briefly mentioned, the very existence of an "early period," i.e. before 1400, has been questioned with some reason. The first mention of Jacopo's name in the sources is Ghiberti's mid-Quattrocento account in his *Commentarii* of the well-known competition for the commission of the Florentine Baptistery Doors of 1401–03.[1] If we assume that Jacopo was born around 1375, or even a year or so later, this would mean that his first documented work was produced when he was between twenty-five and thirty years of age, for those times already an age of some maturity, since it was customary in the Renaissance to think of forty as marking the division between youth and age.[2] Since, as we shall see shortly, Jacopo's competition piece is no longer extant, we must turn to the marble Silvestri Madonna (pls. 5–9) in Ferrara as the first extant documented work. This statue could not have been begun before 1403 and may well have been

1. Most recent edition of the original text is in the Morisani edition of Lorenzo Ghiberti, *I commentarii* (Naples, 1947). The description of the competition is in Book 2.

2. For a lively study of the terminology of age in Renaissance usage see C. Gilbert, "When Did a Man in the Renaissance Grow Old?" *Studies in the Renaissance, Publications of the Renaissance Society of America,* 14 (1967):7–32. Gilbert points out that our modern concept of middle age really has no place in the Renaissance view of a man's life-span. Then, a man passed from "youth" to "age," which was roughly equivalent to our notion of old age—that is, generally failing powers and premonitions of death which, generally speaking, for active, hard workers could normally be expected to descend as early as fifty.

finished as late as 1407/08,[3] or at the time when Jacopo was fast approaching the point of leaving his "youth."

Thus, there is an enormous gap in our knowledge of Jacopo's beginnings as an artist, and precisely at what Plato calls "the most important part of the work," assuming, as he implies, that a man's life through education and the practice of virtue may be thought of as something "made," like a work of art itself. Vasari, writing close to one hundred and fifty years after the event, does indeed mention Jacopo's participation in the Baptistery Doors competition in 1401. In one place in the *Vite* he transmits a description of the Sienese sculptor's lost relief in bronze as "well-designed and diligently executed, but the figures were not well enough handled in perspective for a good composition" ("aveva bonissimo disegno e lavorata diligentemente, ma non a partito bene la storia col diminuire le fighure").[4] Given Jacopo's later lack of interest in perspective or related illusion of space through the "diminution of figures" in the backgrounds of his reliefs, in contrast to the developed relief styles of both Donatello and Ghiberti, which Vasari quite understandably praised, this report has a ring of authenticity, even though in the same sentence Vasari describes a nonexistent competition entry by Donatello. An earlier reported work by Jacopo, the equestrian figure for the Duomo of the Sienese general, Giovanni d'Azzo Ubaldini, who died in 1490, was advanced by Vasari as the main piece of the Quercia juvenilia. That mysterious funeral monument was evidently constructed of temporary materials. Some critics have suggested that the same monument, intended also for the Sienese Duomo, was for a coleader, Gian Tedesco, who was buried in the Duomo in 1395. Though this commission and date would better suit current estimates of Quercia's birthdate, we are left in a quandary that all in all seems insoluble and, when all is said, is more important for a genre or type than for our view of the artist's own work.[5] What we should be looking for is Jacopo's first work either in marble or bronze, or possibly in wood.

The scholarly position on Jacopo's initial training is not seriously in

3. See below, p. 31. The design may have been established in 1403/04, as suggested by Gnudi. Documented activity on Quercia's part may be established for 1406/07.

4. In the 1568 vita of Brunelleschi, where the critiques of the other contestants' designs are given. Vasari may have had access to a summary of the written reports of the judges of the competition, which by now have completely disappeared.

5. See above, p. 16. Vasari specifies the materials as wood, plaster, and tow. Whether by Quercia or not, this is one of the earliest Tuscan equestrian statues on record, as emphasized by W. A. Valentiner (Bibliog., no. 106). The genre was much earlier favored by north Italy.

question today. He must have begun with his father, Piero d'Angelo della Quercia, who was a master goldsmith, a sculptor in wood, and, apparently, the son of a wood-sculptor. The work currently attributed to Jacopo's father is far from inspiring. An angel from an Annunciation group at Benabbio probably most favorably represents what is believed to have been his style (fig. 14). In the early 1490s, Piero d'Angelo della Quercia left Siena to find a new base of operations in Lucca.[6] Whether his son Jacopo went along with him to Lucca at that time is not known. It is more likely, given no evidence to the contrary, that Jacopo stayed in Siena or went elsewhere to find the training he needed in order to become the great stone-sculptor we know he became. To model and cast bronze on a miniature scale and then to gild it, as Jacopo was to do in the Baptistery Doors competition shortly after the turn of the century, is to practice a major technique of the goldsmith. This, with the carving of wood for larger-scaled statuary, Jacopo could easily have learned from his father. But in Siena in the 1390s the craft of statuary in marble was a dying trade; no first-class sculptor was practicing in Siena then, and few commissions in marble were forthcoming. There was, to be sure, a tradition of greatness in marble sculpture in Siena left primarily by Nicola Pisano and his son Giovanni. Their work was to be seen at close range on the pulpit in the interior of the Duomo (fig. 15) and high up on the façade on the exterior.[7] Here was invitation enough for emulation. But how and where to learn?

It is at this point that conjecture is unavoidable. There is probably no need to suppose that Jacopo left Italy to spend the time of his apprenticeship in France, as used to be considered a real possibility.[8] On Italian soil there were, as of 1390–95, three centers with important programs of marble sculpture: Milan (the Duomo), Venice (the Doge's palace), and Bologna (the altarpiece of San Francesco). Neither in Venice at that particular time nor in the related center in Milan does there seem to be evidence of Jacopo's presence.[9] However, there is a possibility that Jacopo might have been em-

6. The Lucchese migration is most fully treated in Bacci, *Valdambrino*, pp. 31–88.

7. The pulpit by Nicola and his assistants, among them possibly his son Giovanni, and dated between 1265 and 1268, is still in the Siena Duomo close by the entrance to the choir on the Gospel side. Giovanni's splendid façade figures of 1285–95, also in marble, have been removed under cover to the Opera del Duomo museum, where they may be studied at ground level.

8. See, however, Pope-Hennessy, p. 48, on possible influences from Sluter's sculpture in Burgundy.

9. Only the Milanese documents are sufficiently intact to argue from *absentia* of Jacopo's name in the rolls that he probably did not join any of the Milanese shops at work on the cathedral.

ployed in the finishing and installation of the San Francesco altarpiece in Bologna (fig. 1). The sculpture for this elaborate construction, based on the Venetian type of painted altarpiece, was the product of the dalle Masegne shop in Venice, but there is some evidence that at least one replacement was needed when the time came to put the parts together in 1492–95.[10] Among the numerous hands that are evident on the monument as it has been reassembled in modern times is one which is decidedly original—unusual for the times, to say the least—and which cannot be classed with the normal dalle Masegne Venetian style. This is the hand, strikingly Tuscan in stylistic overtones, that was responsible for the Angel and to some extent, perhaps, also for the Virgin Annunciate (figs. 2–3, 5, 7). A name, the "Gabriel Master," has been tentatively attached to this style, which has evident Tuscan antecedents and relationships (see figs. 4, 14b).[11]

It would be going too far, on the basis of what we think we know, to say that Jacopo and the "Gabriel Master" were one and the same. But if one had to select a style in marble in the first half of the 1490s that might fit our idea of how Jacopo began as a sculptor in marble, the manner of that *anonimo* in Bologna is not very far off the mark. The buoyantly spirited Angel, fully modeled though not yet fully three-dimensional in design, is probably closer to Jacopo's later known style than the Virgin. It is close, too, to what we believe represents Jacopo's first master's style in the figure attributed to his father, Piero d'Angelo della Quercia (see again the Angel in Benabbio, fig. 14a).

Associated stylistically with this remarkable pair of figures in Bologna is a Madonna of Humility in the National Gallery of Art in Washington (Kress Collection), which has been attributed both to Jacopo and to a roughly contemporary Sienese sculptor in wood and master of *intarsia*, Domenico di Niccolò dei Cori.[12] The Madonna in Washington is not large, but it projects, like the Angel Annunciate in San Francesco in Bologna a remarkable impression of monumental scale (pl. 20, figs. 10, 12). The style of the drapery too, relates to that of the San Francesco Virgin Annunciate

10. On the altar's history, see most recently R. Roli, *La Pala marmorea di San Francesco in Bologna* (Bologna, 1964); also on the subject of the Angel of the Annunciation, see I. B. Supino, *L'Arte nelle chiese di Bologna* (Bologna, 1915), pp. 232–34.

11. The term was first applied by Cesare Gnudi in 1950. Gnudi differentiated between the "Gabriel Master" and the master of the Virgin Annunciate, whom he identified as Pierpaolo dalle Masegne.

12. Formerly the Goldman Collection, New York, then the Kress Collection (National Gallery of Art, Washington). For a review of that part of the evidence that favors Jacopo as the artist, see C. Seymour, Jr. and H. Swarzenski, in *Gazette des Beaux-Arts* 30 (1946):129–52. For the suggestion that the piece is attributable instead to Domenico dei Cori, see Pope-Hennessy, p. 211.

(see again fig. 7). There are parallels here that are intriguing, particularly in view of the recorded Italian provenance of the piece in Washington–Bologna.[13] Whether the Washington Madonna of Humility is really by Jacopo early in his career, possibly before 1403, is a question that may never be satisfactorily settled. However, there is much in favor of the attribution. There is also something to be said for an alternative attribution to the Sienese sculptor, Domenico dei Cori, especially if we accept for him the remarkable, though undocumented, Annunciation group in the Museo d'Arte Sacra in Montalcino (figs. 13, 14b).[14] However, we have no sculpture in marble by Domenico, and his only documented wood sculpture in the round, of about fifteen years later, is not in a really comparable style (fig. 25).

If progress in this direction seems somewhat slow, we might turn elsewhere north of Tuscany for traces of the youthful Jacopo della Quercia's development as an artist. Another Annunciation group, this time with the two figures in separate edicules at the summit of the façade of San Marco in Venice and quite evidently early Quattrocento in style, bears a resemblance to the Annunciation group of the San Francesco altarpiece in Bologna (figs. 3, 7). Could Jacopo have carved these figures, and perhaps others, for the Venetians? The dates here could be roughly between 1403 and 1406 or between 1408 and 1412, if Jacopo was involved.[15] We should remember, however, that another Tuscan sculptor, Niccolò di Pietro Lam-

13. This was mentioned when the piece was catalogued while in the Goldman Collection. Holes drilled close to the Virgin's neck indicate that the group was at one time decorated with jeweled ex-voto ornaments. An etching by Rembrandt (Hind, 186, I) is clearly based on the group's design, possibly deriving from a devotional print that traveled north. All of this would indicate that the piece was well known, at least as a religious icon. The motif refers to the seated Madonna of Humility theme (as analyzed by Millard Meiss), which appears frequently in Sienese painting of the later Trecento and well into the Quattrocento. (For an early Quattrocento example in Sienese art, see fig. 11.) The National Gallery of Art marble Madonna of Humility, whether by Jacopo or, as seems less likely, by Domenico dei Cori, is clearly related to the Trecento tradition in Sienese painting; but it is also plastically extremely impressive, a powerful bit of carving in the round. Latterly, an older unfounded attribution to the Sienese sculptor Giovanni di Turino has been disinterred, to my view with insufficient stylistic or programmatic foundation (Del Bravo, p. 33). The Kress Collection Madonna appears to belong to an earlier stylistic context than does the known work of Giovanni di Turino (fl. 1420–55).

14. Carli, pp. 45–46. The Angel (now in the Gardner Museum, Boston) attributed by Brandi to Domenico and discussed by Carli with its possible companion, a Virgin (in the Jacquemart André Museum, Paris), in connection with the Montalcino group, does not fit easily into that context of style; it seems to be earlier and is certainly much more archaic. Del Bravo (p. 29) connects the Gardner angel with the Virgin in the Jacquemart-André Museum and retains the attribution of both to Domenico.

15. The possibility of Jacopo's having worked on the San Marco exterior statuary was first proposed by Cesare Gnudi in a recent study based on excellent new photographs; he has generously discussed his ideas verbally, but at this writing has not yet published them.

berti, was also in demand in Venice at those dates and conceivably might have been responsible for the figures in question.

What these forays into historical conjecture may add up to is not much more than the raw material for interesting hypotheses. It is certainly possible, indeed it may be probable, that Jacopo learned to carve marble in the masterly way he was later to reveal outside of his father's bottega and outside of Siena. Perhaps Bologna, and as a more remote possibility Venice, provided the opportunity he needed. Florence has also been suggested as a locale for his early training and work in marble; the first to publish this idea was none other than Giorgio Vasari. But the evidence, both documentary and visual, is against the possibility; we shall return to it briefly a little later in this chapter.

There remains, to be sure, Lucca, where Jacopo's father had migrated by 1394. It is of course possible that Jacopo accompanied him and transferred his artistic activity from Siena to Lucca. A late Trecento or early Quattrocento relief of the Man of Sorrows between the mourning Virgin and St. John has been inserted into the present Altar of the Sacrament in the Lucca Duomo (fig. 28). This has been ascribed to Jacopo along with a stylistically related holy-water stoup also presently in the Duomo (fig. 29); but in neither case can one affirm much more than the vaguest kind of period-style relationship with Jacopo's early known work in Lucca or elsewhere.[16] The handsome and important central relief of the dismantled tomb-altar of St. Agnellus, now inserted into the altar of the Sacristy of the Lucca Duomo, has more recently been attributed to Jacopo (fig. 30).[17] The style here once again does not ring sufficiently true to Jacopo's evidently native sense of mass and rhythm; the forms of the figure are drawn as much as they are modeled, and the insistence to detail in the drapery, in the head, and in the veined hands suggests an offshoot of the dalle Masegne workshop style; a glance at a parallel figure, though in the round, of about 1400 in Venice will make this verbal comparison clearer (fig. 31). Evidently there is still no "first work" by Jacopo to be identified, as yet at least, in Lucca.

We return perforce to Siena. And it is there that I believe we shall find the first indisputable extant work by Jacopo's own hand. This is the stand-

16. See M. Salmi, in *Rivista d'Arte* 2 (1930):175–91; also Morisani, *Tutta la Scultura*, p. 77.

17. A. Kosegarten, in *Mitteilungen des Kunsthistorischen Instituts in Florenz* 30 (1968): 224–72.

ing Madonna and Child in marble that is preserved, in a disconcerting way quite out of formal and historical context, in the uppermost niche of the Piccolomini Altar in the Duomo of Siena (pls. 1–4).[18] The altar was designed by Andrea Bregno in Rome at the end of the Quattrocento; early in the first decade of the Cinquecento Michelangelo contracted to execute missing figures intended for the niches, and perhaps the seated Madonna now at Bruges was intended for the upper central niche presently occupied by the much earlier standing Madonna I believe was carved by Jacopo. Its placement there has absolutely nothing to do with its original program, which concerned a late Trecento altar in the Duomo. A document exists indicating that this Madonna and Child were finished by 1397.[19] Presumably, the commission was of 1396 or 1395, in other words, after Jacopo had returned to Siena from Bologna or Venice—if indeed he actually worked there.

The attribution to Jacopo depends a great deal on this early dating. If by 1401 Jacopo was sufficiently well known to have stood a chance of winning the Florentine Baptistery Doors competition, he must have already made some sort of reputation as a sculptor—perhaps not in bronze, though his likely training in the shop of his goldsmith-sculptor father would have given him some experience in that technique. A commission for the Siena Duomo in marble before 1397, on the other hand, would have been important as a recommendation for entrance into the competition of 1401–03. The statue itself, though no masterpiece, is still of sufficient quality to warrant that assumption. It can also tell us a good deal about Jacopo's attitude toward his art in or about his twentieth year.

The first thing it tells us is that Jacopo was already acutely conscious of the special stylistic demands of the commission. This is a kind of decorum which is only too rarely mentioned in studies of the art of this period. The figure is about two-thirds life size. It was from the start intended to fit into a niche, but probably not as shallow a niche as that in which it now stands, for the figure of the Madonna has been cut back from the rear on the left side (pls. 1b, 3); the right side (pl. 1a) remains full and expansive.

18. E. Carli, "Una Primizia di Jacopo della Quercia," *La Critica d'Arte* 9–10 (1949–50):17–24. According to Carli and later Morisani, the height is 1.36 meters, presumably including the rather low base which integrally belongs to the figure. The Madonna was, from 1482 until roughly 1575, on the Altar of St. James (San Jacopo Intercisco) in the Duomo. It was placed in its present location only after 1655.

19. It records the painting (at least in part) of the group, which therefore must have been finished qua sculpture at that date. For the reference, see note 18 above.

Nevertheless, the figure was not intended to be seen in the round, though it so expresses the idea of fullness normally linked with roundness that one would expect a well-carved back as well as face and sides. A second characteristic, related to the aspect of decorum of placement, is the tactful echo of earlier sculpture in the Duomo. This Madonna recalls in theme, and in some points of style, the standing Madonna and Child on a smaller scale that decorates the pulpit by Nicola Pisano and his associates (fig. 15). A span of very close to one hundred and thirty years separates Nicola's Virgin from what we believe to be Jacopo's. But certain resemblances to Nicola's style, such as conventions of drapery (pls. 1a-b), leave no option whatsoever to the feeling that here Jacopo was deliberately reviving the past as well as asserting his own voice. Still another characteristic deserves a place in our throughts here. That is the statue's overall expression of gentle optimism. The Child has something of the unique good humor of the three-year-old (despite his minuscule scale). The Virgin (pls. 1–4) combines a queenly dignity with the calm and regularity of beauty of a classic goddess-figure. Thus Jacopo pays a debt to the past in two ways while also projecting his own feeling for form for the future.

After the Madonna of the Siena Duomo there was an interlude of which we have no inkling. Then, in 1401, Jacopo entered the competition for the Florentine Baptistery Doors commission. In this, as we know, he was unsuccessful and shared his defeat with his fellow Sienese entrant, whom he was evidently to know even better in the future, Francesco di Domenico Valdambrino.

The report of the Florentine competition is more widely known than most records of events in any field—whether of politics, economics, or art —of the Italian Renaissance. In the end, Ghiberti and Brunelleschi met head-on as finalists, and ultimately, but only after a bitter controversy, Ghiberti was judged the winner. He gave his own view of the competition and the result with some complacency, perhaps in large part really deserved, in his *Commentarii:*

> To each [of the competitors] were given four plaques [bars?] of bronze. As a trial piece the Committee and the Regents of that temple [San Giovanni, in Florence] wanted each of us to do one story [istoria] for this door; the story they chose was the Sacrifice of Isaac and each of the contestants was to do the same story. These trial pieces were to be carried out within one year and the prize given to him who

won. The contestants were these: Filippo di Ser Brunellesco, Simone da Colle, Niccolò d'Arezzo, Jacopo della Quercia from Siena, Francesco di Valdambrino, Niccolò Lamberti [excluding Ghiberti himself]. We were six [sic] taking part in this competition, which was a demonstration of many aspects of the art of statuary. To me the palm of victory was conceded by all the experts.[20]

Ghiberti then goes on to say that this acclamation of his work was also concurred in by the losing contestants, a doubtful surmise that we can ignore here. It is certain, however, that had Jacopo won, not only his own career but possibly also a large segment of the early Quattrocento development in Italian and European art as a whole, would have taken a different course. The unusually heavy emphasis placed on the Baptistery Doors competition in traditional art history is, if anything, weaker than it should be. The tragedy is that the losing pieces, aside from Brunelleschi's, were destroyed, so that, save through Vasari's laconic description, we have no way to visualize what was a key piece for our artist's first period.

From 1403 on, we know what happened to the winner. We are less well informed about the reactions of the losers. A tradition picked up by Vasari might indicate that Brunelleschi went off on a study-trip to Rome. Vasari also claimed that Jacopo stayed on in Florence, not only during the competition proper but for some years afterward. This surmise does not appear at all likely. For we find, according to recent scholarship, that in 1403 Jacopo was already far from Florence in Ferrara, where he had committed himself to a program of sculpture for the Duomo there.

The program at Ferrara is none too well defined. First of all we know only that Jacopo was involved in making a "cappella" for the Silvestri family, evidently in the cathedral rather than, as has at times been suggested, in the bishop's palace. By "cappella" I think we may understand, not an elaborate architectural chapel but, more simply, an altar with possibly a chantry or grilled-in space protecting it. The beautiful Madonna and Child that Jacopo carved to be placed above the altar-mensa, probably against a wall or in a niche, as will be shown below, is now preserved in the museum of sculpture and other objects of church furniture from the medieval cathedral, located in the upper story of the narthex of the Duomo (pls. 5–9).

According to a modern inscription based on a documented payment of 1408, the Ferrara, or Silvestri, Madonna was until fairly recently dated to

20. Translation in Krautheimer, pp. 12–15.

that year. Evidence is now well within the public domain that the work probably was begun five years earlier.[21] Therefore, the second extant work we can safely attribute to Jacopo is the Silvestri Madonna.

This strikingly beautiful sculpture already shows a considerable advance in scale and in confidence of technique over the earlier standing Madonna in Siena. The forms from the front and sides are full; the volumes are solid; the back, however, is hollowed out from behind, indicating intended placement in a niche or against a wall. The surfaces are rounded and smoothed, though not overly polished (pls. 5, 9). Now, rather than creeping back into the main mass of the block, the Christ Child emerges quietly yet confidently out into the observers' space, standing firmly on his mother's left knee (pl. 7). This is sculpture that boldly takes its place in a spatial context, even though its probable placement in a niche would have detracted somewhat from the strong effect we gain from firsthand observation today; it is a design totally poised, totally balanced.[22] Its powerful, yet refined and civilized serenity of expression has no counterpart in Italy that I know of as of that date (pl. 9). Though dependent in type on earlier examples (fig. 16), it strikes out in a new direction. Despite recent statements in the literature, its style is at last becoming independent of the dalle Masegne; here, unmistakably, is Quattrocento sculpture.

We come now to what until recently was considered Jacopo's earliest extant work and, in some periods of criticism, his masterpiece. This is the famous sepulchral monument of Ilaria del Carretto-Guinigi in the Duomo at Lucca (pls. 10–18). The main problem for us here is no longer that of dating the sculpture or of identifying the subject, as was the case not too long ago. It is to see the work as sculpture rather than as literature or the raw material of literature.

Both the vision of artistic inspiration and the quality of execution justify positive reactions. What is remarkable in the Ilaria Monument is that it elicits not just admiration or delight but brings to the surface emotions deeply associated with basic human decisions.

For Ruskin, as we noted earlier in the Introduction, his first contact with the tomb of Ilaria in 1845 "at once altered the course" of his life. The

21. See M. Rondelli, "Jacopo della Quercia a Ferrara 1403–08," *Bullettino senese di storia patria*, 71 (1964), *Miscellanea di studi in memoria di Giovanni Cecchini* 2:131–42.

22. It is interesting that the measurements indicate that the block was exactly twice as high as it was broad and deep. Something of this mathematical relationship seems to reappear in the relationship of part to part in the finished work.

twentieth-century thinker and novelist of distinction and depth, Charles Morgan (also mentioned earlier) used Ilaria's monument as the scene for the turning-point in the love affair between the two protagonists of *Sparkenbroke*. The erotic element in the sculpture's forms and symbolism is not difficult to find. Nor is its transcendent quality, which evidently appealed to the mid-nineteenth century. The monument of Ilaria is redolent of lilies and (one is tempted to add) of sesame, of incorruptibility, and of the unfading beauty of eternal youth. All this Ruskin quite clearly understood. But the monument still challenges us to define what we should think about it in our own terms and in our own times.

Ilaria del Carretto was the lovely and evidently much beloved wife of Paolo Guinigi, the wealthy merchant-prince of early Quattrocento Lucca. His palaces in Lucca are still to be seen, and they are indeed admirable. His fine taste and sophisticated, cosmopolitan interests can in part, at least, be reconstructed.[23] In December of 1405 Ilaria died in childbirth. Presumably her memorial was not deferred in the planning. And accordingly, and doubtless correctly, its date is generally given as 1406. Possibly the carving extended into 1407 and the assemblage into 1408, for the monument is not at all insignificant in scale or detail of finish. Originally the monument was more elaborate than we see it, with a protective baldachin very probably over the effigy. There was undoubtedly a good deal of polychromy, and the whole would have gleamed with gilt and color from the shadows of the Guinigi family chapel located, it is believed, in the nave of the cathedral. After the decline of the Guinigi fortunes the chapel was broken up, but Vasari gives us the quite credible story that so beautiful was her tomb, and so beloved was Ilaria, that the main sculptural elements were spared. Today the monument has been restored and placed in the north arm of the transept. On a summer's day, when the weather is good, the transept portal is opened and the clear Tuscan light flows over and around the marble body on its marble bier (pl. 14a).

There can be no question that we are dealing with what remains of Ilaria's monument. The coat of arms, which has once more been brought back to the head of the sarcophagus, carries the devices of both the del Carretto and the Guinigi families.[24] The style seems to be adapted to the

23. See S. Bongi, *Le Richezze di Paolo Guinigi* (Lucca, 1874).

24. For a long period of time the coat of arms was separated from the monument. Today it fits its position precisely, and there is clear visual evidence that the wings of the corner putti were originally present but later hacked off. There can be no doubt that we have here an authentic element of the original monument. This would tend to establish a date as 1405–1406/07 rather than some fifteen years later, as suggested on the basis of style alone by

program. It is at once more subtle in delineation of detail and more "international" in style and taste than the Madonna in Ferrara, which by 1405 Jacopo had well begun, if he had not already finished it. The costume is that usually associated with the very early years of courtly fashion in the Quattrocento; the wreath around the brow could be bridal (pl. 12). Seen from the side (pls. 10a-b) the effigy's design emphasizes a marvelously long, simple sweep of the robe over the abdomen clear to the feet. The head may be idealized, but it also strongly suggests an individual (pls. 12a-b). The hands, crossed in repose, are as carefully characterized, and the marriage-ring (on the right hand) is well in evidence (pl. 13a). At her feet is a small dog, the symbol of fidelity, who looks up toward her face (pl. 13b).

Much of this imagery could as well be found in tomb sculpture outside Italy, in France or Burgundy. But in one respect the monument of Ilaria del Carretto departs from northern medieval practice, and in fact sets a new and original standard for Tuscany. This consists in the decoration of the sides of the sarcophagus with winged putti bearing swags of foliage and fruit, on the model of a commonly seen antique Roman motif (pls. 16, 17). These funerary genii are also, in the way they are treated, *erotes*. They are the first putti on a monumental scale of Italian Renaissance sculpture.

Some time ago it was felt that different hands were responsible for the individual sides of the sarcophagus.[25] It is hard to disagree with that view today. One of the sides (pl. 16a) is characterized by fuller, more compact forms and richer modeling. The other (pl. 16b) emphasizes the plane and in some ways tends to flatten and regularize the shapes. In detail these differences show up more strongly. The sculptor responsible for carving the side nearest the wall appears to have been Francesco di Domenico Valdambrino, who is known to have been in Lucca during the period the

Lányi (Bibliog., no. 92). It must be added that Rondelli (see note 21, above) has recently argued that, since Jacopo may be placed by his interpretation of the Ferrarese record in Ferrara as being at work on the Silvestri Madonna, the Ilaria Monument cannot fall within the bracket of 1405–07. There is no reason why the work on the Ferrarese cappella, apparently started in 1403, could not have been interrupted by the more important Guinigi commission, which would have been prompted by Ilaria's unexpected death in 1405, and completed (when Jacopo returned to Ferrara in late 1406) by his *compagno*, Francesco di Domenico Valdambrino. Concurrent programs, as will be seen, are not unknown in Quercia's oeuvre. Nor does the admittedly advanced style require a post-1407 dating of 1413 (as suggested by Del Bravo, p. 26). The supposed dependence of the style on that of Nanni di Banco's St. Luke (ca. 1410–14) does not appear as a realistic factor here.

25. This idea was first proposed by Peleo Bacci. Usually his archivist's eye was not so sensitive to form. In this case, on the basis of stylistic data listed in my text, I think he was absolutely right.

Ilaria monument was commissioned and carved.[26] While Jacopo must probably have designed both sides of the sarcophagus, drawing not only from Roman sources in sarcophagi but also from other types of relief (fig. 17), the tighter, more pinched, and somewhat more timid manner of Francesco's style as seen elsewhere does indeed come to mind in the execution of the wall side. His way of constructing a youthful face, so different from Jacopo's, can best be seen in the polychrome wood figure of Sant' Ansano, in the church of Santi Simeone e Giuda in Lucca (fig. 18). Compare this construction with the face of the putto illustrated in plate 16b.

Francesco was far from a minor figure in his time. He was one of those who competed for the commission of the Florentine Baptistery Doors. He was clearly capable of marble carving, and was also proficient in the easier technique of wood carving. Remains of an equestrian figure in wood at San Cassiano are very probably from his hand (fig. 19).[27] He did, as is better known, work for the Siena Duomo, for example, the four wooden statues of patrons, of which only three busts remain (see fig. 20). He may have helped Jacopo later on the masks of the Duomo of Lucca.[28] His most beautiful group in wood, which is much freer and more convincing than the norm of style generally attributed to him, is the Annunciation in Asciano, of which the Virgin is illustrated here (fig. 23). Finally, probably to be placed in his last manner, is a very beautiful Virgin Annunciate in Volterra (fig. 24).

By the time we find Jacopo at work on the Ilaria del Carretto Monument he quite evidently had reached a point considerably beyond mere juvenilia. He had acquired control not only over the technical aspects of sculpture but over some of its stylistic possibilities. At least he seems to have reached the stage where he could choose between nuances of style to suit the program upon which he was to work. He also had reached the point where he could call upon assistance as it was needed, not from apprentices or minor journeymen, but from reputable artists of his own generation, like Francesco di Domenico Valdambrino. He was on his way.

26. See above, p. 25, note 6.
27. Del Bravo, pp. 45–46, though still more recently there has been opinion favoring part authorship by Jacopo.
28. See below, p. 37.

3 Lucca and Siena, 1409–1425

Even before Jacopo became actively involved with the Trenta Chapel in Lucca and with the actual construction of the Fonte Gaia in Siena he was very probably employed on still another program for the Duomo in Lucca. On this program we are singularly poorly informed by either documents or sources. We know only that in 1411 a campaign of sculptural decoration was begun on the Duomo in Lucca, and we may suppose that Jacopo was the most likely master available to be put in charge of the work. There is nothing in the documents against the choice of Jacopo at this time. However, it is primarily the evidence of style that permits an attribution of the striking standing Apostle (pl. 21), recently placed in the interior of the Duomo, to Jacopo's own hand, about 1412. For some centuries, it would seem, the figure had stood at the foot of a buttress on the exterior, not the interior, of the nave, on the south side (pls. 22, 23). The statue is not in good condition. Weathering has worn and blackened a good deal of the surface; joints in the left arm at one time were loosened so that the entire left arm from shoulder to wrist is missing. However, the statue preserves elements of beauty both in general design and in detail.

The program that called into being this lonely Apostle may hypothetically be imagined as one which foresaw the placement of twelve Apostles at buttress-level of the nave of the Lucca Duomo. There is support from Florence for this reconstruction. Early in the Quattrocento (before 1410) the operai of the Florence Duomo had begun a search to provide for the exterior buttresses around the tribuna of their new church, a series of statues of Old Testament prophets. Of these, only two marbles, soon to be rejected because of their unsuitable scale, had been completed by 1408 by Donatello and Nanni di Banco.[1] In 1410 a much larger and lighter statue in terra-cotta was produced by Donatello as a prototype for this exterior series.[2] Presumably, a similar series of Apostles was foreseen for the buttresses of the nave at Florence at about this time. Here, then, is a striking parallel with the program at Lucca into which Jacopo appears to have been drawn. A date of 1412, which has been mentioned before in the literature,

1. The full documentation is in Poggi, *Il Duomo di Firenze* (Berlin, 1909) recently reissued by the Kunsthistorisches Institut, Florence.

2. Ibid. See also C. Seymour, Jr., *Michelangelo's David* (Pittsburgh: University of Pittsburgh Press, 1967), pp. 28–30, 112–47.

is not unlikely for the Lucchese program. One would have, I think, to give the precedence to Florence in this juxtaposition of two virtually contemporaneous series. However, the smaller scale of the architecture of San Martino, the Lucca cathedral, provided a far better chance for success in completing the program of exterior statuary than at Florence. In both cases the very similar plans ended in the similarity of failure.

The lone survivor of the projected series of Apostles at Lucca was quite evidently designed to be seen from below. The upper torso is elongated, the head somewhat enlarged and the neck lengthened, the legs shortened, the lower edges and volumes of the volutes of the drapery somewhat exaggerated. Jacopo here presents us with his first attempt at a standing male figure, the classic subject of Antique *statua*. Antique influences are unquestionably at work. Not only is the head, with its curly, shortened hairstyle, in the Antique mode (pls. 32, 33), but the full folds of the lower drapery and the loosely sandaled feet (pl. 35) belong in the rather generalized style of interpreting the Antique in the period of 1410–20 in Tuscany, as we can see it in the work of Ghiberti and Donatello.[3] Something of the bold, steady, and direct gaze of Jacopo's Apostle is to be caught a little later in the expression of Donatello's St. George for Or San Michele. But the relaxed pose of Jacopo's Apostle, which asserts a curvilinear design in three dimensions, is probably closer to Nanni di Banco than to anything we can surely ascribe to Donatello.[4]

Nearby, both in space and perhaps also in time, is a most interesting series of heads, which have been incorporated into the masonry of the nave at the juncture of the arches framing the windows (figs. 26–27). Adolfo Venturi was apparently the first seriously to consider that some of these heads adjacent to Jacopo's Apostle might be part of one and the same program and attributable to our master; more recently Heinrich Klotz has advanced the theory that some of the heads are not only by Jacopo but represent in a cryptic way interpretations of the various humours with which mankind is endowed in the classico-medieval view.[5] The influence of both the Antique and the study of quite earthy human types is evident here; as a sample related somewhat in mood to the Apostle earlier discussed, I am illustrating one head out of many that might just as well deserve a place in this presentation (figs. 26 or 27). Jacopo and his co-

3. Krautheimer, pls. 4, 6; Janson, vol. 1, pl. 18.
4. See, for example, P. Vaccarino, *Nanni* (Florence, 1951), pls. 16, 45.
5. H. Klotz, "Jacopo della Quercias Zyklus der 'Vier Temperamente' am Dom zu Lucca," *Jahrbuch der Berliner Museen* 9 (1967):81–99.

worker in Lucca, Francesco di Domenico Valdambrino, may quite conceivably have been given—sometime between 1408, let us say, and about 1412—a commission to supply decorative heads for the cathedral in Lucca. I would not like definitely to back this supposition as a fact now; but the historical possibility is a real one.

The years 1408–09 bring us to the commissioning of the Fonte Gaia in Siena and the situation which was to split Jacopo's activity between Lucca and Siena for more than a decade. For the sake of clarity it is necessary to separate the discussions of Lucchese and Sienese projects, even though in actuality they overlapped. Let us begin with the Trenta Chapel in San Frediano, Lucca.

Lorenzo Trenta, the patron of Jacopo's work in San Frediano, was a wealthy Lucchese merchant. In 1412 he obtained permission to build a family burial chapel on the left flank of the nave of San Frediano, abutting near the choir upon the lowest story of the bell-tower. This was the last chapel to be built in sequence off the left aisle of the older church. The Trenta Chapel today opens out with two impressive arches into the nave. The Trenta coat of arms was carved at the central springing of the entrance arches. Inside the chapel are two tomb-markers set into the pavement in front of a small but intricately carved marble altar dossal. Under the restored altar mensa is a Roman burial urn with an added medieval inscription attesting to the fact that it contains the remains of "San Riccardo Re" (pl. 28).[6]

6. P. Puccinelli, *S. Riccardo Re e la sua cappella* (Lucca, 1947), pp. 34–35, 42–47 (the author was then prior of San Frediano). For sources on "San Riccardo Re" see *Analecta Bollandiana* 49 (1931):353–97 and also *Acta Sanctorum*, Jul., 2 (Lives of Sts. Willibald and Winnebald, the presumed sons of "St. Richard the King"); *Monumenta Germaniae Historiae* 15 (i):80–106; see also G. E. Parks, *The English Traveler to Italy* (Rome, 1954), pp. 69–74. There exists a late manuscript *Life* of "St. Richard" in the Biblioteca Governativa of Lucca; I have not consulted it. In the mid-twelfth century ("poco dopo 1150"), there was a solemn invention in San Frediano of the relics identified with the remains of the legendary Anglo-Saxon king. The cult of the saint mainly dates from that time; it is probably not pure coincidence that at just about this date the name Richard entered the English royal line of the Plantagenets (Richard I, son of Henry of Anjou and Eleanor of Aquitaine, born 1154). In addition to the relics of "St. Richard," the church of San Frediano also contained those of San Cassio, San Fausto, and San Frediano (the Irish St. Fridian) himself. The relics of "San Riccardo Re" are preserved in the Roman burial urn inscribed with his name and now under the altar in the Trenta Chapel (pl. 28, fig. 52). The reuse of the Antique urn logically dates from the time of the ceremonies in the mid-twelfth century; the rather rough imitation of Roman majuscule letters in the inscription may conceivably offer support to the idea. Quercia's inspiration from the little flying female figures supporting the *clypeus* is discussed in connection with the sculpture of the Fonte Gaia.

The documents give us the most trustworthy idea of the chronology of the project as a whole. Work on the chapel proper—no inconsiderable architectural task—must have taken at least a year, perhaps more. This brings us to the question of dating the sculpture. Given the known facts of the accusations against Jacopo and his assistant Giovanni da Imola late in 1413, it would appear that at that time they were already deeply involved in the Trenta Chapel commission. It is equally clear from the same evidence that shortly before the New Year (our style) work abruptly stopped. Only in 1416 did Jacopo return to Lucca for a period of several months. From that stay must date the finishing of the tomb-marker of Lorenzo Trenta, dated MCCCC16 (sic).[7] The commission for the altar is probably to be documented as of the same year, 1416.[8] Probably—but one cannot be dogmatic on the point—the altar was begun by Jacopo during that stay in Lucca. We find him back again in Siena in November 1416. The next available documentary evidence indicates that Jacopo was in Lucca in 1417 and that in the same year Giovanni da Imola was released from prison. He was freed with financial help from the Trenta family. The inference is that the Trenta were getting impatient and wanted their chapel finished, with altar and tomb-markers complete. Evidence of the hand of Giovanni da Imola, both in the tomb-marker of Lorenzo's wife and in the altar, is available, as will be shown shortly. Then there is a hiatus in the evidence. Finally, an added date of 1422 on the altar itself seems to spell *finis*.

The altarpiece today is incomplete. Clearly, finials of an elaborate Gothic type were once envisaged; today the dossal looks uncomfortably truncated (pl. 28), and it has lost all trace of polychromy. In general type, the altar shows a reminiscence less of sculptural altarpieces of the late Trecento

7. The inscription evidently was just a little too long to fit the space; hence instead of "MCCCCXVI," as the date reads in the adjacent slab, the bastard form of "MCCCC16" was used. Arabic numerals were also used in the date 1422 added to the inscription on the altar in the Trenta Chapel (see p. 53). Arabic numerals had already been in use for some years in inscriptions on works of art in Tuscany. A good example is the date of 1407 on the important small bronze St. Christopher in the Boston Museum, thought at first to be simply Florentine; then believed by the late George Swarzenski to have been by Nanni di Banco; then by Hanns Swarzenski to be by Brunelleschi; and most recently by Giulia Brunetti to be, most likely, by Donatello. For a summary of this question, see her article "I Profeti sulla porta del campanile di Santa Maria del Fiore," *Festschrift Ulrich Middeldorf* (Berlin, 1968), p. 110.

8. A chronicle of the Abbey of San Frediano (Biblioteca di Lucca, MS 914) states that on 16 February 1416 Lorenzo Trenta received permission to redo and renovate ("rifare e rinovare") the altar of San Riccardo in the church, as reported by Puccinelli, in *S. Riccardo Re*, p. 43. *Renovatio*, in the usual Renaissance sense of the term, implied a new work, a "redoing," a "remaking," but with respect for the older work replaced. Actually, what we are inclined to call the Renaissance was, in the minds of most Quattrocento thinkers and many writers, a *Renovatio*.

than of painted altarpieces. Undoubtedly the great altarpiece of San Francesco in Bologna finds some echo in Lucca (see again figs., 1 and 35). Still, the echo is weaker than one might expect. The model for the Trenta altarpiece was at least double: an altar in San Francesco, Pisa, in stone and a painting—complete with predella at its base—in the Tuscan rather than the Venetian style. The curiously remote and inhuman style of the major figures of Jacopo's Trenta altarpiece has raised questions.[9] The Madonna, in very high relief, though noble, is nonetheless mannered (pls. 31, 36). The attendant saints have at times difficulty in finding a firm stance and a positive pose (pls. 32, 33). Are they Jacopo's work? I think that in the main elements of design and in some of the execution, the answer is yes. An exception is the St. Jerome, which is almost entirely by another hand, to be identified with the style of Giovanni da Imola, as described below. How to account on the whole, however, for this strange deviation in style from what we would expect of Jacopo at the middle of the second decade of the Quattrocento? The answer, I believe, is in the terms of the commission. In 1416, Lorenzo Trenta was given permission to "renew" and "remake" the altar of San Riccardo Re in his own family chapel. What we see is a kind of compromise between an older altar, probably a painted one, and what Jacopo's patron, Lorenzo Trenta, believed to be a suitable replacement.

The interplay of past with present is characteristic of the entire Trenta commission. The chapel as a *new* addition to a very *old* church provides the basis. Then the permission to *renew* an older altar and to bring the relics of San Riccardo Re into the context of the contemporary Trenta family patron saints (Jerome, Lawrence, Ursula) continues the pattern. A *new* altar constructed in an *old* style would not be at all incongruous in this context. What we must imagine here is an unexpected elasticity of stylistic capability on Jacopo's part as a sculptor. We must think of him as deliberately working in a style that would harmonize with the past rather than with the present or the future. This concept of so flexible a style for an artist of the Quattrocento may not be easy for us to accept. But in Jacopo's case, as we see it today, I believe there is no alternative. He worked for a certain program at a certain time; the style evolved to fit the need, and was chosen, or emphasized, for the occasion or the place.

The altar of the Trenta Chapel is not a large monument, and the marble relief dossal is about average size if compared with painted dossals of the

9. See Hanson, p. 47.

period—that is, from about 1400 to 1425.[10] It is composed of three distinct pieces of marble of greatly varying size and of differing texture and color. The largest piece of marble was that used for the Madonna, flanking saints, four half-length prophets on the pinnacles over the niches housing the saints, and the framing elements that survive (pl. 30). To carve so many figures and so much delicate detail from a single relatively shallow slab of

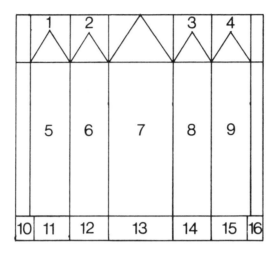

The Trenta Altar
Schematic Division of Subjects

1–4. Prophets (half length)
 5. St. Ursula (full length)
 6. St. Lawrence (full length)
 7. Virgin and Child (full length)
 8. St. Jerome (full length)
 9. St. Richard the King (full length)
10. St. Catherine (half length, relief)
11. Martyrdom of St. Ursula (relief)
12. Martyrdom of St. Lawrence (relief)
13. Pietà (half length, relief)
14. Miracle of St. Jerome (relief)
15. Miracle of St. Ursula (relief, 17th-century?)
16. St. Ursula (half length, 17th-century?)

10. According to Morisani, the altar measures 4.39 m. high from the floor, the predella being just a fraction of a centimeter over 3 m. in length. In addition, my measurements (to an eighth of an inch only) are: height of dossal, 90 in.; height of predella, 16⅝ in.; height of plinth below it, 5 in. The standing figures of the dossal measure between 45 and 45⅝ in. in height, in other words, not much above half natural size. Photographs and even firsthand experience of the monument give a false impression of greater size than is proved by measurement.

marble is in itself quite a tour de force, and undoubtedly Jacopo must have had assistance in the phase of execution, though not necessarily in the phase of design. From the documentation we know that he had one assistant for his work on and in the Trenta Chapel who was not listed as a master, a certain Masseo, of whom we know nothing more. There was another assistant, who has achieved a place in the annals of Sienese sculpture, a certain Giovanni, who originated in the Emilian center of Imola.[11] Both Masseo and Giovanni da Imola were mentioned in the accusation leveled against Jacopo in December 1413. Since Jacopo went back to Siena and did not return to Lucca for an extended period until 1416, and since Giovanni da Imola was not released from prison until early in 1417 (our style), the collaboration of Jacopo and Giovanni on the sculpture's execution could not have occurred until as late as 1416/17. After Jacopo's return to Siena in 1416/17 to finish the Fonte Gaia, he probably left Giovanni at Lucca to complete the altar dossal.

We know reasonably well what Giovanni's personal style in marble might have looked like at this time from documented reliefs of two Evangelists (Mark and Luke) which he laid out, carved, and evidently all but finished in the early 1420s for a pulpit in the Siena Duomo (fig. 37). It is a rather harsh and angular style, somewhat aggressive and mannered, featuring a combination of flattened planes and active lines most apparent in rather violently twisting folds of drapery. This style appears in the tomb-marker of Lorenzo Trenta's wife (fig. 32), dated 1416. Very possibly Jacopo laid out the design; but in every vital stylistic respect, including depth or protuberance of mass in relief, this marker plainly differs from the companion marker for Lorenzo (see pl. 29). In the man's marker the relief is stronger and the drapery less fussy, and the form of the body more clearly suggested beneath it. This figure represents a recognizable step beyond the Ilaria effigy of a decade earlier and already suggests the style of the Fonte Gaia figures and some aspects of the style of Bologna, somewhat later. Though the face and right hand are abraded by centuries of careless scuffling of feet, the essential quality of the work remains virtually intact; it is one of the finest monuments of its kind of the entire Quattrocento, quite comparable in quality to similar programs by Donatello and Ghiberti (Duomo, Siena, and Santa Maria Novella, Florence).

It is altogether possible that Giovanni da Imola worked with Jacopo on the little half-length prophets of the altar; the weakest head is that of the

11. See Carli, p. 120.

bearded prophet at the extreme left, which could be entirely by Giovanni (pl. 35a). As earlier noted, Giovanni's hand is most recognizable in the head of the standing St. Jerome (pl. 33, fig. 33). It is to be compared with what I take to be Jacopo's design and probable execution of the head of San Riccardo Re. The full, regular forms of the head, the shapes of the mouth and the smallish rounded chin, the handling of the hair are all very close to comparable elements in the head of the Lucca Duomo apostle (figs. 33, 34), which must be by Jacopo himself.[12] On the other hand, the drapery of the king's image has much of the hardness and fussiness that we might well associate with Giovanni's style. He could have worked on the drapery of some of the figures as well as on the head of the St. Jerome. The question of collaboration here is most difficult, and we need a full photographic corpus—enlarged and detailed—to push the study toward more definite conclusions. It would be wisest to leave the matter in an admittedly fluid state.

However, this is not to relax in any way a firm critical standard regarding style and quality. For example, in the predella—of which we shall discuss three scenes later (those under the figures of St. Ursula, St. Lawrence, and St. Jerome)—there is what seems to be clear evidence of an assistant's hand in the central group of Christ between the mourning Virgin and St. John (fig. 36), though the striking design must be Quercia's own work. A much more alien hand is evident in the relief under the San Riccardo Re. The marble is of a very different quality from that of the rest of the predella, and the style is far closer to the Baroque than to the Early Renaissance. There is a break in the continuity in the moldings as well as in the marble, which shows clearly in figure 38. It would appear that the original right corner of the predella was at some time damaged and a copy of the original design, showing a miracle of the "saint," was substituted. We know from an inscription still preserved in San Frediano that the altar was thoroughly worked over and added to in or about 1625.[13] Possibly the supposed damage and replacement occurred at that time. At all events,

12. See, however, A. C. Hanson's doubts of Jacopo's own hand in the standing saints and central Madonna of the altarpiece. Hanson, pp. 47–48.

13. Remodeling work began in 1616 (Morisani, p. 64). The inscription recording the end of work reads as follows: ALEX. PHANUNTIUS. PATRICIVS. LVCEN. CONSTRVI. FECIT. A.D. MDCXXV. It refers to the patron of the remodeling, who was Alessandro Fanucci of Lucca. The stone is preserved in the inner courtyard of the claustral buildings of San Frediano; it was formerly in the Trenta Chapel proper, close by the altar. The Baroque additions to the altar were removed in 1883. In 1947 the present modern altar-table was consecrated after a new verification of the contents of the urn containing the relics of the saint.

the highly pictorial relief style (see fig. 39) should not be confused with Jacopo's own style, even though the compositional basis must be closely derived from his original.

We may now turn to the more or less contemporaneous sculpture of the Fonte Gaia. The project as a whole antedates the beginning of the sculpture by at least six to seven years; the most optimistic estimate of the chronology of Jacopo's slow and far-from-steady progress on the sculpture for the fountain can hardly place the earliest reliefs before 1414, or possibly even 1415. The original commission, as we know from the relatively complete documentation, dates from 15 December 1408. A second, modified contract of 22 January 1409 followed. It specified that a drawing, at full scale, of the fountain as it was to be executed was to be made on a wall of the Palazzo Pubblico overlooking the site close by the curving eastern edge of Siena's central piazza, called the Campo. Jacopo's Fonte Gaia was to replace an older Trecento fountain on very much the same location; we have no clear idea of what that earlier structure was, but we do know that it contained a painted image of the Virgin, who was the chief patron of the city, and that for a time an Antique statue of a female (Venus?) also decorated it.[14]

In contrast to the main portion of the Trenta Altar, which is as we have seen, so permeated with medievalism, the sculpture envisioned by Jacopo for the Fonte Gaia is strikingly motivated by enthusiasm for the Antique. The architectural form of the fountain, with its roofless open construction, its rectangular double basin with multiple spouts for the ingress of the water, its carved marble figures in shallow niches, as well as its free-standing figural elements (pl. 48), recalls a rare type of Roman nymphaeum; in a mid-fifteenth century poem the Fonte Gaia was actually referred to as "sacred to Apollo and Muses."[15] To be sure, the Virgin and the theological

14. Hanson, p. 9.

15. a) Est urbis medio Campus quo pulchrior usquam
 Non datur in terris cerni mortalibus alter
 Hac qua parte sacer Musis argenteus exit Fons.

[Chigi MS, fol. 14, in a poem, "De immanitate pestilentiae," addressed to Goro Lilli]

 b) Quaere iter ad fontem Phoebo Musisque sacratum,
 Quo non Castalii gratior unda fuit.
 Est in conspectu geminos enixa Quirinos
 Ilia, marmorei nobile fontis opus.

[Ad librum suum de Institutione Reipublicae quem Senam mittit]

Quoted by L. F. Smith, "A notice of the Epigrammata of Francesco Patrizi, Bishop of Gaeta,"

Virtues are given places of prominence in the imagery of Jacopo's pro-
gram; but from the start, or close to it in any event, the inclusion of the
Roman legendary personages Acca Larentia and Rhea Silvia, mother and
foster-mother of Romulus and Remus, was to symbolize the Roman foun-
dation of Siena and its traditional link with the mainstream of Roman
history.

There were at least three major phases in the fountain's design and pro-
gram of imagery. The first we do not know as well as we might like to,
since the text of the original contract, which exists only in a confirmation
of 1412 and 1416, does not specify subject matter. However, the early
modification of the program, an evident enlargement of the sculptural
scheme, exists in fuller written form (see Appendix) and, fortunately, also
in two fragments of a drawing on parchment made to record visually in a
notary's file for future reference what the contract of 1409 specified ver-
bally. One of these fragments is in the Victoria and Albert Museum; the
other is in the Metropolitan Museum in New York (figs. 40, 41). Together
with a missing center strip that probably showed the Madonna and Child,
which we must supply mentally, they give a remarkably clear, though
somewhat generalized, stylistic view of what Jacopo and his patrons of
the City Council (*Concistoro*) had in mind.[16] In plan, the second phase of
the Fonte Gaia may be reconstructed as follows:

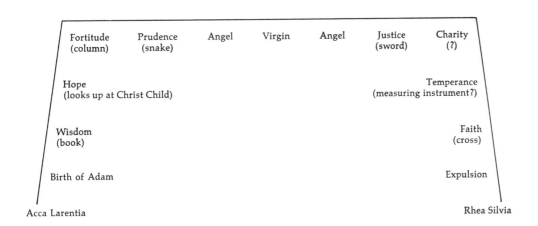

Program of Imagery for the Fonte Gaia as of January 1409 (after Hanson)

Renaissance News 15 (1968):92–143. As an example of the type of Antique nymphaeum that
might be related in plan and program to the Fonte Gaia, see the Roman nymphaeum at
Olympia, close by the commercial port of Pyrgos, available to Italian ships.

16. For the most recent summary of opinion on the two drawing fragments, see C. Sey-
mour, Jr., "Fatto di sua mano" (Bibliog., no. 103).

In 1415 a second modification in the plans for the fountain occurred. The wings of the fountain were to be splayed outward from the back base and also lengthened. Similarly, the back was to be lengthened. Two angels were to be introduced to flank the Virgin in the central arch of the rear interior wall, and two scenes from Genesis, the Creation of Adam and the Expulsion from Eden, were to be added to the interior of the wings; furthermore, the Angel and Virgin of the Annunciation of the 1409 drawing were to be replaced by Virtues, bringing the total of the Virtues to eight (the three theological Virtues and the four cardinal Virtues plus a generic Christian Virtue, Wisdom).[17] This revised scheme is suggested below:

Ape					Dog
Fortitude (column)	Faith (cross)			Justice (sword)	Humility (burning candle)
Temperance (pitcher)					Prudence (3 eyes)
Angel Gabriel (lily)					Annunciate Virgin (without wings)
Acca Larentia					Rhea Silvia
Metropolitan Museum					Victoria and Albert Museum

Program of Imagery for the Fonte Gaia as modified in 1415 (after Hanson)

Recorded is a decision by the Sienese Council in 1416 to change the waterspouts to she-wolves (*lupae*) ridden by putti, but to our knowledge this was never acted upon; however, a spout in the form of a *lupa* without any putto was on the fountain as late as the mid-nineteenth century (see pl. 38a). This figure has not been brought up to the loggia with the remainder of the fragments from the Fonte Gaia but instead has found an obscure resting-place on an upper landing of the stairs in the Palazzo Pubblico. It is not in the best condition (fig. 44), and it does not easily fit the requirements of Jacopo's style—or, for that matter, of his period. The drawing of 1409 suggests that an emblematic she-wolf, possibly a spout figure, was even before 1416 considered for the fountain (see again fig. 40). Unfortunately, with the dismantling of the Fonte Gaia in 1858, many of the secondary, utilitarian, and even decorative elements have been lost,

17. For the rich conjunction of civic and religious meanings in the imagery of the Fonte Gaia, see the most recent analysis in Hanson, pp. 22–34.

though valuable casts of the major sculptural units were taken; we shall have reason to return to them shortly.

The chronology of the sculpture of the Fonte Gaia, which must bring to bear the stylistic data on the outline of the planning of the fountain as a whole, has recently been reexamined and stated elsewhere with admirable brevity and firmness.[18] It would be superfluous to reenter the closely reasoned argument, based on acutely observed phenomena of forms and style. There is only one point, or possibly two points, of difference of opinion that should be mentioned here. The first, in logical order, concerns the date of the beginning of Jacopo's work on the sculpture. It has been suggested that Jacopo may have begun the Virgin and Child for the fountain by 10 January 1414, or possibly even earlier; some three to five figures in relief in all are advanced as being part of a first phase of work between 10 January 1414 and 18 January 1415. Again, considering the documentation, it would seem that a date of 1414–15 for this phase is over-optimistically early. Rather than ending in January 1415, I would see the first phase as beginning, still with the Madonna, at about that time or even several months later. This would, in general, push the work of carving and installation forward in time, and into three, rather than four, separate periods or phases of intense activity on Jacopo's part—with important assistance, particularly toward the close, during the course of the years 1418 and 1419. As I would imagine the process, the sculpture was done bit by bit in constituent parts (whether ornament, relief, or free-standing) and was finished before installation. The installation would have come last of all, obviously, in 1419.

There is so much homogeneity of style in what is left of the sculpture of the Fonte Gaia that I believe we must suppose Jacopo personally designed the *modelli* from which assistants worked, and that his hand is to be found in virtually all parts of the surviving pieces of figural sculpture, as well as in some of the ornament (see, for example, the charming putto in an accanthus rouleau shown under an angel in pl. 47b). Possibly the main ideas for the design of the Fonte Gaia sculpture were worked out before the design of the Trenta Altar. In point of fact, the style is much looser, much more humanistically inclined toward the Antique, than any part of the main section of the Trenta Chapel dossal. In this respect the Fonte Gaia takes up the style of the Lorenzo Trenta tomb-marker and moves on to new, and in some cases surprising, conclusions; one might

18. Ibid., pp. 80–81.

even turn the proposition around and say that the Lorenzo Trenta tomb-marker was the product of Jacopo's early thinking about the Fonte Gaia.

Quite possibly the central Madonna actually, as well as logically, marks the beginning (pls. 37, 42). If so, it reveals a new, unusually lyrical mood, not only for Jacopo but for Tuscan sculpture as a whole. The nearest equivalent is not in the solemn, heavy forms of Donatello (i.e. the so-called Pazzi Madonna, Berlin-Dahlem) but in the more joyful interpretation of the Antique in Nanni di Banco's Virgin of the Assumption in the frontis-piece of the Porta della Mandorla of the Florence Duomo, which Vasari went so far as to ascribe to Jacopo. The sideways pose of Nanni's Assunta (fig. 51) has recently been compared with one of Jacopo's Virtues for the Fonte Gaia (pl. 43).[19] If we take the dates of the two programs without questioning too closely the details of the dates of progress within them, we have to give the priority to Jacopo (1408–19) as opposed to Nanni (1414–22). We might even go so far as to suggest that the motive of Nanni's Vir-gin originated in Siena (fig. 43). However, we know so little about the in-ternal dating of the comparable units of design within each contemporary program that a clear statement of priority is risky, if not impossible. What I believe we *can* state is that, in a general way, Vasari's error is an interest-ing and, for us, a historically fruitful one. At one point in time, say from about 1415 to about 1420, Jacopo and Nanni seem to have been investigat-ing, on parallel paths, possibilities of active shapes in high relief with strong influence from the Antique. Exactly who derived what from whom it is not possible to say; perhaps there was in fact no direct contact be-tween the two sculptors or between one sculptor and the work of the other. They could have come independently to remarkably similar ideas of proce-dure.

The part of purely Sienese tradition in Jacopo's work is important. The type of design of the reliefs of seated Virtues, who appear in an ornate yet very dignified architectural setting, evidently derives from the Trecento decoration of the enclosure of the Cappella del Campo, the outdoor chapel attached to the façade of the Palazzo Pubblico located almost exactly op-posite the site of Jacopo's Fonte Gaia on the other edge of the square.[20] The

19. M. Wundram, "Jacopo della Quercia und das Relief der Gürtelspende über der Porta della Mandorla," *Zeitschrift für Kunstgeschichte* (1965), pp. 121–39.

20. The observation of the relation between Jacopo's Virtues and the Cappella di Piazza Arts is due to Heinrich Klotz, who is working up the question for publication, which I hope will come out very soon. The Geometry (fig. 43), as well as Quercia's figure derived from it, could have been the forerunner of Nanni's Virgin of the Porta della Mandorla; it would be hard to disprove the idea, though it is not too likely within the context of Nanni's art. Quer-

original reliefs of the Cappella di Piazza have suffered much the same adverse fate from weather as has Jacopo's sculpture for the Fonte Gaia; in ruinous condition, the two reliefs representing the Liberal Arts that flank the entrance to the chapel have been replaced by rather tightly designed and somewhat fanciful pseudo replicas in harder, harshly white Carrara marble. The originals are preserved on the landing of the stair just above the entrance to the main floor of the Palazzo Pubblico. The figure of Geometry is in the better state (fig. 43), and the strong resemblance to Jacopo's general scheme is self-evident (pl. 39).

At the same time, influences of this sort from earlier medieval Sienese tradition should not be stressed at the expense of influences from the Antique, which Jacopo could have picked up in Siena and even more easily at Lucca and Pisa.[21] Particularly interesting is the way Jacopo adapted elements of the Roman funeral urn that contains the relics of San Riccardo Re in Lucca:[22] the sharp twist of the heads to the profile in the winged supporting female figures, together with the flowing drapery style, characterize Jacopo's Temperance on the right wing of the Fonte Gaia, which I have already mentioned (see again pl. 43 and also fig. 52). The little funerary genii of the Roman urn in Lucca also seem to have influenced the standing putti above the angel flanking the Fonte Gaia Virgin, to the left (fig. 45). Again and again the ornamental themes seek out classical models (see again fig. 45 and pl. 47b). Heads revert to classical types in all the Virtues which have been preserved in that respect (pls. 43, 44, 47a). The pose of the standing angel to the left of the Virgin follows a familiar Antique balance of the figure's weight in the pose (pl. 40). The flutter of the drapery motifs in the pendant angel to the right, together with contrasting straight and curvilinear folds of drapery over the legs, inevitably take us back to some classical model—unfortunately not easy to pinpoint exactly today, although the general type is familiar enough (pl. 41).

The spirit of classical Antique art is perhaps best exemplified in the reasonably well-preserved and very beautiful Wisdom (pl. 44). It is well known that Wisdom, *Sapientia*, was frequently associated not only with the Creation (represented on the Fonte Gaia) but with the Liberal Arts, the theological Virtues, and the Virgin, mother of Christ (*Sedia Sapentiae*) to

cia's debt to Nanni is dubious; he had constant access to the "Geometry" and only rare access, and decidedly late in date, to Nanni's work for the Porta della Mandorla relief.

21. This aspect of Jacopo's fountain-sculpture has been admirably handled by Mrs. Hanson, pp. 54–66.

22. See above, p. 38.

whom the city of Siena was dedicated.[23] So it is not surprising to find that the eighth Virtue, needed for purposes of symmetry in the design of the Fonte Gaia, is Wisdom. She holds the appropriate attribute of a book which supports her left hand (in a pose not far removed from Donatello's seated St. John for the Florence Duomo),[24] and in her right hand there are remains of what originally was Jacopo's remarkably accurate interpretation of an Antique lamp (pl. 45).

The Virtues were intended to be differentiated—not only by their attributes (in some cases unfortunately missing or badly damaged) but also by pose, proportion, and arrangement of drapery. For example, Faith (pl. 48) is given very long attenuated proportions, and the head moves out over the edge of the rounded summit of the niche.[25] On the other hand, Hope, opposite, fits more gracefully and easily into the niche; from what one can judge of its earlier total proportions from a nineteenth-century plaster cast (fig. 53), it would seem to have had more classicizing proportions and drapery, corresponding in style to the beautiful fragment of the head that has been preserved along with that of the Christ Child. Jacopo's Hope design made an impression on Quattrocento art; it was imitated by Matteo Civitale in a beautiful (unfinished) relief now in the Bargello (fig. 54), and the design also appears in reverse on the back of a marriage-salver of about 1460–70, now in the Virginia Museum of Fine Arts in Richmond.

Because of the frightful damage to the fountain's sculpture—both before and after it was dismantled—the discussion of the remaining Virtues as well as of the Creation scene on the left wing is not easy. Casts made from the originals at the time of the dismantling, as an aid to Sarrocchi, the sculptor of the replacement fountain in the Campo today, have been preserved in the Palazzo Pubblico along with valuable casts of Jacopo's work from elsewhere than Siena that has also suffered weather damage, though not so dramatically severe. Figures 46–47, 53, 56, and 63, though the original values of the stone sculpture are necessarily distorted by the dead

23. See, for the associations of *Sapientia* in early Renaissance and medieval symbolism, Philippe Verdier, "L'Iconographie des arts libéraux dans l'art du moyen âge jusqu' à la fin du quinzième siècle," *Actes du Quatrième Congrès International de Philosophie Médiévale* (Montreal-Paris, 1969), pp. 305–55 (see especially pl. 2).

24. See Janson, 1, pls. 11–12. The figure, completed in 1415, was intended for the façade of the Florence Duomo; it is preserved in the Museo dell'Opera del Duomo in Florence.

25. These proportions, so unusually outside the Quercia canon, recall the elongations in drawings by Parri Spinelli, who was working with his father, the painter Spinello Aretino, in Siena when the Fonte Gaia was first designed and the drawing on parchment made (1408–09). Possibly the elongated Faith by Jacopo retains some echo of that early phase in the fountain's history.

whiteness of the plaster, give the best idea available today of what Jacopo seems to have had in mind.[26]

Still reasonably visible is the relief of the Expulsion from Paradise, probably the most dramatic composition Jacopo had conceived and carved up to then (pl. 49). Here for the first time, on what one may call the adult scale (as opposed to the earlier putti of the Ilaria del Carretto-Guinigi Monument), Jacopo portrayed physical force incarnate in the nude, *all' antica*, motivated by strong human psychology and dominated by an implacable will. The ruined remains of this unforgettable composition stress the tension of taut muscles in contrast to the graceful open hands of both Adam and Eve (pl. 50); these hands grasp only at air, at a new nothingness, quite beyond their knowledge of an earlier experience in Eden. The stride of the Angel expresses the irreversible power of the Old Testament divinity's will in purely physical terms: there is no turning back here, even in the most literal sense of the phrase. In contrast, the reclining torso of the Adam of the Creation (pl. 51) suggests physicality just coming into being; we see only the potential rather than the fully acquired means of strong movement and purposeful action. The influence of the Antique is very strong in both these reliefs. Without its prestige and example, the concept of the heroic nude, here appearing in marble in Quattrocento Tuscany for the first time on a monumental scale, would probably have been impossible for Jacopo to formulate.[27] In the Expulsion relief the narrow stage of action derives directly from the limited space of Roman sarcophagi relief style; and even the pose of Adam as he is pushed from Eden into the new world of work and death as well as knowledge, seems to echo in a stumbling, unutterably tragic way the pose of the hero as he kills the boar in the well known Meleager-type Roman sarcophagi (fig. 57).

Later Quattrocento or early Cinquecento versions in varying materials testify to Renaissance appreciation of Jacopo's inventive design (figs. 58, 59). Quite late in the century, when Antonio Federighi was supervising the commission for the marble font in the Duomo proper of Siena (not that of San Giovanni, below and to the east), the sculptor, whoever he may have

26. For a complete set of photographic reproductions and discussions see: A. Bertini, "Calchi della Fonte Gaia," *Critica d'Arte*, n.s. 15 (1968):35–54.

27. How strange that in his deservedly popular book, *The Nude,* Kenneth Clark should have omitted any mention not only of this relief but even of Jacopo himself. Jacopo's Sienese reliefs precede Masaccio's paintings of the heroic nude by just about a decade. His strikingly similar St. Lawrence relief in San Frediano, Lucca, which we shall discuss very shortly, anticipates Masaccio's Baptism nudes in the Brancacci Chapel by about five years.

been, but doubtfully Federighi himself, followed literally both the Expulsion and Creation reliefs Jacopo had provided for the Fonte Gaia decades earlier (fig. 60).

We now come to the two most remarkable units of the Fonte Gaia sculpture: the free-standing statues of Acca Larentia and Rhea Silvia, each with the twins, Romulus and Remus. One, the Acca Larentia, has quite generally been accepted as Jacopo's work in its entirety; the other, Rhea Silvia, is still the subject of disagreement as to authorship. The problem can be grasped visually by looking at pls. 52a-b, in which both pieces are shown side by side and at the same scale. What one sees in the Rhea Silvia, on the left, is a composition which gives us an impression that the forms somehow never quite got free of the block of marble. The main figure is shown frontally in comparison with the other, and the forms of the subsidiary masses all seem to be crowded together, struggling to reach the same frontal plane. The folds of drapery seem to clog the design rather than to liberate by contrast the gentle swellings and easily flowing curves of the nude portions. Early records of the Rhea Silvia indicate that tradition had it in Siena that the statue was not by Jacopo but by his onetime assistant at Lucca, Francesco di Domenico Valdambrino. This traditional view has been fairly recently opposed, and a closely knit argument has been presented by Hanson to rescue this admittedly beautiful and historically important marble entirely for Jacopo's own chisel.[28] Possibly our view today of the style is flawed by later restorations, including the awkward replacement of the right arm of the woman and the legs of both boy and woman, who stand on the ground (quite evident in the photograph). What this photograph does not show is the back of the group, which is much freer in design and is decidedly more like the style we associate with Jacopo.[29] Conceivably, Jacopo could have shared the execution of the Rhea Silvia with Francesco in his haste to complete the sculpture for the fountain in 1418; in this case we would have to say that Francesco took over the job of finishing the front of the statue—certainly not a usual division of labor between master and assistant, but not impossible here.[30]

28. Hanson, pp. 66–75. Morisani, p. 25, had attributed the design, though not necessarily the execution, of both groups to Jacopo.

29. Hanson, pls. 70, 73, 79. Quite correctly, Mrs. Hanson cites the back-drapery forms of the Rhea Silvia as entirely comparable to the equivalent shapes in the Acca Larentia—"it seems that the formal language of the two figures is the same" (p. 75)—but from this point of view only, not necessarily from the front.

30. One of the arguments raised by Mrs. Hanson against Francesco's part in the Rhea Silvia is that he would have been technically ineligible to take part in the project, since he

The smoothly flowing rhythms of the Acca Larentia set up a more three-dimensional impression (pls. 53, 54). Nowhere up to this point had Jacopo embarked on so daring a combination of the nude and the seminude, of interlocking curves and rounded shapes (pl. 55). Nowhere before, and perhaps never again, was he able to equal so compelling a combination of lyrical thrust and physically joyful eruption of form with the calm control of some Antique Roman forebear's sense of measure.

A carry-over from the Acca Larentia is evident in the three little reliefs that we can attribute to Jacopo in the predella of the Trenta Altar (pls. 56, 57). These reliefs appear to have been carved, perhaps in Siena or perhaps in Lucca, after 1419 when the Fonte Gaia at last was finished. On the base under the central figure of the seated Madonna of the Trenta Altar is an inscription in Gothic majuscule to which a date is added in a different hand and in incongruous arabic numerals:

HOC OPUS FECIT JACOBUS MAGISTRI PETRI DE SENIS 1422.

Usually in the literature this date of 1422 is taken as the terminal date for Jacopo's work for Lorenzo Trenta in San Frediano, and in view of no positive evidence to the contrary, I am leaving the point unchallenged here.[31]

Therefore, a hiatus of several years between the work of Jacopo and Giovanni da Imola on the dossal of the altar and the style of the predella panels may be provisionally accepted. The first scene, starting from the left, is based on the martyrdom of St. Ursula, whose standing figure is placed just above, in the altar dossal. The first impression this relief style gives is one of a considerable difference compared with the convoluted, interweaving, and overlapping elements of the Creation and Expulsion re-

was in titular charge of it as operaio and, as probable guarantor, morally responsible to remain uninvolved. However, there is evidence that early in 1418 Francesco was relieved of those responsibilities in relation to the Fonte Gaia; thus he was theoretically in a position to help just when help was needed most, at the end. There is no conclusive reason to place the Rhea Silvia much, if at all, chronologically ahead of the Acca Larentia; both groups would have been done in 1418, that is, well along toward the end of the active carving for the project—exactly where we would expect the work on these two semi-independent groups to fall logically in the time-schedule.

31. The same date of 1422 occurs in another inscription on a stone sealing the burial crypt of the Trenta family, also to be used for burial of indigent pilgrims. This is reported by Morisani, p. 64, as follows: "HOC SEPULCRUM INSTITUIT LAURENTIUS TRENTA FAMILIIS SUE DOMUS ET PEREGRINIS HAC [sic] PAUPERIBUS XI [sic] PRO SALUTE SUE . . . ET O[M]NIBUS SUORUM. MCCCXXII." The date must be interpreted as reading 1422 rather than 1322, which is wholly out of historical context. I am still assuming that the first part of the Trenta Altar inscription (without the added numerals) belongs to the finished dossal but not to the predella.

liefs of the Fonte Gaia. The relief here is much flatter; there is no actual air between overlapping limbs; the space is radically compressed after the "Roman sarcophagus-space" of the Fonte Gaia Creation and Expulsion reliefs. Plate 57 is a somewhat enlarged detail of the St. Ursula story. What it reveals is a remarkable balance between meticulous attention to detail and a broad, even sweeping sense of line and volume in the overall design. This relief style is a conscious adaptation of the discoveries made in the course of the Fonte Gaia reliefs to the much smaller scale of the Trenta Altar, and also to the unspoken but evidently still felt relationship of the altar's program to the earlier painting it supplanted.

Plates 56a and 56b present stories from the legends of St. Jerome and St. Lawrence, both of whom are represented above the reliefs as patron saints of Lorenzo Trenta and his son Girolamo. Though each scene is presented in an architectural context, there is no effort at all to deepen the impression of space behind the figures, as one might expect in Florentine art. Instead, the figures are given maximum bulk and impressiveness and are brought out as closely as possible to the front-relief plane. The background planes are foreshortened in the St. Jerome relief to prevent the spatial flow in a backward direction away from the front-relief plane (I almost wrote "picture-plane"), and thus provide immediate planar support to the figures in stronger relief. In the St. Lawrence panel a row of Roman arches reminiscent of an aqueduct stretches across the background in very low relief—hardly touching at all the impermeable back-plane that comes up, once again, directly to support the figures. The latter are given a maximum of muscular development and vigor of action. The recumbent saint is drawn from Jacopo's increasing knowledge of the Antique. It also offers one of the plainest models we know for Masaccio's famous nudes of the baptism scene in the Brancacci Chapel.

Between 1419, when the Fonte Gaia was finished, and 1425, when Jacopo received the commission for the Porta Magna of San Petronio in Bologna, there was a five-year period in the artist's career in which there was no single, large, dominant project to occupy his attention. We must probably imagine him as busy with a number of concurrent smaller, but by no means uninteresting, tasks. There were of course the predella reliefs for the Trenta Altar in Lucca to complete, and, as we shall see in the next chapter, Jacopo still owed a relief to the Baptistery Font in Siena. But quite obviously there was hardly enough here to occupy him or his bottega in Siena for so long a period as five years. Accordingly, it is not surprising to

find him employed as architect rather than sculptor by the Commune of Siena in its military defense system, and inspecting in the spring of 1423 the Sienese strongholds of Cetona, Sovanna, and Manciano.[32] From this period may also date Jacopo's best-known compositions in wood sculpture. Wood was easier for him to work than stone. It was also easier for him to complete, since the finish of wood statuary was elaborately colored by painters, with a base of gesso on which gilt and bright pigments were applied. Perhaps from about this period—that is, ca. 1425—dates the *beginning* of an entire class of wholly undocumented secondary objects—some in wood but others in terra-cotta and stucco, also polychrome—based to some extent on Jacopo's style but in most cases probably not even from his bottega. This kind of production must be thought of as continuing on a desultory, still largely uncharted course until 1500.

Let us begin with the category of works in polychrome wood. We have seen in the previous chapter that Jacopo could have learned the first rudiments of his art in his father's shop, which besides goldsmith work specialized in wood carving. We do not know, however, what precisely his first work in wood was. A recently discovered Virgin Annunciate now in Berlin-Dahlem has been stated to be by Jacopo and dated to an early part of his middle period, about 1410.[33] The lifesize figure, though evidently somewhat restored, is attractive (pl. 19). It may be the prototype of a Virgin in the Louvre (fig. 21) and would appear to be that of the Annunziata (see fig. 22) now in the Rijksmuseum, Amsterdam, and attributed to Francesco di Domenico Valdambrino. This latter Virgin with attendant Angel has a provenance from Pienza.[34] The provenance of the Berlin-Dahlem figure is not published, and if provided by the dealer, whose name is also unpublished, would normally require rather lengthy checking. We are consequently left at this time without much needed collateral information, indeed, with the data of style alone as a criterion for attribution; up to now informal inquiry has indicated no unified consensus either in favor

32. At about this time we find Jacopo's name linked with that of the extraordinarily interesting Quattrocento engineer who went by the name of Taccola, and who in many ways prefigures not only the later Sienese Francesco di Giorgio, but the Florentine Leonardo da Vinci. In 1428 Quercia stood as godfather to one of Taccola's children. Taccola and his drawings, which have fortunately survived in some quantity, are the subject of a publication recently brought out in Italy by James H. Beck: *Mariano di Jacopo detto Il Taccola. Liber Tertius de Ingeneis ac Edifittiis Non Usitatis* (Milan, 1969), pp. 14, 18, 19.

33. M. Wundram, "Die Sienische Annunziata in Berlin, ein Frühwerk des Jacopo della Quercia," *Jahrbuch der Berliner Museen* 6 (1964):39-52. Since 1964 the attribution to Jacopo has been contested in favor of Francesco di Domenico Valdambrino (Bibliog., no. 110).

34. Carli, p. 60, pl. 90b.

of the presence of Jacopo's own hand or against it. The chance for a possible attribution to Jacopo is sufficient, however, to warrant the provisional —but only provisional—inclusion of the Berlin-Dahlem figure in Jacopo's oeuvre. There are evident links with the style of the Ilaria del Carretto Monument in Lucca (pl. 18), though the quality of carving and the intensity of expression is not nearly as evident as in the Ilaria effigy. However, the importance of this piece for the history of the long line of Sienese polychrome wood Annunciation Virgins of the early Quattrocento must be reemphasized here, though a place claimed for it at the very head of the line of succession is perhaps overly optimistic.

We are on much firmer ground with the Annunciation group in the Pieve of San Gimignano, which dates from approximately a decade later than the proposed date for the Berlin-Dahlem figure. The style here is much more confident (pls. 58, 59). The Virgin's head and the long unified sweep of the drapery certainly preserves something of the earlier example of the type, but the most telling comparison is with the little St. Ursula figure of the predella of the Trenta Altar in Lucca, which we believe was being carved between 1420 and 1422 (see again pl. 57). These dates precisely bracket the earliest possible date for the Annunciation group at San Gimignano, which is 1421. However, the actual carving may date as late as 1425.[35]

More advanced yet still close to the style of the San Gimignano figures is the central standing Virgin of a group of five rather smaller statues in wood that decorate an altar on the right side of the nave of the church of San Martino in Siena (pls. 60a-b, fig. 69). The four male saints that flank her, two to a side, are usually recognized today as bottega work divided between at least two sculptors, one of whom (according to Carli) was almost certainly Giovanni da Imola.[36] Since we know that Giovanni died between 1423 and January 1425, we can date the Madonna by Quercia at about that time. The Madonna is a figure of great monumental dignity mingled with a striking expression of human tenderness; its remarkable design includes a double curve, lateral and to the rear-front axis, with the left hip

35. The problem of the date lies partly in the fact that it is known only through an eighteenth-century copy of the original MS source. Most scholars today accept the evidence given by the copy, which also specifies Jacopo as the sculptor. As given by the inscription on the base of the Virgin, the polychromy was by the Sienese painter Martino di Bartolommeo and was completed in 1426: M. CCCC. XXVI. MARTINUS BARTOLOMEI DE SENIS PINXIT.

36. Carli, pp. 71–72. For the accompanying male saints, see fig. 69. For a differing view from Carli's see Del Bravo, p. 73, where Federighi is brought, perhaps gratuitously, into the stylistic equation.

acting as a fulcrum. In this respect the San Martino Virgin combines a graceful stylistic device found in French Gothic ivory Madonnas with the classicism of a Roman Vestal.

Echoes of the San Martino Madonna appear in numerous places and guises: for example, in a less classicized form in a Querciaesque wooden figure of some charm at Villa a Sesta, near Siena (fig. 71);[37] and in seated form as recently published by Ragghianti (fig. 68).[38] Out of this general stylistic ambience emerged a considerable number of related variants (figs. 64–67), mostly of the Madonna and Child of the half-length type. It is not possible to attribute them directly to Jacopo's bottega, but they reflect the influence that his growing fame and capabilities were spreading throughout Tuscany.[39] Sometimes it is possible to find a direct derivation, such as the stucco bust now in the Rijksmuseum, Amsterdam, which was taken from the head and shoulders of the Wisdom of the Fonte Gaia (fig. 63). At other times whole figures in wood were produced in close derivation from the standing saints of the Trenta Altar: for example, in my own view, the charming St. Leonard in the church of Santa Maria degli Uliveti at Massa, near Lucca (fig. 70). Scholarship has not yet reached a point where definite attributions can be assigned to this kind of constantly interesting, often beautiful, generally derivative work. This is true of the small polychrome wood St. John the Baptist now in the Siena Baptistery (fig. 72). This figure may serve as a bridge between Jacopo's experimental middle period, which we now leave, and the period of full maturity, which we shall examine next.

37. Carli, p. 72. See also in this connection Carli's more recent article "Due Madonna Senesi (tra il Ghiberti e Jacopo della Quercia)," *Antichità Viva* 2 (1962), available to me only in paginated extract.

38. C. Ragghianti, "Novità per Jacopo della Quercia," *La Critica d'arte* 12 (1965):35–41.

39. The best examination of this whole question is still Krautheimer's early article, "Terracotta Madonnas," *Parnassus* 8 (1936):6–8.

4 Bologna and Siena, 1425–1438

The final period of Jacopo's activity was more than ever entangled with the conflicting demands of overlapping programs. He began his work on the San Petronio façade portal in 1425 while still engaged on his share of the Siena Baptistery Font. In the last three years of his life he was concurrently architect-in-chief both for the principal portal of the façade of San Petronio in Bologna (left unfinished) and for the Siena Duomo. In Siena, also, he was in charge of two other projects. The larger was the principal civic loggia: the Loggia di San Paolo or della Mercanzia; the other was the altar, or cappella, commissioned by the Sienese cardinal, Antonio Casini, in the Duomo. Add to all this the project of the Vari (later Bentivoglio) Tomb in Bologna, which, on stylistic grounds, Jacopo seems to have designed as a whole but executed only in part before his death in 1438.

The documents for this last period are not surprisingly peppered with irritable claims on his presence by both the Bolognese and the Sienese authorities; as we have seen in the chapter that deals with the elements of the artist's biography, he was more than once threatened with legal reprisals by the same authorities. Torn between two positions of honor and responsibility in two distinct cities, and between differing sets of aesthetic requirements, he struggled, with the help of assistants, to maintain a balance between the many imperious demands on his attention. One feels that his death in 1438 was hastened both by overwork and by the very real rigors of several years of travel over northern Italy and between Bologna and Siena. When he died, as much of what he had undertaken was left undone as was completed. This is not a triumphant record, admittedly. But perhaps it would be accurate, as well as charitable, to recognize the extraordinary quantity—and in most cases quality—of the production of that last decade. It was accomplished under circumstances that a less rugged spirit might have found paralyzing.

It must be recognized that under these circumstances technical assistance was more than ever needed. The kinds of help that we may assume Jacopo had, came under two headings. First was the need for a trusted associate in Bologna and another in Siena who could be empowered to oversee and carry on the work set forth in Jacopo's designs during his frequent absences from one place or the other. Second, on a lower echelon there had, as before, to be a group to carve secondary elements. Perhaps

these assistants were numerous; there was, first of all, the sizable job of carving marble. Also, there might well have been some duplication of personnel in the two botteghe at various times. But what the master really required was no less than a double workshop, with one complete team of assistants on a permanent basis in Bologna and another in Siena. The names of some of these assistants are recorded, but they so far remain mere names: for example, Nanni (Giovanni) di Niccolò, or Polo (Paolo) di Niccolò. We know, however, that the latter came from Bologna to work as "garzone" for Quercia in Siena in the 1430s, and that his salary was initially 28 florins a year.[1] (Federighi got 40 florins a year.)

In Bologna, the chief assistant appears to have been Cino di Bartolo. But he is indeed a shadowy figure, although there is independent evidence that he was a member of both stone-carvers' and goldsmiths' guilds in Siena. After 1433 he was not infrequently on the wrong side of the law, even to the point of once being accused of the classic crime of violating a nun. He was by a wide margin the most prominent of the assistants mentioned in Quercia's will and received a special legacy of 50 florins (this in addition to the 10 florins he was to receive *ex aequo* with Pietro della Minella). Cino was on hand to close up the Bologna bottega. And Cino is also mentioned in the will as a possible husband for Quercia's niece, Caterina, to whom Jacopo left no less than 400 florins for her dowry.[2] Still, we know very little about him as an artist.

Pietro della Minella is also mentioned as a potential husband for Quercia's favorite niece, and both Cino and Pietro are called "maestro," indicating that they were on a level superior to the other assistants who appear in the will. These include "Castore di Nanni" (possibly related to the Jacopo di Nanni of the documents in Siena), "Giovannino," "Paolo" (Polo?), and "Tonio di Baccio." Other assistants mentioned in the Bolognese documents may be listed as Antonio (Nanni?) di Andrea da Lucca (in 1428), Bartolo di Antonio da Firenze (in 1428), Domenico di Antonio da Fiesole, possibly too Giovanni di Mencio who was later to become architect of the Duomo in Orvieto, and Giovanni di Pietro da Firenze.[3] At this writing it would seem unlikely, I trust over-pessimistically so, that the hands of these secondary assistants during Quercia's last period could ever be definitively sorted out in the sculpture that still survives.

Even more problematical, however, is Jacopo's failure to mention Antonio Federighi explicitly by name in his will. Federighi's talent made him

1. Bacci, *Quercia*, p. 300.

2. See Appendix, p. 126.

3. See also Bacci, *Quercia*, pp. 307-15, 322-23.

the closest artistic heir to Quercia, and it is thought that he was later to take over a part of the statuary Jacopo was committed to do for the Loggia di San Paolo. Of the Loggia sculpture, to be shared later by Federighi with Vecchietta, the splendid San Vittorio has been considered one of the witnesses both to Antonio's ability as an artist and to his debt to Quercia's personal style.[4] By 1438 Federighi could have been a first-class sculptor in wood and marble, though evidently not a worker in bronze. It is permissible to think of him, despite the negative evidence in the will, as an assistant sculptor to Quercia from 1435 on, but active in the Sienese branch of the firm rather than the Bolognese branch. Cino, whoever or whatever he may have been, is the leading candidate for chief assistant sculptor in Bologna. But until one can find a documented independent piece by him, there can be nothing but some uncertainty as to what he was as an artist.[5] He does not seem to have been active as an independent sculptor after his return to Siena in 1438. So far the reason has not emerged.

After Quercia's death the double bottega, if such it can be called, seems to have been disbanded very soon, and there is some evidence that the studio located in Bologna may have been taken over by the ex-Florentine, Niccolò di Piero Lamberti. There is no written evidence of continuity of Quercia's original bottega in the parts of the Vari-Bentivoglio Monument in San Giacomo Maggiore in Bologna, which were finished up in his general style; and it must be said that parts of the monument were evidently carved at some time after 1443 in quite another style. The same must be said for the figures planned for the Loggia di San Paolo in Siena, which had to wait until the 1450s and 1460s for its sculpture and the sixteenth century for its completion. The San Petronio project was dropped abruptly after 1438. Even the St. Ambrose, the pendant to Jacopo's splendid St. Petronius of the lunette, though perhaps planned and roughly sketched out in design by Quercia, was carved by a different hand three-quarters of a century after Jacopo's death.[6] The impression one retains is of an extraordinary personality who provided leadership to others, even after death. But in almost every case on record, once that personality ceased to

4. See pl. 134. For Federighi's relation to Jacopo, see J. T. Paoletti, in *Art Bulletin* 50 (1968): 281–84. In his recent research on Federighi, Paoletti has come to believe that his role as a sculptor in Siena has perhaps been overestimated as against his role as entrepreneur. See, however, for a diametrically opposed view, Del Bravo, pp. 60–89.

5. Possible intervention by Cino in work on Jacopo's design in Bologna is discussed on p. 74 of this chapter. The latest summation of what is known of Jacopo's Bolognese assistants is provided in Beck, pp. 137–40.

6. See fig. 97; also J. H. Beck, in *Mitteilungen des Kunsthistorischen Instituts in Florenz* 9 (1964): 193–94.

exist, the work soon ground to a halt, to be taken up again only much later.

For clarity in handling the complexity of the artist's mature period, this chapter is divided into three parts, as follows: (1) Jacopo's part in the Siena Baptistery Font; (2) his part in the Porta Magna of San Petronio in Bologna; and (3) a consideration of the late secondary projects, such as the Vari-Bentivoglio Tomb, the Casini Altar, and the Loggia di San Paolo.

The extraordinarily beautiful font in the Baptistery Church of San Giovanni in Siena (pl. 61) is often chiefly associated with the name of Jacopo della Quercia. Actually, his part in some of the design and execution of the monument, and in its unusually complex program of sculpture, was merely that of one of a number of rather loosely associated artists over the period of close to seventeen years the work required for completion. The lack of single, overall direction from start to finish is very possibly the reason why the Font is an unusually difficult monument to analyze from the point of view of effects of collaborative effort in the early Renaissance. It is an exceptional case. The relatively lax organization of the contributing sculptors, however, had the positive advantage of a free interchange of artistic ideas, not only between individual sculptors, but between developments in Florence and Siena during a crucially important pair of decades (1415–36). Here is an opportunity to watch Jacopo at work in a kind of competition, not only with such admittedly inferior sculptors as the local Sienese Turini, but with such Florentine giants as Ghiberti and Donatello.

Jacopo's part at the beginning seems to have been hardly more than minor. At the time he was deeply involved not only with sculpture for the Trenta family in Lucca but with the final stages of the Fonte Gaia in Siena, as we saw in the preceding chapter. Moreover, as of 1416/17, the star of Lorenzo Ghiberti was more in the ascendant than ever before. According to the version provided by the documents, it was Ghiberti the Sienese city-fathers singled out as the primus inter pares of the artists who were to begin work on the Font. He was twice wined and dined in Siena between the spring of 1416 and that of 1417 on visits for consultative purposes. In May 1417 he was offered the commission. His ideas, particularly the novel introduction of bronze as the major material for the first phase of the Font's construction, were central to the drawing up of the program. He was very early assigned two of the six bronze reliefs and originally perhaps all of the bronze statuettes of Virtues that were to stand in shallow niches between the reliefs. He obviously had the predominant share of the work.[7]

7. Krautheimer, pp. 139–40.

In 1417 Jacopo was assigned two of the remaining reliefs, while at the same time the last two were given to Turino di Sano and his son Giovanni di Turino, the chief Sienese *aemulus* of Ghiberti. On the completion of the Fonte Gaia in 1419, Jacopo was offered and took a sizable advance of 120 florins on his two reliefs, but failed to make much headway on the bronzes because of conflicting commissions (see earlier pp. 38–54). In 1423 one of his reliefs was taken from him and handed over to Donatello (the Feast of Herod). In the meantime work languished in every quarter—so much so that in 1425 a special committee was formed to get more rapid results. The bronze reliefs began to come into Siena from Florence in 1427. In that year Donatello was paid for his Feast of Herod and began two Virtues (Faith and Hope).

Meanwhile nothing from Jacopo. It would seem that the authorities decided to tempt him with more obvious bait. In June of 1427 he was placed in charge of finishing the entire Font, including the impressive marble tabernacle, or ciborium, surmounted by the figure of John the Baptist. Thus, whether by design or chance, his dilatory behavior transformed his status from one of several more or less coequal collaborators at the beginning of the work to that of *magister operis*. Over the next four years, with delays resulting from Jacopo's commitments to Bologna, the sculpture of the Font progressed irregularly. Only by 1434 could it be called complete.

So much for chronology. What of Jacopo's contribution from the point of view of style and aesthetic ideas? Although it was evidently finished later than the marbles, the work in bronze by Jacopo deserves our first attention. And first in line here is surely the massive relief in bronze gilt, entitled the Annunciation to Zacharias, which was inserted into the rear panel of the hexagonal lower portion of the Font (pl. 62). The accompanying drawing indicates the position of Jacopo's relief in relation to those by Ghiberti (and his shop), Donatello, and the Turini. The usual comparison from the point of view of style is with the main panel by Ghiberti (Baptism) and the Feast of Herod (sometimes called Salome's Dance), which scholars are now agreed is entirely by Donatello.[8]

One contrast is that between Jacopo's Annunciation and Ghiberti's Baptism. The latter probably was designed after 1420 and makes a kind of transition between the late phase of Ghiberti's First Baptistery Doors and the beginning of the Second Doors.[9] Here there is a suggestion of formal

8. Illustrated, Krautheimer, pl. 73; Janson, 1, pl. 93. For Donatello's relief see Janson, 2:68–72. The Quercia and Donatello reliefs are illustrated side by side for easy comparison in C. Seymour, Jr., *Sculpture in Italy: 1400–1500* (Harmondsworth, 1966), pls. 28 and 29.

9. Krautheimer, p. 139.

The Siena Font
Schematic Division of Participants and Subjects

 A Ghiberti: Baptism
 B Ghiberti: Arrest of the Baptist
 C Donatello: Feast of Herod
 D Quercia: Annunciation to Zacharias
 E Turini: Birth of the Baptist
 F Turini: Preaching of the Baptist
 G Quercia: Tabernacle (door by Turini)
 1. Donatello: Faith
 2. Donatello: Hope
 3. Quercia (design): Fortitude
 4. Turini: Justice
 5. Turini: Charity
 6. Turini: Prudence

architectural structure in the design, even though the poses and grouping of the graceful, elongated figures set up a gently swaying natural rhythm. Donatello's design, in contrast, is based on an architectural setting that is largely, in turn, based on perspective. The figures more closely resemble the stocky characters in Quercia's scene than in Ghiberti's, but the emotional tension of the *istoria* in Donatello's hands is on a totally different

level of intensity. Where Jacopo seems most to follow Donatello's lead is
in the prominence of the architectural setting and the emphasis on drama.
But rather than suggesting spatial volume in depth, his arched structure
seems to move outward toward us into actual space. The oblique placement
of the architecture escapes even a vaguely implied one-point perspective
formula (see again pl. 62). Jacopo's compositional devices do not seem to
invite the overall distance view of the whole that the more pictorially ori-
ented work of Ghiberti and Donatello encourage. Instead, as one looks
down at the relief from a close vantage point, the shapes both of the figures
and the architecture jut out toward the observer (fig. 80). The reproduction
given here is from a study-photograph after a cast, as is the following
view (fig. 81), where the three-dimensional aspect of the figure at the ex-
treme right is strongly emphasized. As the visitor walks past the relief to-
day, the sculptural, rather than the pictorial, interest predominates. It is
not unlikely that the sculptor intended that effect.

Jacopo's relief, though it may appear at first glance to be dependent to
some degree on Donatello's example, is in reality very different in its visual
effect and in the means used to achieve it. Jacopo remains more thoroughly
a sculptor, dealing in actual voids and masses rather than the illusion of
either. The tilted flooring of his scene (see again fig. 81) does indeed follow
a perspectival formula used by both Donatello and Ghiberti; but it is read
as a sharply sloping plane as much as the illusion of a retreating floor. To
criticize Jacopo's structural devices as less "progressive" than the Floren-
tines' is to miss the point. His aesthetic choices add up to quite a different
sum, in which the whole is immeasurably greater than the parts.

Jacopo seems to have followed Donatello more closely in the model he
provided for the figure of Fortitude, which was executed sometime be-
tween the fall of 1428 and August 1431, when the final payment was made.
The documents clearly give the executant's name as Goro di Neroccio, a
Sienese goldsmith of only moderate reputation. There is nothing in his
known oeuvre to suggest the beautiful and striking design of the Fortitude
of the Font (pls. 64a-b, 65). On the other hand, the proportions, the pose,
the facial type, and the impression of calm and grace fit very well into
Jacopo's work of the 1420s and early 1430s, for example, the Virgin of San
Gimignano (pl. 58) and the later St. Petronius in Bologna (pls. 86, 87).[10]
The sharply defined folds of drapery branching out like tendrils from a

10. In the published literature on the Font, the Fortitude in toto, including design, is
uniformly given to Goro di Ser Neroccio. However, in the most recent study of the Font as
a whole, Paoletti tends now to ascribe the design of the figure to Jacopo.

central stalk (pl. 64a) have a good deal to do with the drapery formula of Donatello's Hope for the Font.[11] The design of the Fortitude most probably represents a rushed contribution by Quercia to the finishing up of the program at a time when he was not only busy with the marble tabernacle of the Font in Siena but with the portal sculpture in Bologna. Hence the reason for hiring an amanuensis in the person of Goro, whose hand and psychology is probably most evident in the ornamental detail, so unlike anything we know in Quercia's usual style (pl. 65).

It is likely that Jacopo left the bulk of the blocking out of the marble ornament, as well as the figures in the tabernacle (pl. 67), to assistants, of whom the chief was Pietro della Minella. His appointment, in March of 1428, as master in Jacopo's absence indicates Jacopo's confidence in his ability, though later in the summer Pietro's leadership was challenged by Nanni da Lucca, another member of the bottega. Jacopo's part in the design of the ciborium-tabernacle can be surmised rather than strictly documented. There does not seem to have been a small-scale drawing for it, as there had been previously for the Fonte Gaia and for the first, or lower, portion of the Font. The full-scale drawing of the ciborium was executed by the Sienese painter Stefano di Giovanni, better known as Sassetta, probably after conferences not only with Jacopo but with the Duomo authorities. The date of the payment for the drawing in December 1427 provides a rough date for the start of work. Actually, the documents contain references to purchase of marble two or three months earlier.

When the design was determined (see again pl. 67), it showed a complex structure including, not only the unusual placement of bronze figurines near the top, but overtones of Florentine, rather than Sienese, precedent. Like the tabernacle of Or San Michele by Orcagna, the Siena Font ciborium is crowned with an architectural echo of the cupola of the Florence Duomo; and though the relief-figures of prophets in niches owe much to Antique precedent, they derive directly from the Virtues of the Coscia Tomb in the Florence Baptistery (fig. 77).

The literature of the past has occasionally—but only occasionally—thrown doubt on Quercia's authorship of the largest single sculptural element of the ciborium: the terminal marble figure of John the Baptist. The statue's awkwardness and stiffness of pose to a great extent can be explained by the semiarchitectural function of the figure as well as by the viewing angle, of necessity rather sharp, from below. Recent photographs

11. Janson, 1, pls. 72–75.

taken from below provide a more correct and fairer basis for judgment (pl. 66, fig. 79). The statue would certainly seem to be from Jacopo's design and largely, if not entirely, by his hand.

There is a good deal of variety in the style of the relief-figures of prophets in niches in the main, central zone of the design. Whether this means that several hands are present is a question that probably should be answered cautiously and largely in the negative; a possible modello for a figure in a similar nichelike context has recently surfaced in the art market in Italy, and if by Quercia might indicate an earlier experimental handling of the niche figure motif (fig. 75). If the work was begun early in 1428 and was not paid for completely until mid-1430, a sufficient interval of time for slight shifts and development in style would have existed. Of course, one cannot rule out the hands of assistants in some parts of the work, but one feels that in general the quality is on such a high level that Jacopo must be held responsible for the great bulk of it. At times his hand seems incontrovertibly present, as in the beardless "Cicero-type" prophet, so boldly conceived in the wake of Roman Antique portraiture and as boldly carved out in sure, powerful strokes of the chisel (pl. 74). Again one finds differences in drapery formulae. Rather carefully yet still boldly organized forms (pl. 76) contrast with a much freer ripple of continuous shapes where an anatomical detail like a hand, or an abstract curvilinear motive like a scroll, are brought into a common flow of cascading form (pl. 77). In one interesting case a head that evidently turned out badly on the first try was replaced; the patchwork is quite visible today (fig. 78). Presumably, the color and gilt that must have originally been present on the monument would have concealed the joint.

Probably no single creation of Jacopo's was more influential than his ciborium of the Siena Font. Not only do we find echoes of its prophets in the Porta Magna prophets in Bologna, but the Quattrocento type of the monumental and architectural ciborium seems to derive from it, occasionally readapted in a rather original way, as in the provincial example in Massa Marittima (fig. 73). More often the type is expanded, as in Vecchietta's elaborate bronze tabernacle on the main altar of the Siena Duomo (fig. 74), or as in the later Florentine examples by Desiderio (now in the National Gallery of Art) and Benedetto da Maiano, still in place in the Pieve of nearby San Gimignano.

The design for the Porta Magna of San Petronio (pl. 79) evolved in three quite distinct phases. A first design is spelled out part by part in the con-

The San Petronio Portal: Division of Subjects
First Scheme, as planned

A. Crucifix
B. Ascension
C. St. Peter
D. St. Paul
E. Martin V with Legate
F. Madonna and Child
G. St. Petronius
H. Scenes from Infancy of Christ
I. Scenes from Genesis
J. Prophets
K. Lions

tract dated 28 March 1425, apparently recorded in a drawing executed
for filing with the contract, which has been lost. What appears to be a copy
of Jacopo's design for the portal, by Peruzzi, is included in one of the six-
teenth-century series of competition drawings, preserved in San Petronio
mainly for the completion of the façade (fig. 82). Chief credit for recogni-
tion of the importance of this drawing for Quercia's ideas goes to James
H. Beck.[12] He has also underlined the political reasons for changing the

12. James H. Beck, in *Journal of the Society of Architectural Historians* 24 (1965): 115–26.
See, too, G. Zucchini, *Disegni antichi e moderni per la facciata di S. Petronio di Bologna*

1425 design in 1428. In 1428 the Bolognese forcibly evicted the papal legate, the Gallican leader Cardinal Louis Aleman, archbishop of Arles. This event resulted in a major shift in the portal's imagery. Though peace was restored between the citizens of Bologna and the church by the new legate, Gabriel Condumier, a little later to be elected Pope Eugenius IV, the original double portrait of pope and legate as patrons originally intended for the portal's lunette, had by then become inappropriate. The two figures were to be replaced by a single standing figure that may have been sketched by Jacopo before his death, but was not executed until 1510 by Domenico da Varignana. The subject, St. Ambrose, was a fitting pendant to St. Petronius, since the Milanese bishop had figured prominently in the founding of the primitive church in Bologna, and in the Bolognese liturgy shared the same feast day with St. Petronius (fig. 97).

It would seem, also, that in 1428 some modifications of the relief-sculpture program were found to be advisable. The lintel scenes of the Childhood of Christ were increased from three to five and the Old Testament scenes on the pilasters were reduced in number from fourteen (seven on each side) to ten.[13] As far as is known, the large figures of Sts. Peter and Paul, two statues of lions, the gable-frontispiece with a seated Christ (possibly an Ascension), and the crucifix for the summit of the gable were never even begun. A reconstruction of the design as planned was published by Supino and modified by Beck (figs. 83, 84). Evidently Jacopo drew to some extent on earlier portals for his design: the Romanesque portal with relief sculpture at Modena; the more recent, lateral portal for the unfinished nave of the Siena Duomo; and the still more recent Porta della Mandorla of the Florence Duomo (particularly the relief of the gable).

Another probable modification of the first design has not been discussed in the literature. The original program called for the presentation by the

(Bologna, 1933), p. 15 and pl. 3; also P. Pouncey and J. A. Gere, *Italian Drawings in the Department of Prints and Drawings in the British Museum. Raphael and his Circle* (London, 1962), pp. 143–46. The drawing in London does not contain the design of the original portal, which in the Bologna example (Zucchini, pl. 3) is inscribed in a contemporary hand (on Pouncey's authority, Peruzzi's own hand): "questo e l'ornamento de la porta grande come quello di Messer Jacopo da Siena cioè el suo disegno in membrana." As explained in the Summary Documentation of the Portal (pt. 2, chap. 9), the original parchment drawing is no longer extant; hence the importance of this particular drawing still preserved in the Fabriceria of San Petronio.

13. Seven is a canonical number. The reduction to five probably was for visual reasons. A similar reduction from a preliminary scheme was made by Ghiberti for his Second Doors in Florence. Beck (pp. 63–74) provides the basis of a new political and doctrinal interpretation of the program of the San Petronio Portal, and emphasizes the influence of the theology of St. Ambrose, already invoked by Krautheimer for the Florence Baptistery Old Testament Doors. The latter recently (reviewing Beck) defined two phases in 1428.

The San Petronio Portal: Division of Subjects
Final Uncompleted Scheme, as executed

A Madonna and Child
B St. Petronius
C St. Ambrose

1. Nativity
2. Adoration of the Magi
3. Presentation in the Temple
4. Massacre of the Innocents
5. Flight into Egypt
6a.
6b. } Putto console-figures
7. Creation of Adam
8. Creation of Eve
9. Temptation

10. Expulsion
11. Labors of Adam and Eve
12. Sacrifices of Cain and Abel
13. Death of Abel
14. Noah leaves the Ark
15. Drunkenness of Noah
16. Sacrifice of Isaac
17–25. Prophets, left jamb
26–34. Prophets, right jamb

pope (Martin V) of his kneeling legate to the Madonna and Child. The de-
sign of the seated Madonna, which ultimately found its way to the lunette
(pls. 80–85) clearly reflects demands of the first, discarded program. The
Virgin's head turns slightly to the left, in the direction of what was to have
been the figure of the kneeling legate, and the Child energetically moves
forward toward the same goal (pl. 84). Once the program was altered the
pose of the Madonna and Child logically required a change as well. A more
frontal pose for the Child was in order. The wooden Madonna (pl. 126) in
the Louvre may well represent Jacopo's ideas for a new design for the cen-
tral figure of the lunette. The scale of the figure, whose provenance is a re-
ligious house in Bologna, is precisely equal to that of the Madonna of the

lunette still in Bologna, and the drapery scheme, as well as the action of the hands of the mother, are strikingly similar. The Christ Child in Paris is extremely close in type to the nude putti that decorate the consoles under the lintel of the portal (fig. 85).

For a time I wondered whether the Louvre Madonna might not actually be the full-scale modello, prepared by Jacopo or by an assistant under his direction, as a substitute Madonna for the San Petronio portal. This supposition still remains a possibility; but one must recognize the total lack of any mention of a second Madonna in the documentation for the portal, and the elaborate polychromy (to be sure, much restored) of the Louvre Madonna may well reflect a different function than that of a modello; modelli are generally thought of, moreover, as being of clay or wax rather than of wood. However, it would not be at all too hazardous to consider the Louvre piece a close derivation from the hypothetical second design for the lunette figure. The polychromy is admittedly somewhat unpleasant and undoubtedly detracts from the Louvre piece; but if one looks beyond it to consider the design as a whole and the details of the heads, hands, and so forth, the quality appears to be very high indeed. The Louvre Madonna deserves to be ranked with the wooden polychrome Virgins in Berlin and San Gimignano as being by Jacopo himself—or at least very close to his personal touch.

The Louvre Madonna would consequently be datable after 1428 (when the revised San Petronio program came into existence). By the same reasoning one can safely date the existing lunette Madonna (pl. 81) between 1425 and 1428. It is thus the first of the sculptures for the portal, and represents the artist at the height of his powers, before the overcrowded years of the last decade of his life when he was forced increasingly to rely on assistance from the bottega. If there is one piece of sculpture that can be ranked as Jacopo's masterpiece, it is probably the seated Madonna of San Petronio. The trancelike beauty of the Virgin's face (pls. 82, 85) finds echoes in Michelangelo's work (the Medici Madonna, for one example). And the energy explicit in the active little Child, with its formal environment of equally active drapery forms, seems to anticipate the Roman Baroque of Bernini (pl. 84).

If we date the Madonna to the period centering on Jacopo's busy and successful year of 1428, the accompanying St. Petronius (pl. 86) must come a little later. The stone block for the figures seems to have been acquired only in 1431, when Jacopo had just been freed from the final phase of the Siena Baptistery Font; and only by 1434 had the figure finally been lifted into place. Earlier than 1434, certainly, are the prophets of the

jambs and the lintel reliefs of the Infancy of Christ. On the evidence of style alone, the scenes of Genesis would finally follow (see pls. 106–25).

In the series of relief sculpture the presence of assistants' hands is evident in portions of the execution, though not necessarily in design. There is, for example, a noticeable weakening of figure-style in the Massacre of the Innocents (pls. 93a, 94b). The central group of the Presentation (pl. 94a) lacks the firmness and definition one would expect of Jacopo's own hand. However, the design of both those compositions must surely be the master's work. The architectural setting of the Presentation is a close and interesting variant of that of the Siena Baptistery Font bronze Annunciation to Zacharias (see again pl. 62). The flow of the drapery style of the Adoration of the Magi (pl. 92a) has a good deal of the quality noticed earlier in the marble carving of a prophet on the Font's ciborium-tabernacle (pl. 71).

The relationship of the half-length prophets, with their heavy drapery and curving scrolls, to the Siena prophets is obvious enough in general theme (see again pl. 69). Here again, as in Siena, the designs must all go back to the master, either for direct formulation or for inspiration. However, there are differences in style between the left- and right-hand *sides* of the portal here. The differences can best be seen by comparing plates 99 and 100. The concept of form is, in general, sharper and more precise in the series on our left; to the right the shapes are pudgier, fatter, the action more tentative; it is possible that, in addition to several panels to the left, Jacopo assigned the execution of the entire right-hand jamb to one or more assistants. There is also a difference of quality within the left-hand jamb. A division-line can be established between the fourth and fifth prophets (reading from the top; see pl. 99). The lower prophets seem to be the finer in quality (pls. 100b, 103). Prophet number two to the left would seem to relate to the norm of the series on the right. (See pl. 104 compared with pls. 103 and 105.)

More than once in the past it has occurred to students of Renaissance art that Jacopo's prophets in Bologna, with their wide variety of human types and ages, must have strongly influenced Michelangelo in his designs for the Sistine Chapel Ceiling. It is certain that Michelangelo could have closely studied the jamb-figures of San Petronio just before he began the Ceiling; in the period 1506–08 he was intermittently in Bologna, sometimes for extended stays, while he modeled and cast the bronze seated statue of Pope Julius II that for a few short years decorated the façade of San Petronio in a place especially prepared for it just above Jacopo's central portal. Beck has pointed out that there was in the period roughly be-

tween 1505 and 1510 an important phase in the portal's history—a dis-
mantling and rebuilding, in fact, of the portal—when it was moved
forward in order to provide more depth in the façade to accommodate the
pope's statue; the work seems to have been done under Michelangelo's
advice if not actual supervision.[14] At this time there was a completion of
the prophet reliefs of the lunette very much in Quercia's manner (fig. 98),
and the St. Ambrose by Domenico da Varignana was introduced into the
lunette to balance the St. Petronius (fig. 97). Shortly after the work on the
central portal, work began on the lateral portals. Here again, the extraor-
dinary power of Jacopo's earlier inventions was exerted in the design
and execution of reliefs by a whole group of sixteenth-century artists, in-
cluding Girolamo da Treviso and Michelangelo's onetime follower, the
Florentine Tribolo (figs. 99, 100).

The influence of Jacopo on Michelangelo is easiest to see in the Genesis
reliefs decorating the pilasters of the portal. There are ten of these (see
again pls. 96, 97), five to each side; and once again there appear to be dif-
ferences in style of execution which may well indicate some assistance for
the later panels of the series, on the right side. Very fine is the often repro-
duced Creation of Adam (pl. 106), which leads off the series to the left.
Here the figures are reversed from those of the same subject on the Fonte
Gaia (fig. 55), which Jacopo had completed some fifteen years before. The
inspiration for the seated figure of Adam may have been drawn partly
from the Adam of an early medieval ivory in the Bargello (fig. 86).[15] At
the same time there appear reminiscences of a painted Trecento Genesis
cycle in the Campo Santo in Pisa (figs. 88, 89). The pose of Adam in
Jacopo's first panel is repeated in his later Drunkenness of Noah (pl. 122).
This panel by Jacopo (next to the last of the series) must have made a deep
impression on Michelangelo, who used the Adam-Noah figure motif in
his early fresco design for the Sistine Ceiling (fig. 92). The figure of the
digging Noah in the background of the Sistine version of the Drunkenness
of Noah could well have been inspired by Jacopo's Adam tilling the soil in
the fifth panel (pl. 115).

The power of Jacopo's Genesis designs, with their accent on restraint of
action and clear monumental relationships between figures (see, for ex-
ample, pls. 106, 107, 111, 120) find few manifest echoes in the Quatro-
cento (though one can find some traces of contemporaneous influence in
painting and sculpture [fig. 91]); rather, the great epic of the Sistine Ceil-

14. See J. H. Beck and M. Fanti, "Un probabile Intervento di Michelangelo per la 'porta
magna' di San Petronio," *Arte antica e moderna* 20 (1964):349–54.
15. First pointed out by H. W. Janson in 1962.

ing seems to have been the major work to gain from Jacopo's discoveries. Even earlier, when he was completing the shrine of St. Dominic in Bologna, Michelangelo had drawn heavily on Jacopo's St. Petronius for his own interpretation of the same subject (fig. 93); here he followed Jacopo's lead of identifying the city of Bologna by including its two famous "leaning towers," those of the Asinelli and the Garisenda, which are still in place at the heart of the city (fig. 94).

It is clear that the shop, which had already played a role in the execution of the sculpture for the Porta Magna in Bologna, took over increasingly in the last years of Jacopo's activity. As explained earlier, the art historical situation here is hazardous. We do not have sufficient documentation or knowledge of personal styles to provide an accounting for this last phase in detail comparable to that available for some of Jacopo's earlier work.

In or about 1435 one can date the approximate design and beginning of the Monument of Bartolommeo Vari (pl. 128), a jurist who was originally from Ferrara. Whether a document of 1433 referring to a purchase of marble relates to this monument, as is occasionally asserted in the literature, is highly uncertain. All we know is that Priamo della Quercia believed as of January 1439 that 200 florins were still owed Jacopo's estate on the tomb (la sipoltura). We believe that 50 of the 250 florins that was the price agreed on for Jacopo's work had already been advanced, but we do not know how much of the monument had been completed by the time Jacopo died. As will be seen from remarks below, we have some reason to believe that he had not only designed the whole but had designed, and *in part* executed, the several reliefs and a little of the statuary. The sculpture was being carved in the master's shop in Bologna when he died. It was taken over by the authorities of San Petronio after Jacopo's death and was released to his heirs only in 1442, when it was described as "worked on and carved by the late Messer Jacopo" ("quamdam [sic] sepolturam marmoream laboratam et sculptam per dictum quondam dominum Jacobum ad istantiam illorum de Variis de Ferraria [sic]").[16]

The next year, 1443, when the Bentivoglio took control of Bologna, Annibale Bentivoglio acquired the marbles originally intended for the Vari Monument and put into action the sequence of events that transformed its original purpose as a memorial to Bartolommeo Vari to the tomb of Antonio Galeazzo Bentivoglio. After 1443, the missing or incomplete elements were finished up in a different style and the monument installed

16. See Milanesi, *Documenti*, 2:183; L. Biagi, *Jacopo della Quercia* (Florence, 1946), p. 48.

very close to the entrance to the Bentivoglio Chapel, in the ambulatory of San Giacomo Maggiore, where it still remains today. Since there is evidence that the Florentine sculptor Niccolò di Piero Lamberti had taken over Quercia's studio in Bologna after it was released by his heirs, it is possible that he was responsible for the finishing and assembling of the Bentivoglio Monument. Though we tend to think of him as a medieval artist, Niccolò Lamberti lived on until 1451, though little or nothing is known about the work of his late years.

The Vari-Bentivoglio Tomb's design is conventional, not to say ultraconservative; it depends quite obviously on Andrea da Fiesole's Saliceto Monument (Bologna, Museo Civico) of 1412 (fig. 103). Similarly, the motif of the scholars seated at their desks while the university teacher lectures can be traced back into the Trecento (fig. 102). Jacopo must have made the designs at least for the panels of the lecturer and those flanking him (pls. 129a–b). But the execution of one is due to an assistant of lesser talent (Cino di Bartolo?). The designs of the St. Peter and the Madonna are authoritative and quite probably represent Jacopo's late style in design at least, and probably in large part the execution (pls. 127a–b); but like a good deal of the sculpture of the Vari Monument (see also figs. 108, 109), they could have been retouched some years later when the Bentivoglio took over the marbles.

Bottega work is evident also in the Budrio pavement-tomb just outside the Bolognese city limits at San Michele in Bosco (fig. 106). A small triptych divided between the Museo Civico in Bologna and the Schnütgen Museum in Cologne is apparently almost entirely shop-work (figs. 111–13). An interesting problem finally is posed by the rather small-scale, marble standing Bishop-Saint (St. Maurelius?) preserved in the Duomo museum in Ferrara (fig. 115). In the literature the piece has had a tendency to creep into the Quercia oeuvre not so much for its style as, perhaps, because of its physical propinquity to the Ferrara Madonna of 1403–08. What the Ferrara Bishop cannot possibly be is an example of Jacopo's work of the early period. In his last period he was in touch with Ferrara through the Vari Monument program. Is the Bishop-Saint to be connected originally with that program? Or is it merely an example of Jacopo's late-style influence? It would seem to me to date not much earlier than 1450. Perhaps it might be the work of some Quattrocento sculptor in Ferrara such as Niccolò Baroncelli or Domenico di Paris, whose large-scale bronze Crucifixion group is still in the Ferrara Duomo. The little marble Bishop-Saint, however, is much more energetic in style than any of the figures of that bronze group. It recalls somewhat the style of Niccolò dell'Arca in the

small statuary of the Shrine of St. Dominic in San Domenico, Bologna (fig. 116). Who the sculptor was, I would not want to try to state any more definitely at this time. All I would say is that it does not fit easily into the picture of Quercia's development that I have outlined.

Jacopo's last work in Siena includes the impressive fragment of a lunette which was in the Ojetti Collection in the Villa Salviatino near Florence (pls. 130–33). The fragment is sizable (49½ in. high by 53¾ in. wide). It is reportedly carved from a local marble, called "Ravaggione," still occasionally quarried near Siena. The fragment was discovered before World War I in a villa garden (not in a chapel, as is sometimes said) at Corsano, near Siena, before its acquisition and transfer to the Ojetti Collection.[17] The documentation gives a fairly full circumstantial account of the program: (1) the patron was the Sienese Antonio Casini, bishop of Siena and Grosseto, who was made a cardinal by Martin V in 1426 with the *titulus* of San Marcello; (2) the lunette was to decorate an altar dedicated to the Virgin and St. Sebastian in the Siena cathedral; (3) the painted altarpiece below the marble lunette represented St. Sebastian.

We know, also from the documentation, that Jacopo received a good deal of help from the bottega in the creation of the altar as a whole.[18] Weaknesses in some of the detail of the relief, for example in the Christ Child, are to be attributed to an assistant's work. However, the general impression made by the relief-style is extremely good. In some areas the detail is as strong as anything by Jacopo in his last years (pls. 131, 132).

Missing today is one lateral figure, presumably a standing saint, which flanked the Virgin to the left. It could not have been a St. Sebastian, as once suggested by Bacci, because that saint was shown in the painted altarpiece beneath the lunette—nor a St. Anthony, as more recently suggested by Ragghianti, because of just as inappropriate a duplication in the relief proper. It might have been a familiar Sienese patronness, such as St. Catherine (of Alexandria) or St. Dorothy, both present in prominent positions in Duccio's *Maestà* for the Siena Duomo. A drawing in the Albertina showing a female saint to the Virgin's right may be connected with the design as first worked out by Jacopo (fig. 114).[19]

We may assume that the Casini Altar in the Duomo was complete, and

17. Bacci, *Quercia,* pp. 279–86; Morisani, p. 73. The full documentation is given by Bacci, *Quercia,* pp. 297–350. The chapel is often given the title of "di San Sebastiano" in the documents.

18. Bacci, *Quercia,* pp. 305–10.

19. For a summary of opinions and bibliography, see C. Seymour, Jr., "Fatto di sua mano," (Bibliog., no. 103), notes 26–27 and postscript, pp. 104–05.

probably installed, by the time of Jacopo's death in 1438. Left very much unfinished, however, was what I believe to have been in good part his design for the splendid Loggia di San Paolo, which opens up on the city's main thoroughfare just behind the Campo and the site of Quercia's Fonte Gaia. The documentation clearly indicates that before he died Jacopo had provided the model for the massive capitals of the loggia's lower story (pl. 134).[20] The design of the architectural niches for the statuary is also very much in his manner. He was to have done all six figures of saints for the niches, but he completed none, though he may have begun their plan. Only in the decade of the 1450s was the sculpture program renewed. It is interesting that Donatello was temporarily involved as a contributing sculptor, although he never followed through with finished work. The upper portion of the loggia cannot be considered on Jacopo's design. Left unfinished, finally, was a St. Peter for the Cappella di Piazza.

20. The Loggia di San Paolo has been studied mainly in connection with its sculptural decoration, but the history of the design of the fabric deserves a great deal more attention than it has received. Jacopo was brought into that history as early as 1428, when he was asked to recommend a practicing architect to take charge of the construction. This ultimately turned out to be Paolo di Martino, a Sienese. After Paolo's death in 1437, Quercia appears to have taken full charge. Documentation on work on a capital in Jacopo's bottega, quite obviously before his death in 1438, is published in Bacci, *Quercia*, pp. 308, 314–18. Cararra marble for the niche statuary was acquired by Quercia (ibid., pp. 309–10).

5 Conclusion: A View of the Whole

We have been looking, at times in some detail, at what remains of the work of a great sculptor. The term *sculptor* usually means an artist who works upon the illusion of humanly sensed reality with the densest and most tangible—often the earthiest—of substances in their most material manifestations and in the actual light and space of daily existence.

Viewed in this way sculpture as an art stands somewhere between architecture and painting. On the one hand, like architecture, it exists in the "real" space and "real" light of our physical environment. Like architecture too, which most strikingly modifies that physical environment, and indeed is capable of creating entirely new environments of its own, sculpture is structured, in some cases constructed. But again, like painting, sculpture is also capable of conveying meaning directly through images, through precise visual equivalents of our being, and through references to our activity in the world. In its capacity for image projection, no matter how far removed from actual reproduction of what the eye sees, or what we may think it sees, sculpture affects not only our physical sensation of environment and of experience; it can form and lead thought.

Sculpture may thus be seen as something more than an object, a motionless thing merely situated in space, time, and use; it may become, and frequently does become, a mute presence, a formative influence, a wordless guide for ideas and ideals. It may communicate privately to the sensibility of the individual. It may also appeal publicly in its own eloquent language to the mind of a whole age, of a segment of an entire culture, indeed of a civilization. In constructing his images, as one modern sculptor, Naum Gabo, has said, the sculptor constructs nothing less than "the image of his world."[1]

This larger role of the sculptor and of the art of sculpture requires for its understanding a broader stage than the cramped quarters offered by close formal analysis and historical documentation of individual works and programs, which has characterized the preceding chapters. Suppose for a moment that we move off a little to get a more complete view of Jacopo's achievement. What should we be looking for?

I would think that this search for an overview would first of all focus

1. N. Gabo [Pevsner] in *Three Lectures on Modern Art*, N.Y. Philosophical Society (1949), p. 86.

77

on the idea of wholeness, of a certain kind of integrity. Does the work of Jacopo della Quercia as we have examined it bit by bit, year by year, really add up to a sum that can be recognized as a true unit, different from any other unit of a similar kind or order? Does it hang together naturally and coherently of itself, rather than by virtue of some imposed system or norm? Secondly, I would think we might inquire whether there are any strikingly individual and personal traits or principles of vision and form-making that offer clues to why and how that coherence, if indeed it does exist, came into being. How did Jacopo handle the element of past tradition? How and where did he experiment in order to find some new and original solutions that might better fit the environment, both physical and mental, of the new age of which he was a part? Finally, I think it would be worthwhile to attempt, even if very briefly and incompletely, to come to grips with some evaluation of his significance as an artist, not only for his own generation, but also in the context of the broader currents of Western art. For as an artist he undoubtedy belongs to a much larger historical setting than Tuscany of the period bounded by his life-span from about 1375 to 1438.

First comes the question of wholeness and integrity in his work from start to finish, as we know it. Does such a wholeness exist? The answer, I think, is yes; but only if we are prepared to accept the idea that Jacopo was capable of working in multiple manners—in changing "styles," as Renaissance writers were fond of using the Italian term *maniera*—to fit not only his own demands on himself as a growing individual, but to fit what he and his patrons may have determined as the demands of often markedly varying programs. These demands may well have been aesthetic in the first instance, but they also grew out of a strong sense of cultural decorum, of what would be fitting for the function of the work of art in its social as well as purely formal context.

We live in a period in which the impact of a work of art is very often measured from day to day by its explosive breach of aesthetic and social decorum. It is perhaps difficult for some of us to imagine an artistic revolution that might be both aesthetically effective and socially, as well as aesthetically, decorous at the same time. But, paradoxical as it may appear, this was the case in the early Quattrocento. Thus, if we are prepared to accept the attribution to Jacopo of the Madonna of 1395–97 (pls. 1–5), still in the Siena Duomo, we must recognize that it follows a much earlier formula, which demanded respect because it was so closely related to the

spiritual and civic, as well as the architectural, fabric of the Duomo itself: the prestige of Nicola Pisano's Pulpit. What one also senses in the figure is a kind of generous ebullience of form, a feeling for rounded rhythms, a suggestion of clear, uncomplicated psyche in the relationship of mother to child, and a certain dignity that keeps the work of art a little aloof— at a distance. This is perhaps the most "Gothic" of Jacopo's works. But it leads with a hardly perceptible break into the more "classic," more firmly plastic, Silvestri Madonna at Ferrara (pls. 6–11).

One of the substantive advances in Quercia scholarship over the past few years has been the pre-Ilaria dating of the Silvestri Madonna. The Silvestri Madonna is a work of unusual strength: architectonic rather than pictorial; frank, direct, and extrovert rather than the usual Jungian alternative. In contrast, the Ilaria Monument at Lucca is in almost measureless terms more complex; it leads the observer inward, and it plays in a way unparalleled for the time on the mysterious relationship between life, death, and love. Stylistically, it marks an advance over the Silvestri Madonna in subtlety of expression and, in the effigy, certain refinements of form. Nonetheless the formal connection between the two remains unquestionable.

Over the next decade Jacopo entered a new phase. We can see him first at grips with what one can probably call an insurmountable problem, the sculpture of the Trenta altarpiece. Perhaps by the very terms of the contract, which unfortunately no longer exists as far as we know, the curious constrictions—and at the same time liberties—of form could have been predicted. Here the past infringed, it would seem, more than could possibly be justified. The rather unreal historical basis for "San Riccardo Re" appears to have affected the style of his altar in San Frediano. It leans toward the deep "medieval" past, no longer real even in 1415, and finds no firm foothold in Jacopo's own present.[2] Only with the scenes of the predella, a little later probably than the *pala* proper, do we find Jacopo once more firmly in charge.

Concurrently, the work on the Fonte Gaia opened up still greater possibilities. Here the Antique Roman past, implicit in the location of the work and in the history of the city and the fountain's predecessor, came to bear upon the question of style. The inspiration from Antiquity is present in virtually every composition of the numerous reliefs and two remarkable free-standing figures that are the major components of the fountain's

2. See above, p. 40.

sculpture. One can search in vain for anything quite like this early Renais-
sance nymphaeum in Florence—or, for that matter, in Venice, Naples, or
even, unless it were underground, in Rome. Here Jacopo began to find his
mature style.

The transition from what we believe to have been the design for the
Creation of Adam that Jacopo carved for the Fonte Gaia (fig. 56) to the
composition he made for the Porta Magna on the same subject a few years
later (pl. 106) is to the casual eye a small one. Actually, there is a difference
of some importance, which has mainly to do with character and type of
relief rather than with conception of the subject and organization of forces
within the architectural framework to express its meaning. At Siena Jacopo
was deeply influenced by the style of the faces of Roman sarcophagi; at
Bologna he was concerned more with the suggestions he received from the
ends of sarcophagi. We shall return to this point later.

We come now to the figures in the full round in Bologna (pls. 80–89).
The style of the Madonna is a progression, in a curiously connected way,
from that of the Trenta Altar Madonna, perhaps even more than from the
style of the Madonna of the Fonte Gaia.[3] The great figure of St. Petronius
is a more monumental and heavier version of what Jacopo had created in
the form of the Acca Larentia of the Fonte Gaia. Meanwhile, in the prophet
figures of the Porta Magna Jacopo, with his assistants, was quite evidently
sculpting variations on the prophets of the ciborium in the Baptistery of
Siena (pls. 67–77, 98–105).

It would be possible to go on drawing relationships in this way for some
time, clear to the Casini Altar relief (pls. 130–34). While we may quite
obviously find increasing evidence of bottega assistance, the imprint of a
single mind in control and constantly alert is stamped even on shop-work
until we reach the end, which was not a gentle phasing out but, from every
evidence, a brutal cutting off.

Turn back now to the first Madonna in Siena (pl. 2). She is the clear
forerunner, through several gradual metamorphoses that can all be cata-
logued, of the last Madonna, that of the Casini Altar relief (pl. 132).

Within the apparent visual unity of the documented work either by
Jacopo's hand or partly under his immediate supervision, there may be
found certain dominant and continuing attitudes toward the making of
form. One of these, it would seem obvious to anyone who has had to deal

3. See above, pp. 48, 70.

over a period of time with the originals, is paramount: the importance, even hegemony, of sculptural mass as a key to Jacopo's art. From the beginning, as far as we can judge, Jacopo was far more a sculptor than his goldsmith-father—who, incidentally, may quite conceivably have had his son's help in the work in wood we are inclined to attribute to him alone (for example, fig. 14a). Jacopo was also more of a sculptor than his friend and occasional associate, Francesco di Domenico Valdambrino. The latter was not as proficient as his champion Peleo Bacci (who curiously linked him, as an "emulo," to Ghiberti rather than to Jacopo) believed. But, nonetheless, we should not be too critical of Francesco; any artist who was invited to enter the Florence Baptistery Doors Competition, as was Francesco, deserves our respect and attention.

Where Jacopo differed most from Francesco di Domenico Valdambrino appears to be precisely in the important matter of sensing sculptural mass and its enormous potential for shaping and ordering form for expressive purposes in art. Perhaps to create great sculpture it is necessary to be driven by an inborn urge to be ruthlessly, intractably expressive: to find the most vibrant and most striking shape rather than the soothing, the agreeable, or even the most mollifying shape. There can be no doubt on which side of that divider we can expect to find Francesco. In fact, it is precisely because of the evident cast of Francesco's emotions and mind that Bacci's suggestion that the putti of one side of Ilaria's sarcophagus in Lucca were executed in part by him and not by Jacopo (see again pl. 17) seems so eminently sensible.[4] Jacopo's parallel putti belong to a different order of sculptural mass as well as human symbolism. They push out into space, rather than retire back to the plane (pls. 15, 16). They seem in some way to be more aggressive, less gentle, and also less stereotyped and regularized in some way, than Francesco's—or at least than those figures I think were carved by Francesco. I think also, in a way that is hard to articulate, that the sculptural beings I believe Jacopo carved in the form of these putti express much more the real nature, as one observes it at close quarters in family life, of two-year-olds. Francesco's putti, rather like his Annunciates, except for the sensual beauty at Asciano, are too much on their good behavior to be convincing.

The element of mass, sometimes at rest but most often suggested as being in motion or quasi motion, is the sculptor's most efficacious equivalent to the potency of human presence. This, I think, is probably reason

4. See above, p. 34.

enough for Jacopo's insistence on mass, his emphasis on the third dimen-
sion. He never, as far as I can judge, sacrificed mass to line. And where, in
my view, linear and volumetric elements in the design strive for su-
premacy, as for example in some aspects of the Trenta Altar, some able
critics have had reason to wonder whether Jacopo's hand and mind were
fully responsible for what we see.[5]

Today the notion of a Sienese "linear" art as opposed to a Florentine
"tactile," volumetric art is a gross oversimplification of what was, when it
was first enunciated, a subtle and defensible critical distinction. Certainly,
for the early Trecento some valid discriminations along those lines can still
be made. But sooner or later they break down. In which camp, for example,
do we place the Sienese painter Ambrogio Lorenzetti (who, incidentally,
greatly appealed to the Florentine sculptor-painter Lorenzo Ghiberti)?
The style of Jacopo, as a Sienese, in any event was much more closely allied
to that of Ambrogio Lorenzetti than to the more mellifluous and "linear"
Simone Martini, whom Dossena selected to forge in marble, perhaps be-
cause his style was in so many ways both Sienese and unsculptural (*credo
quia impossibile est!*).

The notion of line in sculpture, like that of line in nature, proposes seri-
ous problems that have as much to do with modern concepts of optics and
psychology of vision as with traditional aesthetics. What we may read as
a boundary "line" in the contour of a mass in sculpture is nothing more
than the edge, or the turning, of a plane. This we see in nature mainly as
a contrast of values—of figure against ground. That kind of line Jacopo
undoubtedly was conscious of and as certainly tried to use, one feels de-
liberately at times, to create the sculptural expression he was searching
for. A good example is the case of the putti of the sarcophagus that we
have just been discussing. But an even better example would be the "lin-
ear" definition of the profile of the effigy in the Ilaria Monument (pls. 10,
18). Here the long, almost interminable, and virtually unbearably beauti-
ful silhouette emphasizes so simply and so directly, as few other formal
devices might, the pathos of the subject. Conversely, contour lines in the
figure of the Acca Larentia (pls. 52b–55), with their liveliness and vivid
rhythms, set up in us a feeling of buoyancy of spirit and vitality of body
that the subject quite probably was intended, among other things, to ex-
press.

5. In particular, Hanson, pp. 48–49. See again, however, Morisani, "Struttura e plastica
nell'opera di Jacopo della Quercia," *Arte Lombarda* 10 (1965):78; who takes the position that
the Trenta Altar style may be deliberately archaic ("un volgersi definitivamente e volontaria-
mente indietro").

The concept of rhythm may involve both mass and line in sculpture. Rhythm in a general way is usually defined in terms of repetition and division. It might be defined as the recurrent pattern of accent on points separated by nonaccented intervals. In music an interval is often called, rather strikingly, a "rest." In looking at sculpture, as in listening to spoken poetry or to music, we should first ask: what are the points of emphasis? How do they recur? This is mainly the auditory basis of rhythm. But visually, there is a slight yet all-important difference. We must look at not just the pattern of the points of emphasis, the elements of the beat, as it were, but at the ways they are related each to each. What joins them? That, not just what separates them, is the crux. Vision, as we normally think of it, is continuous; it permits as a rule no interruption, no syncopation. We see wholly, completely, what comes into the field of our vision. There are no "empty" spaces. There are no "rests." However we see, and whatever we see, we also do not normally see "rhythmically." How, then, may the concept of rhythm enter the provinces of visual experience and of visual art?

The answer in the case of Jacopo della Quercia is not hard to find. Rhythm in his case, as with almost all sculptors of his period, depends on repetition of accentuated shapes; and between those shapes, plastic sequences of related intermediary shapes or related intervals, which tend in the end to be read as simpler two-dimensional rather than three-dimensional units. There is an obvious rhythm inherent in the repetition of forms across the face of the Trenta Altar. This is to some extent true of the arrangement, in a nonarchitectural environment, of the Madonna flanked by four saints in San Martino, in Siena (fig. 69). There is also a kind of subrhythm of secondary beats, going on in the linear patterns of the forms of the Madonna and the saints of the Trenta Altar. Drapery shapes come into the situation here. These we normally look at mainly in terms of imagery of "real" drapery and of the logic of "actual" folds. Did the artists of the Quattrocento feel the same way in every case? Did Jacopo feel constrained by what is called a "life-situation" in modeling drapery, or did he attempt to set a beat and join the points of emphasis so that the whole made a visually rhythmic entity? The answer to this question may very well determine the approach to a number of important problems that face us in the study of Quattrocento sculpture today. We know so little of what motivated these artists, whether they be Nanni di Banco, Donatello —or Jacopo della Quercia.

Rhythm is clearly a major consideration in the formal analysis of Quercia's sculpture. We find it in drapery patterns, and also in nudes. The repetition of gesture and movement of the nudes in Jacopo's Expulsion on the

Fonte Gaia sets up a pattern of beat and counterbeat that no modern eye can escape, even though the losses in the forms are extensive today (pl. 49). The element of rhythm—of movement in an overall rhythmic pattern that looks for an echo or answer, or of movement that must find a counterweight and a new resolution of opposing forces—is the basis for many of the designs of Jacopo's Genesis series of the Porta Magna of San Petronio, Bologna. Thus, in the very first of the Genesis reliefs of the Porta Magna, the Creation of Man (pl. 106), the rich and complex linear rhythms of the Almighty's drapery find a contrasting echo in the starker linear rhythmic patterns of the nude body of Adam; just as the triangular, Trinitarian halo, in its geometric simplicity, opposes the linear and plastic complexity of the adjacent foliage of the fig-tree under which Adam rests. More closely related to the Fonte Gaia style-phase is the Expulsion relief in Bologna (pl. 112), which at first glance seems to repeat exactly the composition of the same subject of the Fonte Gaia (see again pl. 49). But a second glance will show that the relief in Bologna has been reduced in depth; with this reduction there has come a subtle change, a marked increase of clarity in the rhythmic basis of the design—and of accent on the nexus of the visual drama: the opposing push and reacting thrust between the Angel and Adam.

Often in the Bolognese Genesis reliefs Jacopo used a diagonal axis as part of the armature for the rhythmic accents of his design. In comparison to the vertical or horizontal, the diagonal, as we know very well from studies of the Hellenistic Baroque or the Roman Baroque of the seventeenth century, is a prime source of dynamic. Not only through mimesis of gesture does the Bologna Expulsion achieve a powerful effect but by the opposition of the strong and active diagonal axis of the figure of Adam to the more nearly vertical, and thus calmer, figure of the Angel. The apparent weakness of the Angel's stance and action here may also be thought of as a reference to the irrevocable strength of the Divine Will behind the act, which has decreed the incident in the biblical epic we find here portrayed in stone.

Thus from the so-called formalistic elements of design, which involve the rhythmic interplay of mass and void, of line and volume, of axis and motion, we come—inevitably in Jacopo's case—to subject. We pass without transition from "tactile imagination," in Berensonian terminology, to "illustration."

When creating his images, Jacopo made use of many devices to enhance

their meaning through references not only to literary texts and traditions but to formal motives and even earlier styles of art. Thus we have seen that the "first" Madonna in the Siena Duomo acquired meaning for its original placement, which we believe to have been much closer to the observer's eye than at present, because it recalled so strongly the style of the Duomo's most precious sculptural possession, the Pisano pulpit. Similarly, the curiously involuted style given the imagery of the Trenta Altar's main portion (excluding the predella) may be dependent on the special relationship of Jacopo's altar to the older altar dedicated to San Riccardo Re, which it supplanted.

This use of older motifs as well as styles should not surprise us. Jacopo was not at all ashamed to reuse, in the design of his relief in Bologna of the Death of Abel, motifs to be found not only in the mosaic Genesis of San Marco, Venice, but in the Trecento-painted Genesis by Piero di Puccio da Orvieto of the Campo Santo in Pisa. By 1430 the painting's grouping was in an outmoded formal context (see fig. 89 in comparison with pl. 119). However, the special prestige of the Campo Santo in Jacopo's eyes and those of his contemporaries might in this visual reference have conferred a certain dignity on the imagery of the murder relief on the façade of San Petronio. And after all, it does have dignity, even though powerfully motivated and, in this case, brutal beyond the usual norm of ecclesiastical decoration, particularly, as at Modena, because of its visible place.

It has been pointed out that the same old-fashioned Pisan Genesis cycle was also drawn upon for public sculpture by Ghiberti (probably at about the same time, or a little later). "It is hard to imagine how Ghiberti could have found in the coarse daubs of Piero di Puccio inspiration for the superb figures peopling his Gates of Paradise," writes Krautheimer, who suggests that behind such cycles as that in Pisa Ghiberti might have sensed lost prototypes of an immeasurably greater quality by Ambrogio Lorenzetti, whose name figures prominently in the *Commentarii*.[6] Such, indeed, may have been the case with Jacopo; we find among his borrowings from the same Pisan cycle the pose of the Adam of the Creation of Man (see fig. 88), as well as the more generally repeated design of the Temptation, Adam, and Eve flanking the Tree with the serpent of the female head, traditionally identified with manifestations of Satan in the form of Lilith or Lamia (pl. 109). Here the serpent's tail pierces the Tree to kill it; the dead tree upon which Christ is hung appears in the contemporaneous fresco that in-

6. Krautheimer, p. 223.

cludes the subject of the Temptation, by Giovanni da Modena in the interior of San Petronio. The interest of Giovanni's slightly earlier painting for the imagery of the portal has been stressed by Beck in his study of the San Petronio portal's sources and meaning. Nonetheless, just as was emphasized in the above analysis of Ghiberti's analogous borrowings from paintings, motifs of this order were completely recast into the sculptor's own personal style when they appeared in his work.

Often, too, such references to other forms of art that appear in Jacopo's new contexts of design are so subtle or so obscure to our modern eyes that we might well overlook them. An example, while we are on the topic of Jacopo's San Petronio Temptation, is the remarkable detail of the closed eyes of Eve (pl. 110) as she reaches for the fruit. This conceivably is a cryptic reference to Eve as symbol of the Synagogue, the universal iconography for blindfolded eyes in the Middle Ages, and which indeed does appear with this meaning as a secondary figure in a panel by Giovanni del Biondo, a rare occurrence in Trecento Tuscan art.[7] At one time, thanks to James H. Beck who brought it to my attention, I was very much inclined to accept that interpretation. But it would seem, perhaps, that this temporary blindness in the San Petronio Eve may reach beyond a symbolical, to a literary origin. The idea of a sudden change in the power of sight as a metaphor for knowledge comes from the biblical interpretation of the effects of eating the forbidden fruit. In a twelfth-century French Christmas play based on the text of Genesis, the *Mystère d'Adam*, Eve takes the fruit and, against Adam's vehement objection after having eaten a piece of it, she exclaims: "Or sunt mes oie tant clervéant, / Jo semble Deu le tuit puissant" (in Auerbach's translation: "Now my eyes are so clear-sighted, I seem like God the Almighty").[8] In Jacopo's imagery she has not yet taken the bite, as Adam is expostulating with her just as in the play, and is refusing to accept the fruit that Satan has offered. In comparison with what she will experience in heightened vision after she has first eaten of the fruit, Eve is at that point, so to speak, sightless—her eyes are not bandaged, but closed; this is indeed how she appears in Jacopo's relief. She is still technically in a state of grace, but one could also say that she is already exhibiting a state of perverse blindness to God's command. It is probable, of course, that Jacopo had the tradition of a "blind Eve," incorporated into

7. For a "Synagogue" of the late Trecento, see C. Seymour, Jr., *Early Italian Paintings in the Yale University Art Gallery* (New Haven, 1970), p. 45 (illus.).

8. E. Auerbach, *Mimesis* (Princeton, 1963), p. 145. Closed eyes may also be linked with intemperance, and Eve's act stood in the Middle Ages as related to the sin of gluttony.

the French play, from a far more diffused source such as the Vulgate itself although not, as in Milton's case, rabbinical commentaries. Those well-known lines from *Paradise Lost* suggest much the same general theological sources, as Satan addresses Eve:

> "You eat thereof, your eyes that seem so clear
> Yet are but dim, shall perfectly be then
> Open'd and clear'd; and ye shall be as Gods
> Knowing both good and evil as they know."
> [*P.L.*, ix, 689–92]

In the scene presented by the panel in Bologna, it is important that so very early in the Renaissance Jacopo combines a traditional theological meta-phor with a delicately and humanistically presented Eve and a strongly classical nude like that of the Adam.

This point leads naturally to a consideration of Jacopo's relation as an artist to the art of Antiquity, one of the touchstones of what has been called the Early Renaissance in Italy. It is a more complicated matter than might appear. One of the difficulties in evaluating the role of the Antique as a source for Quattrocento style in Italy are the quite obvious facts that both periods not only share the same geography but that the second is a lineal descendant of the first. Where does deliberate revival begin in such a situation, where both the land and the cultural continuity are so shared over so long a period of time? For the pose of Jacopo's Adam in the Crea-tion relief of the San Petronio portal we have just invoked as a possible source a motif in a Trecento picture (fig. 88). But this source, in turn, would appear almost certainly to come from an Antique source that for reasons of the subject, which is not pagan, we would do better to call Early Christian. For a comparable example of a similarly posed and constructed Adam in small-scale ivory sculpture, it is necessary only to turn again to figure 86. Whether Jacopo ever saw that particular ivory is not important; he could have seen some other Early Christian-Antique version of the same, or very similar type. Or perhaps he really did depend on the fresco alone. We shall probably never know.

Even in his immediate background of sculptural tradition in Siena the Antique was strongly present, if only through its reflection in the art of Nicola Pisano. We would do well to consider that the Renaissance, as we call it, which came into being in the Quattrocento, received the influence of the Antique not only directly through rediscovered originals but through Dugento and Trecento works of art that had already incorporated

earlier reactions to other, but related, Antique originals. If one were to adopt an analogy to the chemistry of the human body, one might say that by 1400 in Italian art there had already been built up an irreversible affinity to the Antique. In that process the Trecento had its own extraordinarily important part in the Renaissance.

This tendency was still not sufficient completely to inhibit other tendencies, for example, north European late fourteenth-century naturalism, which to a considerable degree colors the sculpture of Jacopo's effigy of Ilaria del Carretto. But in contradistinction, the putti of the Ilaria sarcophagus, which we have already looked at on at least two occasions in this text, assert in no uncertain terms the Antique heritage which as early as 1405–06 was not to be denied in Lucca any more than in Florence (pls. 15–17).

It has been noted in an earlier chapter that the art, and to a considerable extent the spirit, of Antiquity was one of the decisive factors in the creation of the then new style of Jacopo's Fonte Gaia. The influence of the Antique in the Fonte Gaia is more pervasive than in any other large ensemble of marble sculpture from the second decade of the Quattrocento, not excepting Nanni di Banco's frontispiece for the Porta della Mandorla. The power of the Antique here is partly to be explained by the fountain's program, which was meant to commemorate not only Siena's legendary founding by Senis, son of Romulus, but to celebrate civic virtue on the Roman model as well as religious fervor, as the Sienese Commune's birthrights and continuing ideals. In the poses, and in many cases in the proportions of figures such as that of the Wisdom, Jacopo went to Antique models for inspiration. The very relief-style used for the Expulsion was, as we have also noted, evidently derived directly from the style normally to be found on the faces of Roman sarcophagi. The clue to that source of inspiration in this particular relief is given by the motif of the Adam, which probably is an echo of the central figure in the well-known Meleager-type sarcophagi (fig. 57). It is interesting that as Jacopo's Fonte Gaia Expulsion relief was imitated or copied later in the Renaissance, Jacopo's vivid interpretation of Roman spatial design and overlapping rhythmical devices of form are progressively seen to become weaker (figs. 58–61). By the last quarter of the Quattrocento, in the hands of later Sienese sculptors, the original active "Roman" component had visibly begun to leach out. The same might be said of the companion subject of the Creation of Adam, also on the later Quattrocento font in the Duomo of Siena.

At Bologna, in the Genesis cycle of the Porta Magna, Jacopo created a

different relief-style—shallower as to space, with the forms brought as uniformly as possible up to the front plane. This is no less "Antique" a device than that used for the Expulsion in Siena. The difference is that, rather than using as a model the deeper cut style of the face, or front, of Roman sarcophagi, Jacopo instead went to a more planar, shallower relief style that was most often used in Antique practice for the ends of a sarcophagus (fig. 87). Whether he may have gone even further at Bologna in his emulation of what he believed to be Antique practice is a question that still requires further investigation. At all events, when one of the Genesis reliefs was partially cleaned with water in 1955, it appeared as the grime and deposits of the atmosphere were being mercifully washed away, that the reliefs were originally coated with a greenish protective agent. As the unexpected color appeared, the washing process at this point was called to a halt, and as far as I know has not been continued since. No one has, to my knowledge, gone back to continue the process begun in 1955, and in these circumstances a chemical analysis of the material used as a coating is not at present available.[9]

However, if what we saw on the scaffolding in 1955 was indeed evidence of a variety of green chromatic covering of the forms of the reliefs, it is possible that the artist intended them in some way to suggest bronze patinated *all'antica*. The shallower style of the reliefs would not be against this supposition. We know from the inventory of Jacopo's bottega in Bologna taken after his death that he owned personally what appear to have been examples of Antique bronze (*Una testa di vecchio, di metallo; Due inudi* [sic] *di metallo*). The fine, strong head of the St. Petronius of the lunette of the Porta Magna (pl. 87) could have been based on just such a *testa di vecchio, di metallo* ("a head of an old man in metal [bronze]").[10] There is nothing surprising here; in such direct use of Roman portraits as models for idealized heads Jacopo was, if anything, a latecomer in comparison to Nanni di Banco and Ghiberti. More on this point a little later.

As Jacopo matured both as a man and as an artist, he appears to have found increasing affinities with the deep roots he shared with his own times and culture in Tuscany. In part we can identify these roots as Roman and perhaps Etruscan. But there is also another side to this aspect of a drive toward identity with the past. The world of the Antique was only partially

9. Recently tests have been made of the surface constituents of the sculpture, but it is not clear from what portions of the portal samples were taken. See, nevertheless, the catalogue *Sculture all'aperto* (Ferrara-Bologna, 1969), pp. 63–55. Cleaning and protection are now planned.

10. See Appendix, p. 127.

above ground; much remained below the surface of the earth awaiting discovery, truly as "buried treasure," in the phrase used by Vasari to describe what Donatello and Brunelleschi were thought to be looking for in Rome. Jacopo's sculpture reflects his feeling for earthy, fundamental things. When he imagines humanity in general, as Biagi noted with nice insight in connection with Jacopo's bronze relief of the Annunciation to Zaccharias in Siena (see again pls. 62, 63), he projects a uniquely tough, primitive human type.[11] It is as though we were looking at equivalents of archaic human beings who embody, by analogy to the very materials from which they are formed, some long since past and only dimly remembered Bronze Age or Stone Age. They are in bronze because they belong to the Bronze Age; Stone Age men and women are best represented as if down to the very core of their being they were made of stone. Nothing is more eloquent of this tendency, in which Jacopo differed so greatly from both Ghiberti and Donatello, than the ruggedly carved stone head of Antonio Casini that may be one of his last completed works (pl. 133).

The distance that separates Jacopo as an artist from both Donatello and Ghiberti is as much a matter of psychology as of relative ability. There is little doubt today, not only among scholars and students in Italy but elsewhere generally, that Donatello's towering stature as a creative artist seems to dominate the first half of the Quattrocento. In this view he has no immediate rival in European sculpture of the period as a whole. Ghiberti's carefully balanced art, restricted to bronze but with an unparalleled range from monumental statuary to most delicately articulated relief in miniature, has no equal perhaps in any age; it is unique. In this company Jacopo della Quercia necessarily stands apart.

Donatello appears to have been more visual in his approach to sculpture than the more haptic, tactile-minded Quercia. Donatello "saw" form and the physical environment of which form is a part not so much as a painter as a man of the theater—a *régisseur*, a *metteur-en-scène*. In this respect his sculpture is always visually exciting, not only in photographic detail but in itself, as a vision of a dramatic interlude in human events. In his reliefs he creates stages, equipped with scenery, for the action of his characters, using at a remarkably early date the results of Brunelleschi's research into one-point perspective as a major component of relief-style. In this he was to be joined by Lorenzo Ghiberti, not merely in the great spatial

11. L. Biagi, *Jacopo della Quercia* (Florence, 1946), p. 29.

creations of some panels of his Second Doors for the Baptistery, but in such monumental designs on a small scale as the reliefs of the Shrine of St. Zenobius in the Florence Duomo. There is something frankly dramatic —not merely "pictorial," as this relief-style has often been characterized— in this scenographic sculpture. And it was with a fine recognition of the dramatic possibilities of perspective that the most recent monographist of Ghiberti linked some of the most splendid paintings of urban perspective from the later Quattrocento with the subject matter of stage scenery.[12]

More than Ghiberti, however, Donatello carried his dramatic interests inward. His statues seem to possess each in its own way an inner psychological motivation, as if the pose, the surface-modeling, the drapery (or its marked absence in the Bargello bronze David), all result in a single harmony from a unified, internal emotional source. Jacopo's statuary, although it always suggests some aspect of life below the surface, has little of Donatello's inner intensity or fire. His sculpture remains more distant in its psychological effects on the observer. One wants to draw near to Donatello's statues—to speak familiarly with them, as the sculptor himself is said to have done while he was making them. Jacopo's figures speak from afar, and one is inclined to respect a certain aloofness as an essential part of their being. They belong to a different world, or at least they define in their own terms an environment which is to a degree unworldly: the ciborium Prophets of the Siena Font come to mind; so also the Wisdom of the Fonte Gaia, the Ilaria effigy, and the portal sculpture of San Petronio.

Both Donatello and Ghiberti were capable of making speaking likenesses in portraiture. Portraiture as a genre simply escaped Jacopo, to some degree even in the Lorenzo Trenta effigy where one would expect a personal likeness. It would be just as unlikely to find portraiture in Nanni di Banco's or in Michelangelo's oeuvre as in Jacopo's. Among contemporaries he was closer to Nanni than to either Donatello or Ghiberti in his artistic aims. Like Nanni, he was involved in large monumental programs of civic import. Like Nanni, he was first and foremost a hewer of stone— a *tagliaprede*, as the documents speak of a true carver. Like Nanni, he emphasized the hard and resistant nature of stone in general design of mass and in detail. Like Nanni, finally, he felt an affinity to the rugged aspects of the Antique, to the sculpture of Etruria and the Roman Republic rather than to that of the Empire of the Antonines.

Ultimately, one comes to the sculptor whom Jacopo most seems to re-

12. R. Krautheimer, "Tragic and Comic Scene of the Renaissance: The Baltimore and Urbino Panels," *Gazette des Beaux-Arts*, 6th ser., 33 (1948): 327–46.

semble and whose name was invoked at the beginning of this study: Michelangelo. The chief meeting-place of their art was Bologna, but it would be a grave error to underestimate the strong relationships that also exist between Jacopo's sculpture of the Fonte Gaia and the art of Michelangelo. It belongs to much the same order of more-than-human existence as the latter's beautiful Bargello Madonna relief, the Bruges Madonna, and the painted reliefs and statuary of the Sistine Chapel vault. Both artists shared a deep respect for the natural qualities of stone; they both spent days— even weeks—on the road or at the quarry in search of stones or marbles of highest available quality. In their designs, even of ornament, they were alike in maintaining the character of the material, avoiding where it was possible deep undercuttings combined with shallow sections, which would undermine the visual effect of the stone's solidity and integrity. There are medieval aspects to Michelangelo's approach to sculpture, just as the Renaissance speaks at times through Quercia. Their careers for a time were strangely parallel, at precisely a century's interval: birthdates ca. 1375 and 1475; first major sculpture in 1401 and 1501; acme of creative powers in the late 1420s and early 1430s for Jacopo, for Michelangelo, with the Medici Tombs, in the late 1520s and early 1530s. One should not and indeed cannot push this parallelism too far; the difference in scale of achievement, so obviously and heavily weighted in Michelangelo's favor, should be a sufficient deterrent to doing so.

Nonetheless Michelangelo, strong Florentine that he was as *homo politicus*, appears at intervals to have been virtually a stranger to his times and to his city, an avatar of the ochre-tinged earth and rugged Apennines familiar to the ancient Etruscans. So also, in his own way, though born in Siena and loyal to its already fading fortunes, appears in historical perspective the man of Tuscan oak, Jacopo della Quercia.

PART 2

6 Summary Documentation for the Career of Jacopo della Quercia

Documents are extant except where otherwise noted, and may be most easily found in published form where indicated, e.g. "Bacci, *Valdambrino*." Dates have been uniformly adjusted to the modern calendar. The beginning of the year is considered to be January 1.

1. 1370, April 21	Marriage record in Siena of Jacopo's parents, Piero d'Angelo di Guarnieri, "detto della Quercia," and Maddalena, "detta Lena" (Bacci, *Valdambrino*). The date applies to the handing over of the dowry-money.
2. 1371–ca. 1375	Traditional date-span for Jacopo's birth, based in part on his presumed equestrian statue of 1390(?), of the condottiere, Giovanni d'Azzo Ubaldini. (Vasari 2)
3. 1391	Malavolti uprising in Siena and beginning of temporary Visconti control of the city-state. Exodus of many artists, possibly including Jacopo and his father. (Bacci, *Valdambrino*; Lazzareschi)
4. 1394, February 25	Jacopo's father, Piero d'Angelo della Quercia, is in Lucca. It has been surmised that Jacopo had left Siena by this date. Whether he was by then in Lucca or further north is not known. (Bacci, *Valdambrino*). In this year Jacopo may have made the monument to Gian Tedesco rather than Ubaldini.
5. 1401–03	Jacopo takes part in the Florence Baptistery competition, won by Ghiberti (who recorded it in his *Commentarii* of ca. 1450; see also Vasari 2.)
6. 1403	Jacopo is in Ferrara where he undertakes to carve the large seated Madonna (of the Pomegranate) for the Silvestri Altar in the Duomo. (Documentary reference is available only in a transcript; see Nicco-Fasola, Bibliog. 2 and Rondelli, Bibliog., no. 99).
7. 1405–06 (?)	Jacopo is presumably in Lucca temporarily, where his Sienese colleague and collaborator, Francesco di Domenico Valdambrino, is documented 1405–07. To them in partnership is attributed the Monument of Ilaria del Carretto-Guinigi (d. December 1405). (Bacci, *Valdambrino*; see also Vasari 1, 2).

95

It is probable that Jacopo returned to Ferrara before finishing the Ilaria monument, leaving one side of the sarcophagus for his partner in Lucca to finish.

8. 1408, June 18	The Madonna for the Silvestri Altar in Ferrara is approved for payment. (Document extant in form of old copy only; see Hanson and Rondelli, Bibliog., no. 99)
9. 1408, December 15	Jacopo is back in Siena and receives the commission for the Fonte Gaia. A first contract is drawn up. The document is contained as a *vidimus* in a confirmation of 1412. (Hanson; see also Vasari 1, 2)
10. 1408, December 31	Jacopo is elected for a two-month term to the Consiglio del Popolo of Siena, Monte dei Riformatori, Terzo di San Martino. (Bacci, *Valdambrino*)
11. 1409, January 22	Date of second contract for the Fonte Gaia. (Hanson)
12. 1409, February–1411, May	For these two years there is no mention of Jacopo in available documents. His whereabouts are therefore unknown, but may be assumed to have been between Siena, by this time his main base, and Lucca.
13. 1411, May 6	A new sculptural campaign is decided on for the Lucca Duomo. Probably at this point Jacopo became involved. Document extant for program only. (Bacci, *Valdambrino*)
14. 1412, February 28	Lorenzo Trenta is given permission to build his family chapel in San Frediano, Lucca; Quercia ultimately to be sculptor in charge. Document extant for program only. (Hanson; Lazzareschi; see also Vasari 2)
15. 1412, May 28	Quercia's contract for the Fonte Gaia in Siena is confirmed. (Hanson)
16. 1413, December 18	Jacopo and Giovanni da Imola, his *compagno*, are accused by Giovanni Malpighi of Lucca of rape, theft, and sodomy. Jacopo escapes from Lucca, but Giovanni is seized, tried, and finally (26 April 1414) condemned to prison in lieu of a heavy fine that he is unable to pay. He remains in prison until given a special pardon (17 June 1417) and the remainder of his fine is paid by Girolamo Trenta. (Hanson; Lazzareschi)
17. 1414, January 5–10	Jacopo is once again in Siena, to work on the Fonte Gaia. He has as assistants (for the masonry) Nanni

	di Jacopo of Lucca and Sano di Matteo of Siena. By the spring of 1415 the latter two are joined by Jacopo di Corso (called Pappi) of Florence. (Hanson)
18. 1416, February 16	Lorenzo Trenta obtains permission to transfer remains of St. Richard the King to a Roman urn to be placed under a new altar of his chapel. He also has permission to remake the altar. The ceremony is to take place on 18 February 1417. Later transcript only of original document available. (Cornelius; Hanson; Lazzareschi)
19. 1416, March 11	Paolo Guinigi provides Jacopo with a safe-conduct to return and work unmolested in Lucca. (Hanson)
20. 1416, November 17	Jacopo is back again in Siena and contracts for additional figures (possibly two she-wolf waterspouts) for the Fonte Gaia. (Hanson)
21. 1417, March 31	Jacopo, in Siena, stands as godparent to a son of the painter, Martino di Bartolommeo. (Bacci, *Quercia*)
22. 1417, April 16	Jacopo is commissioned to make two of the bronze reliefs for the Siena Baptistery Font. (Bacci, *Quercia*)
23. 1418, January 11–14	Agreement is reached between the Fonte Gaia Commission and Jacopo for additional sculpture, with corresponding increase in payment. Jacopo is now steadily in Siena for a time. (Hanson)
24. 1418, December 31	Jacopo chosen for Siena Council from the district of the Monte dei Riformatori. (Bacci, *Quercia*)
25. 1419, October 20	The Fonte Gaia is completed. (Hanson)
26. 1420, September–October	Along with the sculptor Domenico di Niccolò, Jacopo is elected Prior for two months from the Terzo di San Martino. (Bacci, *Quercia*)
27. 1420, September 28	Jacopo is one of several who offer guaranties for the painter Martino di Bartolommeo, nominated *castellano* of a fortress in Sienese territory. (Bacci, *Quercia*)
28. 1421, January 20	Jacopo offers surety for four pieces of wooden sculpture on behalf of Alberto di Betto d'Assisi. (Bacci, *Quercia*)
29. 1421, April 25	Jacopo receives advance (?) payment for the Virgin of the wooden Annunciation group for the collegiate church of San Gimignano (fully finished only some years later, in 1426). Document is only in a

later copy. Inscribed date of 1426 is on the base of the statue of Virgin. (Bacci, *Quercia*)

30. 1422

Probable closing date of Jacopo's work on the Trenta Altar in Lucca (by inscription only).

31. 1422, May 5

Jacopo is named by his father to receive money owed him (among others, by Giovanni da Imola) in Lucca. (Lazzareschi)

32. 1423, March 25–April 7

Jacopo makes an inspection tour of the castles of Cetona, Sovana, and Manciano, in Sienese territory. (Bacci, *Quercia*)

33. 1423, October 16

Jacopo receives collateral for a loan to Madonna Dea, widow of Neroccio del Giga, Madonna Antonia, widow of Bartolo di Lorenzo (goldsmith), and Madonna Nanna, wife of Jacopo Capaccini. (Bacci, *Quercia*)

34. 1424, May 24;
 1425, April 21

Jacopo receives from Madonna Eufrasia, widow of Nanni di Domenico Fei, 350 florins as dowry of his affianced bride, Agnese, daughter of Eufrasia and Nanni. There is no evidence, however, that this marriage took place. (Bacci, *Quercia*)

35. 1424, June 2

Jacopo is a guarantor for Angelo di Minuccio, nominated *castellano* of Lucignano di Spara in Sienese territory. (Bacci, *Quercia*)

36. 1425, March, April,
 August; 1426, February

Jacopo is sued by the Opera del Duomo for return of advances made on his two reliefs for the Baptistery Font, which he has not executed. In 1423 one of his reliefs had been allocated to Donatello. (Bacci, *Quercia*)

37. 1425, March 26

Contract for the main portal (Porta Magna) of San Petronio, Bologna. For the next year and a half Jacopo is based in Bologna and spends much time traveling to Milan, Ferrara, and Venice to acquire materials. His chief assistant is Cino di Bartolo. (Supino; see also Vasari 1, 2)

38. 1426

Martino di Bartolommeo completes the polychromy of the San Gimignano Annunciation group (by inscription only). See above, no. 29. (Bacci, *Quercia*)

39. 1427, June 1

Jacopo, in Siena, stands as godparent to a son of the goldsmith Goro di Ser Neroccio. Goro at this time is at work on the bronze figure of Fortitude for the Baptistery Font, for which figure Jacopo appears, on the basis of style, to have provided the model to be cast, gilt and chased by Goro. (Bacci, *Quercia*)

40. 1427, June 20	Commission to Jacopo to finish the upper portion of the Baptistery Font. The contract is confirmed on 20 June 1428. Pietro del Minella is his chief assistant; he is assisted also by Pagno di Lapo, "da Firenze." (Bacci, *Quercia*)
41. 1428, August 26	In Bologna, Jacopo is threatened with a fine if he does not return to work in Siena within ten days. He is back certainly before September 27 and is ordered by the Concistoro not to leave the city without its permission. (Bacci, *Quercia*)
42. 1429, October 24–December 26	Contract for the inner portal of San Petronio, Bologna. In return, Jacopo leaves to the Fabbrica of San Petronio 50 florins owed him, for "the good of his soul." (Bacci, *Quercia*)
43. 1430	Jacopo is once more in Siena for a time. He receives final payment for his work on the Siena Baptistery Font. With his father he has changed residence in Siena from the Terzo di San Martino to the Terzo di Città. His house in Bologna is at this time concurrently rented for him by the Fabbrica of San Petronio. (Bacci, *Quercia*)
44. 1433	At this time Jacopo, with his shop, presumably has begun work on the Vari-Bentivoglio Monument, in San Giacomo Maggiore in Bologna, left unfinished at his death. From about this period also dates the beginning of the sculpture for the Casini Altar (endowed in 1430) in the Duomo. The extant documents do not provide precise beginning dates for either program. (Bacci, *Quercia*)
45. 1434, February 6	Jacopo is given at least six (or perhaps seven) figures to carve for the Loggia di San Paolo (della Mercanzia) in Siena. The marble is to be supplied later by Pagno di Lapo, "da Fiesole." (Bacci, *Quercia*)
46. 1435, January–February	Jacopo is again elected to the Consiglio del Populo of Siena for these months, this time from the Terzo di Città. (Bacci, *Quercia*)
47. 1435, January 11	Jacopo reclaims from the Opera del Duomo in Siena a statue begun by him earlier for the Cappella del Campo outside the Palazzo Pubblico. (Bacci, *Quercia*)
48. 1435, February 2	Jacopo is one of twelve nominees for the position of Rector of the Hospital of La Scala in Siena. He is not elected. (Bacci, *Quercia*)

49. 1435, February 8

Jacopo is elected *operaio* (architect-in-charge) of the Siena Duomo. (Bacci, *Quercia*)

50. 1435, February 9

Jacopo presides over the Consistoro of Siena. (Bacci, *Quercia*)

51. 1435, February 10–11

Jacopo receives payment for the work done on the incomplete statue for the Cappella del Campo, which he now returns, since as operaio he will not have the time to complete it. He is also relieved of the commission to make, in bronze, the grill for the chapel in the interior of the Palazzo Pubblico. (Bacci, *Quercia*)

52. 1435, February 16–27

Jacopo requests permission to finish the portal of San Petronio while carrying on as operaio in Siena. He is sworn in as operaio on February 27. (Bacci, *Quercia*)

53. 1435, August 1

Jacopo is made a Knight of Siena. This honor was traditionally given to the elected operaio of the Duomo. (See Vasari 1, 2)

54. 1435

By this year Jacopo is in full charge of the Casini Altar in the Duomo of Siena, as well as the Loggia di San Paolo. As assistants in sculpture he has Antonio Federighi, Cino di Bartolo, Pietro del Minella; also Giovanni di Mencio, Nanni di Niccolò, Polo di Niccolò, and several others. (Bacci, *Quercia*)

55. 1436, April 27

Jacopo stands as godfather to a son of Paolo di Martino of Siena. The father is listed as a sculptor. (Bacci, *Quercia*)

56. 1436, October 4

Jacopo stands as godfather in Siena to a son of Niccolò di Paolo, an iron-worker (*fabbro*). (Bacci, *Quercia*)

57. 1437, February 27

Jacopo's inventory of the Opera del Duomo of Siena is accepted and approved by the Sienese fiscal authorities (*Rigolatori del Commune*). (Bacci *Quercia*)

58. 1437, March 19

Jacopo receives permission to be absent from Siena for his work in Bologna, for nineteen days only. (Supino, *Porte*)

59. 1437, April 4

Jacopo writes to the Sienese authorities to make up for his failure to return as promised, but nevertheless remains in northern Italy on an expedition to acquire stone for San Petronio. (Supino, *Porte*)

60. 1437, May 20–June 24

Jacopo is once more in Siena. (Bacci, *Quercia*)

61. 1437, June 5

Through the Concistoro of Siena, Jacopo requests from Francesco Sforza a safe-conduct for his sister Elisabetta and her daughter Caterina, to return to Siena from Lucca. (Bacci, *Quercia*)

62. 1437, September 22–27 through at least November 7

Jacopo is in Bologna. He returns by December 2 to Siena. (Supino; Bacci, *Quercia*)

63. 1438, February 5

Jacopo reports that he has fallen ill on a trip between Siena and Bologna. (Bacci, *Quercia*)

64. 1438, March 26

In Siena, Jacopo stands as godparent to Mariano di Giovanni d'Agnolo di Maestro Vanni. (Bacci, *Quercia*)

65. 1438, April 28

Jacopo is nominated for the post of one of the three envoys (*oratori*) from the Commune of Siena to the Duke of Milan and to Niccolò Fortebracci. He is not elected. (Bacci, *Quercia*)

66. 1438, May 15

Jacopo is one of the citizens selected to be on the secret council of the Consistoro of Siena. (However, he does not appear.) (Bacci, *Quercia*)

67. 1438, October 3

Jacopo makes his will, providing, as "eredi universali," for his younger brother Priamo and his sister Elisabetta. He leaves smaller legacies to his niece and his principal assistants, including Cino di Bartolo, Pietro del Minella, and Castore(?) di Nanni da Lucca. (Supino)

68. 1438, October 20

Jacopo dies. He is buried in Siena in the church of San Agostino. (Bacci, *Quercia;* see also Vasari 1, 2)

69. 1439–43

After his death Jacopo is accused of mishandling funds as operaio, especially in connection with the Casini Altar. By 1442 his brother Priamo has made final arrangements with the Fabbrica of San Petronio in Bologna to obsolve the family from any further obligation. (Bacci, *Quercia;* Supino)

7 Summary Documentation for the Sculpture of the Trenta Chapel and the Fonte Gaia

1. 1408, December 15

 Milanesi, 2:100
 B.-P., 2:306
 Hanson, digest 1

 First contract for the Fonte Gaia. A full-scale drawing was to have been made on an interior wall of the Palazzo Pubblico. Terms, including 1,600 florins originally specified for Quercia, are given in a 1412 document; see no. 3, below.

2. 1409, January 22

 Milanesi, 2:100
 Bacci, *Valdambrino*, no. 1
 Hanson, digest 4

 Modified contract for the Fonte Gaia, specifying a drawing (in large part extant) on parchment. Quercia is to be paid 2,000 florins and work is to be completed in twenty months following April 1 (i.e. by 1 December 1411). Nothing occurs in consequence.

3. 1412, June 1

 Milanesi, 2: no. 44
 B.-P. 2: 3-6-08
 Hanson, digest 15

 Contract of 1409 (no. 2, above) is renewed. Contains original terms of contract drawn up in 1408. Very little occurs in consequence.

 Hanson, digests 25-42

 During part of 1412 and most of 1413 Quercia seems to have been busy with work for the Duomo authorities and for Lorenzo Trenta in Lucca. On 6 May 1411 a new campaign of sculpture for the Duomo in Lucca had been authorized. And on 28 February 1412, Trenta was given permission to enlarge the chapel (including a new altar) of St. Richard in San Frediano in Lucca as his family place of burial; Jacopo, with Giovanni da Imola as an associate, was in charge. Jacopo may have been infrequently in Siena (a small payment of 75 lire in connection with the Fonte Gaia, recorded 12 November 1412); but on 12 May 1413 the Sienese authorities stated that all advances made on the Fonte Gaia, including those for masonry-work, were to be refunded if work was not immediately resumed. Again, on December 17 of the same year, the Sienese authorities threatened action against Quercia if he did not return from Lucca within eight days (i.e. by Christmas 1413). On the day after Christmas, Francesco di Valdambrino, chief operaio in charge of the fountain (*operaio delle acque e bottini*) was threatened with the forced return of all monies advanced on the Fonte Gaia, and a letter

to Paolo Guinigi, Lord of Lucca, was sent on the same day, urging the release of Jacopo from Lucchese territory. Meanwhile, on December 18 the Lucchese Giovanni Malpighi had made his complaint against Quercia and his assistant Giovanni da Imola, accusing them of theft, adultery, and sodomy. Giovanni was imprisoned, but before 10 January 1414 (see no. 4, below), Jacopo had been permitted to leave Lucca and was in Siena again.

4. 1414, January 10

Della Valle, 2:162–65
Hanson, digest 43

Contract between Quercia and new workers in stone and marble, Nanni di Jacopo of Lucca and Sano di Matteo of Siena. A carver of ornament (Jacopo di Corso of Florence) was to be selected later with the concurrence of Francesco di Valdambrino, who was to be operaio in charge of the whole project on a salaried basis. Nanni and Sano were to receive 2,200 lire at a monthly rate of approximately 120 lire (30 florins). The fountain was to be finished in eighteen months, beginning on March 1 (see no. 6, below).

Hanson, digests 48, 59

A bottega is rented for Quercia in the Opera del Duomo in Siena as of January 1 (two years' rent due, January 1416). Work on the Fonte Gaia starts slowly, and unevenly. A dispute arises over the poor quality of two pieces of marble delivered to Quercia, recorded on 3 January 1415 (to be made good by 1 March 1415). This is the first indication that marble for the sculpture of the fountain had been delivered.

5. 1415, January 18

B.-P., 2:322–24
B.-P., 81
Hanson, digest 49

Decision is taken to decorate the exterior of the fountain to harmonize with the "beautiful" interior ("bello lavorio che viene dalla parte dentro"). The wings of the fountain are to be lengthened and splayed toward the front. Costs are estimated at an additional 400 florins, to be paid to Jacopo.

Hanson, digests 52, 64

On 4 August 1415 the decision is ratified; but payment is ultimately authorized only on 17 February 1417.

6. 1415, May 28–August 1

Bacci, *Valdambrino*, no. 16
Hanson, digest 51

Fragmentary accounts of payments disbursed by the operaio of the Duomo of Siena—designated from the first as the chief paymaster of the project. It appears that Quercia had received for payments or as advances approximately 1,250 florins. The monthly salary of the masons at a rate of 20 florins

for fifteen months had been paid. Jacopo di Corso of Florence had received (as an advance?) about 90 florins. Work on the Fonte Gaia is by now progressing in earnest.

7. 1416, March 16

Lazzareschi, 96
Hanson, digests 53, 54

Quercia has been given a safe-conduct to Lucca. This marks the beginning of a rather lengthy stay in Lucca on Quercia's part, the second since he had contracted to make the Fonte Gaia. On 16 February 1416, Lorenzo Trenta obtained confirmation for rebuilding the altar of San Riccardo Re in his chapel, with completion scheduled within a year's time for dedication ceremonies of the translation of the relics of St. Richard. Quercia designs and begins tomb slabs for the Trenta Chapel, both dated 1416. He completes one (Lorenzo's). The wife's slab appears to have been completed later by Giovanni da Imola (see no. 11 below).

8. 1416, July 8 and
 November 17

B.-P., 2:325–27
Hanson, digests 59, 60

Decision to alter waterspouts of the Fonte Gaia. They are now to be planned as dolphins or wolves ridden by putti, and are to replace the two (?) *lupae* as suggested by the drawing of 1409. From the terms of the document it appears that Quercia was not in Siena when the decision was made.

9. 1416, December 11 and 22

Milanesi, 2: no. 52
B.-P., 2:327–30
Hanson, digests 61, 62, 63

Jacopo is back in Siena. The contract for the fountain as a whole is once again reviewed and renewed according to the terms of 1409. Only in 1417 were the additional 400 florins allocated in 1415 actually authorized; see above, no. 5.

10. 1417, April 16

Milanesi, 2: no. 58
Hanson, digests 65, 66,
 67, 68

Quercia is in Siena to sign a contract for two reliefs on the Baptistery Font. He was most likely in Lucca during much of the second half of 1417. Giovanni da Imola, his helper, had been released from prison (see below, no. 11). The stoneworkers on the Fonte Gaia had fallen behind schedule, and this may have been used by Quercia as an excuse for nondelivery of his own work in Siena (document of 12 September 1417).

11. 1417 (?), April 20; June 17

Lazzareschi, 71
Hanson, digest 66

Giovanni da Imola is released from prison and 100 florins remaining from his fine is paid by Girolamo Trenta.

12. 1417, October 12

A completely new committee of three overseers (operai) for the Fonte Gaia is to be selected. They

Milanesi, 2: no. 63
B.-P., 2:322
Hanson, digest 69 (cor-
 recting B.-P. above

are to see to it that the fountain is finished within six months of the date they take office (probably 1 January 1418). Quercia is apparently still away in Lucca.

13. 1418, January 11–14

B.P., 2:334–36
Hanson, digest 72

Jacopo is finally back in Siena again. A new agreement on the Fonte Gaia is reached, which specifies 280 additional florins to Quercia in payment for his part in the enlargement of the 2 2/3 braccia on the back and the 2 2/3 braccia on each of the wings of the fountain (see above, no. 5). This is an important date since it serves as the likeliest *terminus post* for the angels of the back and the reliefs of the Creation and Expulsion of the sides. It was determined as of this time to push the work to completion by June 1. As of 1 January 1418, Francesco di Valdambrino was to be relieved of his former duties (as *operaio delle acque e bottini*), though he kept an account through April 1418. As of April 16, an extension of the completion date of the fountain was granted to July 1; this was overly optimistic, and on August 19 the date was further extended to November 1 or December 1.

Hanson, digests 70, 71, 73,
 74, 75

14. 1418, August 1

Bacci, *Valdambrino*, no. 14
Hanson, digest 76

Quercia is authorized to pay Jacopo di Corso 300 florins, presumably for his ornamental carving on the Fonte Gaia. With ca. 90 florins already advanced (see above, no. 6) the sum came close to the 400 florins authorized for work connected with the enlargements and exterior decoration of the fountain in 1417. The carving of the exterior can thus be considered finished, or nearly so.

15. 1419, January 19, 24

Milanesi, 2: no. 65
B.-P., 2:338–39
Hanson, digest 77

Agreement in principle on the method of settling accounts for the Fonte Gaia.

16. 1419, February

Della Valle, 2:155
Bacci, *Valdambrino*, 304
Hanson, digest 78 (amend-
 ing both Della Valle and
 Bacci, above)

The masonry shell of the Fonta Gaia is complete; installation of the sculpture begun.

17. 1419, May 4

Bacci, *Valdambrino*, no. 14
Hanson, digest 79

Last recorded payment for masonry of the Fonte Gaia; steps and bench on exterior of the fountain.

18. 1419, September 1

B.-P., 2:342–43
Hanson, digest 80

Inspection of the Fonte Gaia by the operai. It is presumably complete.

19. 1419, October 20

Milanesi, 2: no. 67
B.-P., 2:339–42
Hanson, digest 81

Final agreement on payment for the Fonte Gaia. Quercia is paid a total of 2,280 florins. All records of previous contracts extending from document of 1 June 1412 (see above, no. 3) are cancelled.

20. 1422

Date is inserted into earlier inscription recording Quercia's authorship of the Trenta Altar in San Frediano, Lucca. It probably records the date of the completion and installation of the predella section of the altar.

8 Summary Documentation for Quercia's Part in the Sculpture of the Siena Baptistery Font

1. 1417, March 10–April 10

 Bacci, *Quercia*, pp. 102–03

 Payments for the model of the Font to Sano di Matteo of Siena, and Jacopo Papi (di Corso) of Florence.

2. 1417, April 16

 Milanesi, no. 56
 Paoletti, nos. 1, 2

 Commission for four bronze reliefs, two to Quercia and concurrently two to Turino di Sano and Giovanni Turini (his son). This is the first mention of Jacopo's name in connection with the documented history of the Font.

3. 1417, April 21

 Bacci, *Quercia*, p. 103

 Payment for parchment for a drawing of the Font. The name of the artist who was to make the drawing is not mentioned. Perhaps Ghiberti had the responsibility of having the drawing made on his specifications; nothing further is known about this design.

4. 1417, May 20–21

 Bacci, *Quercia*, p. 109
 Krautheimer, doc. 137, digest 53
 Milanesi, no. 61
 Paoletti, nos. 4, 20

 Commission to Ghiberti for the remaining two bronze reliefs; promise also of six additional figures. Ghiberti is entertained in Siena on this occasion.

5. 1419, October (?) 8

 Paoletti, no. 5

 Quercia's revised contract for the two reliefs.

6. 1419, October 9

 Bacci, *Quercia*, p. 123

 Jacopo receives in advance 120 florins (at a rate of 4 lire per florin) on the two reliefs for the Font allocated to him.

7. 1423, May

 Bacci, *Quercia*, p. 124
 Janson, p. 65
 Paoletti, no. 7

 Donatello is to execute the Herod's Feast relief, which had earlier been allocated to Quercia (see no. 2 above), and Quercia is ordered to hand over 50 lire, 1 soldo to Donatello, to be transmitted by the Duomo opera.

8. 1424, November 5

 Quercia is condemned for not having finished his relief.

107

9. 1427, January 26
 Paoletti, no. 9

 Bacci, *Quercia*, pp. 162–63
 Paoletti, no. 15

Election of a special commission of three to expedite completion of work on the Font.

10. 1427, May 12

 Krautheimer, digest 133
 Milanesi, no. 85 (as 1426)

Ghiberti writes that his two reliefs are complete except for gilding.

11. 1427, June 20

 Bacci, *Quercia*, p. 174
 Paoletti, no. 19
 Beck, no. 50

Jacopo is given the commission to finish the Font. He is to use "good Carrara" marble; the work is to be done in fifteen months. Also at this date Ghiberti yields to Quercia as the leading artist in the design of the Font; bronze, likewise, yields to marble as the dominant material of the upper portions to be erected under Quercia's direction.

12. 1427, September 24–
 January 1 (1428)

 Bacci, *Quercia*, pp. 158ff.,
 198

Payments for acquisition of Carrara marble for the Font.

13. 1427, December 11–18

 Bacci, *Quercia*, p. 197
 Milanesi, no. 177

Payments to Stefano di Giovanni (Sassetta) for a drawing "on the wall of the church" (i.e. of the Baptistery) of the design of the Font as it is to be completed.

14. 1428, February 8

 Bacci, *Quercia*, p. 198
 Milanesi, no. 103
 Beck, no. 75

Jacopo is requested to come to Siena from Bologna to finish the Font; the marble has been assembled.

15. 1428, March 23

 Milanesi, no. 103

Contract with Pietro del Minella to carry on in Jacopo's absence from Siena.

16. 1428, April 14

 Bacci, *Quercia*, p. 191

Purchase of a marble block for a "large figure" (*figura grande*) for the Baptistery Font. This probably refers to the crowning figure of St. John the Baptist in marble.

17. 1428, July 7

 Milanesi, no. 109
 Beck, no. 102

Jacopo, in Bologna, is urged by the authorities to return to Siena to complete the Font; there is disagreement between Nanni da Lucca and Pietro del Minella, who have been left in charge.

18. 1428, August 18, 19

Milanesi, no. 111
Beck, no. 118 (as
 August 19)

Jacopo is again urged to return to Siena, this time with a threat of a fine of 100 florins if he does not appear within ten days. This fact is recorded again as of August 23 and 26 (Milanesi, no. 111, note; Bacci, pp. 208-09).

19. 1428, September 15

Milanesi, no. 111, note

Jacopo, still absent from Siena, is again threatened with a fine.

20. 1428, September 27

Milanesi, no. 111, note

Jacopo is prohibited to leave Siena without permission until the work he has contracted to do is finished, on pain of a fine of no less than 100 florins.

Bacci, *Quercia*, p. 211

Presumably, Quercia has returned from Bologna to Siena to work on the Font; he is directed at this time (28 September) to pay Pagno di Lapo da Fiesole (stone carver) for arrears.

21. 1428, October 25

Milanesi, no. 113
Paoletti, no. 21

Goro di Neroccio (the Sienese goldsmith) is given the commission for a figure for the Font. This is probably for casting an already prepared design of one of the Virtues; the artist of the model to be cast seems, on the basis of style, to have been Quercia himself.

22. 1428, December 3

Milanesi, no. 115

Jacopo petitions for cancelling of all penalties in connection with his absence earlier in the year.

23. 1428, December 22; 1429, March 5

Bacci, *Quercia*, pp. 235, 238

Payment for materials for scaffolding needed to construct upper part of the Font. Work on the carving of the tabernacle has now progressed quite rapidly toward completion.

24. 1429, April 18–August 18

Bacci, *Quercia*, pp. 87, 89
Paoletti, no. 28

Payment to Goro di Neroccio for a bronze figure (probably Fortitude).

25. 1429, April 1–22

Bacci, *Quercia*, pp. 221, 223
 (as 1429)
Janson, p. 66 (as 1429)
Milanesi, no. 94, note
Paoletti, nos. 25, 26, 27

Payments to Donatello in anticipation of figurines of genii; a small advance for the sportello (tabernacle door) of the Font. This is not the only indication that Donatello and Michelozzo were to make the tabernacle door, though it was later done (in 1434) by Giovanni Turini (see no. 29, below). On August 18 of that year, in a memorandum to the Sienese authorities, there is specific reference to a sportello and part payment for it, as of April 22

(see above), by Donatello whose design was "rejected" by the operaio (Janson, 2, p. 66).

26. 1430, July 31

 Bacci, *Quercia*, pp. 249, 258
 Beck, no. 165

 Jacopo is paid 180 florins for his relief in bronze (the Annunciation to Zacharias). On July 3 he had been reimbursed for gilding the relief.

27. 1430, August 1– August 6

 Bacci, *Quercia*, pp. 259, 262
 Beck, no. 166

 Jacopo receives in payment, apparently for his marble upper portion of the Font, 2,320 lire (or 580 florins at a rate of 4 lire to the florin). It seems the marble work is complete.

28. 1431, August 18

 Paoletti, no. 28

 A gilded bronze figure (Fortitude) is received from Goro di Ser Neroccio; his pay (ostensibly the total payment) is 240 lire, or 60 florins at the then going rate.

29. 1434, January 26

 Milanesi, no. 115, note
 Paoletti, no. 32
 Beck, no. 221

 Jacopo is freed from all penalties he has incurred during the making of the Font. He repays a small debt to the Opera. His responsibilities have been fulfilled and the Font is finished, or nearly so (see next item).

30. 1434 (no month specified)

 Bacci, *Quercia*, p. 245

 Giovanni Turini is paid for a sportello of bronze gilt. This completes the sculpture of the tabernacle as far as the record goes.

9 Summary Documentation for the San Petronio Portal in Bologna

1. 1425, March 28

 Milanesi *Documenti*, 2:
 no. 86
 Supino, *Porte*, no. 1
 Beck, no. 1

First contract (in Italian); see Appendix for full text. The contracting parties are, on the one hand, Jacopo della Quercia and, on the other, the papal legate, the archbishop of Arles, Louis Aleman, called "Signore della Città." Quercia is to receive 3,600 florins for the work, and materials are to be supplied to him. The work is to be completed within two years, according to the data of a pen-and-ink drawing stated to be by "Quercia's hand" (for the usual meaning of the phrase, see p. 45). Contract stipulates that the portal be within 40 to 43 feet* in overall height. It is to be provided with carved columns, capitals, bases, friezes, moldings, etc., and to contain the following items of sculpture: (1) on the jambs a series of 28 prophets at half-length (the frame for each prophet to be 1¹/₂ Bolognese feet high); (2) on the flanking pilasters fourteen scenes from the Old Testament (each frame 2 Bolognese feet high); (3) on the lintel three scenes from the Infancy (literally "Nativity") of Christ (each scene 2 Bolognese feet high); (4) under the lunette a central seated statue of the Madonna and child (3¹/₂ Bolognese feet high) flanked by standing figures of San Petronio (3¹/₂ Bolognese feet high) and of Pope Martin V (same height) presenting the kneeling legate (to proportionate scale); (5) two flanking lions ("lifesize"); above on (free-standing) pilasters, standing figures of Sts. Peter and Paul (5 Bolognese feet high); (6) in the gable-frontispiece between, a seated figure of Christ (4–4¹/₂ Bolognese feet high) carried heavenward by angels (each angel 4 Bolognese feet high); (7) at the summit of the frontispiece a crucifix (the figure of Christ 2 Bolognese feet high). The sculptor is left latitude to determine the depth of the reliefs. The drawing gave only half of the Old Testament designs, and missing were the designs for the Seated Christ and four other figures (possibly the two lions and the two papal saints); the style of these figures

* The Bolognese foot of the early Quattrocento may be estimated at slightly less than 0.40 m. (Gatti) or 0.38 m. (Beck).

was to be determined in accordance with the wishes of the legate-patron (called here "Monsignore"). Several points must be raised in commenting on the data of this contract. (a) The drawing has unfortunately disappeared; (b) In 1428 considerable changes were found necessary and these were incorporated, it would seem, into a new drawing; a none too clear copy, presumably by Peruzzi, is preserved in his drawings for the façade in the Fabbriceria di San Petronio (Fig. 82). In the second version, the number of the Old Testament reliefs of the pilasters were reduced from seven to five on each side (see 2, above); the three lintel reliefs were increased to five (see 3, above). The Virgin and Child and the St. Petronius, but not the Martin V nor the legate's figure, were completed by 1434. In place of the Pope and legate a single statue of St. Ambrose was ultimately set up. (c) The latter could have been roughed out by Quercia before his death, but documentation is completely lacking with regard to purchase of the marble block, and Beck has categorically denied Quercia's hand to any part of the statue as it stands today. Note, however, that a "Sant'Agostino" in wood was requested by Jacopo's brother, Priamo della Quercia, to be returned to him from the confiscated remains of Quercia's effects after his death. The title of the statue is conceivably an error of identification by the brother, and the wooden statue was possibly the working-model for the planned but unexecuted pendant to the finished San Petronio. At all events, the marble St. Ambrose was completed only in 1510–11, in a style imitative of Quercia's, by Domenico da Varignana. At about the same time, the arch of the lunette was completed, the piers of the lunette raised, and the whole portal moved outward from its original position by nearly a meter. It has been established that the general disposition of the parts of the portal made by Quercia was not altered.

Supino, p. 22

Supino, no. 74

Beck, 1964 (see Bibliog., no. 69)

2. 1425, August 9

Supino, p. 12, n. 2
Beck, no. 5

Payment is made to the painter Giovanni da Modena of 25 lire for part of the drawing of the portal ("disegno della porta") on the wall closing the nave to the east. This must have been a full-scale working drawing, similar in function to that ordered for the Fonte Gaia in the Sala del Consiglio of the Siena Palazzo Pubblico, or to the large full-scale drawing for the Font done on a wall of the Siena Baptistery.

3. 1426, March 22–26 June

Supino, nos. 2–6
Beck, nos, 19, 26

Assemblage of marbles for the main portal of San Petronio begins. Delivery of materials. Quercia is in Milan, Venice, and Verona to acquire stone.

4. 1426, October 10–1427, May 26

Supino, nos. 8, 9, 10, 11, 12, 14, 15, 16
Beck, nos. 39–47, 51–58

Work on the actual construction has begun (covering and scaffolding raised). Quercia continues to travel to Verona and Venice for materials. Two years have elapsed, with the work only partly started.

5. 1427

Supino, nos. 17, 18, 19, 20

Portal begun. Quercia is in Siena for a while to supervise work on his relief for the Siena Baptistery Font.

6. 1428, June 17–July 17

Supino, nos. 23, 24
Gatti, no. 51
Beck, nos. 94–95, 105, 109, 110, 111

Mention of stones of the great arch (lunette?) and piers (stipiti) being set in place. First red Veronese marble column is raised into place, with adjacent elements of foliated ornament. One of the pilaster strips containing prophets is set into place.

7. 1428, August 22–23

Supino, nos. 25, 26
Beck, nos. 120, 122

Quercia writes to the authorities in Siena to excuse his absence because of the pressure of work in Bologna.

8. 1428, September 23

Supino, nos. 26, 27
Beck, nos. 125–27

Quercia is still in Bologna. He arranges for his assistants to act as his deputies in continuing the portal during his absence in Siena.

9. 1428, November 23– 1429, May 4

Supino, nos. 28, 29, 30
Beck, no. 128

Quercia is in Siena but back in Bologna again in May. A small payment is credited to him in Bologna on 4 May 1429 on his house, which he is to occupy while he works on the narrative reliefs ("istorie") of the great portal ("porta de mezo").

10. 1429, October 24

Supino, no. 31
Beck, no. 144

Quercia negotiates a contract for an inner (reverse) portal for San Petronio on a design drawn on paper ("designato per me Jacopo"). Quercia is to pay certain costs of transport of materials and will receive 1,600 florins for the reverse portal. The agreement is notarized 6 December 1429. A document found by Beck, of 24 December 1429, mentions payments to be made on ten pieces of stone for the framed reliefs of the "pilastri" of the portal. These most probably refer to the Old Testament scenes.

11. 1431, January 13

A year's rent paid in advance for the house to be used by Quercia in Bologna. At the end of the year,

Supino, no. 36
Beck, no. 174

on December 14, payment is recorded, in a document found by Beck, for a block of marble that apparently would fit the scale of the statue of San Petronio for the portal.

12. 1432, April 16–June 2/3

Supino, nos. 37, 38, 39
Beck, nos. 181, 186

Quercia once more travels to Venice, Vicenza, and Verona to purchase materials.

13. 1432, October 13

Supino, no. 40
Beck, no. 199

Some marble blocks ("lapides marmoreos") are delivered to Quercia's bottega in Bologna. Possibly these are for sculpture.

14. 1433, May 28; June 24
 and 28

Supino, nos. 41, 42
Beck, nos. 209, 211

Thirty-four pieces of marble are delivered to Jacopo's Bologna bottega (probably for ornament). Quercia is again traveling to Venice, Vicenza, and Verona to purchase new materials.

15. 1434, September 4 and
 after October 9

Supino, nos. 43, 44
Beck, nos. 231, 233

Quercia is in Bologna. He receives a small sum in order to pay workmen for a section of frieze in red marble ("frixo di marmo rosso"). This refers to ornamental bands flanking the pilasters of the outer door with scenes from the Old Testament. Probably, the Old Testament scenes are ready, or nearly ready, for insertion.

16. 1434, November 22

Beck, no. 236
Beck, *Arte antica e
moderna*, 1962 (see
Bibliog., no. 67)

The figure of St. Petronius has been placed in position on the lintel. This may have occurred several months earlier. Presumably, the figure is completed and the entire lower portion of portal (up to the springing of arch of lunette) is finished.

17. 1436, January 21

Milanesi, no. 132
Supino, no. 48

Quercia, in Siena, declares to the Bolognese authorities that he fully intends to finish the portal despite his new responsibilities as Duomo operario.

18. 1436, March 26

Milanesi, no. 129
Supino, no. 49
Beck, no. 263

From Parma Quercia writes to the Bolognese authorities on the subject of a disagreement about accounts and payment. He had left Bologna in order to negotiate as a free man ("per esser libero e non preso"). The differences concerned a relatively small sum. Evidently, the cause of disagreement lay deeper.

19. 1436, June 6–July 26

Quercia is back in Bologna. A meeting between him and the Fabbrica authorities establishes guaranty for continuance of work on the portal. Quer-

Supino, nos. 50, 51, 52
Beck, nos. 265–70

cia's debt to the Fabbrica and his expenses for stone (or marble) in Milan are regulated. Quercia is reimbursed for purchase of Istrian stone (at Venice).

20. 1437, September 26–27

Supino, nos. 54, 55
Beck, nos. 288–90

Quercia is reimbursed for travel expenses to Verona and purchase of stone and marble for the arch of the portal. The date of purchase is stated as 22 April 1437. In addition, payment is approved for delivery of Veronese marble for what may have been the short colonnettes ("sopra baxe") under the arch of the lunette and for two large pieces of Istrian marble for the statues of (two) lions. As far as is known the lions were never carved.

21. 1438, February 5

Milanesi, no. 137
Supino, no. 56
Beck, no. 296

Quercia is in Siena, never to return to Bologna. He is to be reimbursed for expenses withheld in September and October of the previous year because he was sick.

22. 1438, April 3

Supino, no. 57
Beck, no. 298

Last payment to Cino for Quercia's account in Bologna. (Quercia dies in Siena in October 1438.)

23. 1439 (?), January 12– February 11

Supino, nos. 58, 59

Letters are sent by Priamo della Quercia, Jacopo's brother and heir, concerning the sculptor's estate left in Bologna, which Priamo wishes to settle with the San Petronio Fabbrica authorities. The latter have confiscated most of the contents of the house and studio.

24. 1442, September 25– October 9

Supino, nos. 60, 61, 62

Priamo della Quercia is finally relieved of all responsibility for Jacopo's unfinished part of the portal. He is repaid all sums due Jacopo.

It is apparent that after Quercia's death nothing further was done by his chief assistant Cino di Bartolo, and work stopped abruptly. Actually, Cino had been arrested by the Bolognese authorities on a morals charge and jailed in order to keep him in Bologna. This gambit, not surprisingly, failed; Cino, once freed, returned to Siena, where he evidently continued his career as a goldsmith and stonecarver, but without any particular distinction recorded by history.

10 Summary Documentation for the Last Projects in Siena

1. The Casini Altar

1. 1430

Bacci, *Quercia*, pp. 283–84

Endowment by Antonio Cardinal Casini of an elaborate altar ("cappella") in the Duomo of Siena. It is to be dedicated to the Virgin and St. Sebastian.

2. 1433, January 20

Bacci, *Quercia*, pp. 284–85

In a codicil to his will, Cardinal Casini provides for further funding of his altar's construction, in particular for its decoration ("ornamento").

3. 1435, December 21

Bacci, *Quercia*, p. 328

In an inventory of the Duomo of Siena, "The Chapel of St. Sebastian" is described, though only its paintings are specifically listed.

4. 1437

Bacci, *Quercia*, pp. 283–84

Cardinal Casini adds to the endowment of his altar so that the benefice of the chaplaincy will be increased to 100 lire annually.

5. 1439, June 30

Jacopo della Quercia ("Messer Jachomo di maestro Piero chavalier e operario passato") is mentioned after his death in connection with repayment of costs of materials taken by him from the Opera to construct the altar of Cardinal Casini.

6. 1440

Milanesi, pp. 191–93
Bacci, *Quercia*, pp. 305–08

Mention is made of outstanding expenses against Jacopo's name, e.g. amounts of money paid assistants who had worked on the Casini Altar (Matteo di Domenico and Polo [Paolo] da Bologna). In the same document evidence emerges that Jacopo was short-changing the Opera, both with respect to materials and time charged for assistants' work.

7. 1458, October 20

Bacci, *Quercia*, pp. 329–31

In an inventory of the Duomo of Siena, the Chapel of St. Sebastian is more fully described than in 1435 (above). In the lunette over the painted altarpiece ("da chapo a detta tavola"), were a Madonna and other figures of marble ("Nostra Donna . . . e altre fighure di marmo"). The "chapel" is ornamented ("adornata") with carvings, some gilded, and with the arms of the cardinal.

8. 1467, May 9

Bacci, *Quercia*, p. 332

In an inventory of the Duomo, the Chapel of St. Sebastian is described in much the same terms as above; but for the first time three marble figures ("figure") are specifically mentioned in connection with the Madonna of the lunette ("da chapo"). This description is repeated in later inventories (1473, 1480, 1482, 1536, 1563).

9. 1639, July 27

Bacci, *Quercia*, p. 341

In an inventory of the Duomo, the description of the Altar of St. Sebastian carries a marginal note that it has been dismantled and dispersed ("guasta").

2. Loggia of San Paolo (della Mercanzia), Siena

1. 1427, July 4

Milanesi, no. 108 (date given as 1428)

The operaio of the Siena Duomo has requested of Quercia the name of a master capable of building the rear wall of the Loggia di San Paolo. Quercia answers from Bologna, naming a certain Giovanni da Siena, who is known to have worked on the *castello* in Ferrara.

2. 1433, February 2

See below, no. 7

Quercia contracts to have six pieces of marble transported from Carrara to Siena. He is understood to be available to carve these into statues for the Loggia.

3. 1434, February 6

Bacci, *Quercia*, p. 314

Quercia contracts for carving the statuary planned for the Loggia.

4. 1436, November 20

Milanesi, no. 131

The *priori* determine to provide funds for continuing and completing work on the Loggia.

5. 1437, May 29

Bacci, *Quercia*, p. 313

Quercia requests payment to an assistant for *gesso* (plaster?) for the model of a capital for the Loggia.

6. 1438, February 2

Milanesi, no. 138

Quercia asks exemption from public duty for his assistant Pietro della Minella because of pressing work on the Loggia; he requests that the exemption remain valid for the next two years. The work appears to be ornamental in character ("lavorare d'intaglio e di fogliame").

7. 1439, January 12

Milanesi, no. 143

Quercia's successor as Duomo operaio writes to the stoneworker Giovanni di Pietro in Florence to confirm Quercia's previous order of seven (*sic*) blocks

of stone which he (Quercia) was to carve as statuary for the Loggia.

8. 1439, June 8

 Bacci, *Quercia*, pp. 313–14

Cino di Bartolo is to be paid for carving one capital of the Loggia, done in Jacopo's lifetime.

9. [1451–62]

 Milanesi, no. 217 and note (pp. 309–11)

[Two statues for the Loggia were originally allocated to Urbano da Cortona, Donatello's former assistant, and three to Antonio Federighi (1451). Then, in 1456, four statues were allocated to Federighi. In 1458 Donatello was commissioned to do one figure: a male saint, apparently never even begun by him. In 1458 Vecchietta was brought into the group of sculptors; between 1460 and 1462 he completed two figures, Sts. Peter and Paul, still on the monument. Federighi, Quercia's former assistant, is credited in the older literature with three: the Sts. Ansano, Vittorio and Savino.]

10. [1462–63?]

 Milanesi, no. 338 (dated as 1463?)

[Federighi writes the rector of the Duomo (Cristoforo Felice) that he would like a further commission on the Loggia. The marble bench for the Loggia by Federighi (?) is usually dated to 1464.]

Appendix: Selected Documents Relating to the Career and Work of Jacopo della Quercia

1. Fonte Gaia Contract 2, 3. Changes in Design of the Fonte Gaia. 4. Siena Baptistery Font: Bronze *Istorie* 5. Siena Baptistery Font: Marble Tabernacle 6. San Petronio Portal Contract 7. Quercia's Will 8. Studio Contents after Quercia's Death

1. Fonte Gaia Contract

1408/09, January 22 Dipl. — Op. Metrop.
 Bargagli-Petrucci, pp. 306–08.

In nomine Domini amen. [Omissis . . .]

Die xxij januarii deliberaverunt magnifici Domini et Offitiales Balye quod fons Campi fiat per magistrum————* eo modo et forma et prout designatus est. Et quod habeat duo milia flor. auri senenses non obstantibus quibuscunque, et quod promictat et se obliget, etc. Et quod eidem magistro detur locus ubi possit laborare, etc. Item quod eidem explanentur vie sumptibus Comunis, ita quod conducat laborerium, etc.

Conventioni infra il magnifico Comune di Siena etc. e maestro Iacomo del maestro ————†

1. In prima, che maestro Iacomo predetto sia tenuto e debba fare o far fare uno disegno d'una fonte nella sala del Consiglio con intagliamenti, figure, fogliami, e cornici, gradi, pilastri e beccatelli e altri lavorii ragionati.

2. Item, ch'el detto maestro Iacobo sia tenuto e debba infra il termine di 20 mesi, cominciando in calende aprile proximo seguirà nel 1409, edificare, e avere edificata una fonte di marmo in sul Campo di Siena nel proprio luogho là doè la fonte al presente, di longhezza di braccia xvj e di larghezza di braccia otto, cho'le figure, foglame, e marmi che nel disegno soprascritto chiaramente si dimostrano, non diminuendo alcuno lavorio, ma piuttosto migliorare e acrésciare.

3. Item, che esso maestro Iacomo sia tenuto e debba fare e far fare la fonte predetta, così da l'acqua in giù come da l'acqua in sù, a le sue proprie spese d'ogni lavorio; intendendosi che per infino a l'acqua e da inde in giù uno guazzo sia di marmo, e da inde in su di mattoni con certe pietre necessarie e oportune al difitio de la detta fonte, con iscialbi e muro ragionevoli per lo lavorio predetto.

4. Item, che a maestro Iacomo predetto sia lecito mettare e far mettare in Siena tutti' marmi, calcina, calcestruzzo e mattoni e qualunche altre cose fussero necessarie per lo detto lavorìo, senza pagare alcuna cabella; e anco s'intenda essere francho e libero, se per lo soprascritto contratto uscisse alcuna cabella al Comuno di Siena.

5. Anco, che del presente contratto, el detto maestro Iacomo, volendolo publico, el notaio ne sarà rogato non ne possa nè debba avere più che fior————‡

6. Item, ch'el detto magnifico Comuno di Siena sia tenuto e debba dare e pagare al detto maestro Iacomo, per lo lavorìo predetto, quel prezo e quantità de pecunia sarà dichiarata da Francescho di Cristofano, al presente Capitano di Popolo e Gonfaloniere

* Name left blank ‡ Lacuna in text.
† Damage to parchment

119

di Giustizia; non passando però la somma di fior. millesecento senesi, nè da 1500 senesi in giù.

7. Item, ch'el prefato Comuno di Siena sia tenuto e debba dare e fare el detto pagamento di due mesi in due mesi, come tocca per rata della somma predetta, cominciando in kalende aprile proximo seguirà, ricevendo dall'operaio dell'acqua, con que' modi si pagano maestri e lavoranti, lavorano ne'lavorii delle fonti.

8. Item, che al detto maestro Iacomo sia lecito e possa cavare e far cavare a ogni mamiera e petriera per lo lavorio predetto, senza alcuna contraditione, pagando el debito prezo secondo el costume de l'Uopera (sic) Sancte Marie.

9. Item, che tutto e'lavorio vechio de la muragla si levarà da la fonte vechia, sia e essere s'intenda del detto maestro Iacomo.

10. Item, ch'el detto maestro Iacomo sia tenuto e debba fare e curare che le figure de'lavorio soprascritto sieno, et essere s'intendano lustranti, secondo el corso de'buoni maestri, faciendo tutte le predette cose a buona fede e senza frodo.

Ego Cinus olim Guidonis de Belforte id totum quod supra continetur scriptum manu mei, litterali sermone usque in trigesima linea presentis instrumenti, scriptum inveni, vidi et legi in quodam libro sive memoriali facto in Consistorio dominorum Priorum civitatis Senarum, existenti inter abreviaturas et protocolla ser Nicolai Laurentii notarii defuncti, et totum id quod supra continetur vulgari sermone a dicta trigesima linea infrascriptum inveni, vidi et legi in quodam folio bonbicino existenti in quadam filza gestorum in dicto Consistorio manu dicti ser Nicolai.—Ideo hic me publice subscripsi et publicavi. Anno dominice Incarnationis millesimo quadringentesimo duodecimo, inditione quinta, die primo mensis junii.

Ego Franciscus olim magistri Augustini de Senis, publicus notarius, totum quod supra continetur et scriptum et exemplatum est manu dicti ser Cini, inveni, vidi et legi.

Die xx mensis octobris 1419 cassatum et cancellatum per me Anthonium Iohannis Gennari notarium, de voluntate dicti magistri Iacobi ob liberationem factam domino Caterino operario, pro Comune Senarum, Uopere Sancte Marie et dicti fontis de quo constat de manu mea.

2. Changes in Design of the Fonte Gaia (1)

1414/15, January 18 Cons. Gen. Delib.—vol. 206, fol. cclxj.
 Bargagli-Petrucci, pp. 322–24

In nomine Domini, amen. Anno dominice Incarnationis mccccxiiij, indictione viij, die vero veneris xviij mensis januarij. Convocato et congregato Generali Consilio Campane, dominus Prior proposuit atque dixit, super petitione operariorum super fonte Campi, noviter construendo per viam et modum proposite, cuius quidem petitionis tenor sequitur et est talis, videlicet:

"Dinanzi a Voi magnifici et potenti signori, signori Priori et Capitano di popolo della città di Siena, exponsi con ogni debita reverentia per li vostri operai della fonte del Campo che conciò sia chosa che, quando la decta fonte fu data affare, chi la de'affare, per grande volontà che ebbero della decta fonte si facesse, non ebbero tutta quella advertentia che bisogniava al decto lavorio il perchè il decto lavorio pate più e più defecti e'quali se non si correggessero, el detto lavorio verebbe male e appocho contento de'cittadini; et prima nella decta allogagione della fonte non si fece mentione come la parte di fuore d'essa fonte dovesse essere facta, che è quella parte che più s'à a vedere e, non mutando altrimenti, e'maestri la faranno piana e biancha, la quale chosa sarebbe

diforme al bello lavorìo che viene dalla parte dentro; et per questa cagione, noi operaii siamo stati con tutti quelli maestri che ci sonno intendenti et divisato di farvi certo lavorio e adorno per modo che la decta fonte verrà bene et arà il suo dovere; et ancho abbiamo divisato di fare la decta fonte più larga dalla parte dinanzi che di sopra, il perchè dando il pendente a l'ale dallato come sta hora viene accrescere alchuna chosa el decto lavorio; et facendo stima del costo che si crescie alla decta fonte stimiamo sarà fior. cccc o circa, la quale spesa non si può fare senza altra deliberatione. Et per tanto supplicamo la magnifica Signoria vostra che vi degnate per gli vostri Consegli opportuni fare provvedere che la decta spesa si possa fare, acciocchè il lavorio della decta fonte abbia sua perfectione et sua ragione et sia al contento de'cittadini, altrimenti el decto lavorio seguirà secondo l'alogagione e sarà sozo permodo dubitiamo non sia facto disfare a furia e sarà la spesa perduta."*

Igitur si videtur et placet dicto Consilio in nomine Domini consulatur.

Magister Francischus magistri Barthali, phisicus, unus ex consiliariis, super petitione per modum proposite operariorum fontis Campi, consuluit atque dixit quod sit, fiat, observetur et executioni mandetur in omnibus et per omnia prout et sicut in primis propositis continetur.

In cuius summa et reformatione Consilii dato, facto et misso partito, super petitione per modum proposite operariorum fontis Campi, victum, obtentum, statutum et solenniter reformatum fuit iuxta consilium redditum per dictum magistrum Francischum consultorem, quod sit, fiat, observetur et executioni mandetur in omnibus et per omnia prout et sicut in ipsa petitione in modum proposite continetur, per ccxxxiiij consiliarios dicti Consilii reddentes eorum lupinos albos pro sic, non obstantibus lxj ex eis consiliariis dicti Consilii reddentibus eorum Iupinos nigros pro non in contrarium predictorum.

3. Changes in Design of the Fonte Gaia (2)

1417/18, January 11 Dipl.—Op. Metr.
 Bargagli-Petrucci, pp. 334–36

In nomine Domini, amen. Anno Domini ab ipsius salutifera incarnatione, millesimo quadringentesimo decimo septimo, indictione undecima, die undecima mensis januarii, tempore pontificatus sanctissimi in Christo patris et domini Martini, divina providentia Pape quinti, Romanorum Imperatore sede vacante. Vir prudens Ghinus olim Bartalomei, bancherius de Senis, unus ex quatuor operariis fontis Campi Fori Civitatis Senarum, declarator, decisor, desceptator et amicus comunis, electus, nominatus et assumptus ex remissione in eum facta a spectabili et honorabilibus viris domino Catherino olim Corsini, milite, et operario Ecclesie maioris cathedralis civitatem Senarum Thoma olim Vannini, aurifice, et magistro Dominico olim Nicolay, magistro lignaminis, de Senis, operariis fontis prelibati, a magnificis et potentibus dominis, dominis Prioribus et Gubernatoribus Comunis Senarum et Capitaneo populi dicte civitatis, ut dixerunt et michi notario infrascripto asseruerunt, electis, et ad dictam fontem construendam nominatis, dicto Ghino et consociis, ex una parte, et magistro Iacobo filio magistri Pieri, marmicida de Senis, ex alia parte, ad determinandum et decidendum et fine debito concludendum lites, causas, questiones et controversias inter dictos operarios recipientes et stipulantes pro dicto magnifico Comuni Senarum et

* Text is also under the same date in Libri del Concistoro.

magistrum Iacobum prefatum, vertentes occasione certi augmenti et additionis fontis supradicti, scilicet longitudine pro duobus brachiis et duobus terziis, et totidem pro latitudine prout de dicta remissione in eum facta idem Ghinus et supradicti operarii eius consocii dixerunt et affirmaverunt michi notario infrascripto, sibi dicto Ghino antedicto remissionem fare, verbotenus facte dicens et asserens idem Ghinus plenam habere notitiam de dictis controversiis et remissione predicta et, ut dixit, visis juribus dictarum partium, et ipsis pluribus et pluribus vicibus auditis et ipsorum rationibus intellectis; et quidquid dicere et allegare coram eo voluerunt viam amicabilem eligens, supra pedibus stans in loco qui infra dicetur, Christi nomine repetito, vigore dicte remissionis, judicavit, laudavit, decisit, declaravit et sententiavit, in hunc modum, videlicet:

Quod magister Iacobus antedictus pro dicto augmento et additione predicta habeat et habere debeat a Comuni Senarum, seu de ipsius Comunis Senarum pecunia, ducentos ottuaginto florenos, qui ducenti ottuaginta floreni sint et esse intelligantur de illis florenis et illo valore, cuius valoris fuerunt et sunt quadringenti floreni additi prime locationi et condutioni factis de dicto fonte pro Comuni Senarum quodam reaugmento et readditione factis de antedicto fonte: hoc intellecto et declarato, quod dicta sententia, decisio, declaratio seu laudum non extendatur nec proteletur aliquo modo, iure vel causa neque aliquo colore quisito ad locationem et condutionem factam magistro Nanni magistri Iacobi de Lucha et magistro Sano magistri Mathei de Senis, lapicidis, pro reversione revolutionis, seu resuppinationis dicti fontis, presentibus dictis domino Caterino Thoma et magistro Dominico, operariis infrascripti fontis, recipientibus et stipulantibus vice et nomine Comunis Senarum, laudo sententieque ac declarationi et decisioni consentientibus, absente dicto magistro Iacobo. Et dictus Ghinus iudicavit et sententiavit atque declaravit eo modo et forma quibus melius fieri potest et debet, secundum eius remissionem, mandans michi Luce, notario infrascripto, quod de predictis publicum conficiam instrumentum.

Lata et data fuit dicta sententia, declaratioque ac decisio et laudum, Senis in domo Opere Ecclesie cathedralis civitatis predicte in qua inciduntur lapides, in sala inferiori, in primo ingressu per infrascriptum Ghinum, anno, indictione, die, mense et pontificatu infrascriptis, coram Battista Iohannis Personeta de Senis et magistro Bastiano Cursii, marmicida, de Florentia et habitatore ad presens Senis, testibus presentibus et rogatis.

Anno, indictione et pontificatu supradictis, die quarta decima mensis januarii antedictus magister Iacobus magistri Pieri marmicide de Senis audito et intellecto tenore suprascripti laudi, sententie ac decisionis et declarationis ut asseruit et de illo dicens et asserens, se plenam habere notitiam dicti laudi, sententieque declarationis et contentionis in eo ex certa scientia, spontanea voluntate et non pro errore, ratificavit, approbavit et emologavit in omnibus et in totum ut supra continetur; promictens michi notario infrascripto, tamquam publice persone, recipienti et stipulanti, vice et nomine magnifici Comunis Senarum, dictum laudum et sententiam perpetuo firmam ratam tenere et habere et contra non facere vel venire aliqua ratione iure, vel causa, de iure vel de factor, subobligatione omnium suorum bonorum presentium et futurorum.

Actum Senis in Campo Fori, prope fontem dicti Campi, apud ritallium Maritani Buzichelli, coram ser Christoforo Nannis de Menzano, notario, et Bartalomeo Bucciarelli, ritalliero de Senis, testibus presentibus et rogatis.

(L. S.) Ego Lucas filius Nannis Petri Giannini de Senis, publicus imperiali auctoritate notarius et iudex ordinarius prelatione dicti laudi sententie et declarationis et eius ratificationi interfui eaque rogatus, scripsi et publicavi, signumque meum in fidem et testimonium premissorum apposui consuetum.

Die xx mensis ottobris 1419 cassum et cancellatum per me Antonium Iohannis Gennari, notarium de Senis, de voluntate dicti magistri Iacobi ob liberationem per eum factam domino Catherino pro Comuni Senarum, operario Uopere Sancte Marie, et dicti fontis, de qua constat manu mea.

4. Siena Baptistery Font: Bronze *Istorie*

Contract for bronze reliefs for the Font. Text given here is a new reading kindly provided by Professor John Paoletti from the document preserved in the Opera del Duomo, Siena.

1417, April 16 Milanesi, 2, no. 58:86–87
 Lusini, doc. 2, pp. 95–96

Copia effettuale dele storie si debano fare dattone a la fonte del battesimo del duomo.

Per essa cagione ragunato el hoperaio e suo consiglio ne la detta sacrestia come si dichiara di sopra allogaro e patto fecero col savio Maestro Jacomo del Maestro piero di Siena Cittadino due storie del detto Battesimo o piu come piacera al detto oparaio e suo consiglio a suo attone del detto maestro Jacomo per f. c[ento] ottanta sanesi di 1. 4 sol. 4 per ciascuno f. e per ciascuna istoria e debba avere i den. e pagamento in questo modo cioe il terzo del pagamento quando esso cominciara al lavorare in su ie dette istorie cioe darne fatta una e compita infra lanno cioe in kalende Maggio 1418 e cosi avere i pagamenti dessa storia la siconda paga da ine a sei mesi la terza paga compita e acceptata la storia e se piacera e stara bene e accettata sara per solenni maestri deba seguire laltre come detto ene e in quanto non fusse accettata e non stesse bene esso maestro jacomo la deba ritenere per se e ristituire i den. avesse ricevuto. o veramente rifare la detta istoria. di cio die dare buona e sufficiente sicurta al detto oparaio Questo inteso che lhoparaio e suo consiglio debono eleggere quelli maestri uno o piu avedere e giudicare se le dette istorie staranno bene o no come esso a promesso. Anco che lhoparaio e suo consiglio deba dare al detto maestro Jacomo le storie disegnate che piu lo piaceranno e debbano essere di quadro duno braccio e' una oncia di largheza per quadra Anco le die dare dorate con ariento vivo e realmento tette le storie e i campi si che stieno bene dorate a detto dogni orafo ad oro desso maestro In sopracio i detti oparaio e suo consiglio allogarono a Turino——[*lacuna*] e a Nanni suo figliuolo e di suo consentimento obligandosi e conducendo due storie de la detta fonte e lavoro del battesimo dattone come di sopra si contiene ne la allogagione fatta a maestro Jacomo del maestro piero Salvo che del tempo inpero debono dare una istoria compita di qui a octo mesi incominciando in kalende Maggio 1417 e debono avere la prima paga cioe la terza parte quando cominciara la storia, e laltra terza parte inde a quattro mesi. e laltra terza parte reducta a fine la storia e acceptata cioe lavanzo.

(*On the reverse:* Schritta de lalogagione de le storie del Batesimo per maestro Jachomo di Piero e Turino e filiolo.)

5. Siena Baptistry Font: Marble Tabernacle

Declaration of Pietro del Minella to continue work on the marble portions of the Font in Quercia's absence.

1427/28, March 23 Milanesi, 2, no. 103:139–40
 Lusini, p. 35, n. 1; doc. 15,
 pp. 105–06

Anno MCCCCXXVII Ind: VI die XXIII mensis Martii. Actum Senis apud Banchum del cambio Gucci Galgani Bichi de Senis: coram Galgano filio dicti Guccii, Petro magistri Johannis, et Angelo Mazini del Maza, testibus etc.

Cum hoc sit, quod per operarios in Comuni Senarum electos deputatos supra fabrica et perfectione Baptismatis, fuerit facta locatio laborerii predicti magistro Jacobo Pietri della Quercia de Senis, cum certis pactie et modis, de quibus latius patet manu ser Jacobi Nuccini notarii publici: et dictus magister Jacobus deinde fecerit certam compositionem cum Pietro Thomasi dicto del Minella, quod deberet laborare in dicto opere, certo tempore et modis, de quibus invicem convenerunt: et nunc dictus Pietrus velit certificare operarios prefatos de laborando continuo in dicto opere et laborerio: pro tanto ipse Pietrus exercens artem in se, et super se, et major, ut juravit etc.—promisit,— Johanni Francini de Patriciis, et Johanni Pieri Guidi—duobus ex operariis predictis,— stipulantibus pro aliis operariis absentibus, et pro omnibus quorum posset interesse etc. quod durante laborerio dicti Baptismatis, et donce ipsum opus et laborerium fuerit perfectum, ipse Pietrus continuo laborabit, et se exercibit cum persona sua, et tribus laborantibus, ultra personam suam, in opere predicto. Et sic se facturum juravit etc. Et si secus faceret, voluit per pactum expressum posse extrahi de quocumque alio laborerio in quo laboraret, et conveniri et conduci ad laborandum continuo in ipso laborerio cum tribus aliis laborantibus etc.—Et hoc presente dicto magistro Jacobo, et consentiente eidem Pietro, vigore et occasione conventionis, quam simul habuerunt.—

6. San Petronio Portal Contract

Words in parentheses refer to the Milanesi version (Milanesi, *Documenti per la storia dell'arte Senese*, 2:125–27).

1425, March 28

 Archivio di San Petronio, bk. 1, fols. 61–63
 Supino, *Sculture delle porte di S. Petronio*,
 pp. 79–80
 Beck, *Quercia e il portale di San Petronio*,
 pp. 91–92

 Locatio et capitula pro porta magna
 construenda per Jacobum della Fonte

Memoria che questo di sopradetto il reverendissimo Padre e Signor nostro Arcivescovo d'Arli, Legato e Signore nella Città di Bologna, diede e concesse la manifattura della porta grande di mezo la chiesa di San Petronio a maestro Jacomo dalla Fonte da Siena, intagliatore e maestro del lavoriero di marmore, in su la forma che appare per un disegno fatto di sua mano e sottoscritto di sua propria mano; con quelli medesimi lavori e più vantaggiati che non si contengono nel disegno. Et oltre i detti (lavor(ier)i, deve fare le infrascritte figure, con li modi e pacti che di sotto si continene.

In prima, deve havere per manifattura della sopradetta porta fiorini 3 mila e seicento di Camera del Papa (fior. 3600 di camera del Papa), e cosi le promesse il sopra detto

nostro Signore messer lo Legato, per tutta la fattura de la sopra detta porta, e di tutti i lavorieri che in quella si contegono, per questi patti e modi: che al presente deve havere di denari della fabrica di San Petronio, per parte del sopra detto pagamento, fiorini centocinquanta d'oro di Camera (fior. 150 d'oro di camera del Papa), li quali denari si doveranno scontare nelli pagamenti che a lui si faranno, come di sotto si continene: et per questi ci ha dato per cautione e per sicurtà promessa ["e . . . promessa" not included in Milanesi] Alberto di maestro Thomasino da Bressa, il quale promesse di pagare et di restituire alla detta fabrica ogni volta che il sopradetto maestro Jacomo ricusasse di venir a fare il sopradetto lavoriero, ad ogni requisitione di detti Uffitiali che per tempo saranno. E pro messe il sopradetto messer lo Legato (messere lo Signore) al sopra detto maestro Jacomo ch'egli sarà pagato di denari della detta fabrica ogni volta ch'egli lavorerà il sopradetto lavoriero, ogni mese quella quantità di denari della sopra detta somma che havesse francato. Il qual lavoriero promesse d' haver compito al termine d'anni doi, dal dì che le pietre si haveranno e dal dì ch'egli cominciarà la lavorare successivamente.

In prima, l'altezza della porta deve essere quaranta sino xliij piedi.

Item, la larghezza sia quanto si richiede alla sua proportione, che è de la metà de la sua altezza, o veramente alcuna particella, quanto parerà esser convenevole.

Item, lo sporto che deve fare la porta in fuori sia tanto quanto sono li pilastri, o veramente il piè che cinge tutta la facciata della chiesa al presente, perchè pare esser così convenevole.

Item, li pilastri principali de la porta siano piè doi e mezzo larghi, perchè così paiono esser recipienti all'edificio.

Item, le colonne che vanno nella porta, intagliate o dritte o avolte, siano corrispondenti all'edifizio quanto per li lavorieri fatti per li gran maestri si costuma.

Item, la colonna a tre quadri dove stanno li Profeti medesimamente corrisponda con l'altre cose a sè pertinenti.

Item, l'altra colonna a tre quadri, sfogliata, sia corrispondente alla sua debita forma.

Item, le basi da piè delle cornici, i capitelli di sopra, tutti corrispondenti all'edificio et a' suoi membri.

Item, le historie quatordici che vanno in pilastri, del vecchio Testamento, siano le figure doi piedi di lunghezza.

Item, le tre historie che vanno nel cardinale, della Natività di Christo, siano doi piedi ciascuna figura.

Item, li vinti otto mezi Profeti siano l'uno un piede e mezo.

Item, la nostra Donna col suo Figliuolo in braccio sia alta, a sedere, tre piedi e mezo: Nostro Signore messer lo Papa sia ritto tre piedi e mezo; messer S. Petronio sia quanto il Papa: scolpito ciascheduno a tutto rilievo. Le quali tre figure vanno sopra l'arco della porta: Monsignore in ginocchio, quanto si richiede grande.

Item, li leoni che vanno da' lati della porta siano grandi come sono li naturali leoni.

Item, le due figure che vanno di sopre su i pilastri, cioè S. Pietro e S. Paolo siano d'altezza di piè cinque l'uno.

Item, nostro Signore Giesù Christo portato da gli angeli sia a sedere alto piè quattro per sino a piè quattro e mezzo; con gli angeli volanti sia ciascheduno quattro piedi.

Item, nostro Signore in croce posto, il quale sia sopre il fiorone sfogliato del frontespiccio, sia d'altezza di doi piedi.

Le quali tutte figure per sè siano rilevate intieramente, e le istorie dicisette de i pilastri o del cardinale siano rilevate quanto si richiede a lore belezza.

Item, tutti li Profeti rilevati per lo modo che di richiede a star bene nelle cose loro.

Item, che tutte le cose della detta porta siano intagliate et ornate, come per il disegno di mano di maestro Jacomo appare, il quale è posto sopra carta di papiro, disegnato di penna, et etiamdio con più perfettione o ordine che 'l detto disegno non dimostra.

Item, deve fare che nel detto disegno la colonna, la quale non è disegnata, delle sette historie, s'intenda essere come l'altra.

Item, deve fare cinque figure che non sono nel disegno, cioè: la figura di Giesù Christo, e quattro altre figure al senno e volontà di Monsignore.

7. Quercia's Will

1438, October 3

> Archivio dell'Ufficio del Registro di Siena
> Denunzie delle Gabelle de' contratti ad
> annum 1438, fol. 62
> Milanesi, 2, no. 139:178–79
> Beck, no. 302, pp. 133–34

Ser Jacobus Andree Paccinelli notarius denunptiat, quod die Veneris, tertia Ottobris,

Spectabilis miles dominus Jacobus olim magistri Pieri della Guercia, dicto maestro Jacomo della Fonte, operarius opere maioris Ecclesie sancte Marie civitatis Senarum, suum ultimum condidit testamentum, in quo inter cetera de bonis suis disposuit ut infra; videlicet:

Tertio lassa a maestro Piero del Minella fiorini dieci, iure legati fior.x.

Quarto lassa a maestro Cino di Bartolo da Siena, fiorini dieci: fior.x.

Et più lassa al detto Cino fiorini cinquanta, iure legati: fior.L.

Quinto a Castore di Nanni fiorini 5, reliquit iure legati fior.v.

Item decimo, reliquit iure legati e lassa de bonis suis e dispone fiorini quatrocento a Catharina, sua nipote, per le sue dote, et che l'abbi a maritare misser Bastiano, maestro Piero e maestro Cino; e se ella morisse innanzi al matrimonio, che i detti denari se ne mariti fanciulle, e a luoghi piatosi rimanghino, secondo che e detti dispensaranno

 fior.400.

Tertio decimo, lassa a Giovannino, e Sabatello e Antonio Nanii manovale, a ogniuno per sè, fiorini tre per uno capuccio, e al citolo uno fiorino fior.vii.

Ancho, lassa a Pavolo fiorini quatro per uno capuccio fior.iiii.

Ancho, lassa a Tonio di Baccio per uno capuccio fiorini cinque fior.v.

In omnibus autem bonis suis eius heredes universales instituit infrascriptos, videlicet:

Lassa sue universali herede Priamo, suo fratello, e monna Lisabetta, sua suoro, sue crede universali; e vuole che e denari che si trovaranno nella heredità, se ne facci due parti, et che monna Lisabetta sua sorella carnale, ne compri una possessione, la quale essa non possi nè alienare nè contractare, ma debbila lassare dietro alla sua vita, alla figliuola; et se nissuna ereda non ci fusse, lassa al fratello; e se 'l fratello non ci fusse, rimanghi allo Spedale di sancta Maria della Scala.

Et vuole che etiamdio ch'el fratello conpri de' denari contianti, cioè della sua metà, un'altra possessione, la quale per nessuno modo si possi contractare nè alienare, ma dietro alla sua vita rimanere, e che esso la debbi lassare alla sorella; a se la sorella non ci fusse, lassi a Catharina, o sue erede; e se di queste non ci fusse, vuole rimanghi allo Spedale di sancta Maria della Schala.

Et di tutto e resto fare etiandio due parti, e ogniuno tengha la sua parte.

8. Studio Contents after Quercia's Death

Priamo della Quercia's request for arbitration for the return of his brother's possessions, left in the studio in Bologna and taken by Cino di Bartolo at the time of Jacopo's death.

1439, January (?)

Siena, Archivio Communale
Scritture Concistoriali, 113
Milanesi, 2, no. 151: 189
Beck, no. 302, note

Dinanzi da voi egregi et honorevogli arbitri arbitratori electi fra maestro Priamo di Piero et Cino di Barthalo.

Maestro Priamo come rede di misser Jacomo suo fratello, adomanda le infrascritte cose.

In prima, domanda uno lucho di ciambellocto, e quale fu di misser Jacomo; E più la stima d'uno chavallo; E più domanda fior: 4 e quagli sono per uno lodo dato fra loro; E più domanda fior: 7 e quagli mastro Priamo à paghati a l'uopera; E più domanda queste cose, le quagli Cino si rechò a le mani, de' beni di misser Jacomo, ch'erano ne l'Uopera; Una covertina da chavalo nuova; Una berrata di scharlato fodarata di mardole di dentro e fuore; Uno paio di stivali nuovi fodrati di rosso; Una testa di vecchio, di metallo; Due inudi di metallo; Uno lenzuolo; Una carta d'animagli da disegno; Una cassa con più di ciento ferri acti ad intaglio; E più uno chusdiere d'ariento; Uno anello d'oro, al quale Cino chavò di mano a messer Jacomo; Due paia di pianelle di scharlato cho'le fibie d'ariento dorate; Uno staio et uno crivello.

E più domanda fior: dugento di massarizie, le quagli el deto Cino ebe di chasa di misser Jacomo in Bologna, e quelle portò e fecie come volse.

Item, domanda fiorini ottocento e quagli el dito Cino si rechò a le mani di denari contanti del deto misser Jacomo in una borsa fra fiorini et grossi, e quagli so'ritenuti e ritiene indebitamente: cavògli d'una cassa di casa di messer Jacomo.

Riservato ogn'altra ragione ch'egli evesse contra el dito Cino.

Critical Bibliography

The bibliography of Jacopo della Quercia does not approach that of Donatello in complexity or bulk. But it does rival in length those of Ghiberti, Luca della Robbia, and Verrocchio. It is larger than those available for such other well-known Quattrocento sculptors as Nanni di Banco, Desiderio da Settignano, Bernardo and Antonio Rossellino, Antonio del Pollaiuolo, or Benedetto da Maiano. Relatively little of the total amount of printed material on Quercia is in English, and much of that total is ephemeral for modern scholarship. In these circumstances a selective and critical bibliography is a requisite. This bibliography has been compiled according to date of publication for its main divisions; within those divisions the order is alphabetical by name of author.

A watershed in studies on Jacopo della Quercia was the famous exhibition of Sienese art held in 1904 in Siena. With the exception of the 1896 monograph by Cornelius, the older publications on Quercia before the exhibition of 1904 are characterized by uncertainties or factual restrictions and are apt to be windy in formal analysis. Their value today, with a few exceptions, is mainly for the history of taste. After 1904 the pace of publication on Quercia quickened somewhat and more vividly reflected visual impressions of the sculpture, as well as a renewed interest in documentation through archival research. What may be called the "modern era" opened only in 1925–30 with the intensive archival studies of Lazzareschi and Bacci, followed by the impact of the positivistic methodology introduced by Lányi in matters of style and attribution. The divisions of the bibliography provided here follow this timetable. In principle, comments are appended to titles listed, but they are held to a minimum of length. This bibliography is not intended to be exhaustive; for more comprehensive bibliographies, see nos. 1 and 2.

I. Bibliographical Summaries

1. Foratti, A. In Thieme-Becker, *Künstlerlexikon* 27 (1933):513–16.
2. Nicco-Fasola, G. In *Encyclopedia of World Art*, vol. 4 (1961), originally published as *Enciclopedia Universale dell'Arte* (1960), pp. 286–95.

II. Documents and Sources

A. Original documentary material relative to Jacopo della Quercia is mainly divided between Siena (Archivio di Stato and Archivio dell'Opera Metropolitana) and Bologna (Archivio della Fabbrica di San Petronio), with additional material in Lucca (Archivio di Stato, Archivio San Frediano, and Biblioteca Governativa di Lucca). For discussion and exact locations of the Siena material see A. C. Hanson (below) and the Ph.D. dissertation (Yale) by John Paoletti on the Baptistery Font. For location of the Bologna material see I. G. Supino (below) and the recently published volume of J. H. Beck, with some recent articles (see below, section VI). The Lucchese material is described by E. Lazzareschi (below). Published collections of archival material is found under the following titles:

3. Bacci, P. *Jacopo della Quercia*. Siena, 1929. (Contains documents for the San Gimignano Annunciation, the Siena Baptistery Font, and the Casini Altar.)
4. ———. *Francesco di Valdambrino*. Siena, 1936. (Contains material on Quercia's family and early life in Siena and Lucca.)

5. Bargagli-Petrucci, F. *Le Fonti di Siena e i loro aquedotti.* Siena, 1906. 2 vols. Documents in vol. 2 (for the Fonte Gaia).

6. Beck, J. H. *Jacopo della Quercia e il portale di San Petronio a Bologna.* Bologna, 1970. (All the documents for the Porta Magna recently and expertly reviewed as a whole.)

7. Borghesi, S., and Banchi, L. *Nuovi Documenti per la storia dell'arte senese.* Siena, 1898. (Continues Milanesi's work; see below.)

8. Della Valle, G. *Lettere sanesi.* Rome, 1785–86. 3 vols. Documents in vol. 2. (Earliest collection of published documents on Quercia.)

9. Hanson, A. C. *Jacopo della Quercia's Fonte Gaia.* Oxford, 1965. (Contains digests of documents for the Fonte Gaia and the Trenta Chapel, Lucca.)

10. Janson, H. W. *The Sculpture of Donatello,* 2:65–66. Princeton, 1957. Reprinted in one volume, 1963. (Brief summaries in English of the content of archival sources for the Siena Font; see in supplement some additions provided by Paoletti.)

11. Krautheimer, R., and Krautheimer-Hess, T. *Lorenzo Ghiberti.* Princeton, 1956. (Contains digests in English and valuable transcripts relative to the Baptistery Font in Siena; to be supplemented by Paoletti's more recent transcriptions of documents then unavailable.)

12. Lazareschi, E. "La Dimora a Lucca di Jacopo della Guercia e di Giovanni da Imola." *Bullettino senese di storia patria* 32 (1925):63–67. (Still the main source for the Trenta Chapel sculpture documents.)

13. Milanesi, G. *Documenti per la storia dell'arte senese.* Siena, 1854–56; relevant documents in vol. 2. (Though document reference numbers no longer correspond to current Sienese archival ordering, still useful; contains some material not otherwise published in complete form.)

14. Supino, I. *Le Sculture delle porte di S. Petronio in Bologna.* Florence, 1914. (Preferable to A. Gatti, *La Basilica Petroniana*, Bologna, 1913, which publishes the first contract for Quercia's portal only in a slightly differing version; Supino's version is to be considered superior to Milanesi's version of the same document. Beck has emended and added considerably to Supino's documents for San Petronio; see also below, nos. 68–70).

B. The source material on Jacopo della Quercia is mainly that compiled by Vasari, who seems to have had the benefit of aging local Sienese tradition. The two versions of Vasari's vita of the artist differ in emphasis and content. Quercia was first mentioned by Ghiberti (see below). Quercia and his work are also mentioned in early Sienese chronicles still unpublished (Biblioteca Communale, MS A. VII, 44 and MS B. III, 9: Antonio di Martino da Siena, "Cronaca dal 1170 al 1431" and Sigismondo Tizio, "Historiae Senenses"). The manuscript of an early nineteenth-century anonymous compilation from earlier sources is in the library of the Uffizi in Florence (Miscellanea Manoscritti, 60, vol. 2); I am indebted to Dr. Eve Borsook for the reference and a copy of it. The chief published sources are given below:

15. Baldinucci, F. *Notizie de' professori del disegno.* Florence, 1681–1728, 6 vols. (vol. 1); in edition of 1845, vol. 1, pp. 318–19.

16. Ghiberti, Lorenzo. *I Commentarii,* Book 2. In J. Schlosser, *Lorenzo Ghibertis Denkwürdigkeiten.* Berlin, 1912, pp. 35–51. Translated in R. Krautheimer and T. Krautheimer-Hess, *Lorenzo Ghiberti* (no. 11).

17. Lamo, P. *Graticola di Bologna.* Bologna, 1560; in edition of 1844, p. 39.

18. Masini, A. *Bologna perlustrata*, pt. 1, pp. iii, 623. Bologna, 1666.

19. Ugurgieri, Azzolini, I. *Le Pompe sanesi*. Pistoia, 1649. 3 vols. See vol. 2, pp. 343–45.

20. Vasari, Giorgio. *Le Vite de' più eccelenti pittori, scultori e architettori*. Florence, 1568 (Critical edition used here. Edited by G. Milanesi. Florence, 1878–85. 9 vols. Vol. 2 contains the Quercia vita in the second version (pp. 109–30). Best English translation in De Vere edition, London, 1912–15, 15 vols. (Quercia *Vita* in vol. 3.) For complete title and title of first edition of 1550 (also printed in Florence) see List of Abbreviations.

III. Publications, to 1904

21. Bode, W. v. *Denkmäler der Renaissanceskulptur Toscanas*. Munich, 1892–1905. 8 vols. See vol. 7. (First extensive illustration of Quercia's work.)

22. Carpellini, C. F. *Di Giacomo della Guercia e della sua Fonte nella Piazza del Campo*. 2d ed. Siena, 1869. (Written on the occasion of substituting a modern fountain for Quercia's.)

23. Cicognara, L. *Storia della scultura in Italia*. 3 vols. Venice, 1813–18. Passim. (Classic older study which contains one of the earliest favorable estimates of the artist in the revival of interest in Quercia.)

24. Cornelius, C. *Jacopo della Quercia*. Halle, 1896. (First full-length monograph on the artist.)

25. Davia, V. *Le Sculture delle porte della basilica di S. Petronio*. Bologna, 1834. (First study of one of Quercia's programs.)

26. ———. *Cenni istorico-artistici intorno al monumento di Antonio Galeazzo Bentivoglio esistente nella chiesa di S. Giacomo in Bologna*. Bologna, 1835. (First attribution to Quercia of Vari-Bentivoglio Monument.)

27. Lusini, V. *Il San Giovanni de Siena e i suoi restauri*. Florence, 1901. (Still important for study of the Baptistery Font.)

28. Michel, A. "La Madone et l'Enfant attribuée a Giacomo della Quercia," *Monuments Piot publiés par l'Académie des Inscriptions et Belles Lettres*, 3 (1896): 261–69. (First scholarly article on the wooden Louvre Madonna.)

29. Perkins, C. *Tuscan Sculptors*. London, 1864. 2 vols. See vol. 1, pp. 103–11. (First extensive critique of Quercia's art in English.)

IV. Publications, 1904–25

30. [*Anon.*]. *Catalogo illustrato della Mostra della antica arte senese*. Siena, 1904. Review: Poggi, G., "La Mostra d'antica arte senese." *Emporium* 20 (1904): 31–48.

31. Banchi Bandinelli, R. "Appunti attorno a Jacopo della Quercia." *Rassegna d'arte senese* 17 (1924): 65–78. (Unimportant.)

32. Bertaux, E. "Trois Chefs-d'oeuvre Italiens de la Collection Aynard." *Revue de l'art ancien et moderne* 19 (1906): 81–96. (On some terracottas; introduces a problem still unsolved.)

33. Bode, W. V. *Die Italienische Plastik*. 5th ed. Berlin, 1911. Passim. (Routine mentions of main programs.)

34. Gielly, L. "Jacopo della Quercia." *Revue de l'art ancien et moderne* 39 (1921): 243–52. (Mostly art appreciation but important for its evidence of interest in Quercia's art in France.)

35. Landsberg, F. *Jacopo della Quercia*. Leipzig, 1924. (Hard to find today; adds little.)

36. Michel, A. *Histoire de l'art*. Paris, 1905–29. See vol. 3, pp. 2, 539–48. (First non-Italian publication on Quercia in an extensive and influential manual.)

37. Schubring, P. *Die Plastik Sienas im Quattrocento*. Berlin, 1907. Passim. (Written after the Exhibition of 1904 and mainly based on it; the first effort to grasp Sienese Quattrocento sculpture as a whole. Not of first importance for Quercia.)

38. Supino, I. B. *La Scultura in Bologna nel Secolo XV*, pp. 47–82, 144–77. Bologna, 1910. (Now considerably dated in view of Gnudi's and Beck's work.)

39. ———. See above no. 14. (Documents and description of San Petronio portal.)

40. ———. *L'Arte nelle chiese di Bologna*. Bologna, 1915. (See under San Petronio and San Giacomo Maggiore.)

41. ———. "Un'Opera sconosciuta di Jacopo della Quercia." *Dedalo* 2, no. 1 (1921): 149–53. (Dubious attribution.)

42. Venturi, A. *Storia dell'arte italiana* 6 (1908): 67–106. (Historically important survey of Quercia's work.)

43. ———. *Storia dell'arte italiana* 8, no. 1 (1923):28–66. (Supplements, with some revisions, earlier survey of 1908.)

44. ———. "Una Statua ignota di Jacopo della Quercia." *L'Arte* 11 (1908): 53–54. (Mistaken attribution of the San Maurelio in Ferrara.)

45. ———. "Una Statua di Jacopo della Quercia nel Duomo di Lucca." *L'Arte* 23 (1920):160–61. (Lucca Apostle; recognition of its importance in Jacopo's oeuvre.)

46. ———. "San Martino di Lucca." *L'Arte* 25 (1922):207–19. (Quercia's possible part in design of masks on exterior of nave.)

V. Monographs, 1925 to Present

47. Bacci, P. *Jacopo della Quercia* (No. 3).

48. Beck, J. H. *Jacopo della Quercia e il portale di San Petronio* (no. 6). (Important for iconography of Porta Magna as well as for its chronology.)

48a. Review [of Beck, J. H. *Jacopo della Quercia e il portale di San Petronio*]: Krautheimer, R. *Renaissance Quarterly* 25 (1972): 321–26. (Important for San Petronio Portal design and program.)

49. Bertini, A. *L'Opera di Jacopo della Quercia*. Turin, 1965. (Summary of outstanding opinions and problems.)

50. Biagi, L. *Jacopo della Quercia*. Florence, 1946. (Best short summary up to date of its publication; still useful.)

51. Carli, E. *Jacopo della Quercia*. Florence, 1949. (Brief summary in Astra "collana" series; for general audience.)

51a. Freytag, C. "Jacopo della Quercia: Stilkritische Untersuchungen unter besonderer Berücksichtigung des Frühwerks." Munich, 1969. (Ph.D. dissertation, unfortunately not available to me until my text was completed.)

52. Gielly, L. *Jacopo della Quercia*. Paris, 1930. (Unoriginal—a version of Supino's monograph; see below.)

53. Hanson, A. C. *Jacopo della Quercia's Fonte Gaia* (no. 9). (Up-to-date summary of documentation of the Fonte Gaia; a relatively recent attempt to clear up stylistic problems between Quercia and Francesco di Domenico Valdambrino.)

54. Review: Beck, J. H. *Art Bulletin* 48 (1966): 114–15.

55. Matteucci, A. M. *La Porta Magna di San Petronio in Bologna*. Bologna, 1966. (University thesis; modern summary to be supplemented by newer study by J. H. Beck.)

56. Morisani, O. *Tutta la Scultura di Jacopo della Quercia*. Milan, 1962. (As title

indicates, ultrainclusive and in places somewhat impressionistic; contains, however, a usefully succinct chronological survey and bibliography, and good summaries of individual programs with reasonably comprehensive illustration.)

57. Review: Beck, J. H. *Arte antica e moderna* 20 (1962): 456–57.
58. Nicco, G. *Jacopo della Quercia.* Florence, 1934. (Contains good critical insights.)
59. Supino, I. B. *Jacopo della Quercia.* Bologna, 1926. (Routine account for general audience.)

VI. Articles and Catalogues, 1925 to Present

60. Bacci, P. "Le Statue dell'Annunziazione intagliate nel 1421 da Jacopo della Quercia." *La Balzana* 1 (1927): 149–75. (A first publication of material included in the volume of 1929, see no. 3, above.)
61. ———. *Catalogo della mostra di scultura d'arte senese del xv secolo nel v centenario della morte di Jacopo della Quercia.* Siena, 1938.
62. Review: Cohn-Goerke, W. In *Rivista d'arte* 21 (1939): 187–92.
63. Review: Haftmann, W. "Della Quercia and Sienese Sculpture." *Magazine of Art* 32 (1939): 508–11.
64. Review: Pope-Hennessy, J. "A Jacopo della Quercia Exhibition." *Burlington Magazine* 74 (1939): 36.
65. Review: Ragghianti, C. L. In *Critica d'arte* 5 (1940): XXI.
66. Banti, A. "Una Sibilla nel Duomo di Orvieto." *Paragone* 4 (1953): 39–40. (Use with caution.)
67. Beck, J. H. "An important new document for Jacopo della Quercia in Bologna." *Arte antica e moderna* 18 (1962): 206–07. (Concerns the San Petronio of the portal.)
68. ——— (with Fanti, M.). "Un probabile intervento di Michelangelo per la 'porta magna' di San Petronio." *Arte antica e moderna* 27 (1964): 349–54. (Important evidence for Quercia's portal.)
69. ———. "A document regarding Domenico da Varignana." *Mitteilungen des Kunsthistorischen Instituts in Florenz* 11 (1964): 193–94.
70. ———. "Jacopo della Quercia's design for the Porta Magna in Bologna." *Journal of the Society of Architectural Historians* 24 (1965): 115–26.
71. ———. "A *Sybil* by Tribolo for the 'Porta Maggiore' of San Petronio." *Essays in the History of Art presented to Rudolf Wittkower.* London, 1967, pp. 98–101. (Influence of Quercia's style in Cinquecento.)
72. Bertini, A. "Calchi dalla Fonte Gaia." *Critica d'Arte,* n.s. 15 (1968), fasc. 97, pp. 35–54. (Earlier state of statuary.)
73. Bottari, S. "Jacopo della Quercia." *Emporium* 88 (1938): 182–94 (Anniversary eulogy.)
74. Brunetti, G. "Jacopo della Quercia a Firenze." *Belle Arti* 2 (1951): 3–17. (Shaky thesis.) Repeated in English as: "Jacopo della Quercia and the Porta della Mandorla." *Art Quarterly* 15 (1952): 119–31.
75. Campetti, P. "L'Altare della famiglia Trenta in S. Frediano di Lucca." in *Miscellenea di storia dell'arte in onore di Igino Benvenuto Supino,* pp. 271–94. Florence, 1933. (Mainly documentation.)
76. Caratti, E., Longhi, R. "Un'Osservazione circa il Monumento di Ilaria." *Vita Artistica* 1 (1926): 94–96.
77. Carli, E. "Sculture senesi del Quattrocento." *Emporium* 88 (1938): 280–83. (On the Siena 1938 *Mostra*.)

78. ———. *Sculture lignee senesi.* Florence, 1949. (Catalogue of the important exhibition of Sienese sculpture in wood, held in Siena; included were figures by Quercia.)

79. ———. "Una Primizia di Jacopo della Quercia." *La Critica d'arte* 8 (1949): 17–24. (Important recognition of Piccolomini Altar Madonna undramatically and clearly announced.)

80. ———. "Due Madonne Senesi (tra il Ghiberti e Jacopo della Quercia)." *Antichità Viva* 1, no. 3 (1962): 9–17. (An important standing Madonna Annunciate of the Berlin-Dahlem type attributed to Giovanni Turini, and a less Querciesque Madonna and Child.)

81. Corrini, G. "Documenti di Jacopo della Quercia che ritornano a Siena." *Bulletino senese di storia patria* 40 (1933): 303–13. (Concerns an archival transfer.)

82. Foratti, A. "I Profeti di Jacopo della Quercia nella porta maggiore di San Petronio." *Il Commune di Bologna*, September, 1932. (Early attempt to discriminate between Quercia's and assistants' hands.)

83. ———. "Jacopo della Quercia in S. Petronio e la critica moderna." *Archiginnasio* 27 (Bologna, 1932): 141–54. (General aesthetic views.)

84. Gnudi, C. "Intorno ad Andrea da Fiesole." *La Critica d'arte* 3 (1938): 23–29. (Contains interesting views on Quercia's early stay in Bologna.)

85. ———. "La Madonna di Jacopo della Quercia in S. Petronio a Bologna." *Atti e memorie della deputazione di storia patria per le provincie di Romagna*, n.s., 4 (1952–53): 325–34. (Fine analysis of style with evidence of dangerous deterioration of surface.)

86. Klotz., H. "Jacopo della Quercias Zyklus der 'Vier Temperamente' am Dom zu Lucca." *Jahrbuch der Berliner Museen* 9 (1967): 81–99. (New reinterpretation of masks in nave of Lucca Cathedral.)

87. Kosegarten, A. "Das Grabrelief des San Aniello Abbate im Dom von Lucca." *Mitteilungen des Kunsthistorischen Instituts in Florenz* 13 (1968): 223–72. (Dubious attribution to Quercia, but most important recent publication of problems relating to his early period.)

88. Krautheimer, R. "Un Disegno di Jacopo della Guercia." *La Diana* 3 (1928): 276–79. (A suggested attribution to Quercia of an ink drawing of a saint in the Teyler Museum, Haarlem.)

89. ———. "Terracotta Madonnas." *Parnassus* 8, no. 7 (1936): 6–8. (Important for critical viewpoint.)

90. ———. "A Drawing for the Fonte Gaia in Siena." *Bulletin of the Metropolitan Museum of Art* 10 (1952): 265–74. (Perceptive article linking the two extant parts of the Fonte Gaia drawing and suggesting phases of the program of sculpture on the basis of iconography.) See also below, no. 103.

91. Lányi, J. "Der Entwurf zur Fonte Gaia in Siena." *Zeitschrift für bildende Kunst* 61 (1927–28): 257–66. (Important recognition of the London drawing as applying to the Fonte Gaia.)

92. ———. "Quercia-Studien." *Jahrbuch fur Kunstwissenschaft*, 1930, pp. 25–63. (Important for Ferrara Silvestri Madonna, but mistaken as to date of Ilaria Monument.)

93. Marangoni, M. "Una Scultura quercesca." *Critica d'Arte* n.s. 1 (1954): 20–21. (On a derivative half-length Madonna in stone.)

94. Morisani, O. "Struttura e plastica nell'opera di Jacopo della Quercia." *Arte Lombarda* 10 A (special issue, 1965): *Studi in onore di Giusta Nicco Fasola* 75–

90. (Contains recent critical insights, not all convincing, on the relation of sculpture to architecture.)

95. Nicco, G. "Jacopo della Quercia e il problema del classicismo." *L'Arte* 32 (1929): 126–37. (Raises an important art historical as well as aesthetic question.)

96. ——. "Argomenti querceschi." *L'Arte* 32 (1929): 193–202. (Continuation of the preceding.)

97. Parimbeni, R. *Jacopo della Quercia.* Rome, 1938. (Reprint of eulogistic address on the occasion of the anniversary of Quercia's death.)

98. Ragghianti, C. "Novità per Jacopo della Quercia." *La Critica d'arte* 12, fasc. 75 (1965): 35–47. (Chiefly a seated Madonna in wood, location not given.)

99. Rondelli, N. "Jacopo della Quercia a Ferrara 1403–1408." *Bullettino senese di storia patria* 71 (1964). *Miscellanea di studi in memoria di Giovanni Cecchini* 2: 131–42. (Important for date of Silvestri Madonna.)

100. Salmi, M. "La Giovinezza di Jacopo della Quercia." *Rivista d'arte* 2 (1930): 175–91. (Inconclusive suggestions with Lucca as the locale.)

101. Sanpaolesi, P. "Una Figura lignea di Jacopo della Quercia." *Bolletino d'arte* 43 (1958): 112–16. (About an attractive but not altogether convincing figure in Massa.)

102. Seymour, C., Jr. "The Younger Masters of the First Campaign of the Porta della Mandorla." *Art Bulletin* 41 (1959): 1–17. (A refutation of Vasari's thesis that Quercia worked in Florence.)

103. ——. "Di Mano Sua, a Reconsideration of the Drawing for the Fonte Gaia." In *Festschrift Ulrich Middeldorf*, edited by A. Kosegarten and P. Tigler, pp. 93–105. Berlin, 1968. (Against the thesis that Quercia was the draughtsman of the two fragments now in the metropolitan and the Victoria and Albert museums.)

104. ——, and Swarzenski, H. "A Madonna of Humility and Quercia's Early Style." *Gazette des Beaux-Arts* 30 (1946): 129–52. (Concerns the Goldman Madonna, which had recently entered the National Gallery of Art as part of the Kress Collection.)

105. Valentiner, W. "A Statuette in Wood by Jacopo della Quercia." *Bulletin of the Detroit Institute of Arts* 20 (1940): 14–15. (Unconvincing attribution, see Appendix.)

106. ——. "The Equestrian Statue of Paolo Savelli in the Frari." *Art Quarterly* 16 (1953): 280–93. (A very far-fetched attribution to Quercia.)

107. Wundram, M. "Die Sienesische Annunziata in Berlin, ein Frühwerk des Jacopo della Quercia." *Jahrbuch der Berliner Museen* 6 (1964): 39–52. (Important new addition to corpus of Sienese wood sculpture of early Quattrocento; very close to Quercia, if not by his hand.)

108. ——. "Jacopo della Quercia und das Relief de Gürtelspende über der Porta della Mandorla." *Zeitschrift fur Kunstgeschichte* 28 (1965): 121–29. (A not overly successful attempt to link the Temperance of Fonte Gaia directly to the design of Nanni di Banco's Assunta.)

VII. References in Comprehensive Studies, 1925 to Present

109. Carli, E. *La Scultura lignea senese.* Milan-Florence, 1954. (See pp. 69–72, 147–48.)

110. Del Bravo, C. *Scultura senese del quattrocento.* Florence, 1970. (See pp. 9–12, 23–31, 34–48, 53–55, 69–77.)

111. Pope-Hennessy, J. *Introduction to Italian Sculpture*. Italian Gothic Sculpture, vol. 1. London-New York, 1955. (See pp. 45–52, 210–15.)
112. Seymour, C., Jr. *Sculpture in Italy, 1400–1500*. Harmondsworth, 1966. (See pp. 46–49, 65–68, 83–87.)

VIII. Related Tuscan Sculptors (selective)

Domenico di Niccolò dei Cori

113. Bacci, P. In *Jacopo della Quercia* (no. 3), pp. 52–59.
114. Bernath, M. H. In Thieme-Becker, *Künstlerlexikon* 7 (1912): 412–13.
115. Carli, E. *La Scultura lignea senese* (no. 109), pp. 41–50.
116. Pope-Hennessy, J. In *Introduction to Italian Sculpture*, vol. 1, pp. 51, 217 (no. 111).

Donatello

117. Becherucci, L. In *Encyclopedia of World Art* 4 (1961): 427–41.
118. Janson, H. W. *The Sculpture of Donatello*. 2 vols.; Princeton, 1957; 1 vol., 1963.
119. Kauffmann, H. *Donatello, Eine Einführung in sein Bilden und Denken*. Berlin, 1935. Review: Middeldorf, U., *Art Bulletin* 18 (1936): 570–85.
120. Lányi, J. "Problemi della critica donatelliana." *Critica d'Arte* 4 (1939): 9–23.
121. Morisani, O. *Studi su Donatello*. Venice, 1952.
122. Planiscig, L. *Donatello*. Florence, 1939.
123. Pope-Hennessy, J. *Donatello's Relief of the Ascension and Christ Giving the Keys to St. Peter*. Victoria and Albert Museum Monograph. London, 1949.
124. *Donatello e il suo tempo*. Edited by M. Salmi et al. Florence, 1968. Papers given at Donatello Congress, Florence-Padua, 1966.

Antonio Federighi

125. Carli, E. In *La Scultura lignea senese* (no. 109), pp. 73–74, 117–18.
126. Nicola, G. de. In Thieme-Becker. *Künstlerlexikon* 1 (1907): 587–88.
127. Paoletti, J. T. "Quercia and Federighi." *Art Bulletin* 50 (1968): 281–84.
128. Schmarsow, A. "Antonio Federighi dei Tolomei, ein sienesischer Bildhauer des Quattrocento." *Repertorium für Kunstwissenschaft* 12 (1889): 277–99.

Francesco di Domenico Valdambrino

129. Bacci, P. *Francesco di Valdambrino* (no. 4).
130. Carli, E. In *La Scultura lignea senese* (no. 109), pp. 52–63, 118–19.
131. Del Bravo, C. In *Scultura senese del quattrocento*, pp. 9–25, 31–32, 45–51, 57–62.
132. Freytag, C. "Beiträge zum Werk des Francesco di Valdambrino," *Pantheon* 29 (1971): 363–78. (Also contains interesting, though not all conclusive, opinions on Quercia's early work, taken from her Munich dissertation, no. 51a.)
133. Ragghianti, C. L. "Su Francesco di Valdambrino," *La Critica d'arte* 3 (1938): 136–43.

Lorenzo Ghiberti

134. Krautheimer, R., and Krautheimer-Hess, T. *Lorenzo Ghiberti*. Princeton, N.J., 1956. (See also recent revision, 1971.)
135. Planiscig, L. *Lorenzo Ghiberti*. Vienna, 1940.
136. Schlosser, J. v. *Leben und Meinungen des Florentinschen Bildners Lorenzo Ghiberti*. Basel, 1941.

Nanni di Banco

137. Brunetti, G. "Un' Opera sconosciuta di Nanni di Banco e nuovi documenti relativi all'artista." *Rivista d'arte* 12 (1930): 229–41.
138. Lańyi, J. "Il Profeta Isaia di Nanni di Banco." *Rivista d'arte* 18 (1936): 137–78.
139. Planiscig, L. *Nanni di Banco*. Florence, 1940, 1944.
140. Vaccarino, P. *Nanni*. Florence, 1950.
141. Wundram, M. "Donatello e Nanni di Banco negli anni 1408–1409." In Salmi et al., eds., *Donatello e il suo tempo* (no. 124), pp. 69–75. (Most unlikely thesis. Read as corrective in the same volume, pp. 277–81: G. Brunetti, "Riadattimenti e spostamenti di statue fiorentine del primo Quattrocento.")

Index

Saliceto Monument (Bologna). *See* Andrea da Fiesole

San Cassiano (near Lucca): equestrian figure attributed to Francesco di Valdambrino, 35; fig. 19

San Gimignano, Pieve: Annunciation group by Q, 56, 64, 70, 97, 98; tabernacle by Benedetto da Majano, 66; pls. 58–59

Sano di Matteo (assistant to Q), 96, 103

San Petronio. *See* Bologna

Sarcophagus(-i): influence of Roman space-conventions on Q, 34, 51, 54, 88–89. *See also* Roman (Antique) sources for Q's sculpture

Sassetta (Stefano di Giovanni): makes full-scale drawing for Siena Font ciborium, 65, 108

Satan, 85; pl. 109

Savinus (Savino), St., as subject, 118

Sebastian, St., as subject, 75

Senus, legendary founder of Siena, 88

Serpent. *See* Satan

She-wolf (*lupa*), as emblem for Fonte Gaia, 46; fig. 44

Siena, 4, 9; former *contrada* of the oak tree (Quercia), 16; Malavolti uprising (*1391*) in, 17; legendary foundation by Senis, 45, 88; dedicated to the Virgin, 50
—Cappella di Piazza: replicas of reliefs of Liberal Arts, 49; St. Peter for, begun by Q, 76; fig. 43
—Duomo, 4; Piccolomini altar, 4, 17, 29; Q elected *operaio* of, 20, 99; presumed statue of Giovanni d'Azzo Ubaldini, 24; altar of San Jacopo Interciso, 29*n*; Q's "First Madonna," 29–30, 78–79, 85; pulpit by Nicola Pisano and assistants, 30, 85; work for, by Francesco di Valdambrino, 35; pulpit reliefs of Evangelists, by Giovanni d'Imola and Giovanni Turini, 42; tomb-marker by Donatello, 42; bronze tabernacle by Vecchietta, 66; font, under direction of Federighi, 51–52, 88; pls. 1–4; figs. 37, 58, 60–61, 74
—Fonte Gaia. *See* Palazzo Pubblico
—Loggia di San Paolo (della Mercanzia): 20, 58; Q's part in design and sculpture program; 76, 117; pl. 134
—Museo dell'Opera del Duomo: fragment of Casini Altar lunette, 20, 58, 75, 116; St. Crescentius fragment by Francesco di Valdambrino, 35; pls. 130–33; fig. 20
—Palazzo Pubblico: fragments of Fonte Gaia sculpture, 4, 8, 44–47, 47–53; early casts from Q's sculpture, 46–47; fragments of Liberal Arts reliefs from the Cappella di Piazza, 49; pls. 31–55; figs. 40–41, 43–50, 53–56, 62, 63
—San Giovanni (Baptistery): font, 4, 20; its

Siena (*cont.*)
sculpture by Donatello, Ghiberti, Q, and Turini described, 62–66, 71, 80, 90; figure of St. John Baptist in wood, 57; text fig., 61; pls. 61–77; figs. 78–81. *See also under individual artists' names*
—San Giovanni (Baptistery): font, 4, 20; its sculpture by Donatello, Ghiberti, Q, Turini described
—San Martino: Madonna and saints by Q and assistants, 56–57, 83; pl. 60; fig. 69
—Sant' Agostino: Q's burial place, 20; his epitaph formerly in church or cloister, 21
—Santa Maria della Scala (hospital): Q nominated as rector of, 19; remembered in his will, 126

Simone da Colle, sculptor in Florence Baptistery Doors Competition, 31

Sinibaldi, Cino: monument of, fig. 102

Sistine Ceiling (Rome, Vatican), 4, 72; fig. 92

Sforza, Francesco, 100

Sluter, Claus, 25*n*

Sodoma, Il: drawing of Fonte Gaia attributed to, fig. 62

Sovanna: fortifications inspected by Q, 55, 98

Spinelli, Parri: style in connection with drawing for Fonte Gaia, 50*n*

Stefano di Giovanni. *See* Sassetta

Stucco, as material for sculpture, 55

Synagogue: attributes of in medieval symbolism, 86

Taccola (Mariano di Jacopo), author of treatise on engineering, 55*n*

Temperance, as subject, 49; text figs., 45, 46; pl. 43

Temptation, as subject: text fig., 69; pls. 109–11. *See also* Adam; Eve

Throne of Mars, as subject, fig. 17

Trenta, Girolamo: pays fine for Giovanni da Imola, 96, 104

Trenta, Lorenzo, 9, 18: tomb-marker, 39, 42, 47; commissions altar in San Frediano, Lucca, 40, 96, 97, 102, 104; text fig., 41; pls. 28–36, 56–57; figs., 32–34, 38–39

Trenta family: chapel of, in San Frediano, Lucca, 18, 38, 102, 104

Tribolo, Niccolò (sculptor, façade of San Petronio), figs. 99–100

Turini, Giovanni (sculptor, Siena Font), 27*n*, 62, 107, 110, 123; text fig., 63

Turino di Sano, 62, 107, 123

Ubaldini, Giovanni d'Azzo: statue of, 14, 16, 24, 95

Urbano da Cortona, 118

Ursula, St., as subject, 18, 40, 53–54; text fig., 41; pls. 32, 56

PLATES

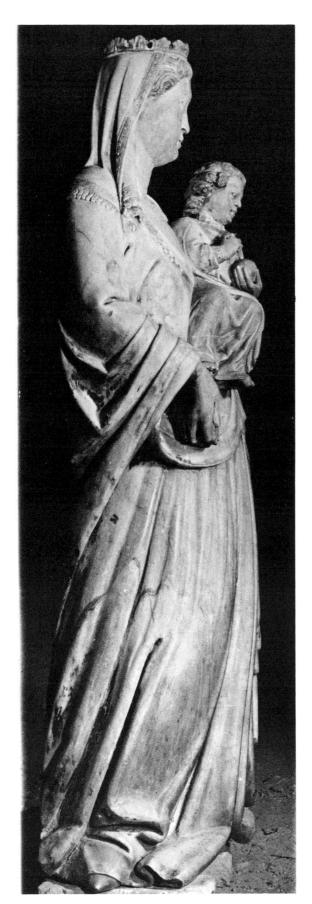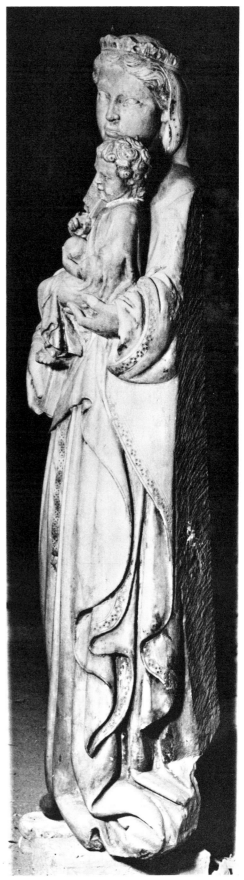

1a. First Madonna, before 1397, from left. Marble. H. overall 136 cm. (53¹/₂ in.). Duomo, Siena

b. First Madonna, from right

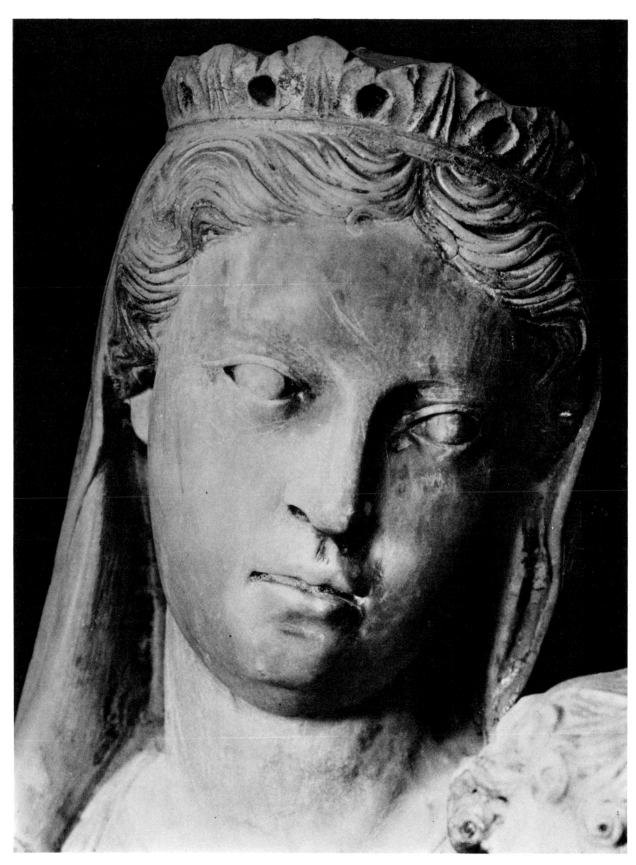

2. First Madonna, head of Virgin

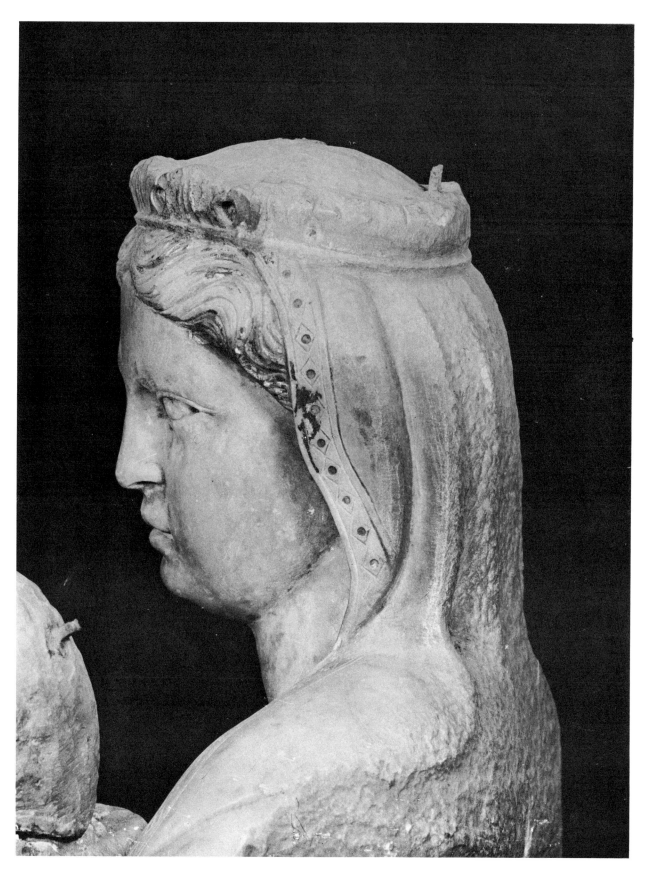

3. First Madonna, head of Virgin, left profile

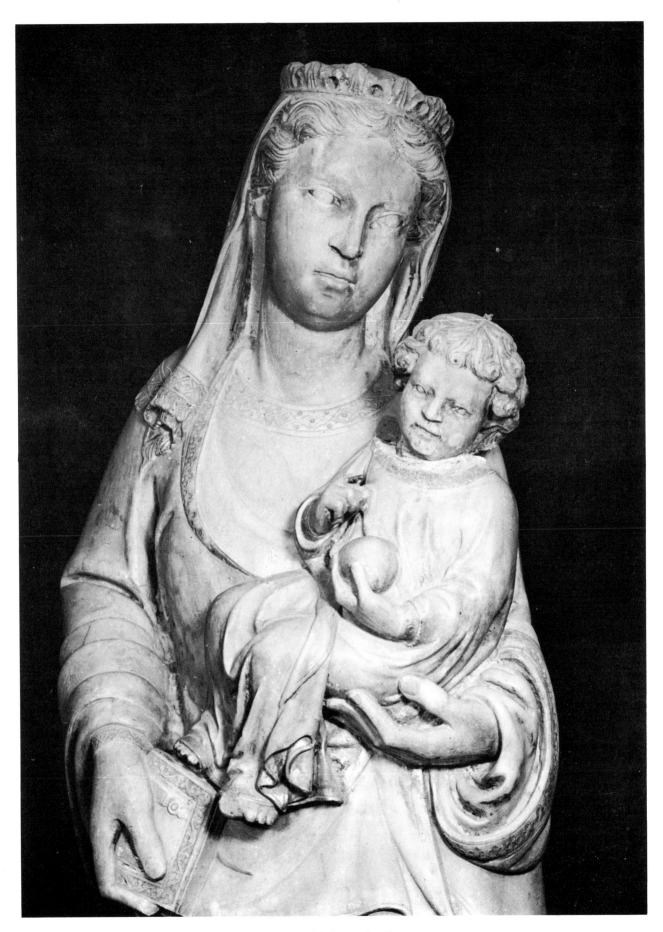

4. First Madonna, detail

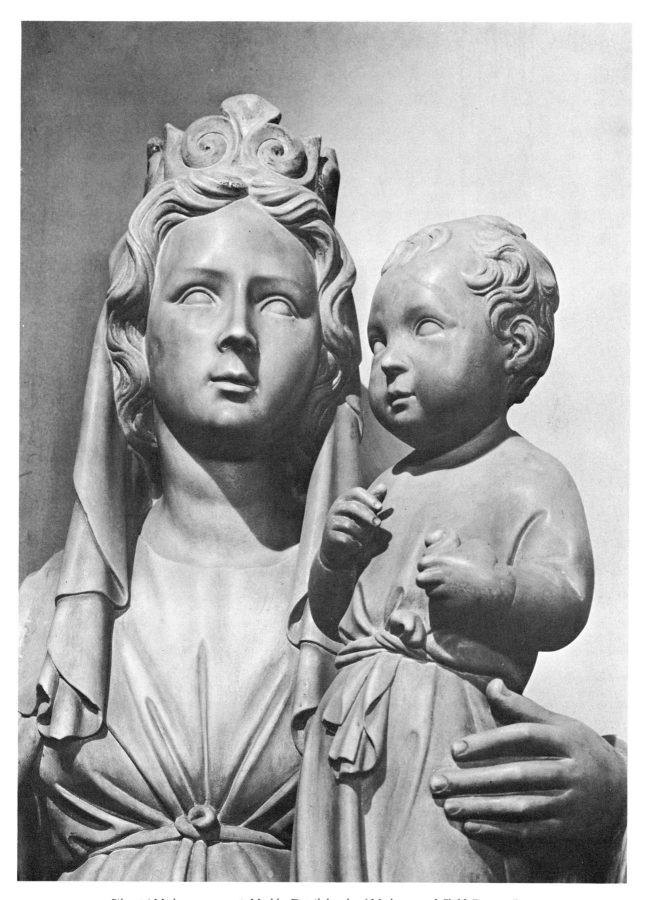

5. Silvestri Madonna, 1403–08. Marble. Detail, heads of Madonna and Child. Duomo, Ferrara

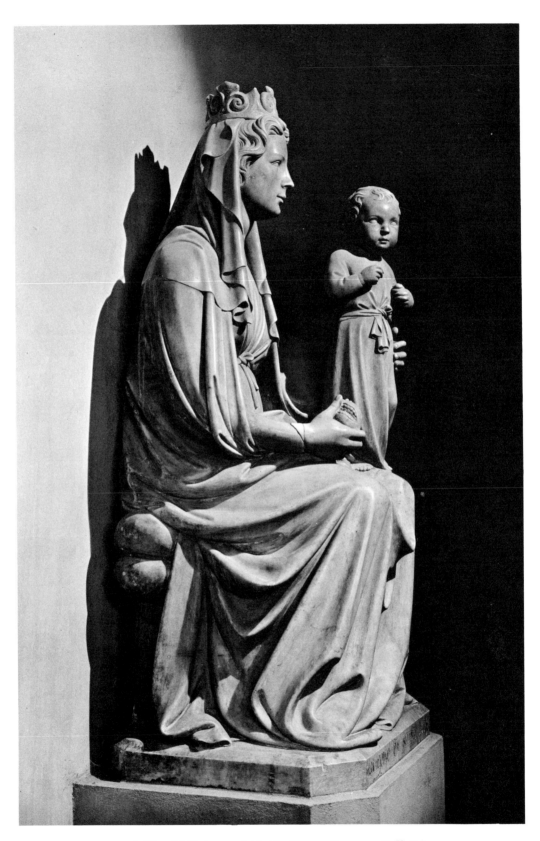

6. Silvestri Madonna, right side. H. overall 152 cm. (60⁷/₈ in.)

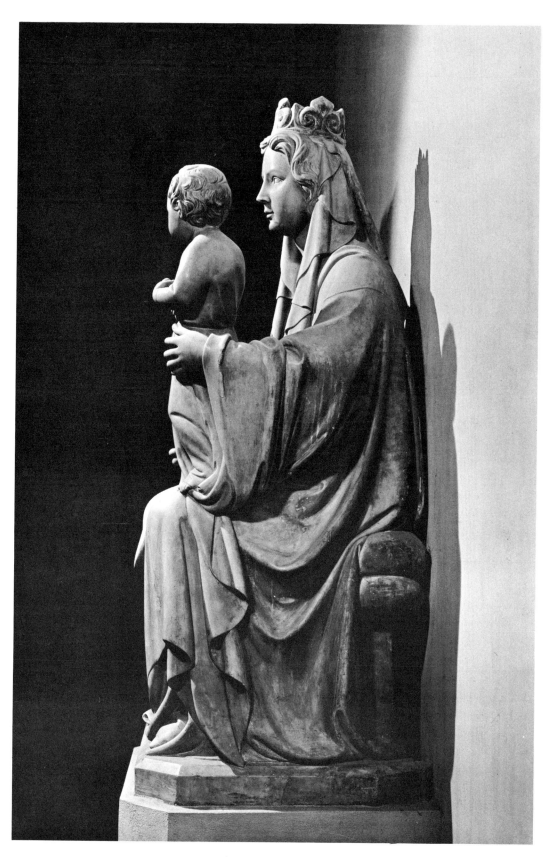

7. Silvestri Madonna, left side

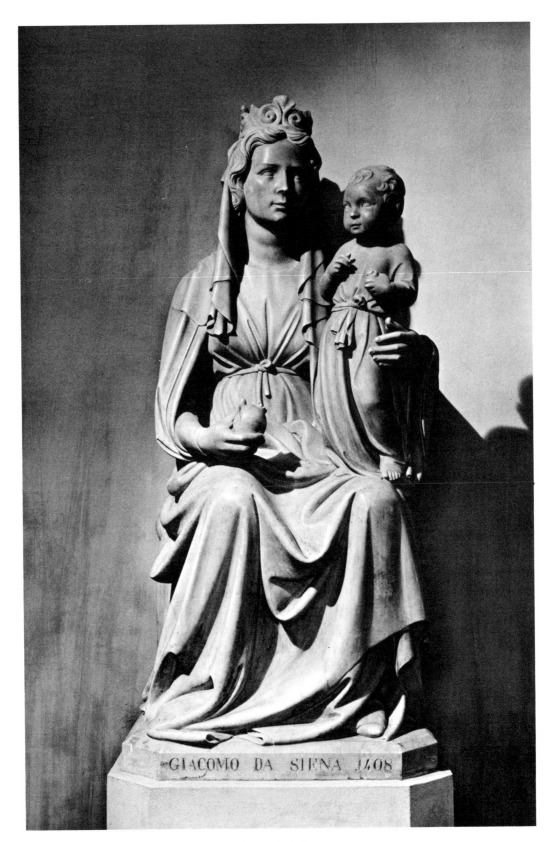

8. Silvestri Madonna

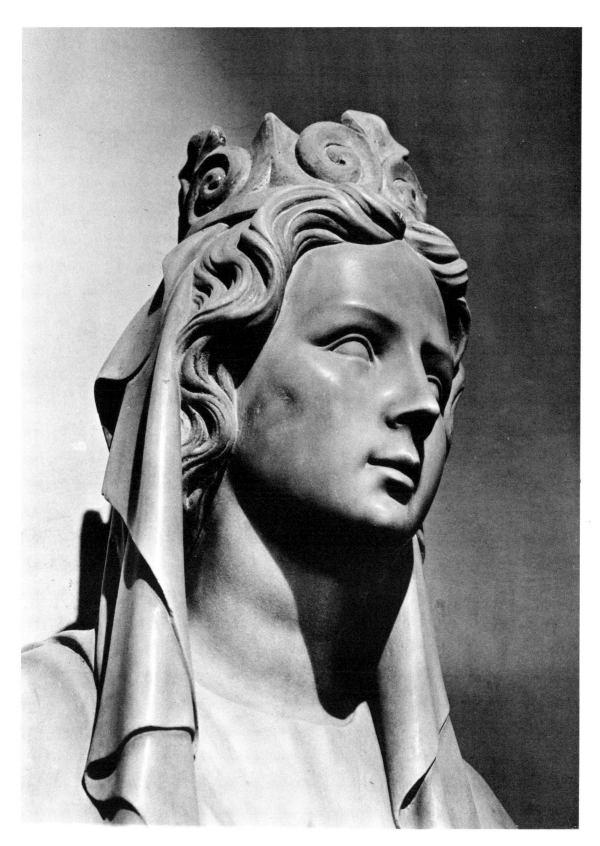

9. Silvestri Madonna, detail, head of Madonna

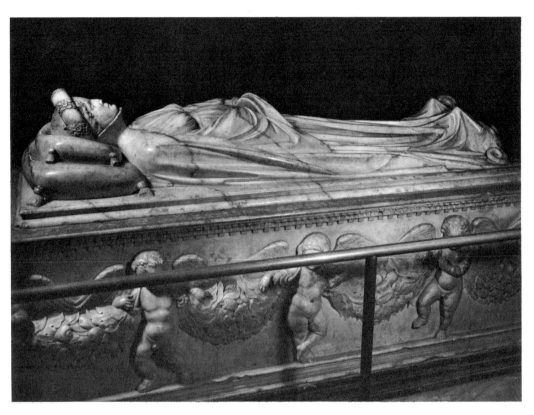

10a. Monument of Ilaria del Carretto (1406?), right side. Marble. H. overall 88 cm. (35¹/₈ in.); L., base under effigy, 205 cm. (82 in.). Duomo, Lucca

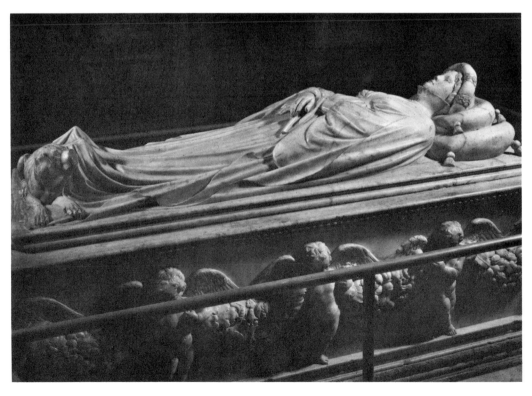

b. Monument of Ilaria, left side

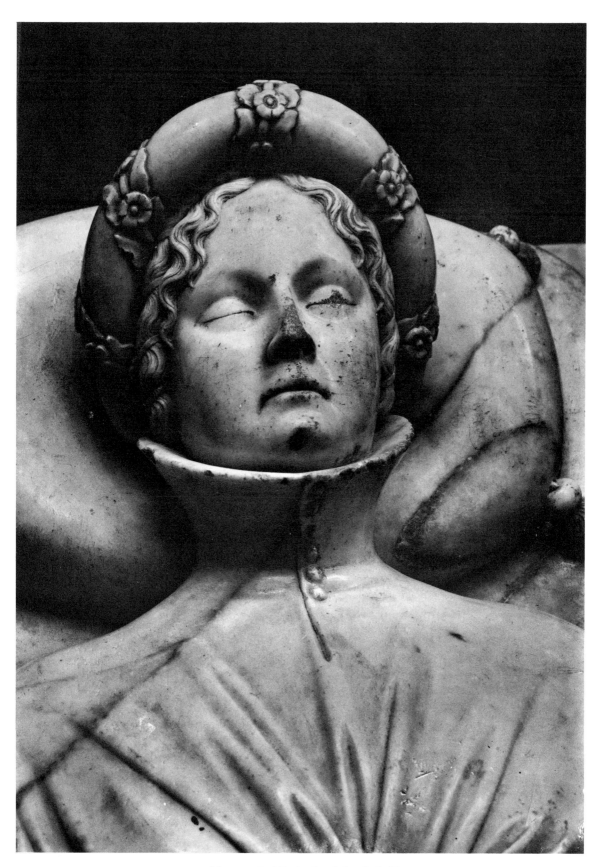

11. Monument of Ilaria, detail, head of effigy

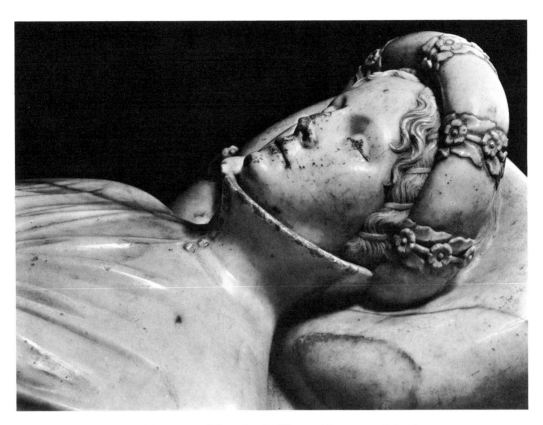

12a. Monument of Ilaria, head of Ilaria, oblique view, left side

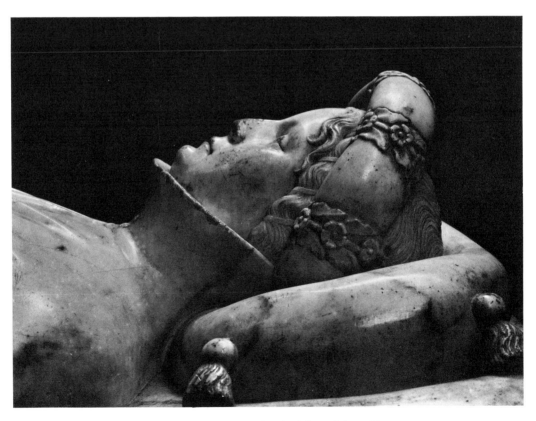

b. Monument of Ilaria, head of Ilaria, left profile

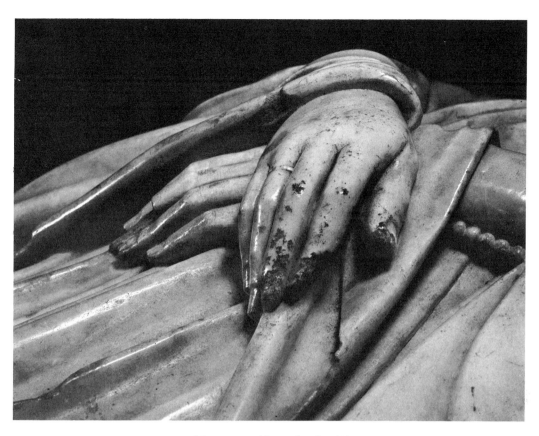

13a. Monument of Ilaria, hands of Ilaria

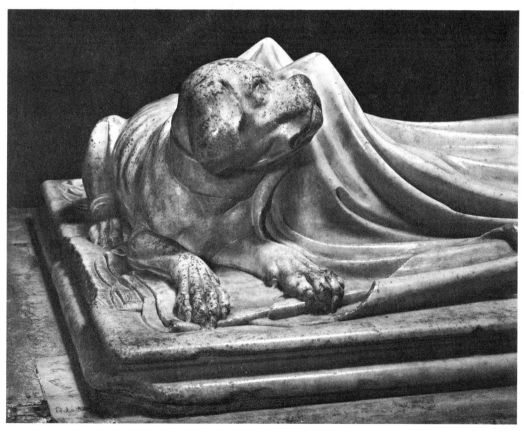

b. Monument of Ilaria, dog at Ilaria's feet

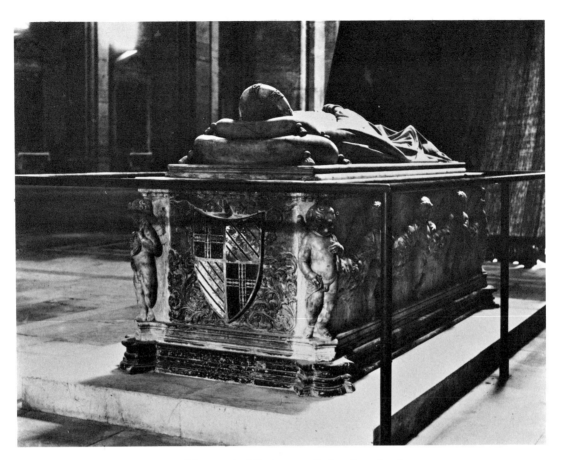

14a. Monument of Ilaria, overall view, from head

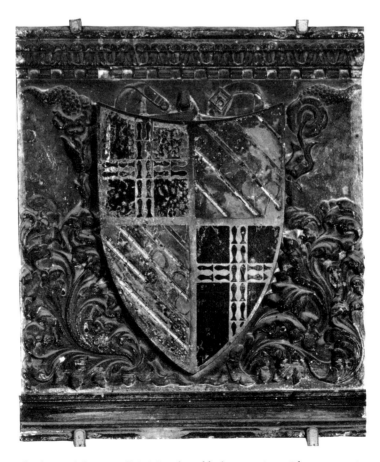

b. Arms of Carretto-Guinigi as found before reunion with monument.

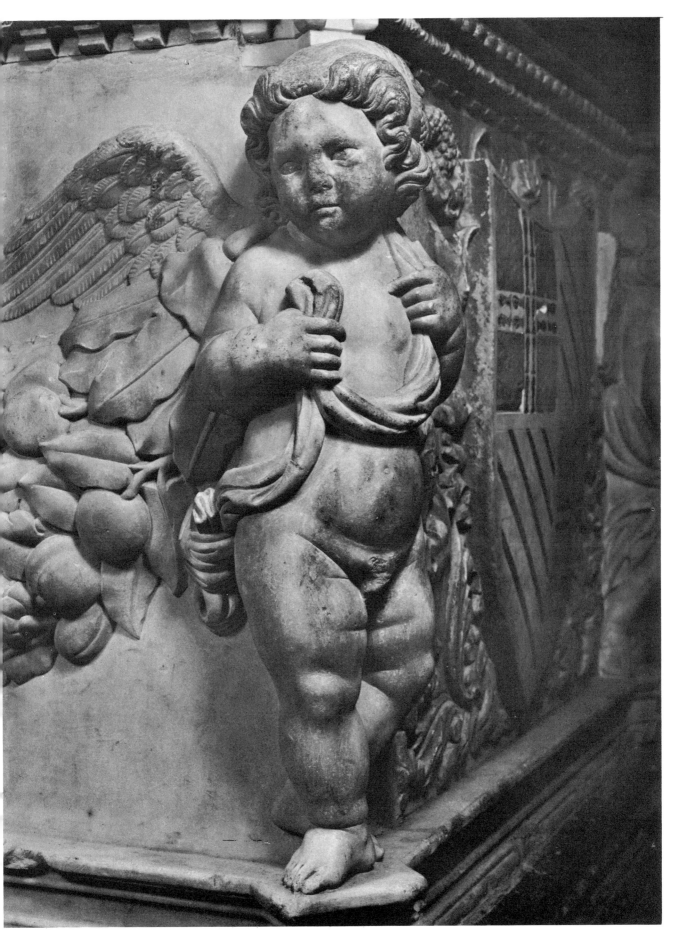

15. Monument of Ilaria, corner putto, right side. H. 49 cm. (19¹/₂ in.)

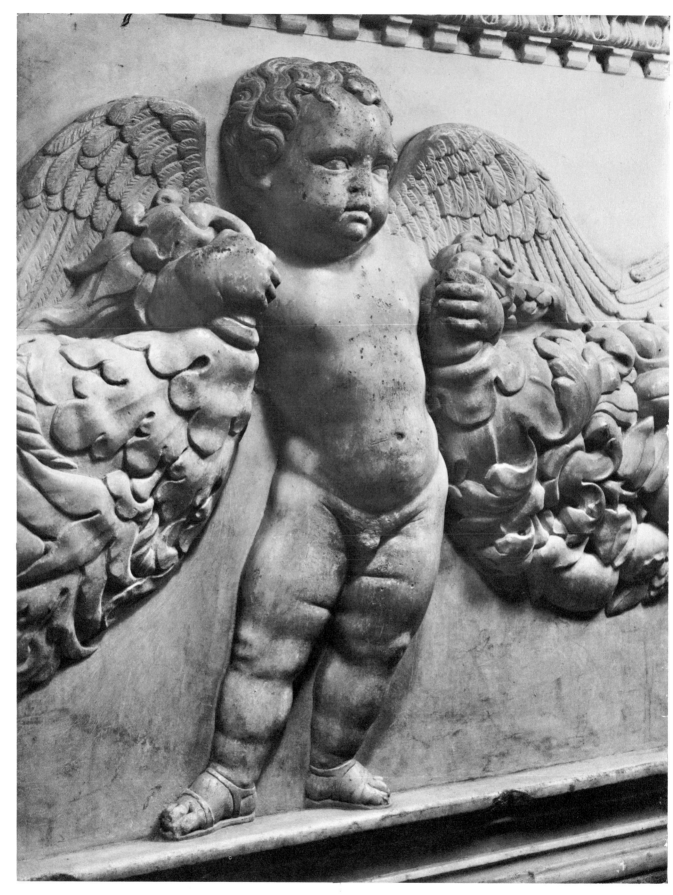

16. Monument of Ilaria, center putto, right side. H. 48 cm. (19 in.)

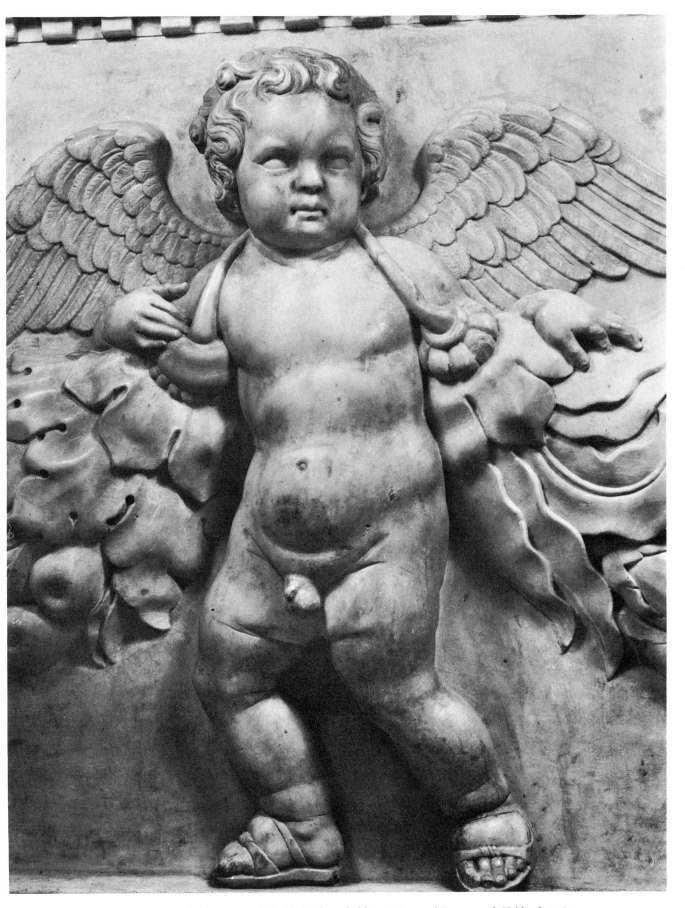

17. Monument of Ilaria, putto, left side (with probable assistance of Francesco di Valdambrino)

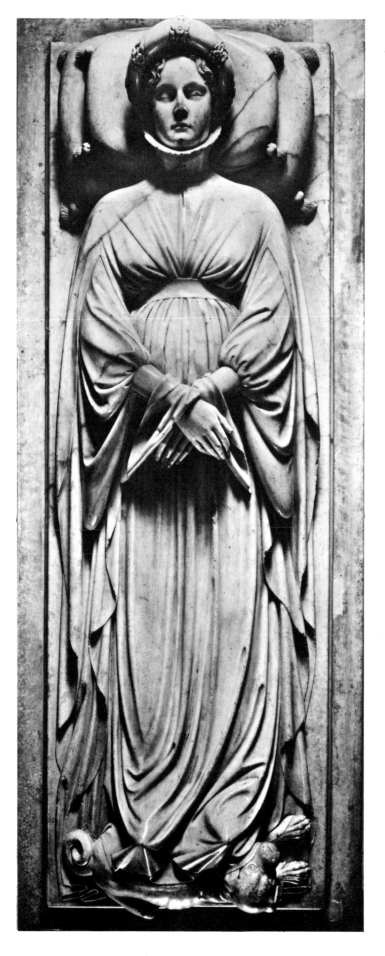

18. Monument of Ilaria, effigy, from above.
L. 1.66 cm. (66½ in.)

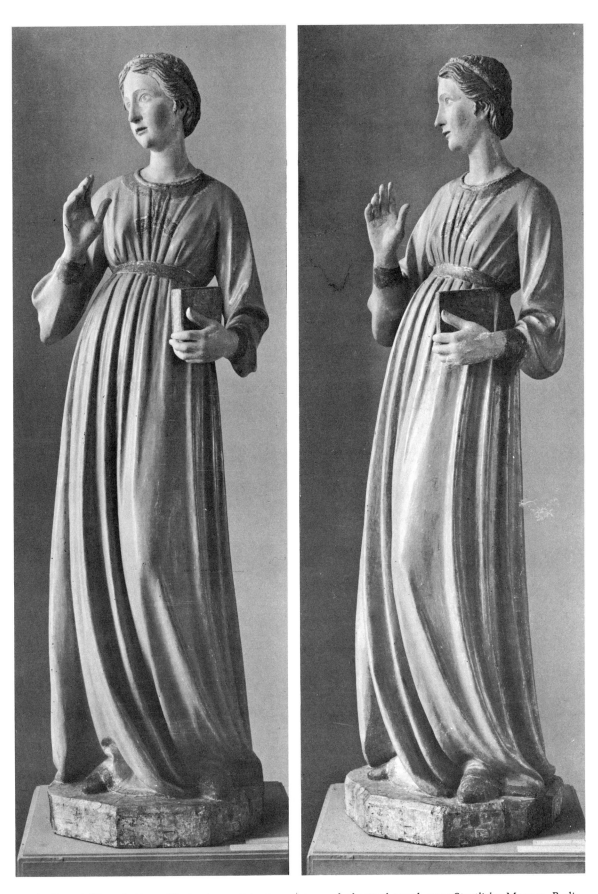

19a-b. Quercia(?) or bottega, Virgin Annunciate, two views, polychromed wood, now Staatliche Museen, Berlin-Dahlem. H. overall, 152 cm. (60⅞ in.)

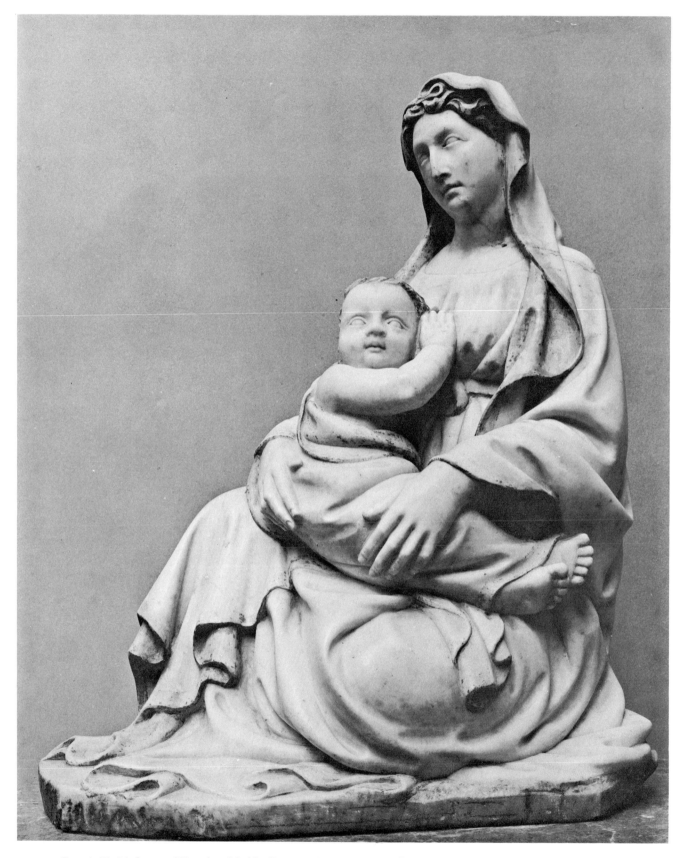

20. Quercia(?), Madonna of Humility. Marble. H. 58 cm. (23 in.) Kress Collection, National Gallery of Art, Washington, D.C.

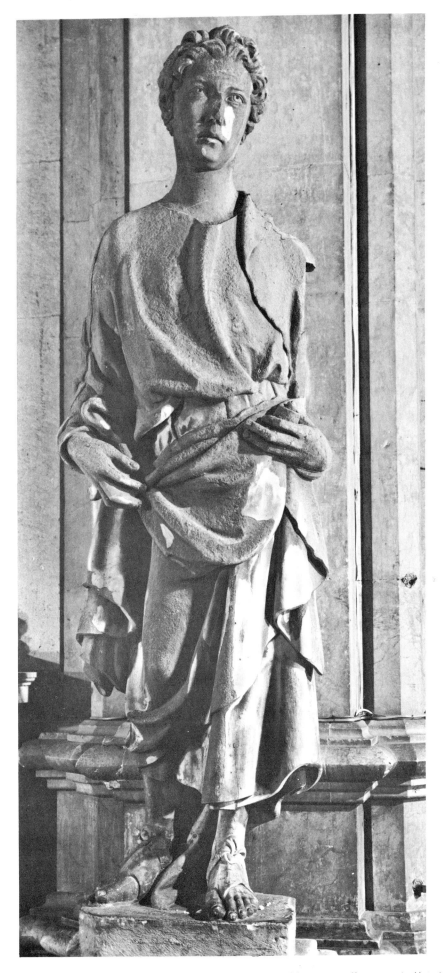

21. Apostle, formerly on exterior, San Martino, Lucca. Marble. H. overall 249 cm. (99¹/₂ in.)

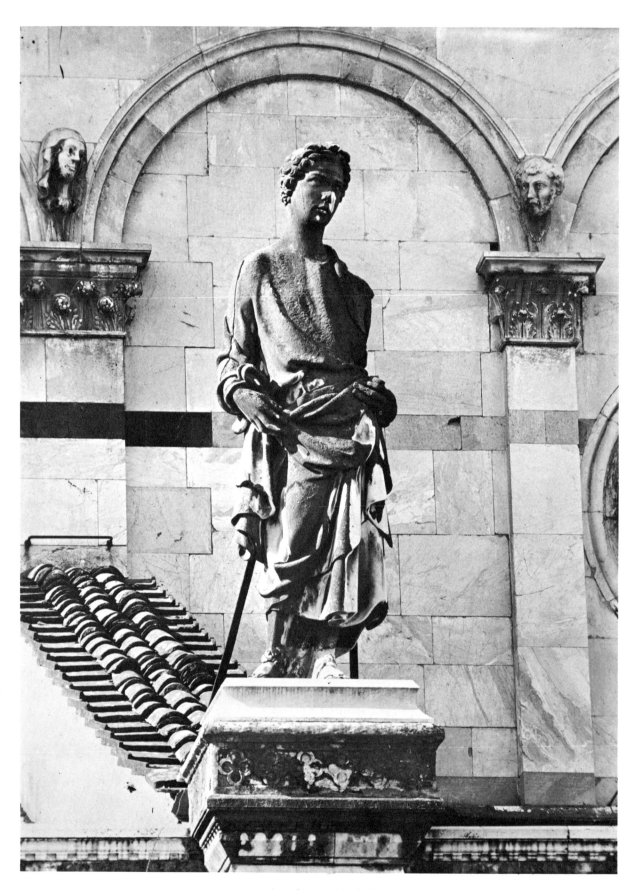

22. Apostle, in original place

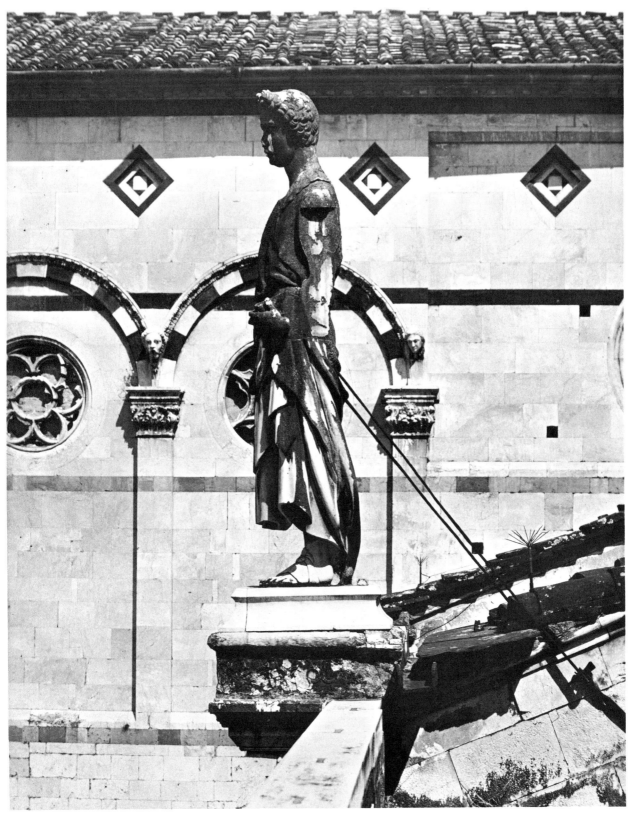

23. Apostle, left side

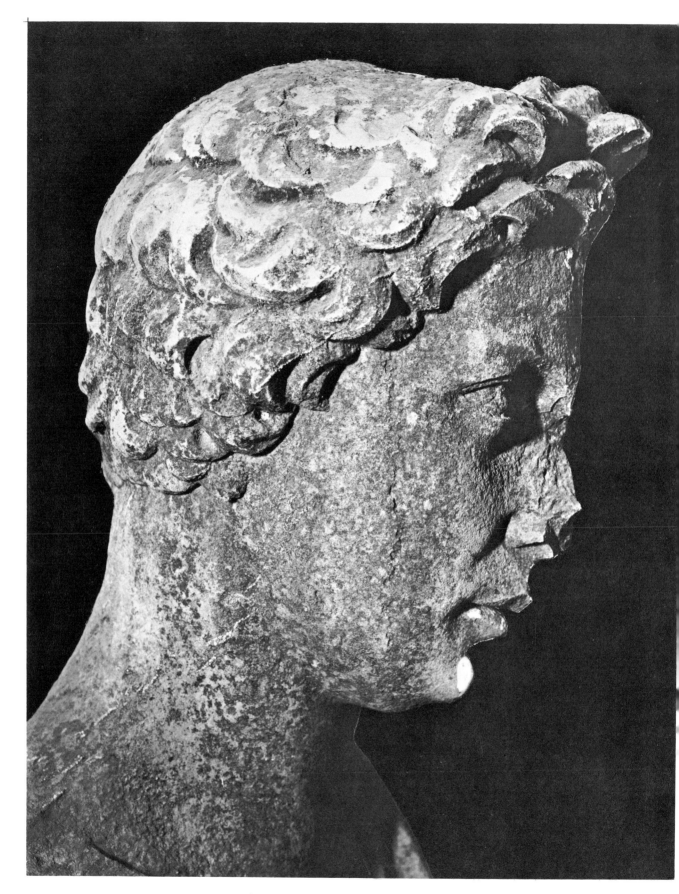

24. Apostle, head, right side

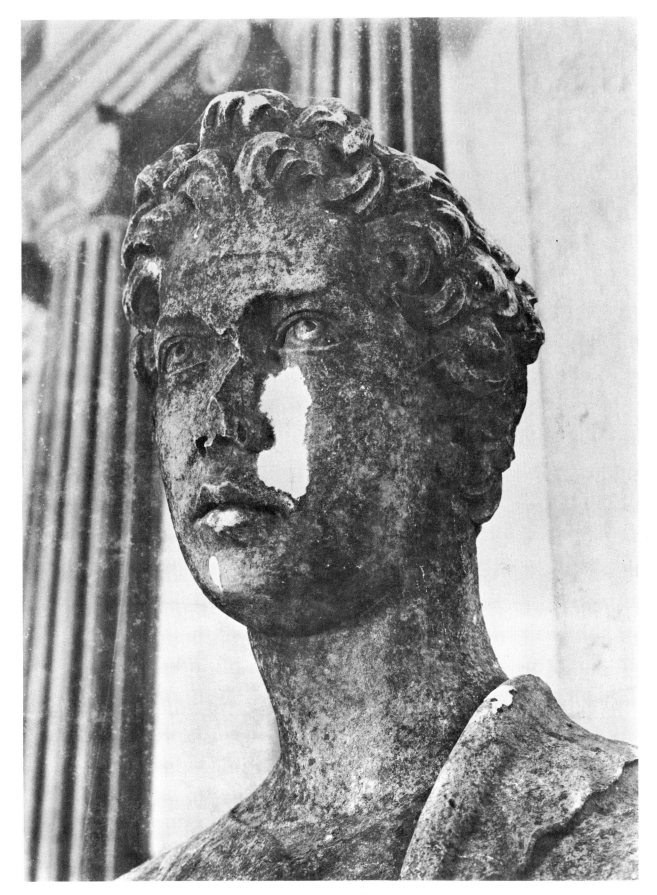

25. Apostle, head, oblique view

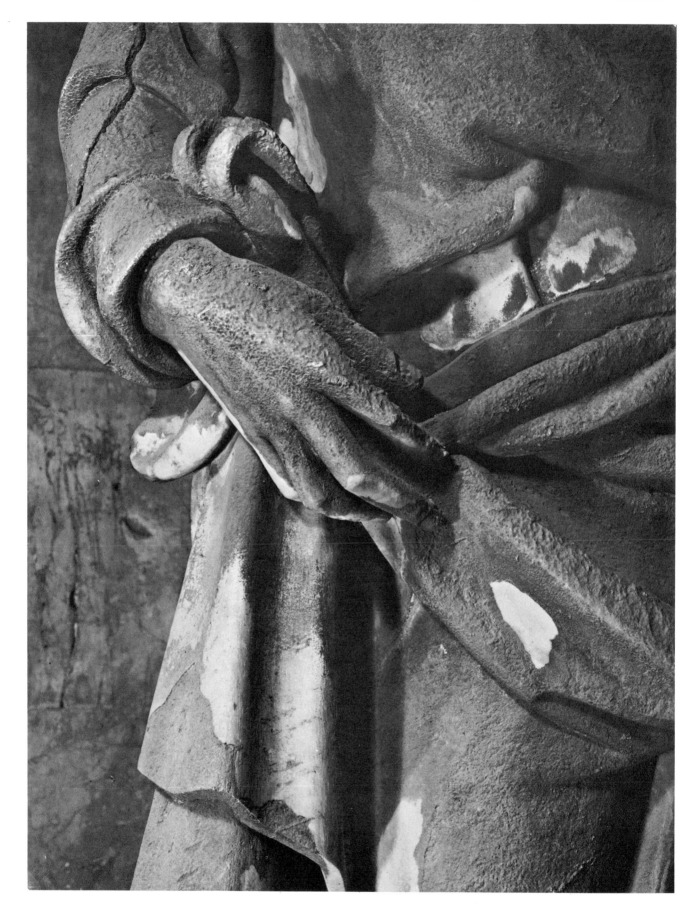

26. Apostle, right hand, with drapery

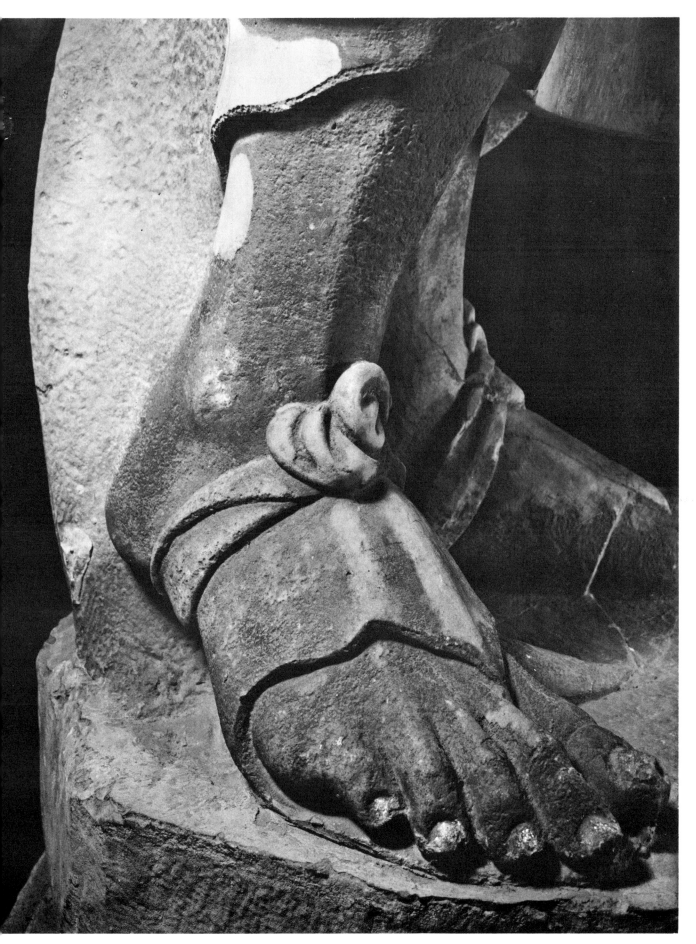

27. Apostle, feet

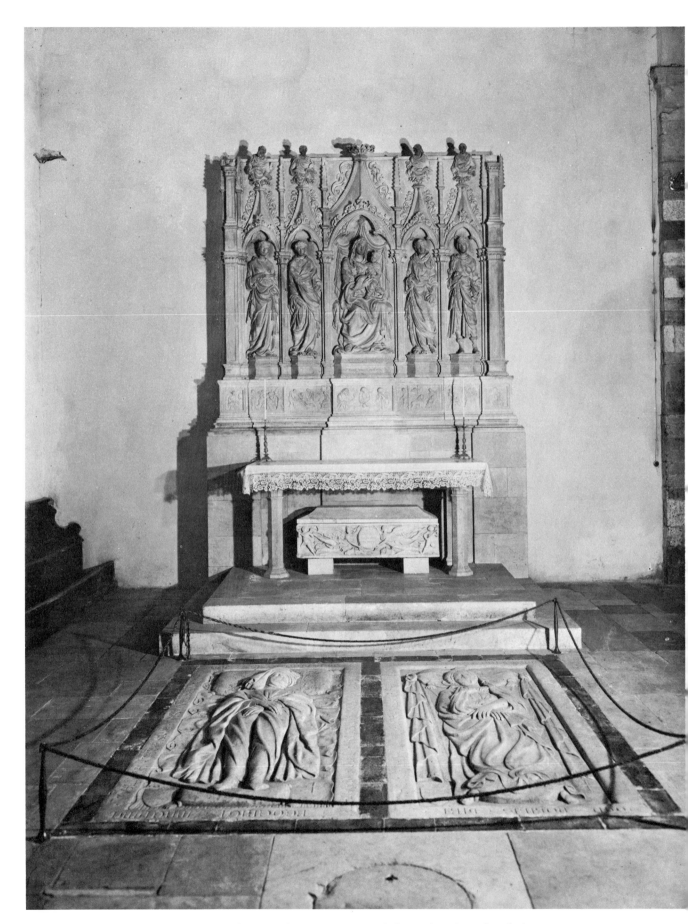

28. Trenta Chapel, San Frediano, Lucca. View of altar and tomb-markers before it

Tomb-marker of Lorenzo Trenta, finished ca. 1416. Marble. L. 2.47 cm. (96½ in.). Trenta Chapel, San Frediano, Lucca

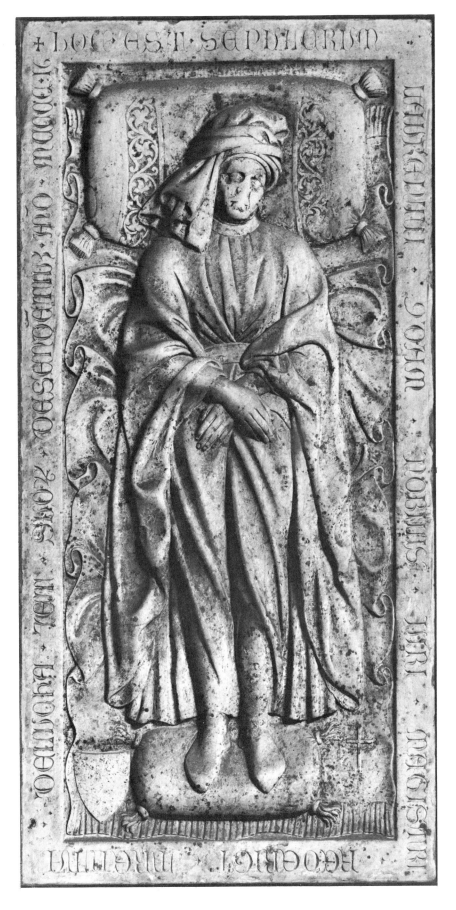

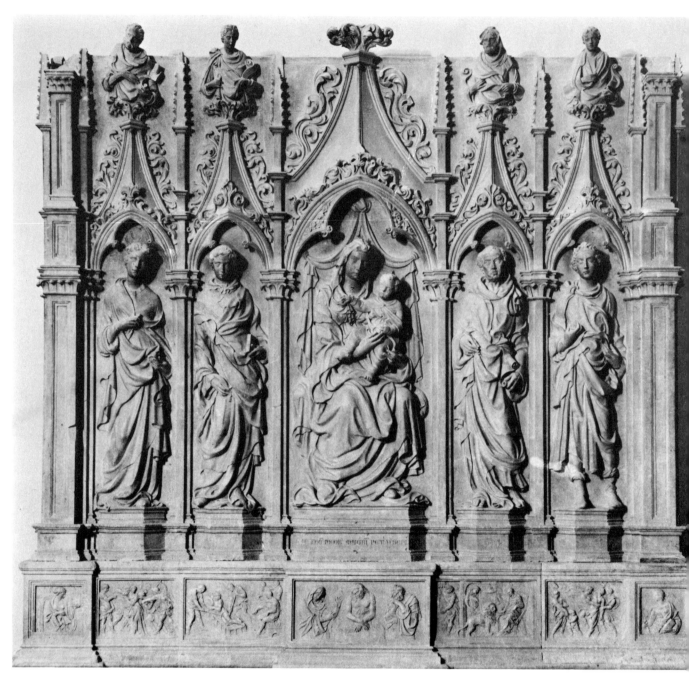

30. Trenta Chapel retable, ca. 1416 (with assistance from Giovanni da Imola and possibly others). Marble. H. 278 cm. (9 ft. 2 in.). San Frediano, Lucca

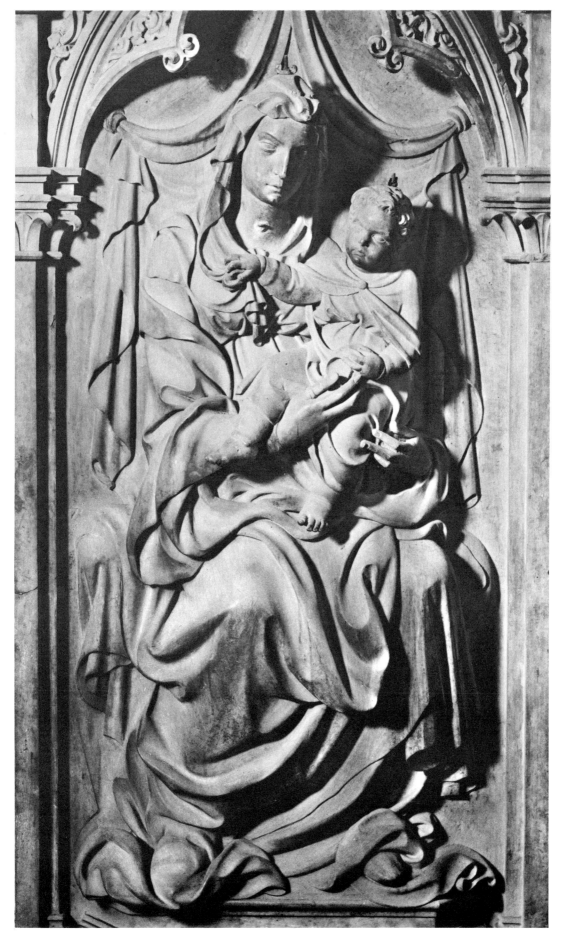

31. Trenta retable, Madonna and Child

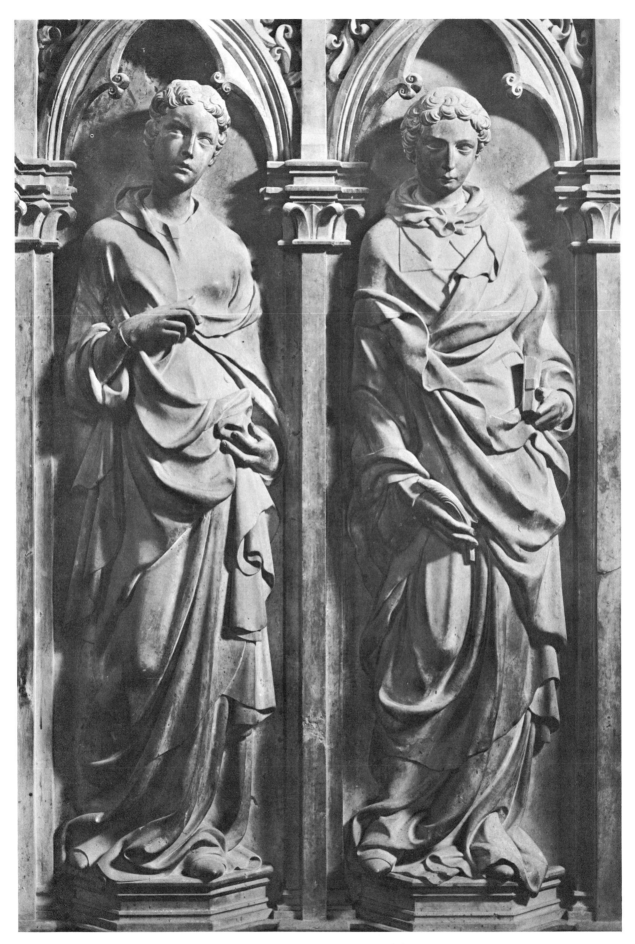

32. Trenta retable, two saints, to left

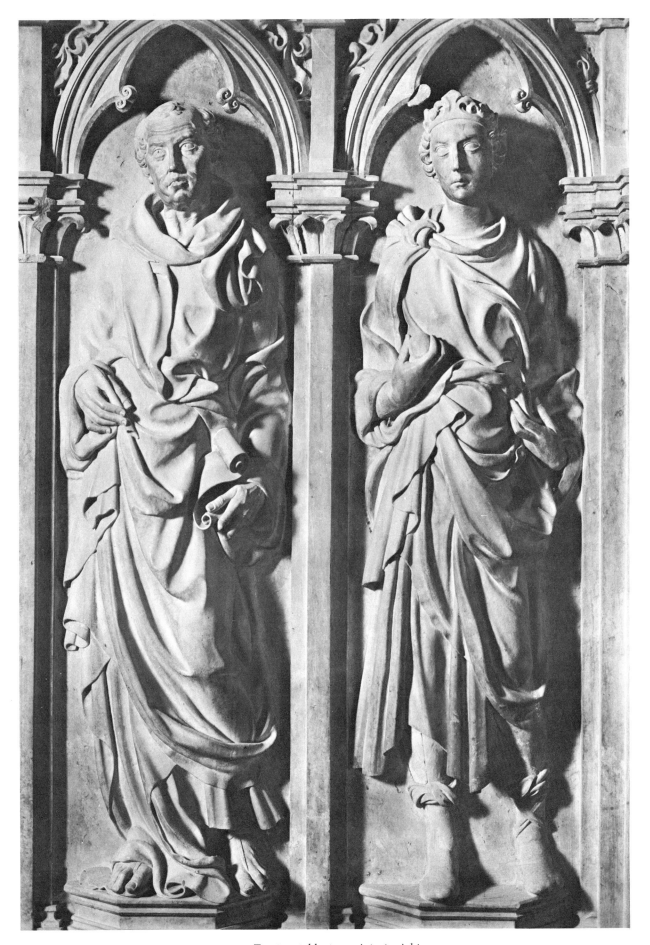

33. Trenta retable, two saints, to right

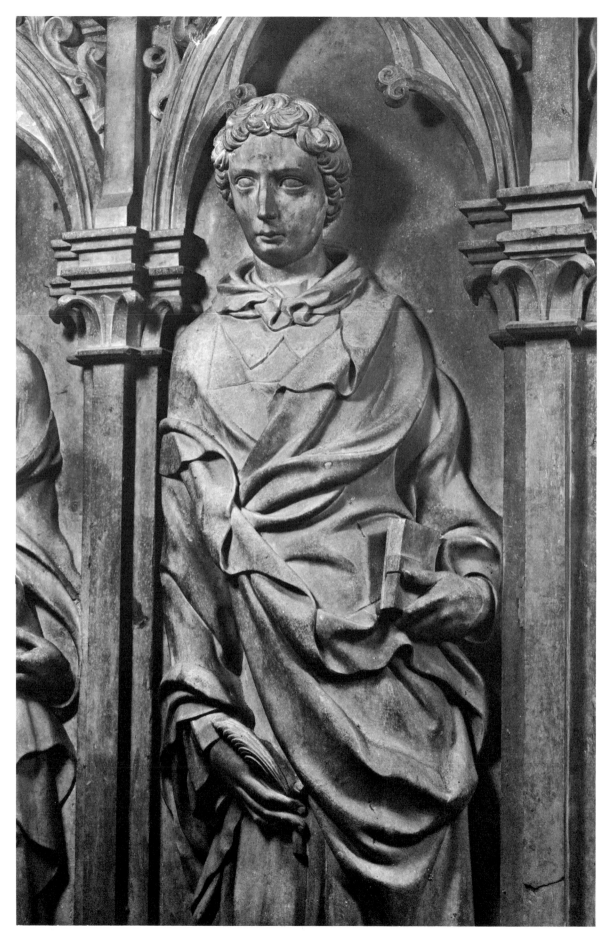

34. Trenta retable, St. Lawrence, detail

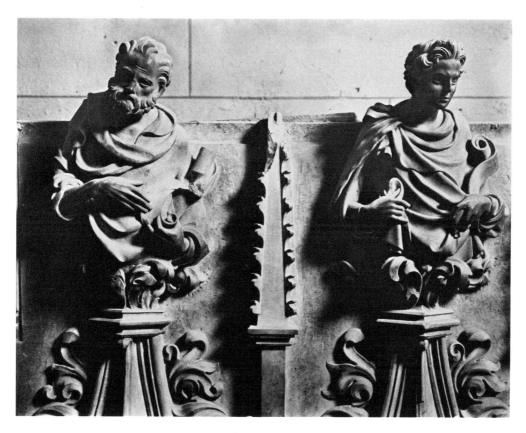

35a. Trenta retable, two prophet busts, to left

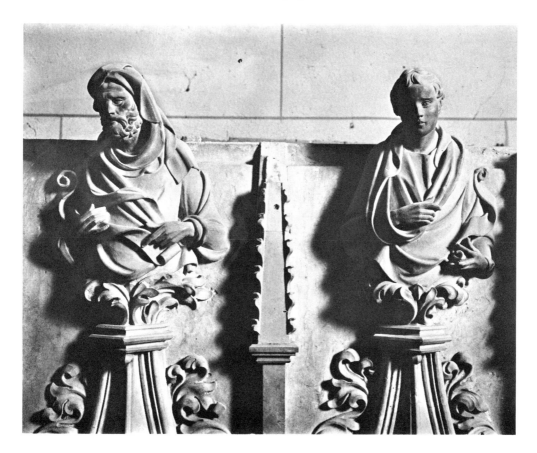

b. Trenta retable, two prophet busts, to right

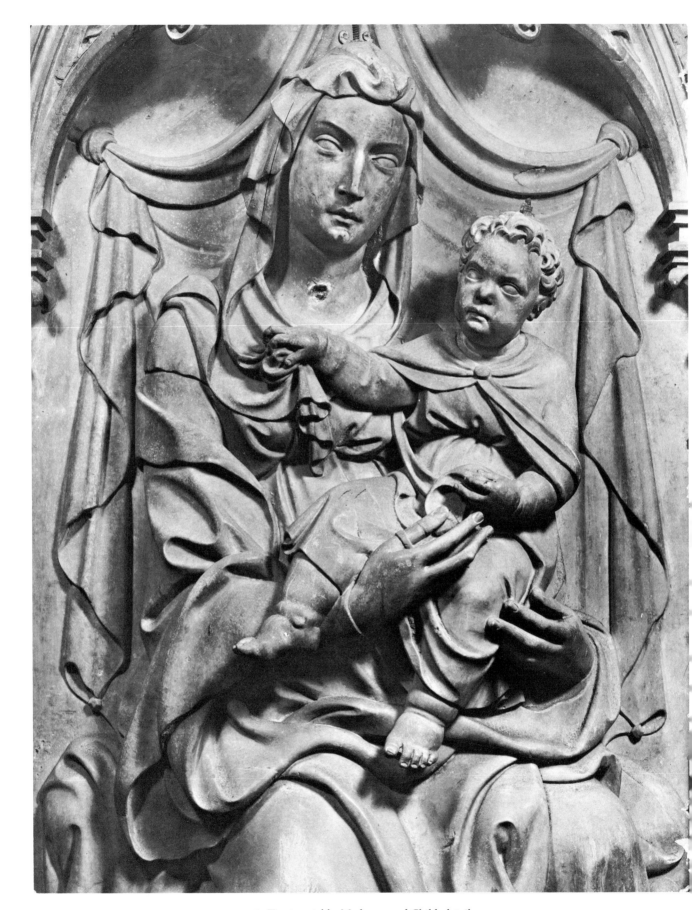

36. Trenta retable, Madonna and Child, detail

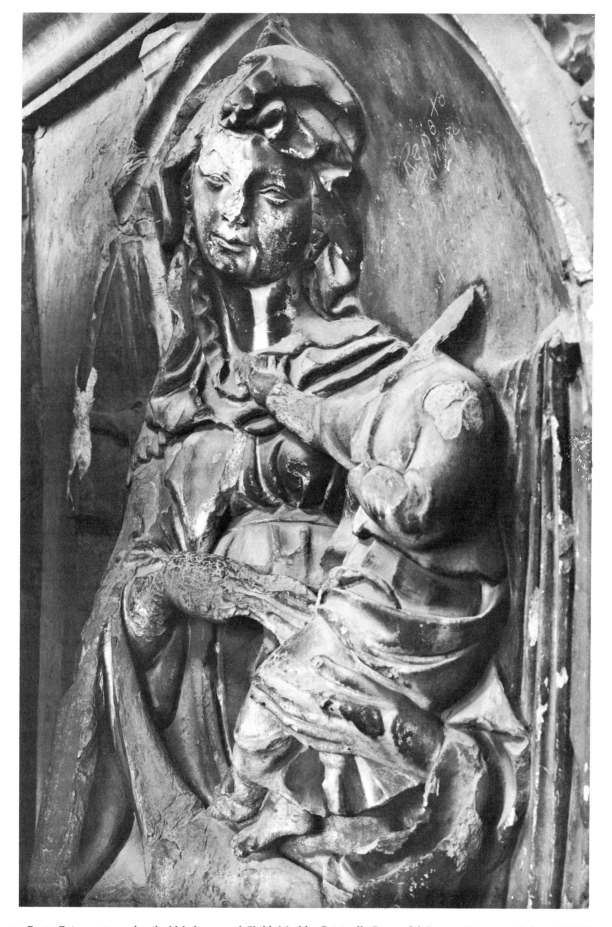

37. Fonte Gaia, 1408–19, detail of Madonna and Child. Marble. Originally Piazza del Campo, Siena, now Palazzo Pubblico

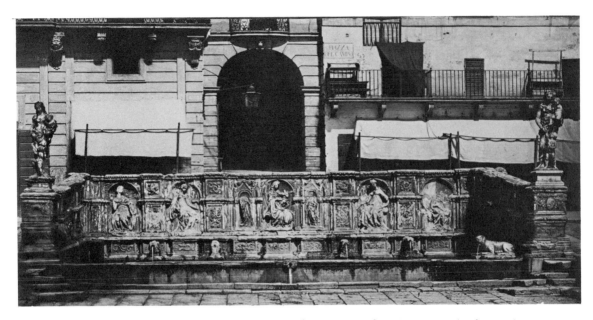

38a. Fonte Gaia, overall view before dismantling. L. (central part) 1,016 cm. (33 ft. 10 in.)

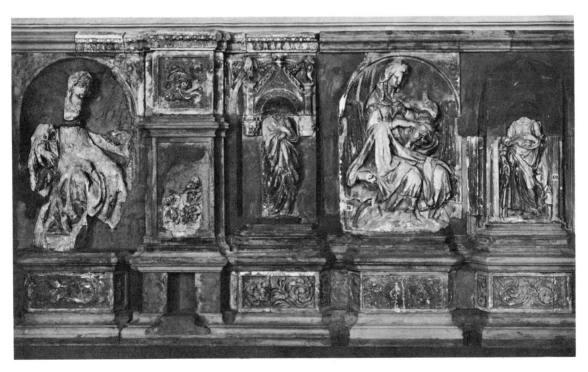

b. Fonte Gaia, back wall, center left portion

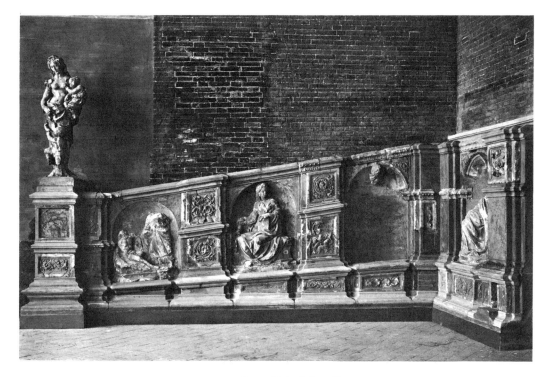

39a. Fonte Gaia, left wall

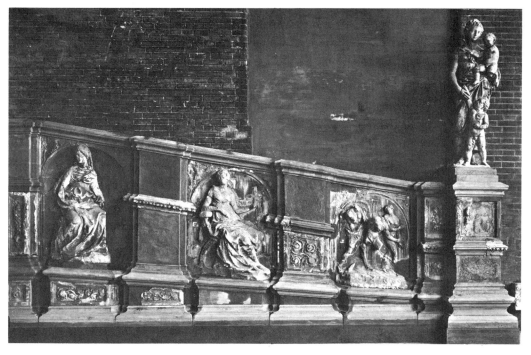

b. Fonte Gaia, right wall

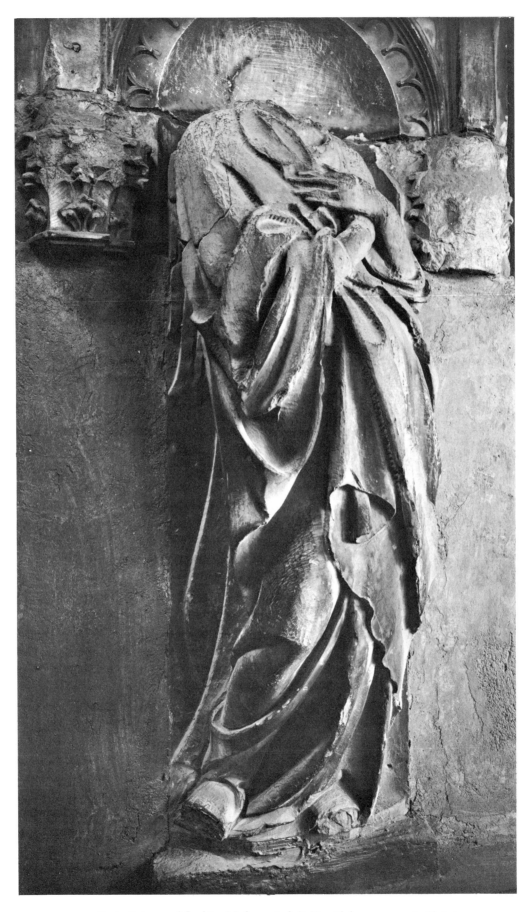

40. Fonte Gaia, angel flanking Madonna to left. H. with base, 73 cm. (29½ in.)

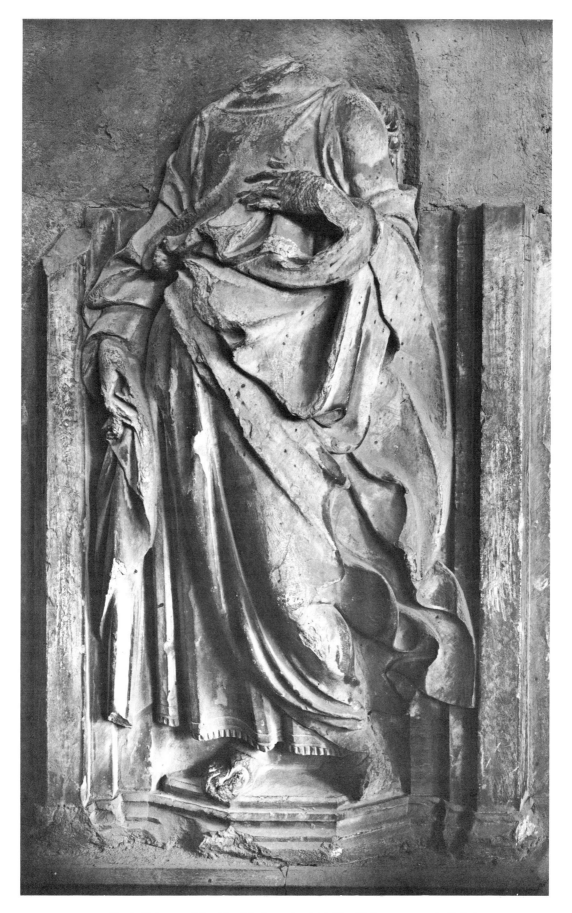

41. Fonte Gaia, angel flanking Madonna to right. H. with base, 74 cm. (29³/₄ in.)

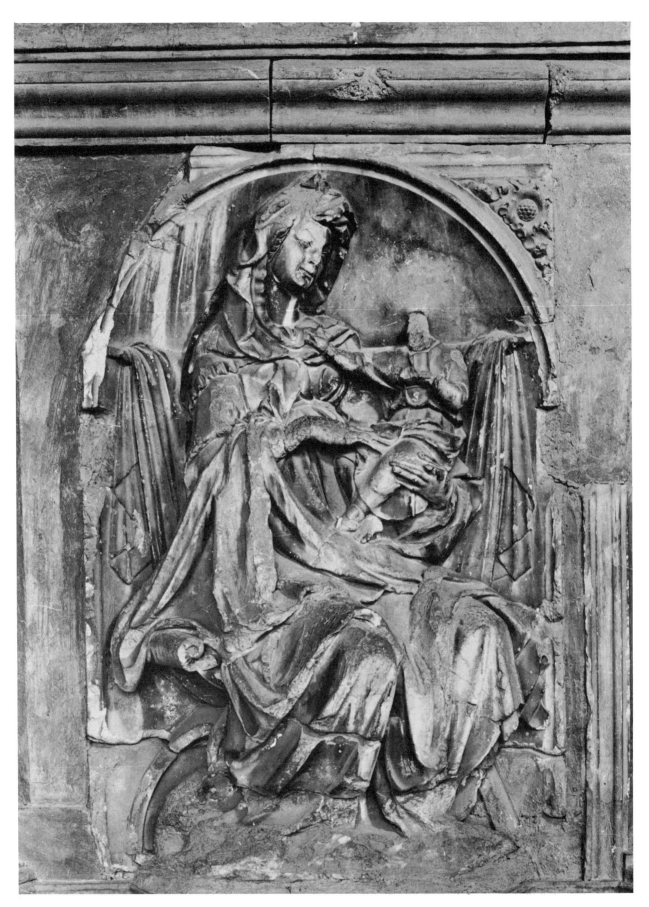

42. Fonte Gaia, Madonna and Child. H. 125 cm. (50 in.)

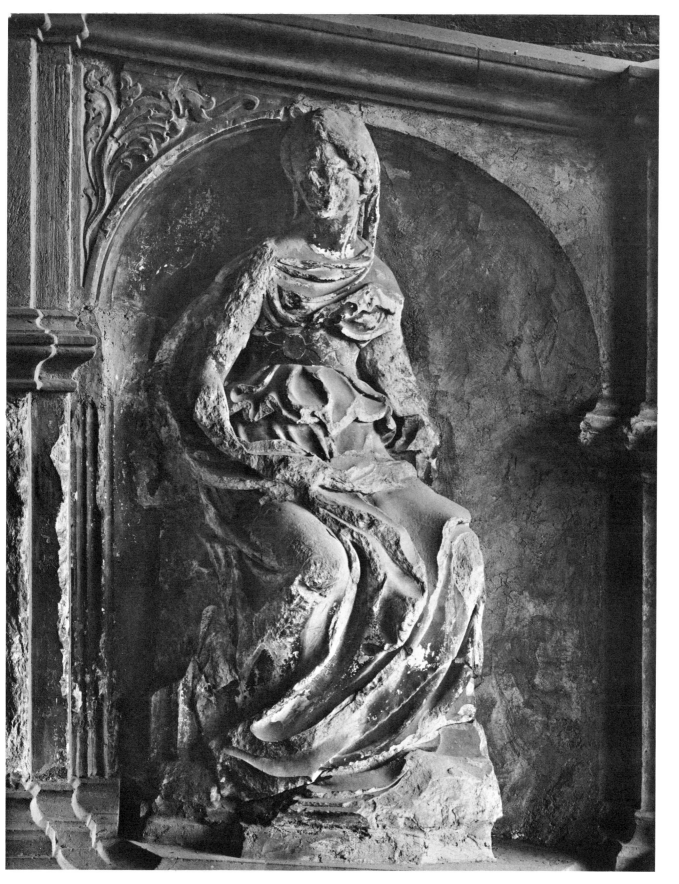

43. Fonte Gaia, Temperance. H. 132 cm. (52⁷/₈ in.)

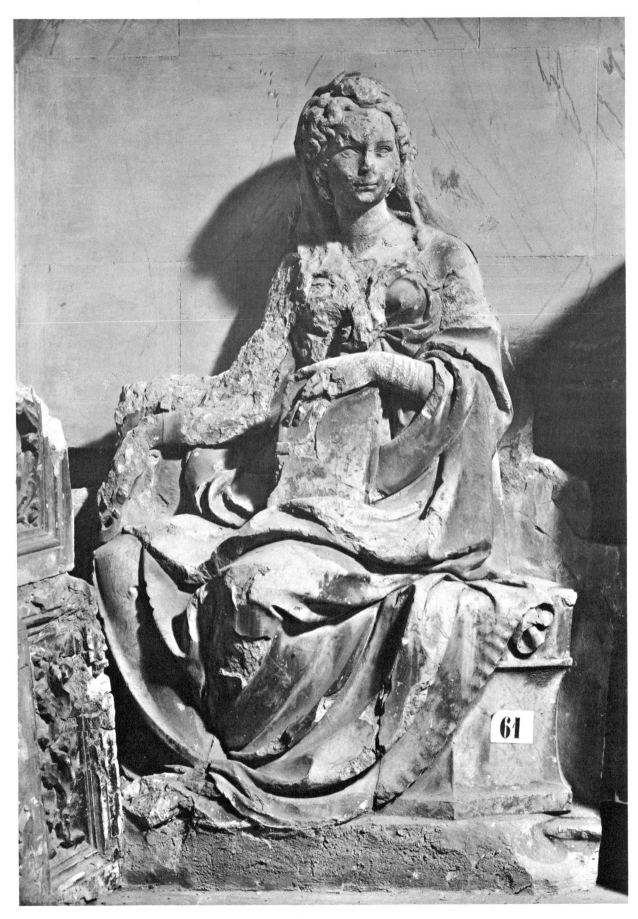

44. Fonte Gaia, Wisdom. H. 108 cm. (43 in.)

45. Fonte Gaia, Wisdom, detail of lamp

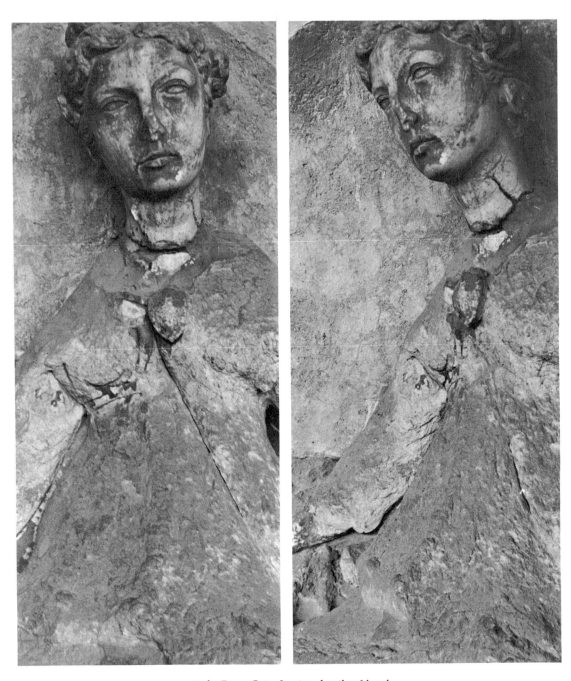

46a-b. Fonte Gaia, Justice, details of head

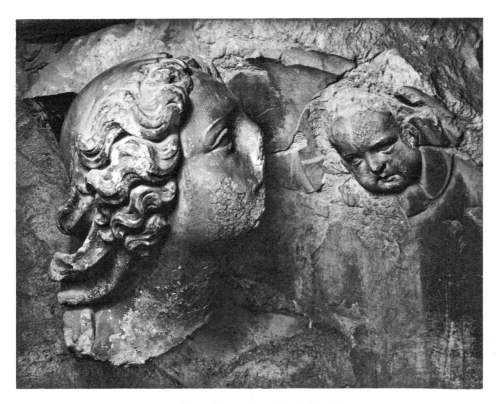

47a. Fonte Gaia, Hope, detail of heads

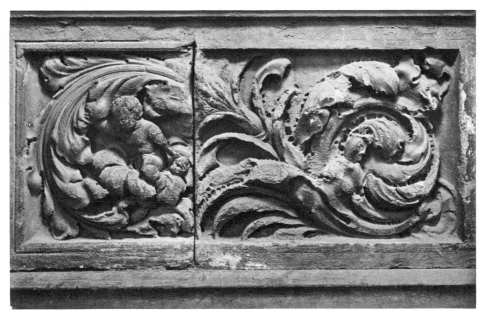

b. Fonte Gaia, detail of ornament

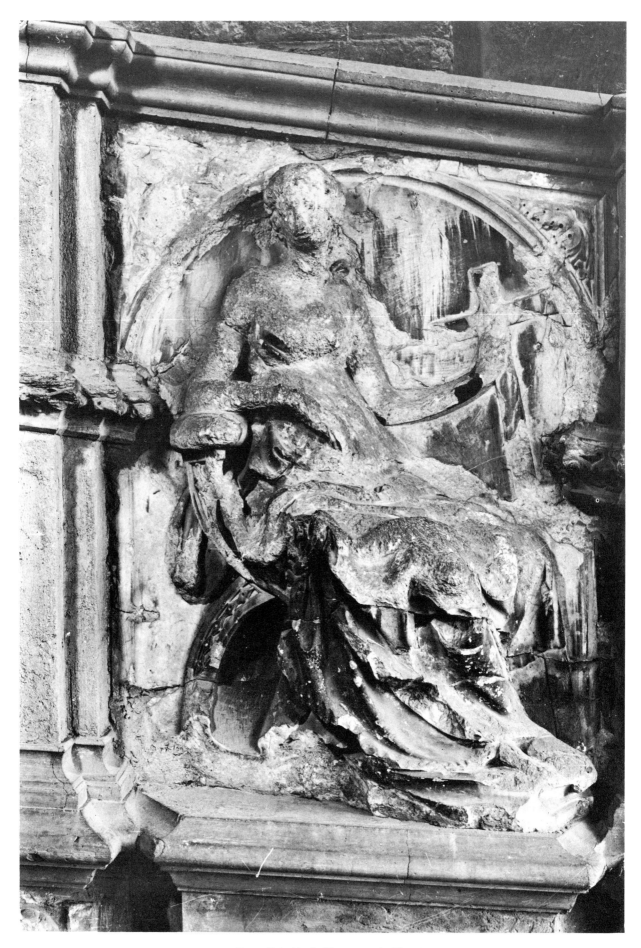

48. Fonte Gaia, Faith. H. 116 cm. (46¹/₈ in.)

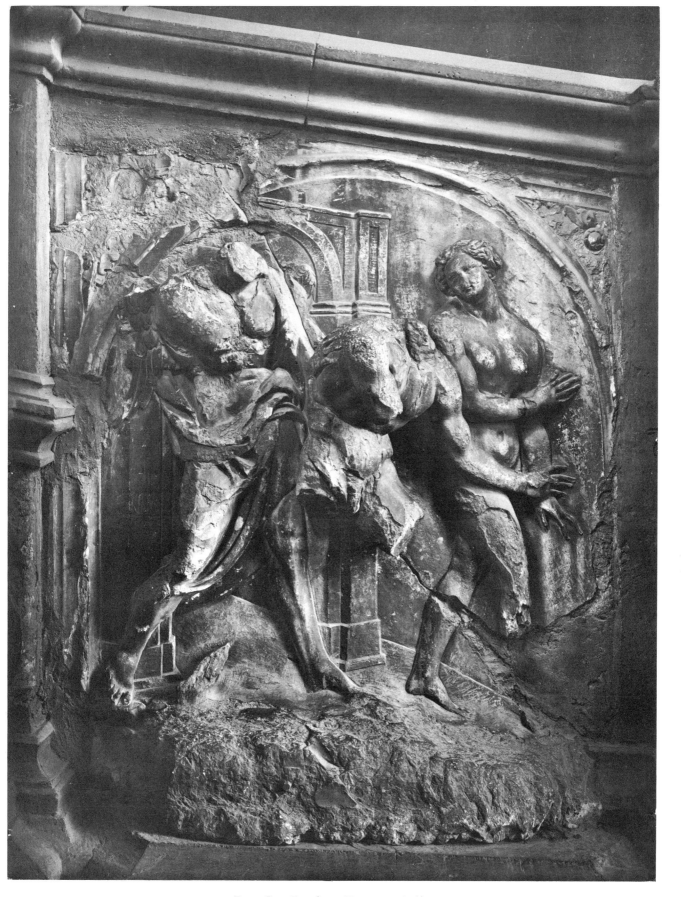

49. Fonte Gaia, Expulsion. H. 104 cm. (41$^{1}/_{8}$ in.)

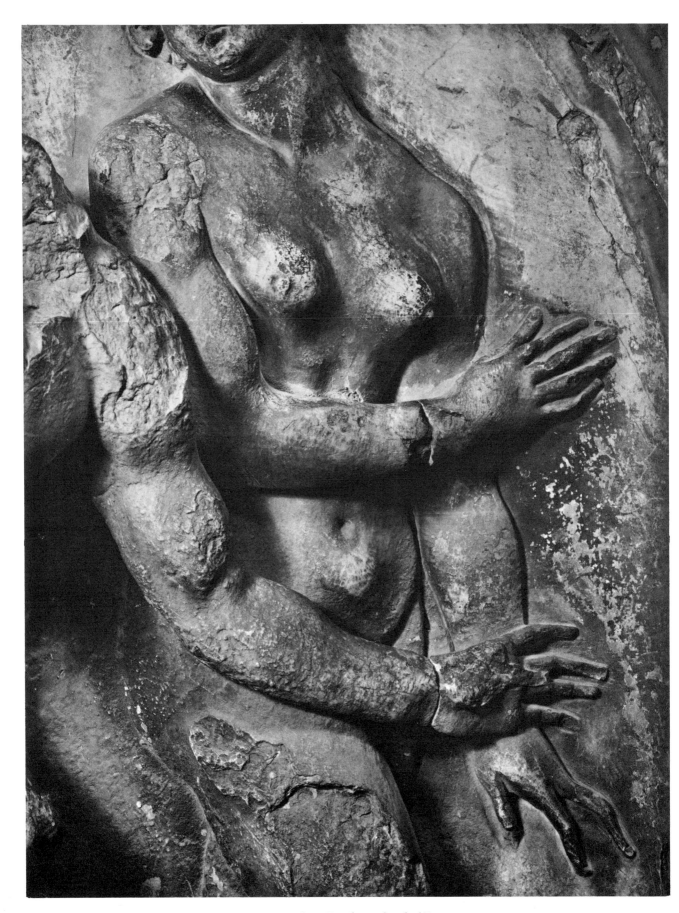

50. Fonte Gaia, Expulsion, detail of Eve

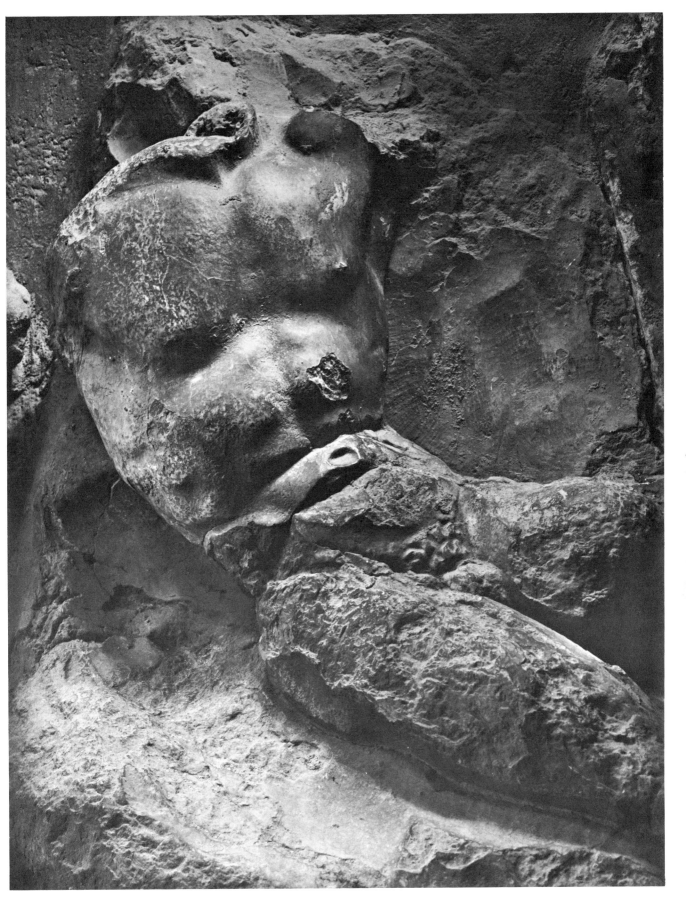

51. Fonte Gaia, Creation of Adam, detail of Adam

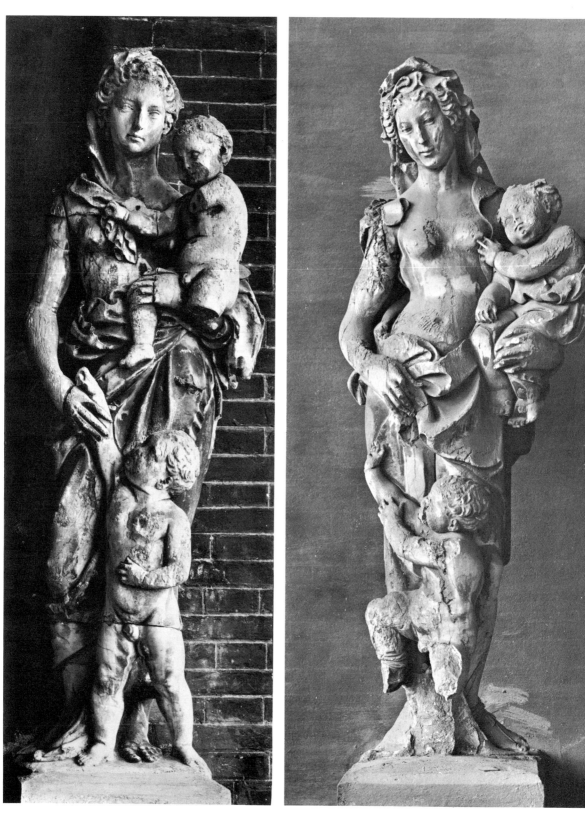

52a. Fonte Gaia, Rhea Silvia (with assistance). H. 160 cm. (64 in.)

b. Fonte Gaia, Acca Larentia. H. 162 cm. (64³/4 in.)

53. Fonte Gaia, Acca Larentia, detail from right, profile view of drapery

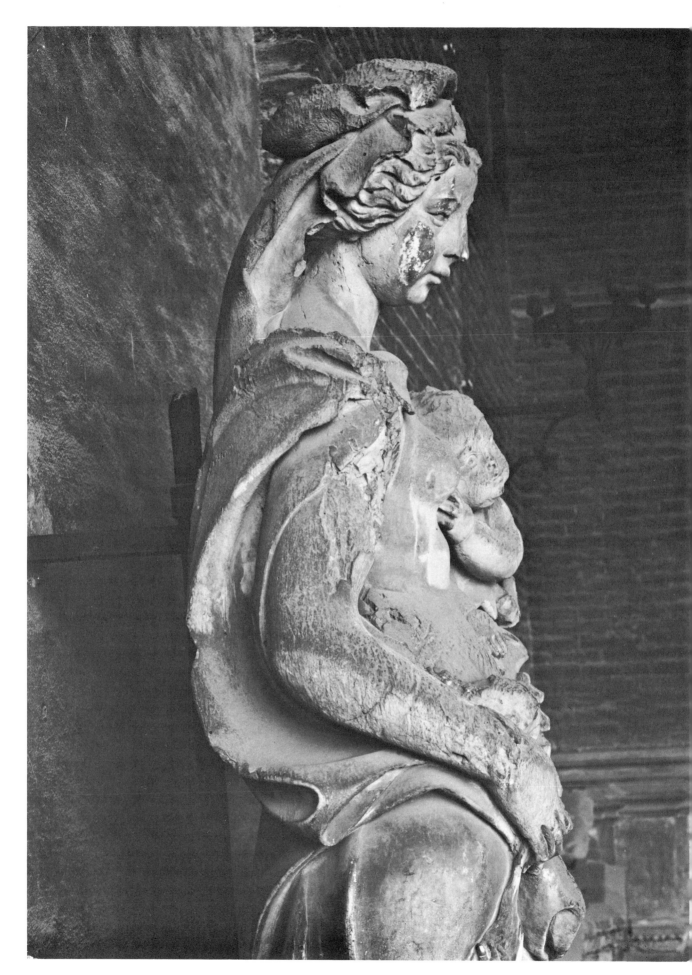

54. Fonte Gaia, Acca Larentia, detail from left

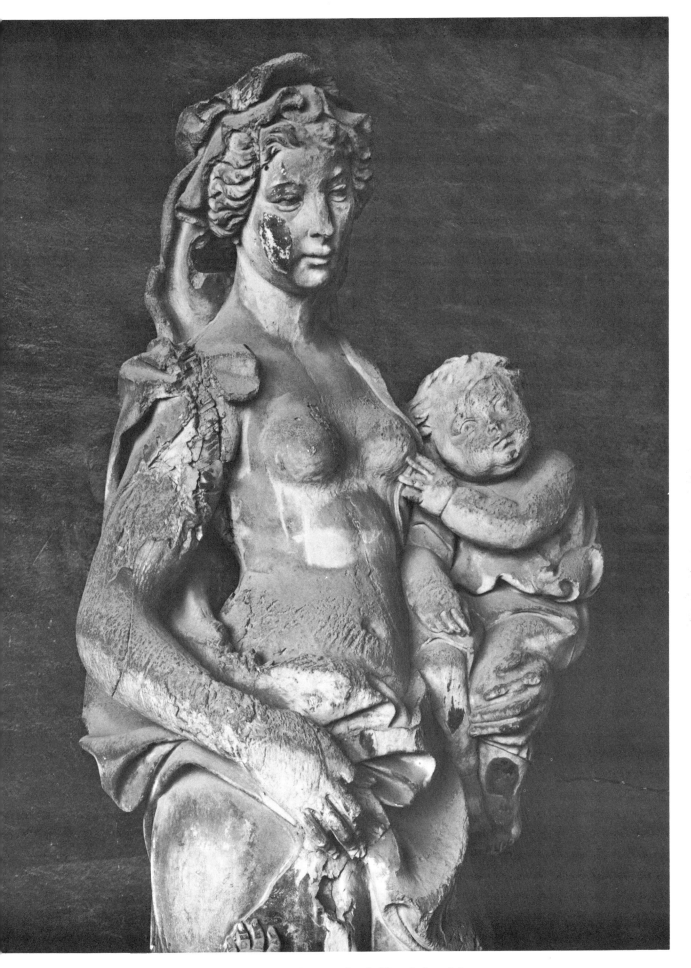

55. Fonte Gaia, Acca Larentia, detail obliquely from left

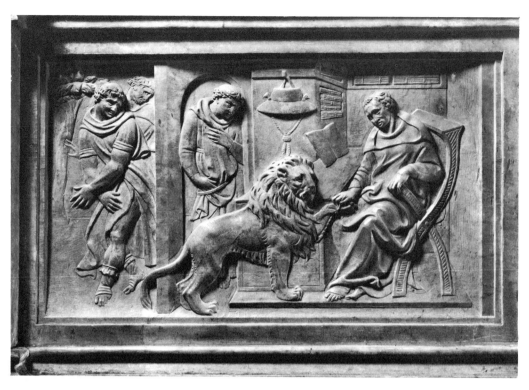

56a. Trenta Chapel, San Frediano, Lucca, retable, predella scenes finished 1422. Story of St. Jerome. Marble. H. 29 cm. (11½ in.)

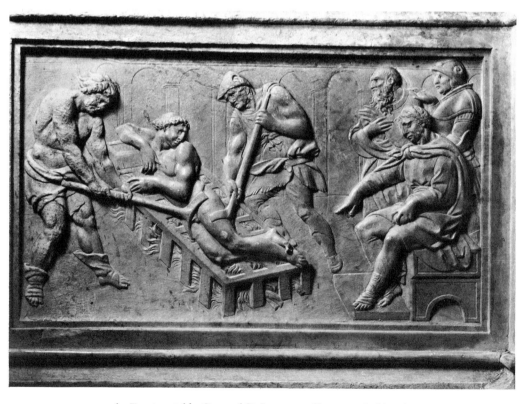

b. Trenta retable, Story of St. Lawrence. H. 29 cm. (11½ in.)

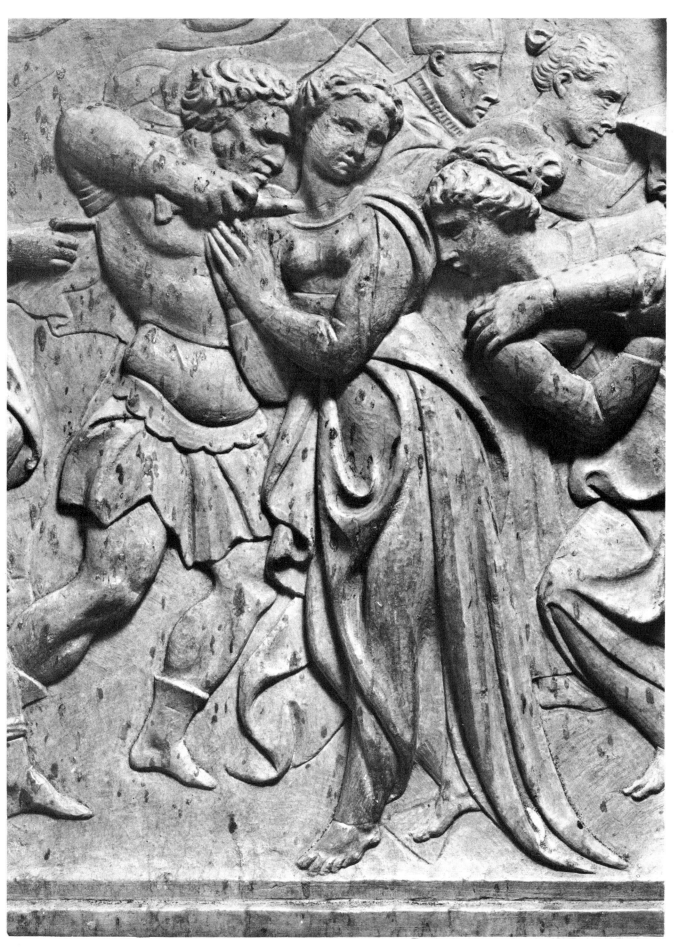

57. Trenta retable, Story of St. Ursula, detail. H. 29 cm. (11½ in.)

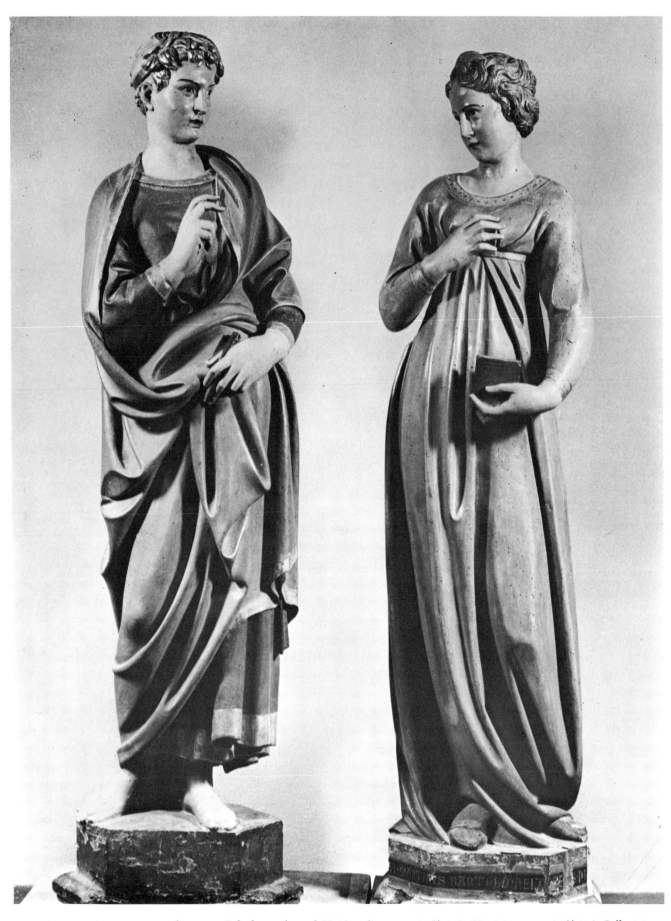

58. Annunciation group, carved 1421–25. Polychromed wood. H. (Angel) 166 cm. (66¹/₄ in.), (Virgin) 164 cm. (65¹/₂ in.). Collegiata, San Gimignano

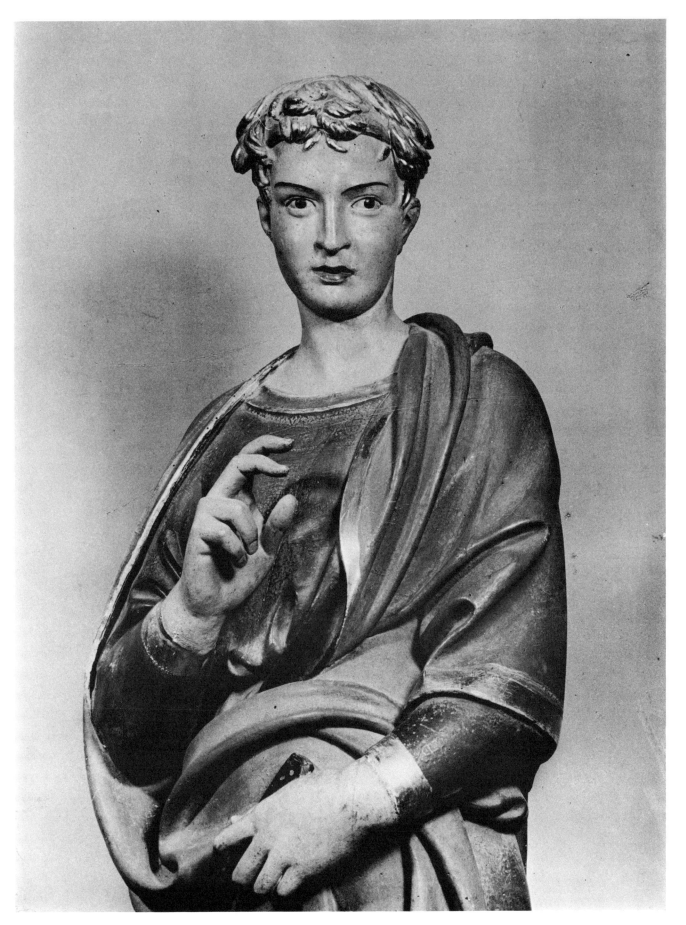

59. San Gimignano Annunciation, angel, detail

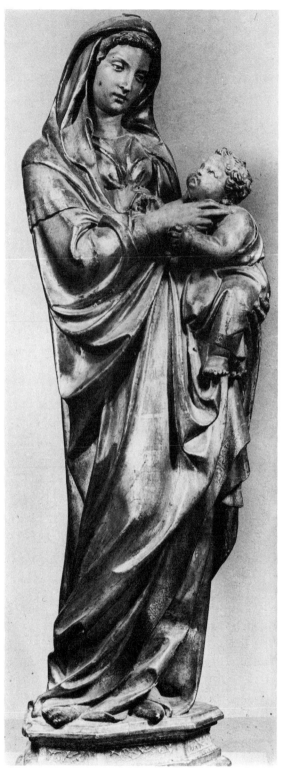 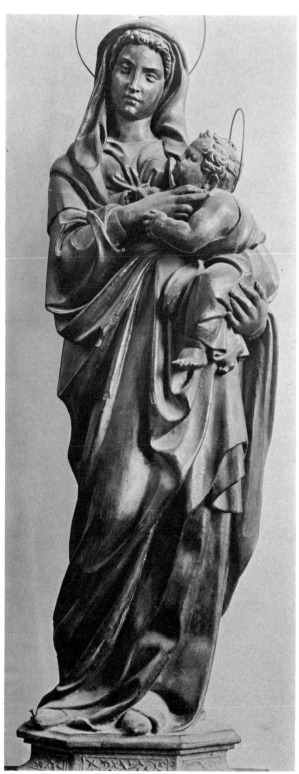

60a. Madonna and Saints, Madonna, ca. 1423 (?), oblique
view. Wood. H. 140 cm. (56 in.). San Martino, Siena

b. San Martino Madonna, front view

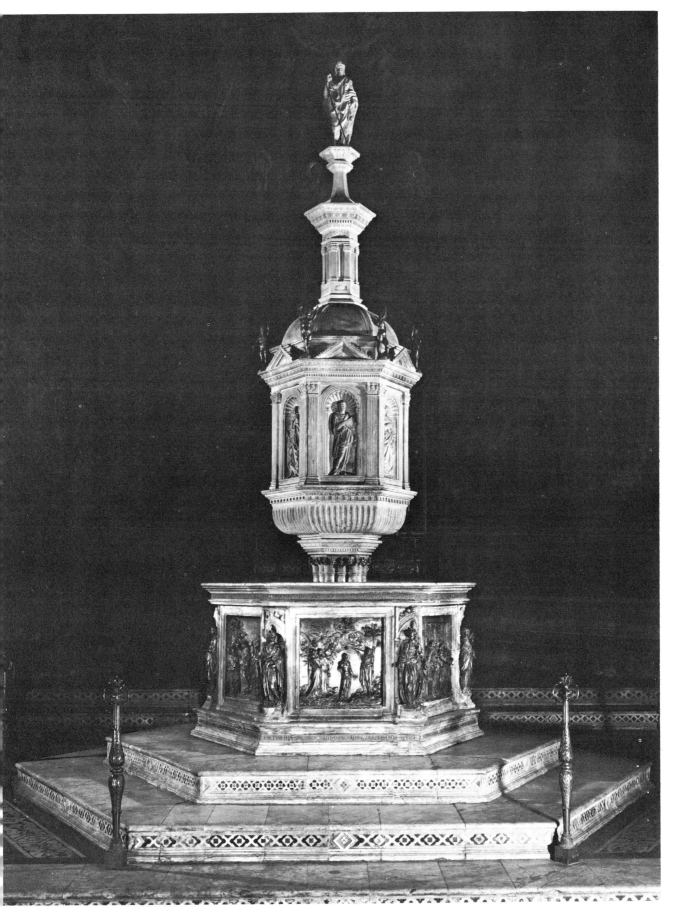

61. Baptismal Font, San Giovanni, Siena, 1417–31. Marble, enamels, and bronze. H. 402 cm. (13 ft. 5 in.)

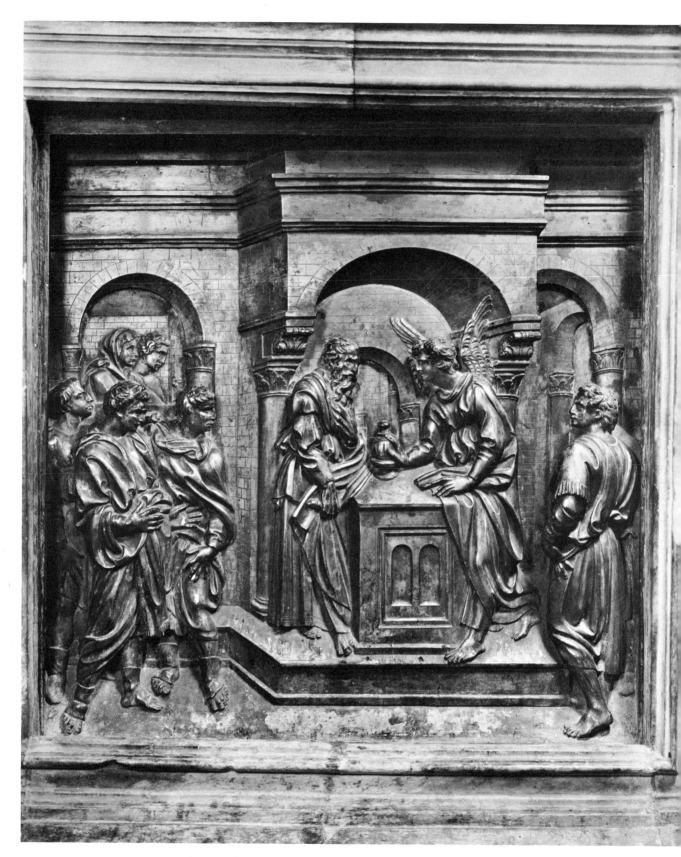

62. Baptismal Font, Annunciation to Zacharias, bronze. H. 60 cm. (24 in.)

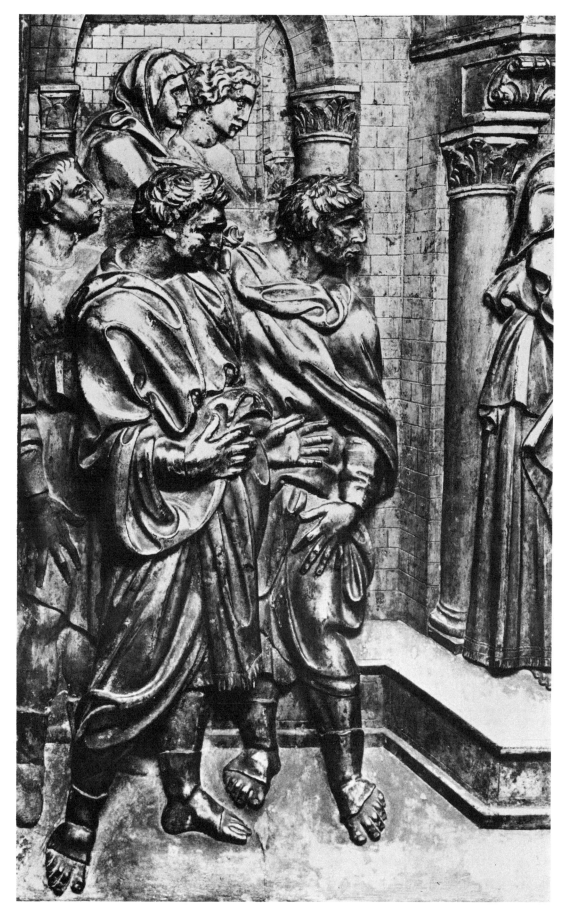

63. Baptismal Font, Annunciation to Zacharias, detail

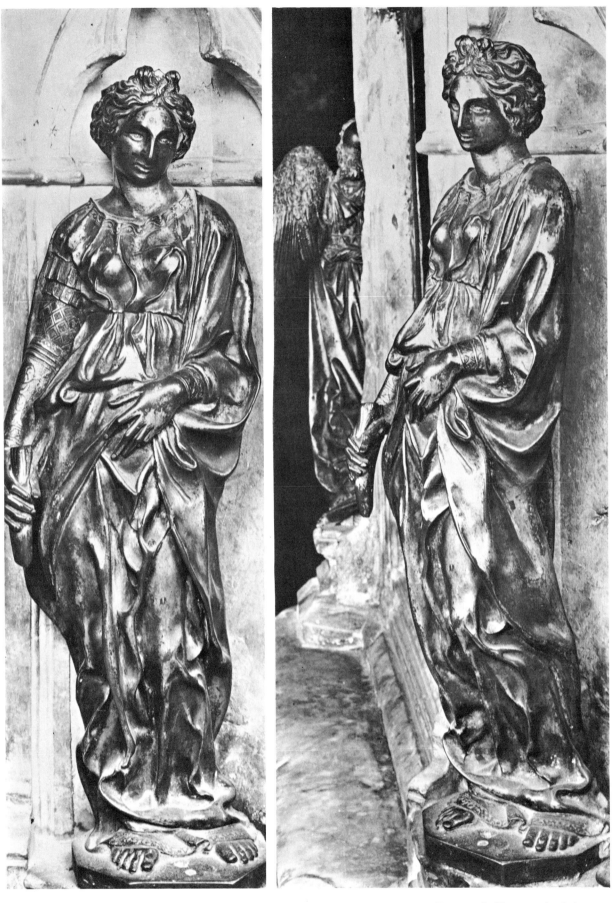

64a-b. Baptismal Font, Fortitude (design only attributable to Quercia), two views. Bronze gilt. H. 52 cm. (21 in.)

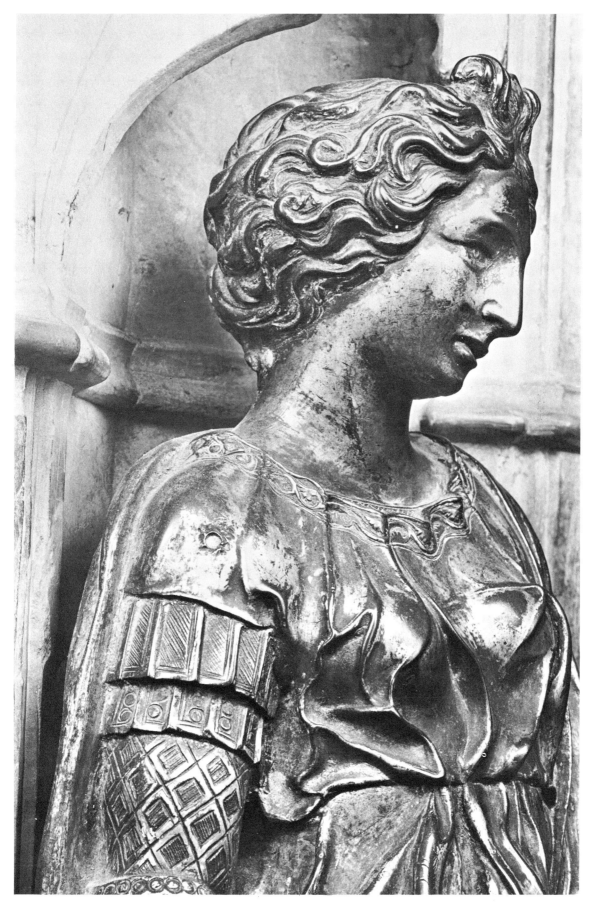

65. Baptismal Font, Fortitude, detail from left

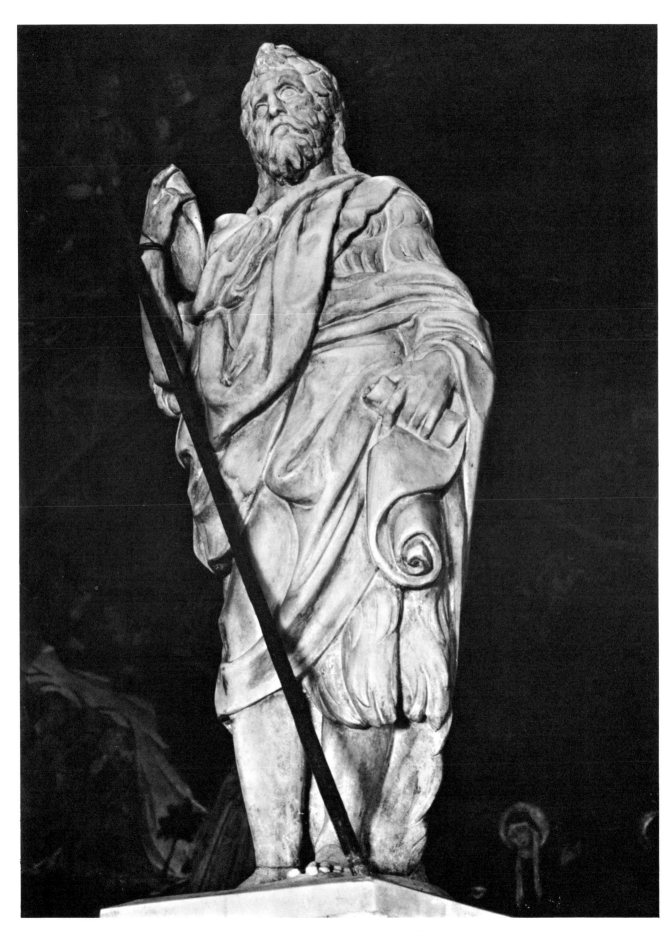

66. Baptismal Font, St. John the Baptist. Marble. H. 80 cm. (32 in.)

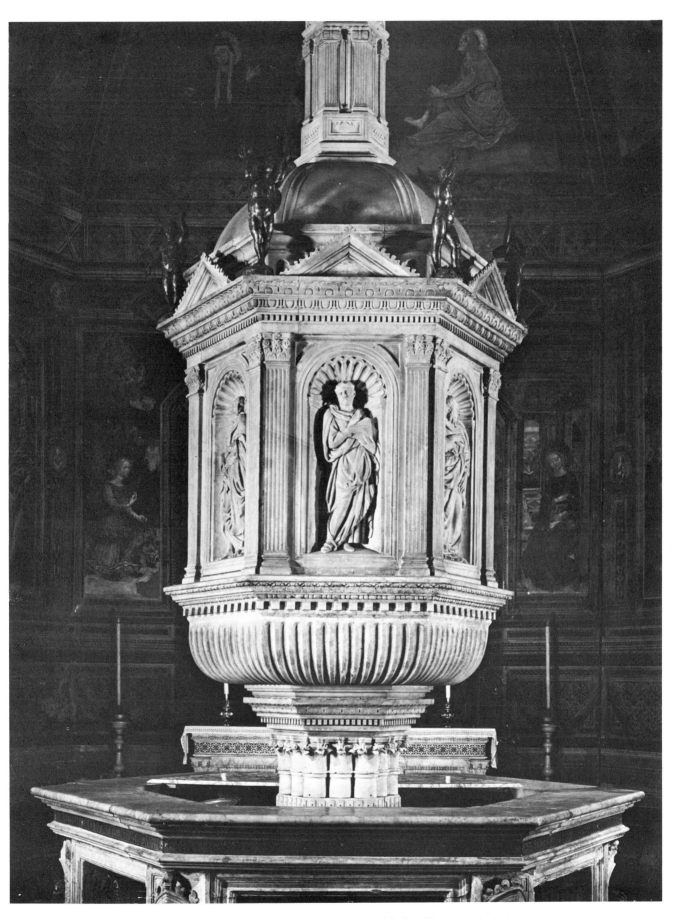

67. Baptismal Font, ciborium, with prophets. Marble. H. 202 cm. (81 in.)

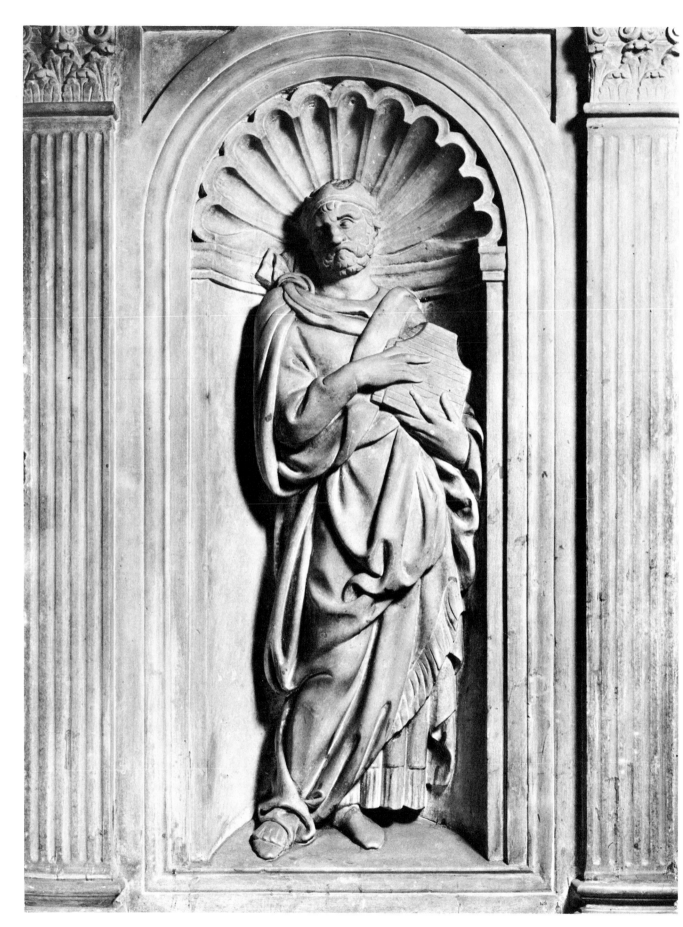

68. Baptismal Font, first prophet, David. H. (panel) 65 cm. (26 in.)

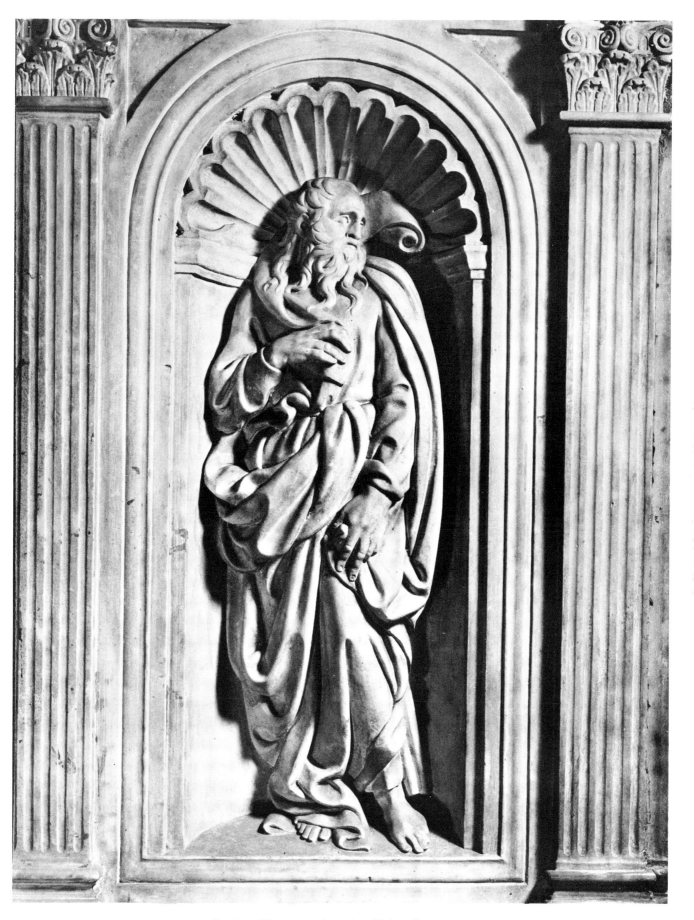

69. Baptismal Font, second prophet. H. (panel) 65 cm. (26 in.)

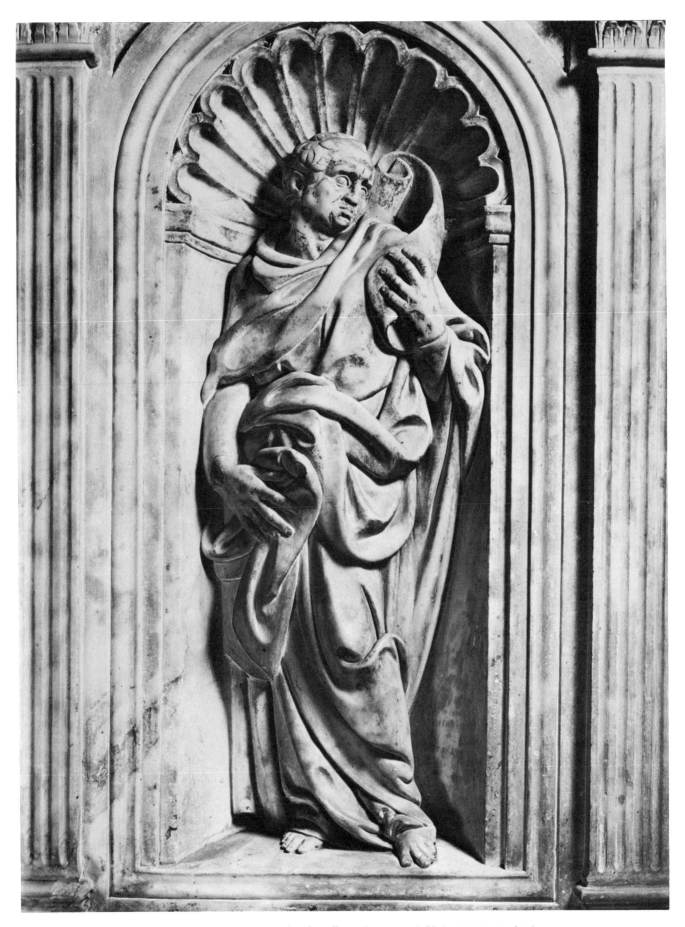

70. Baptismal Font, third prophet, beardless (Cicero-type). H. (panel) 65 cm. (26 in.)

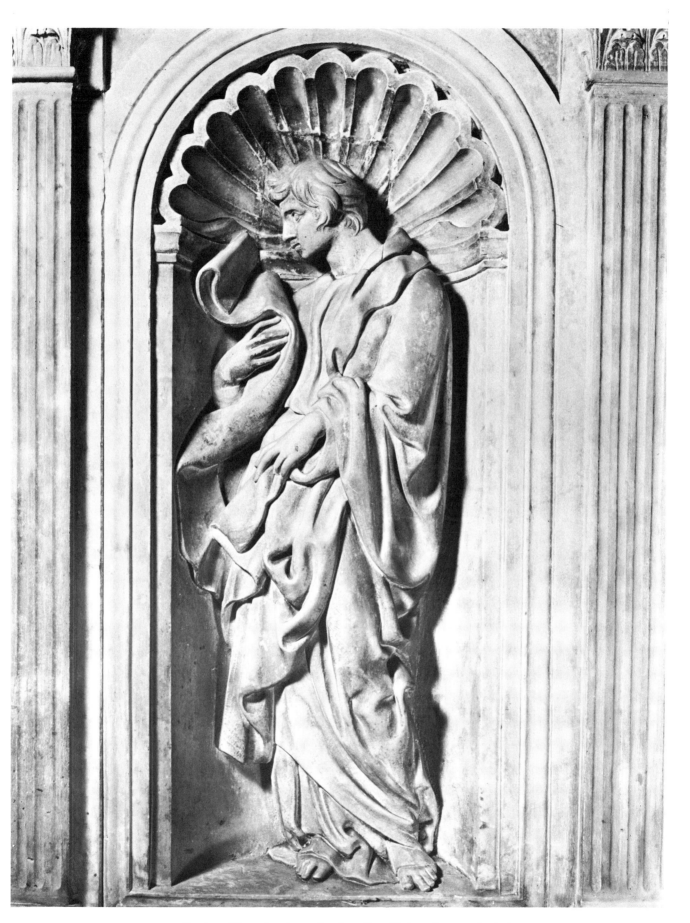

71. Baptismal Font, fourth prophet, beardless. H. (panel) 65 cm. (26 in.)

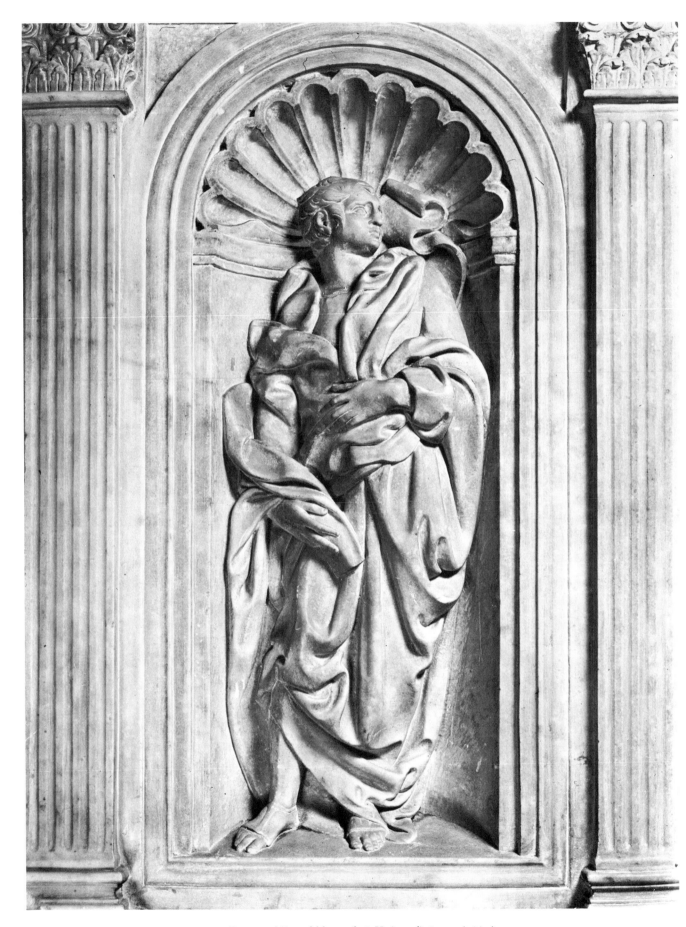

72. Baptismal Font, fifth prophet. H. (panel) 65 cm. (26 in.)

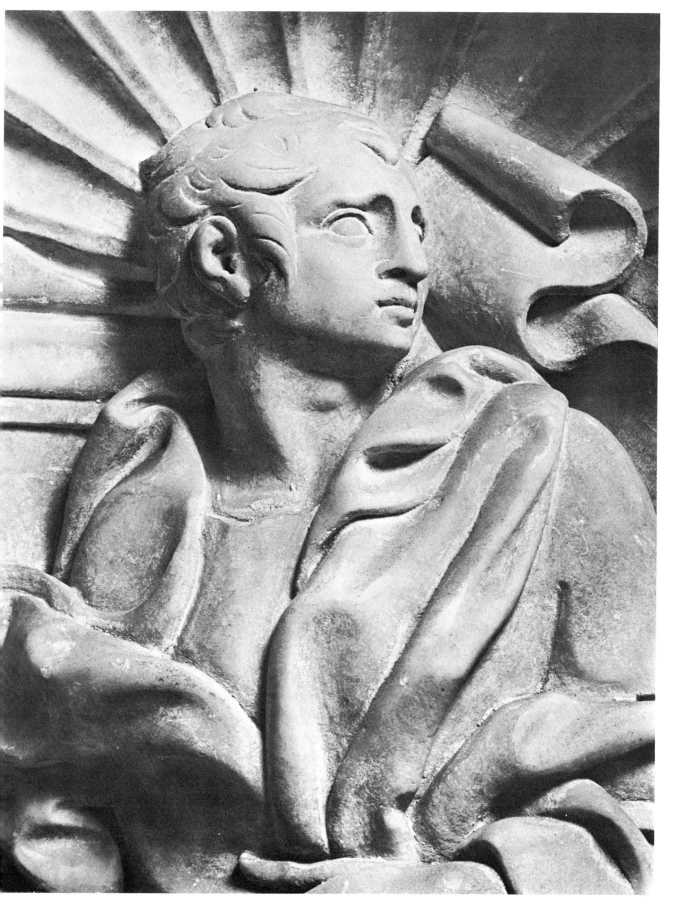

73. Baptismal Font, fifth prophet, head

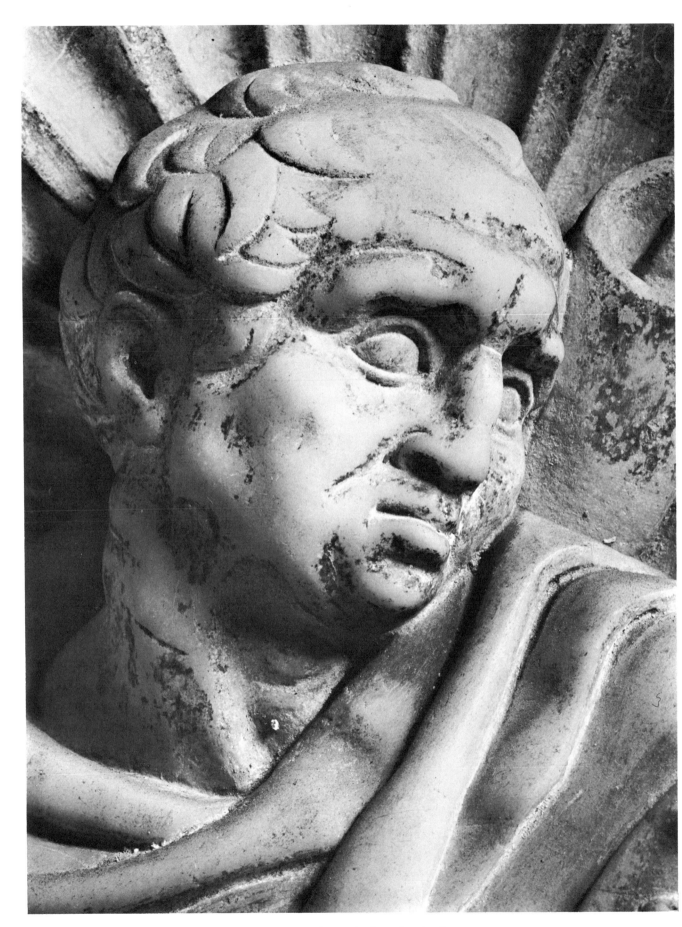

74. Baptismal Font, third prophet, head

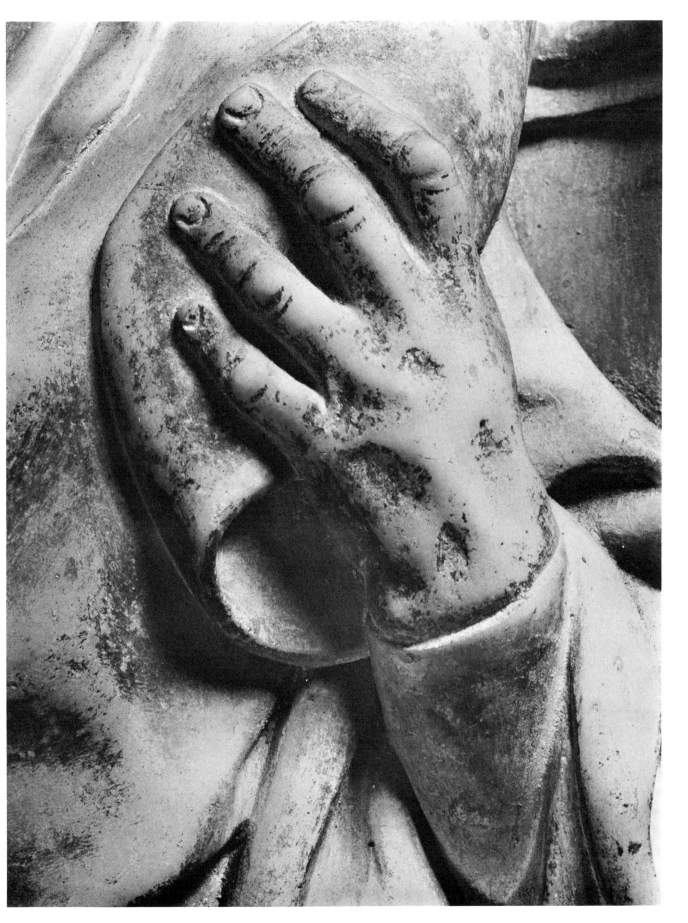

75. Baptismal Font, third prophet, hand

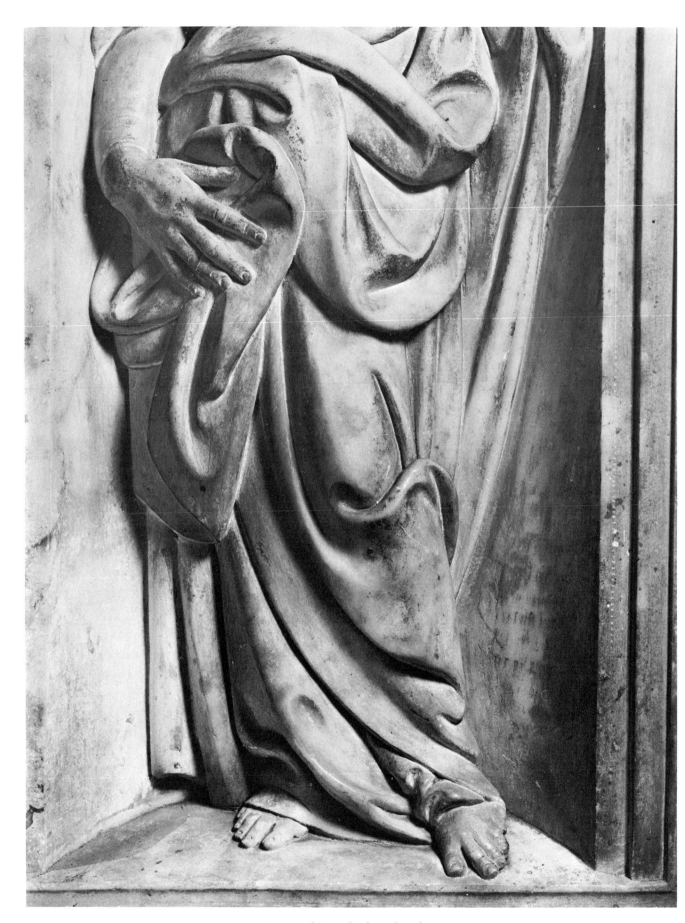

76. Baptismal Font, third prophet, drapery

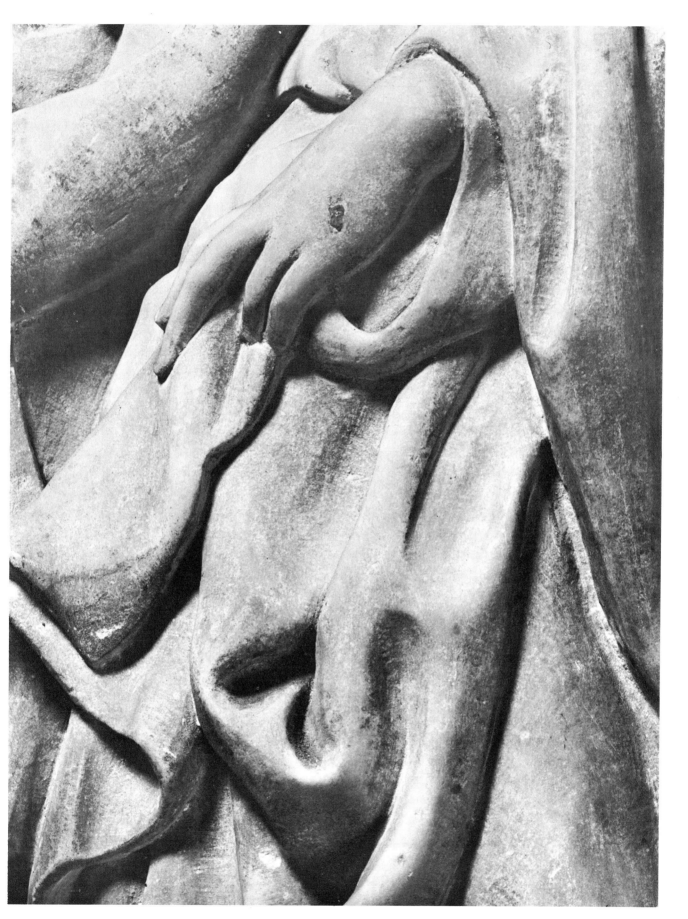

77. Baptismal Font, fourth prophet, drapery

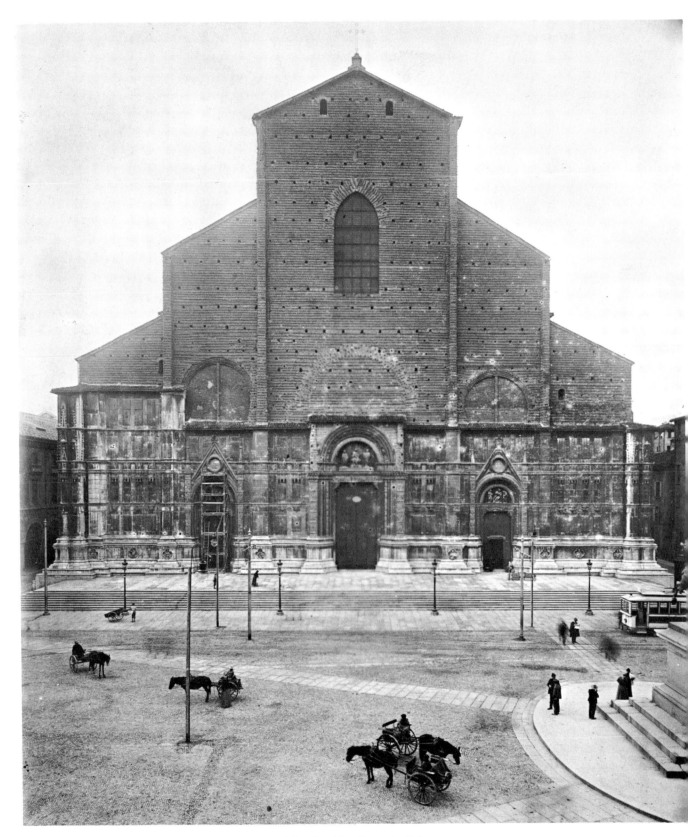

78. Piazza and façade of San Petronio, Bologna, ca. 1900

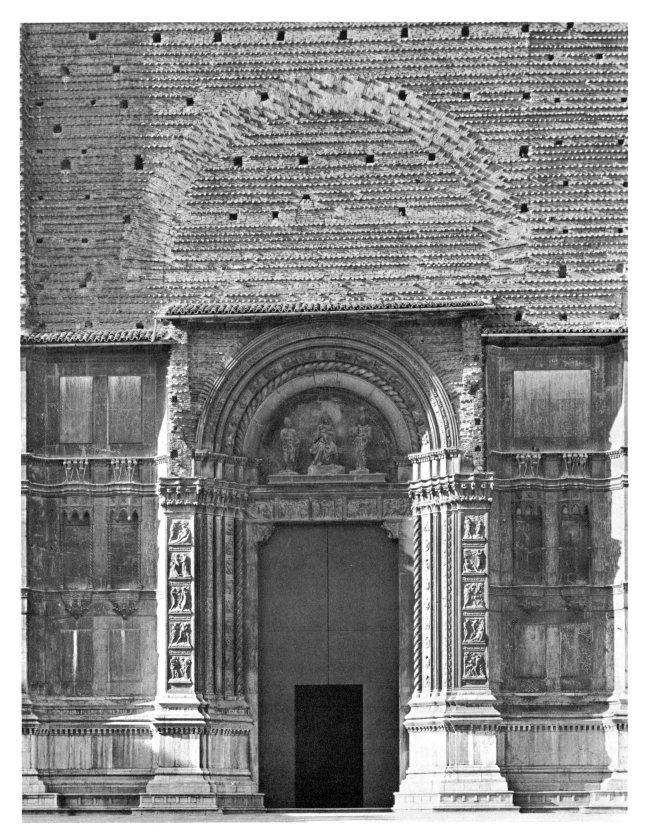

79. Porta Magna (main portal) of San Petronio, Bologna, 1425–38

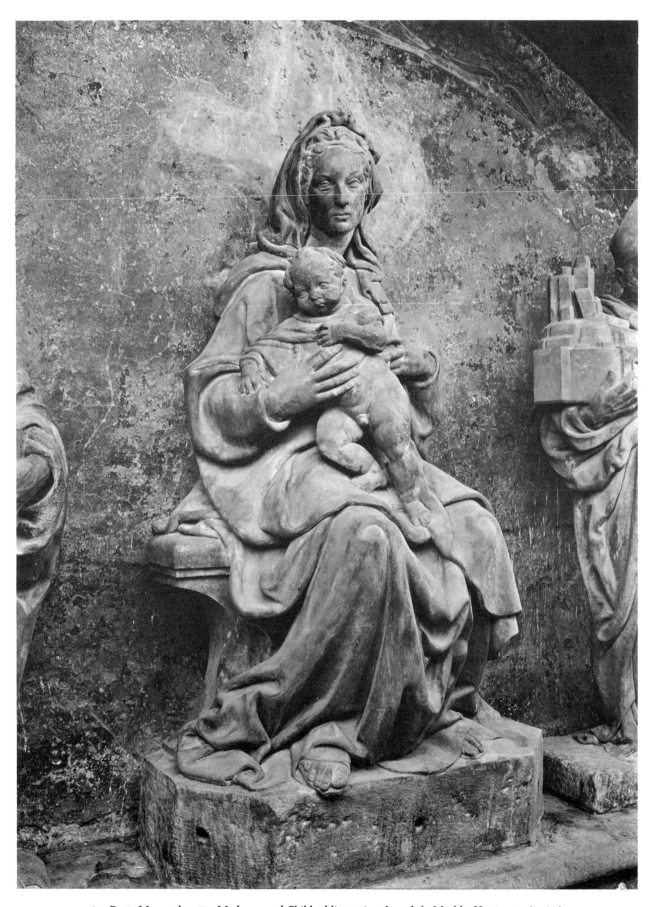

80. Porta Magna, lunette: Madonna and Child, oblique view from left. Marble. H. 180 cm. (72 in.)

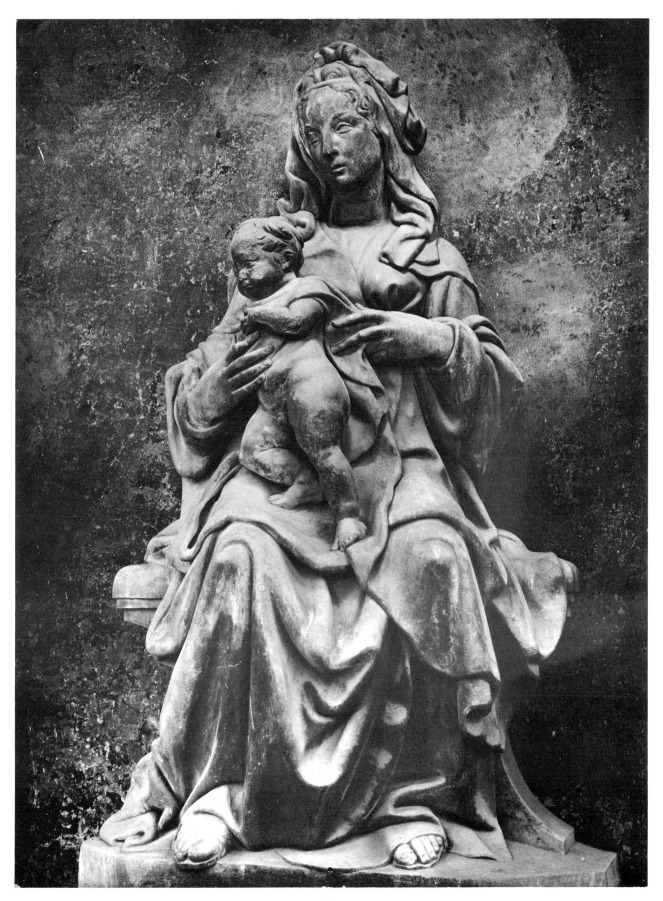

81. Porta Magna, Madonna and Child

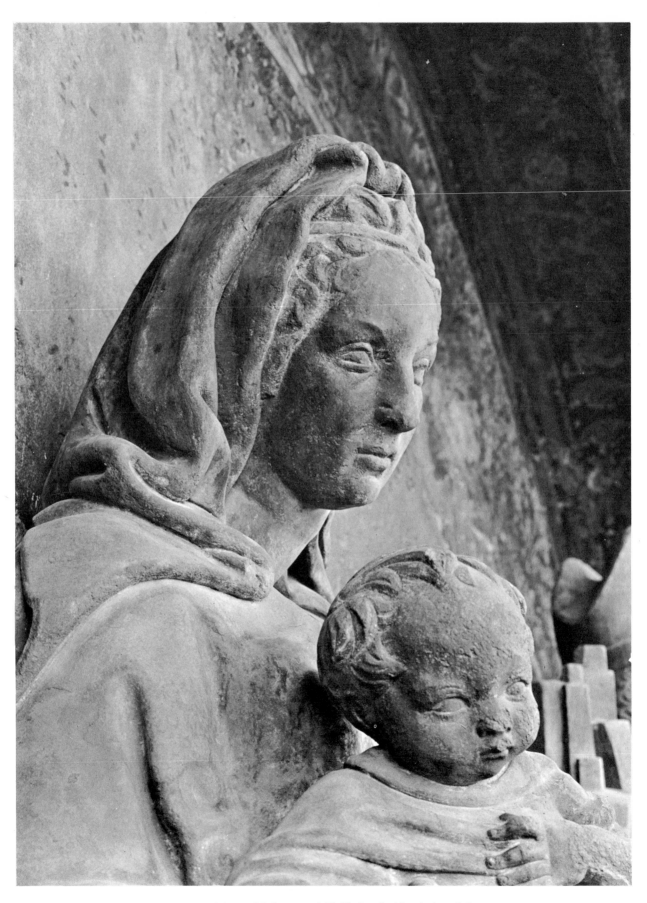

82. Porta Magna, Madonna and Child, detail of heads from left

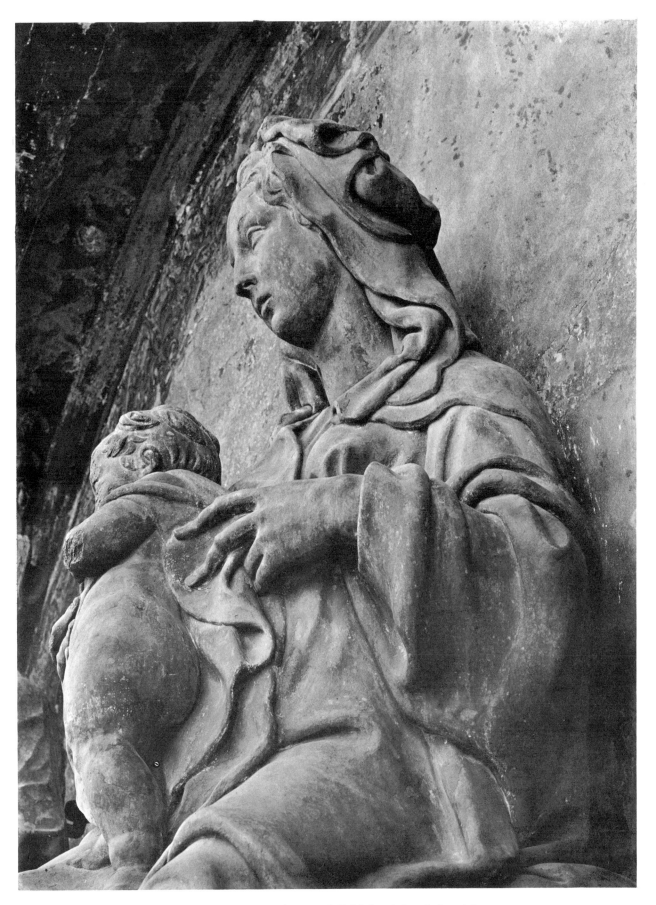

83. Porta Magna, Madonna and Child, detail, from below right

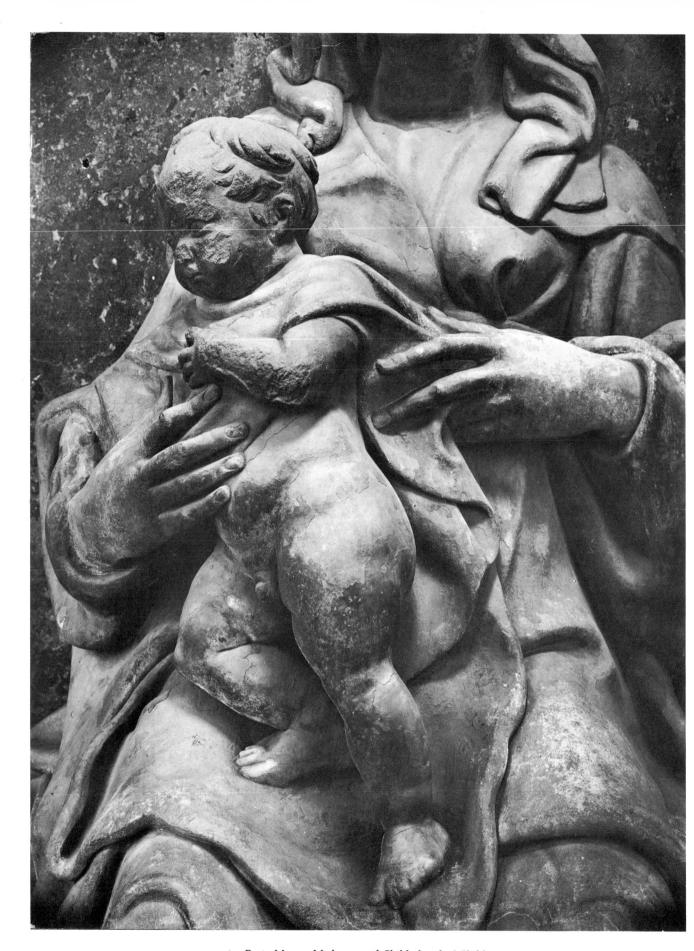

84. Porta Magna, Madonna and Child, detail of Child

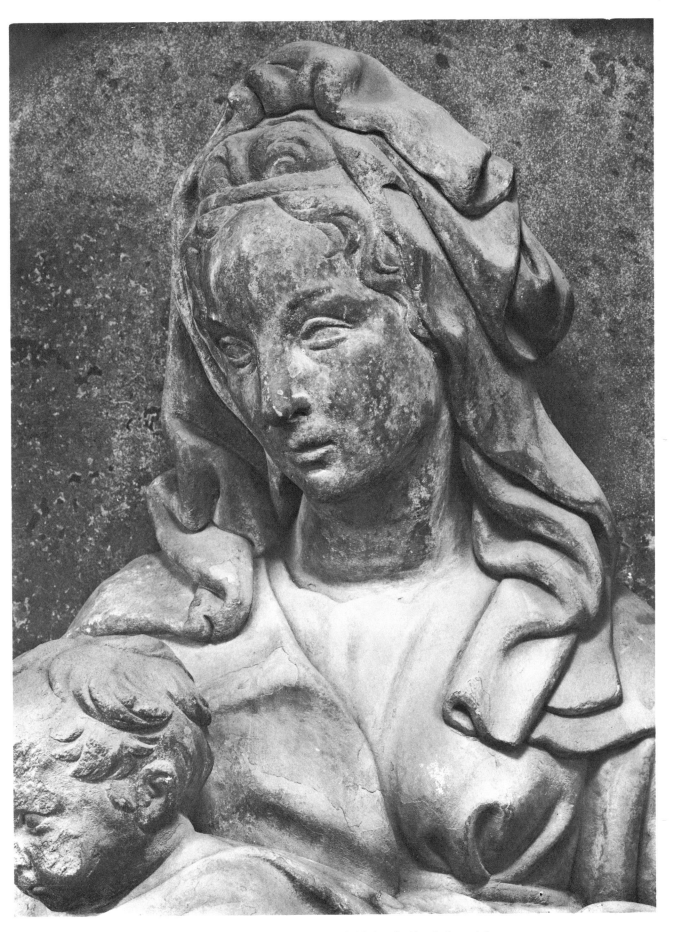

85. Porta Magna, Madonna and Child, detail of heads from right

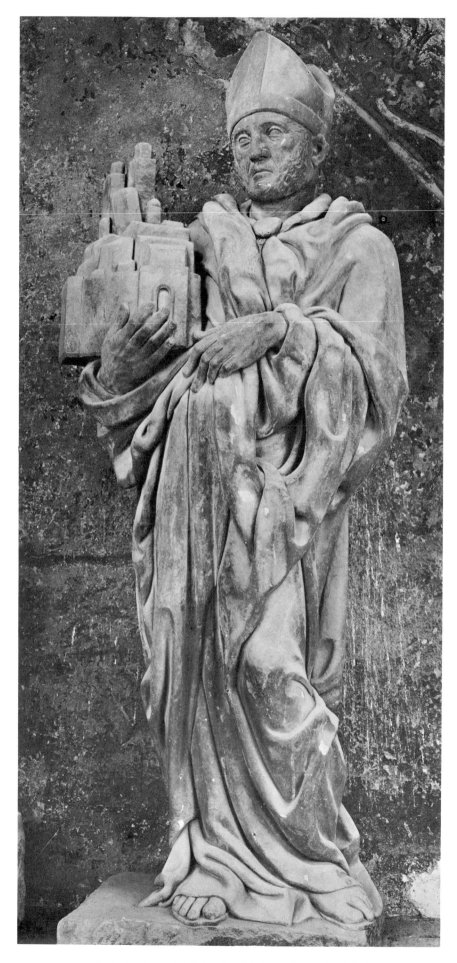

86. Porta Magna, St. Petronius. Marble. 181 cm. (72³/₈ in.)

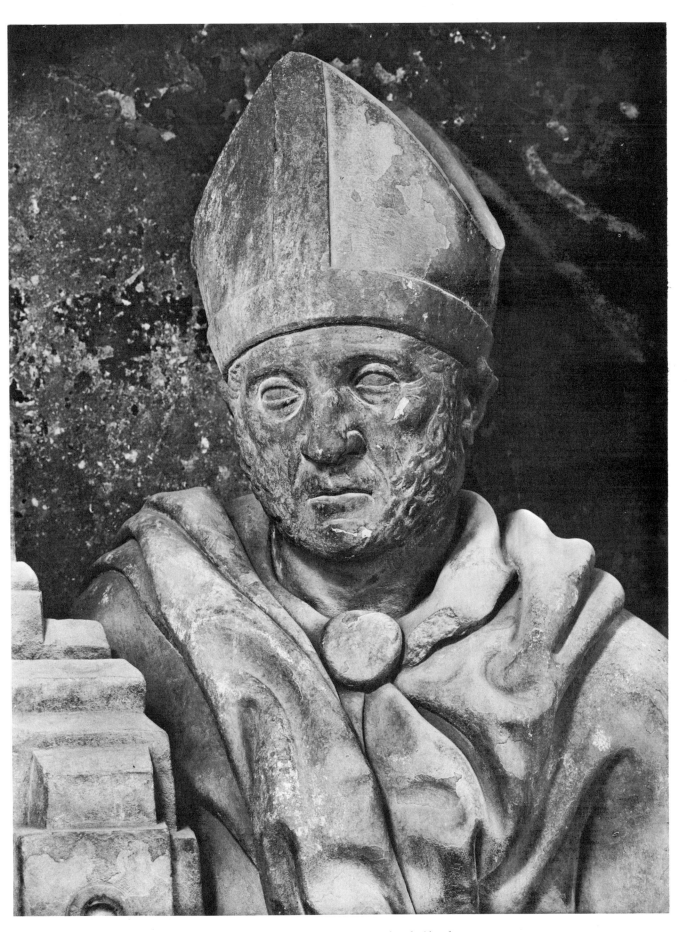

87. Porta Magna, St. Petronius, detail of head

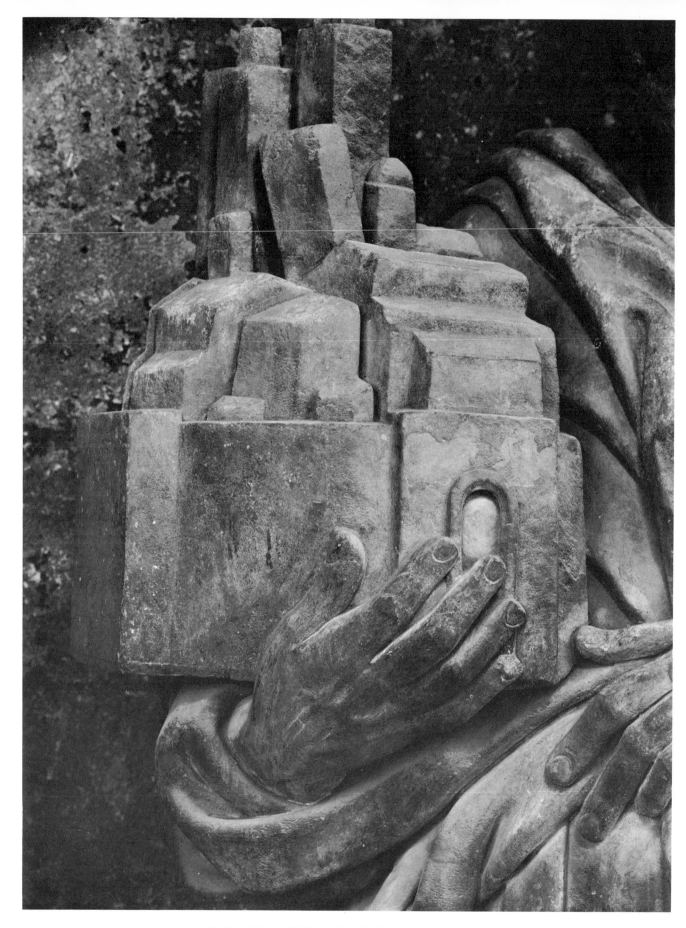

88. Porta Magna, St. Petronius, detail of model of Bologna

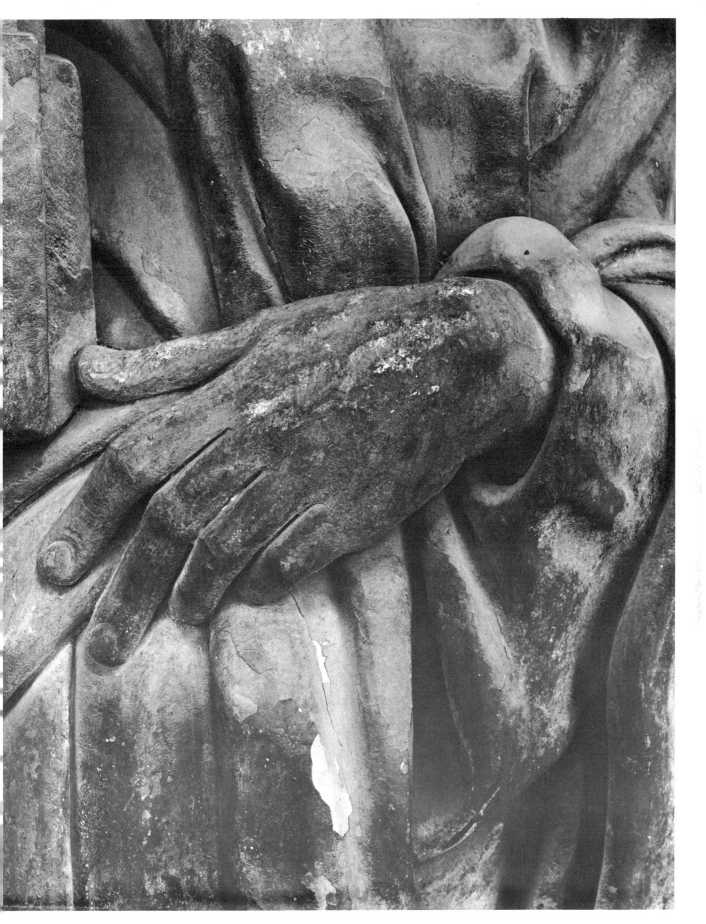

89. Porta Magna, St. Petronius, detail of left hand

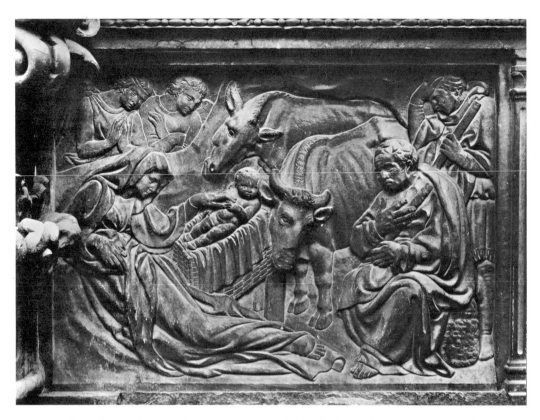

90a. Porta Magna, Nativity (with some assistance). Marble. H. (with frame) 72 cm. (28³/₄ in.)

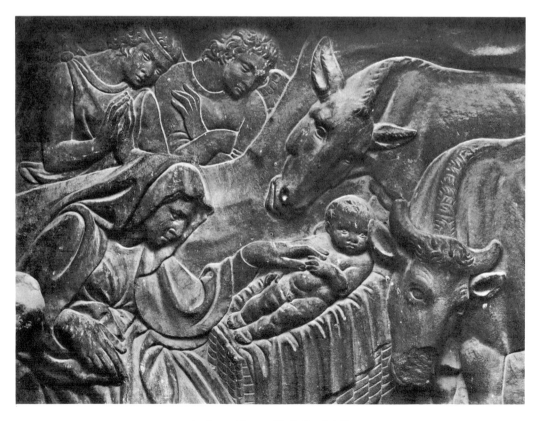

b. Porta Magna, Nativity, detail

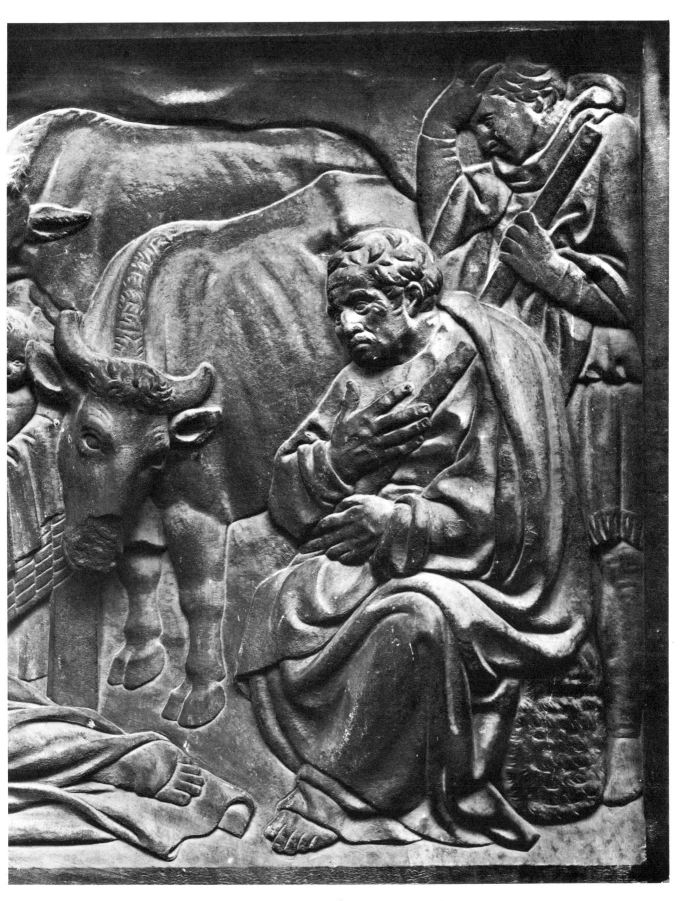

91. Porta Magna, Nativity, detail, St. Joseph

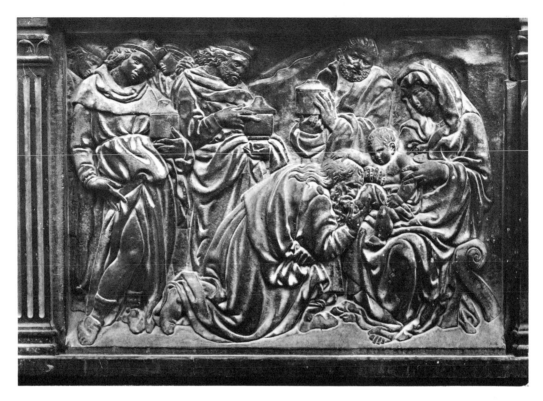

92a. Porta Magna, Adoration (with some assistance). Marble. H. (with frame) 72 cm. (28³/₄ in.)

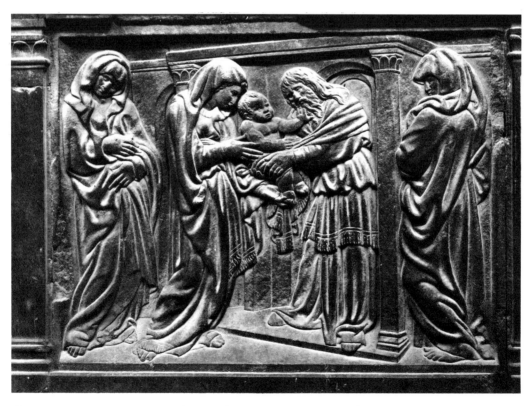

b. Porta Magna, Presentation in the Temple (with considerable assistance). Marble. H. (with frame) 71 cm. (28¹/₂ in.)

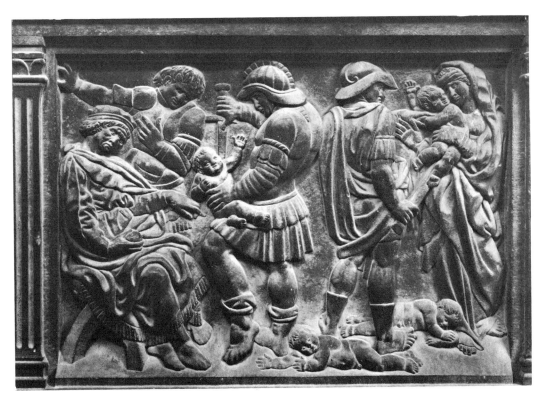

93a. Porta Magna, Massacre of the Innocents (with considerable assistance). Marble. H. (with frame) 71 cm. (28½ in.)

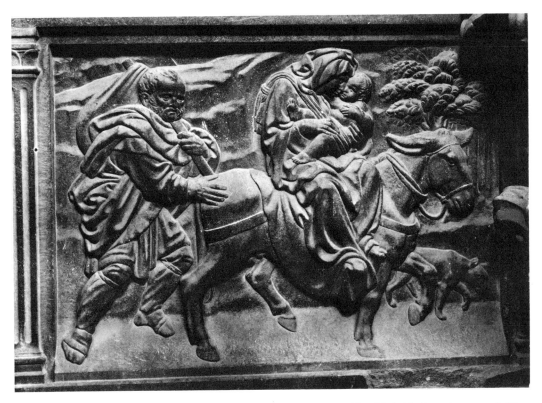

b. Porta Magna, Flight into Egypt (perhaps with assistance). Marble. H. (with frame) 70 cm. (28⅜ in.)

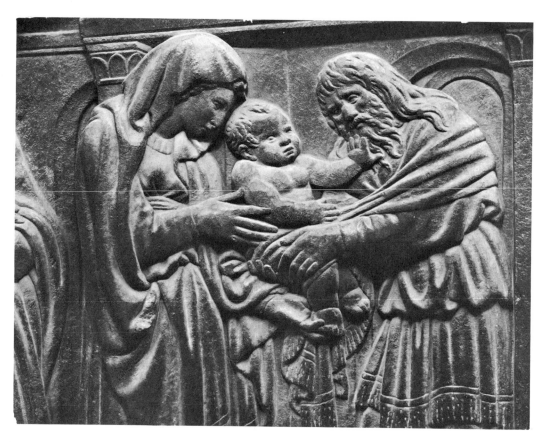

94a. Porta Magna, Presentation, detail (with assistance)

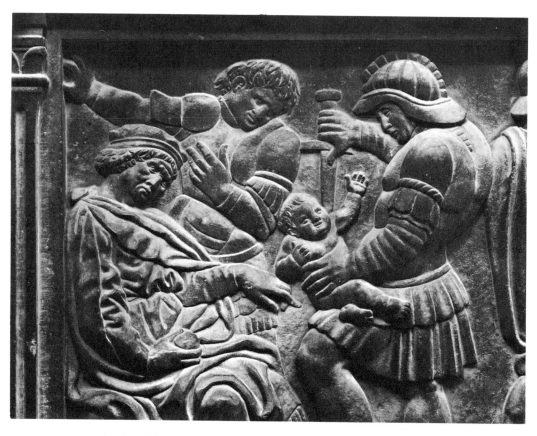

b. Porta Magna, Massacre of the Innocents, detail (with assistance)

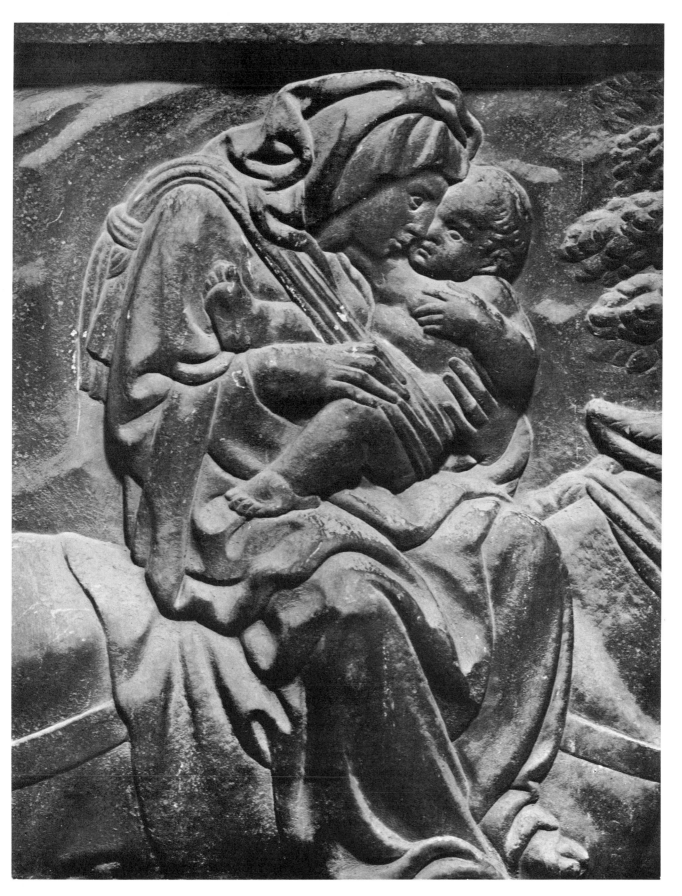

95. Porta Magna, Flight into Egypt, detail of Virgin and Child

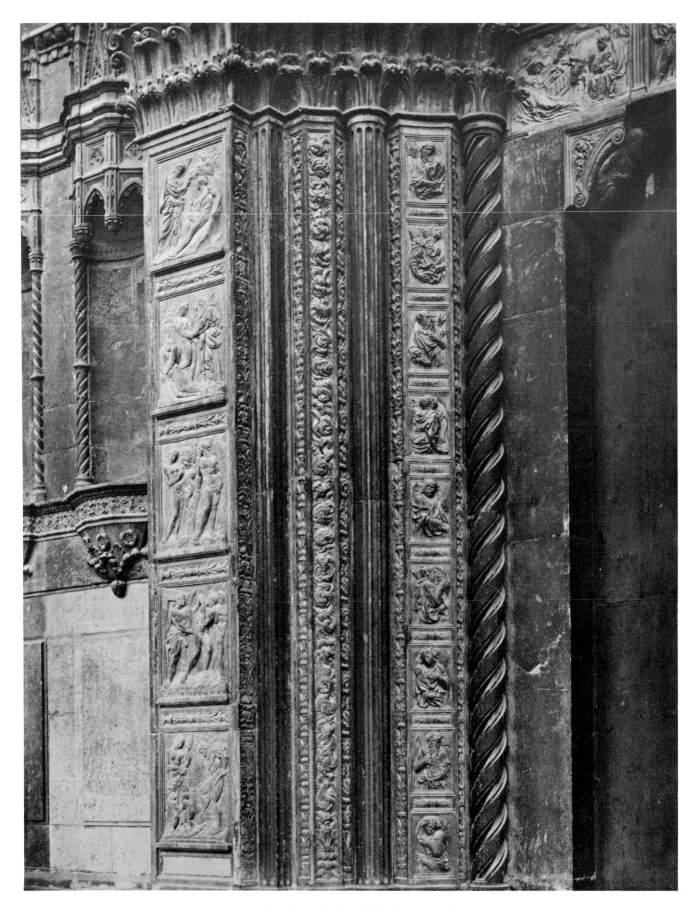

96. Porta Magna, left jamb (with assistance)

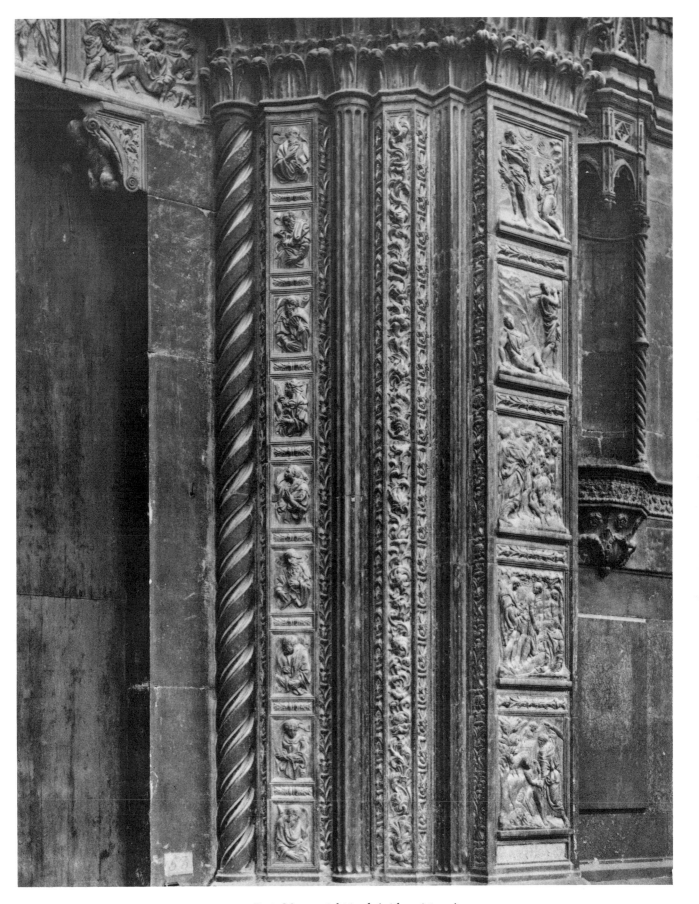

97. Porta Magna, right jamb (with assistance)

98. Porta Magna, propnets to left, 6–9. Marble

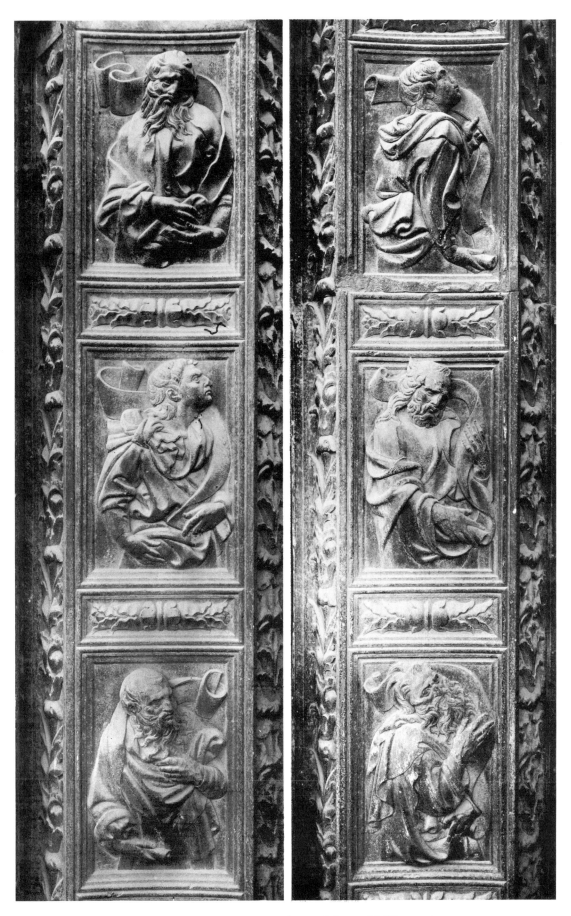

99. Porta Magna, prophets to left, 1–6. Marble

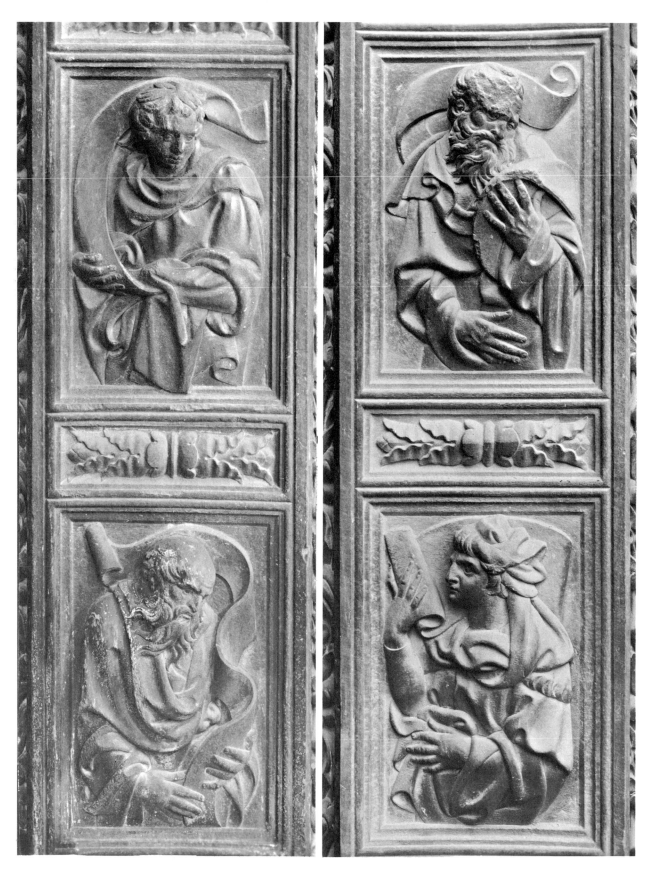

100. Porta Magna, prophets to right, 8–9, 3–4. Marble

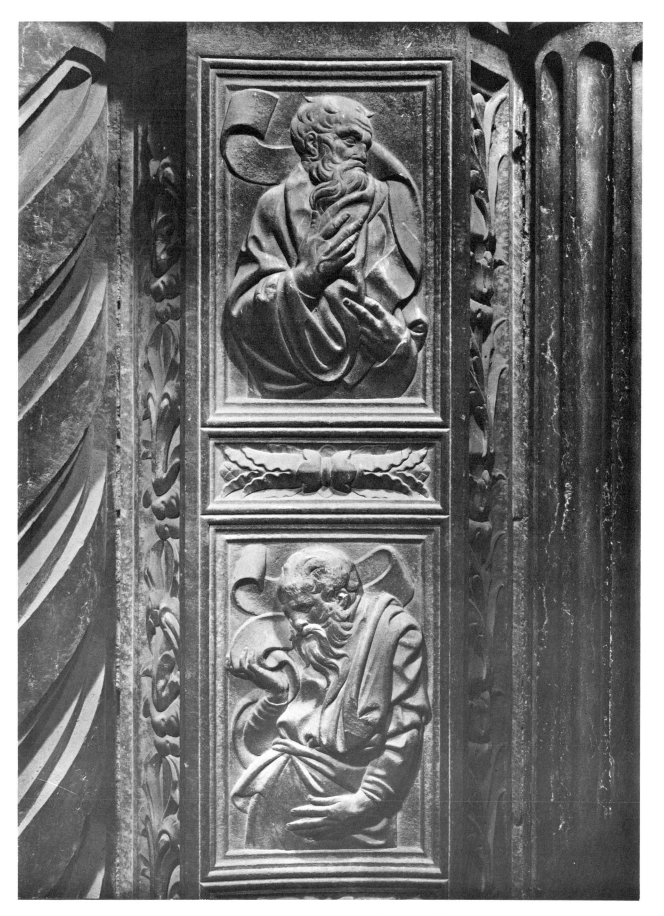

101. Porta Magna, prophets to right, 1–2. Marble

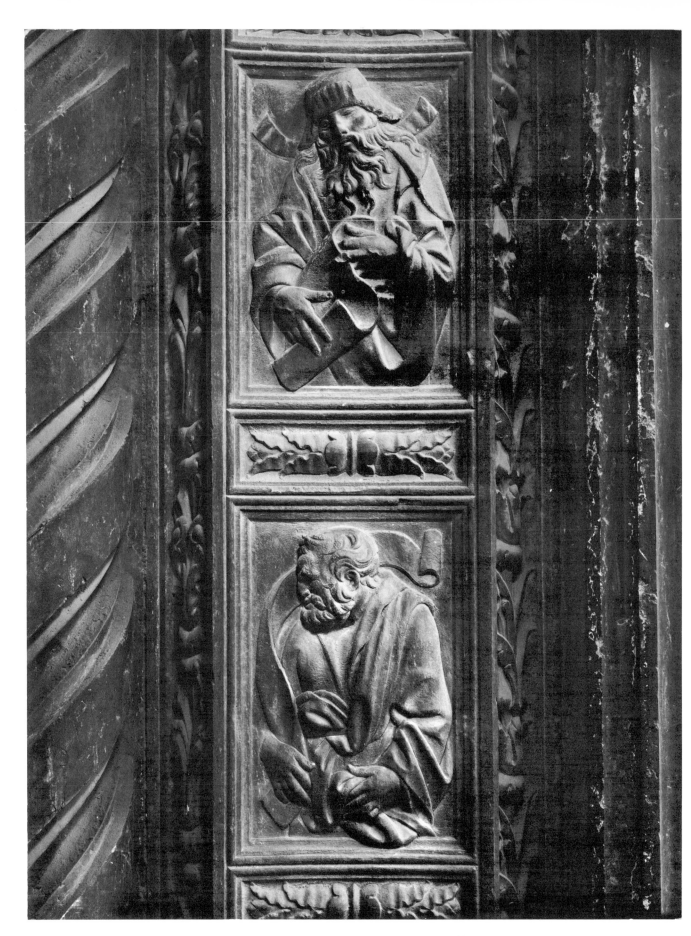

102. Porta Magna, prophets to right. 6–7. Marble

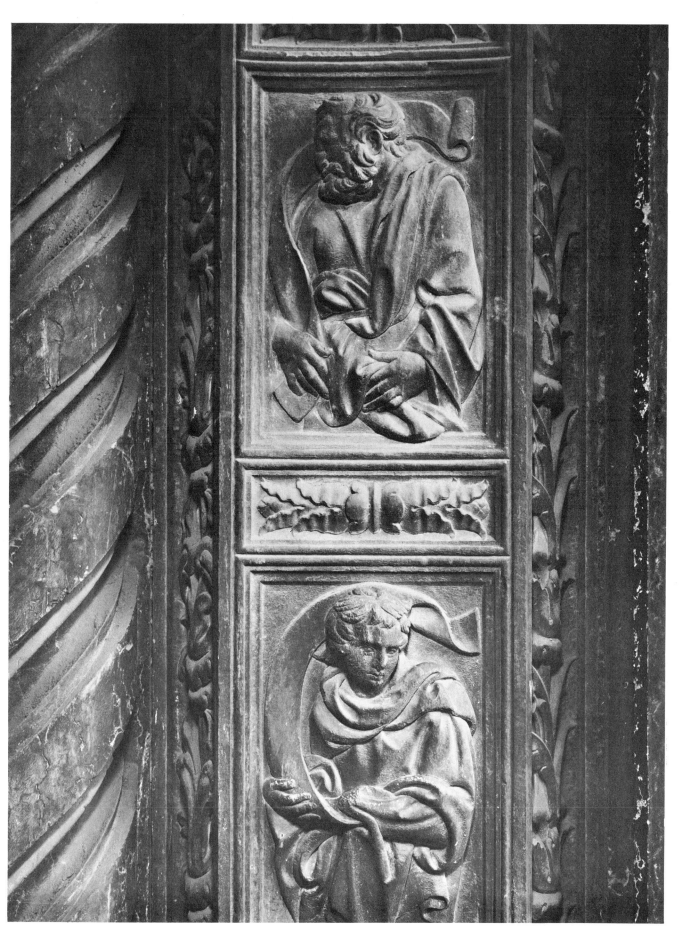

103. Porta Magna, prophets to right, 7–8. Marble

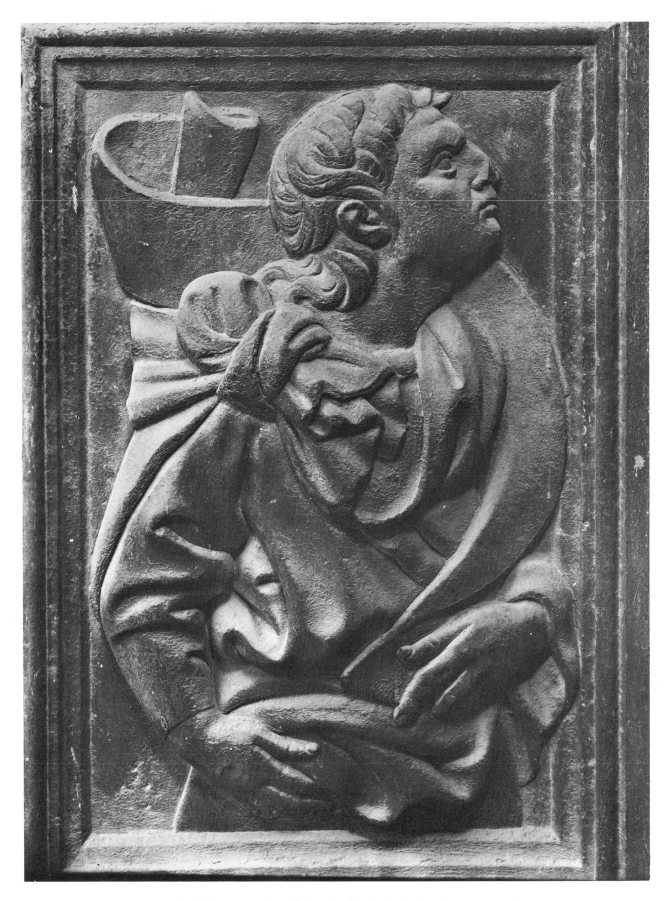

104. Porta Magna, prophet to left, 2. Marble. H. (with frame) 40 cm. (16 in.)

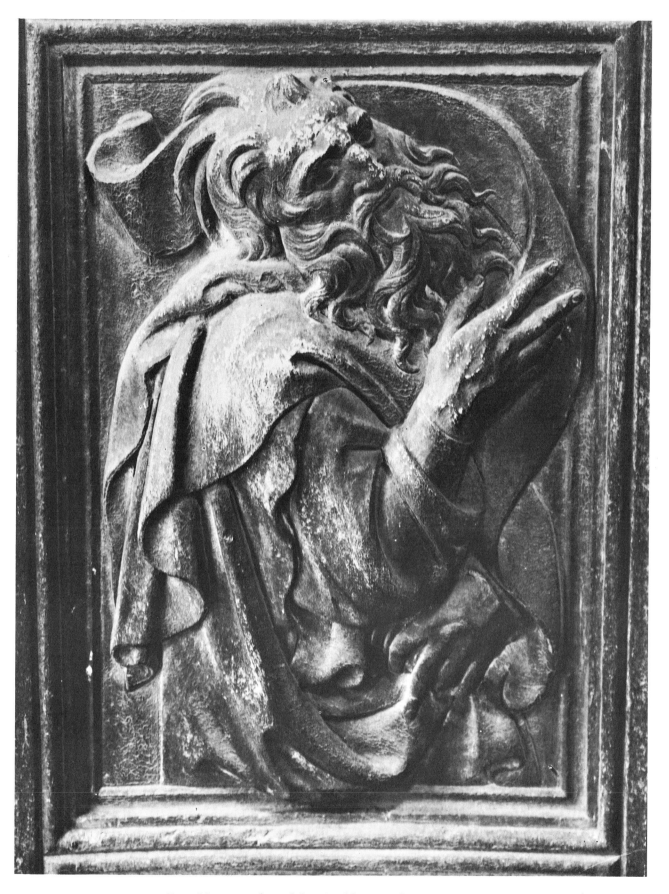

105. Porta Magna, prophet to left, 6. Marble. H. (with frame) 40 cm. (16 in.)

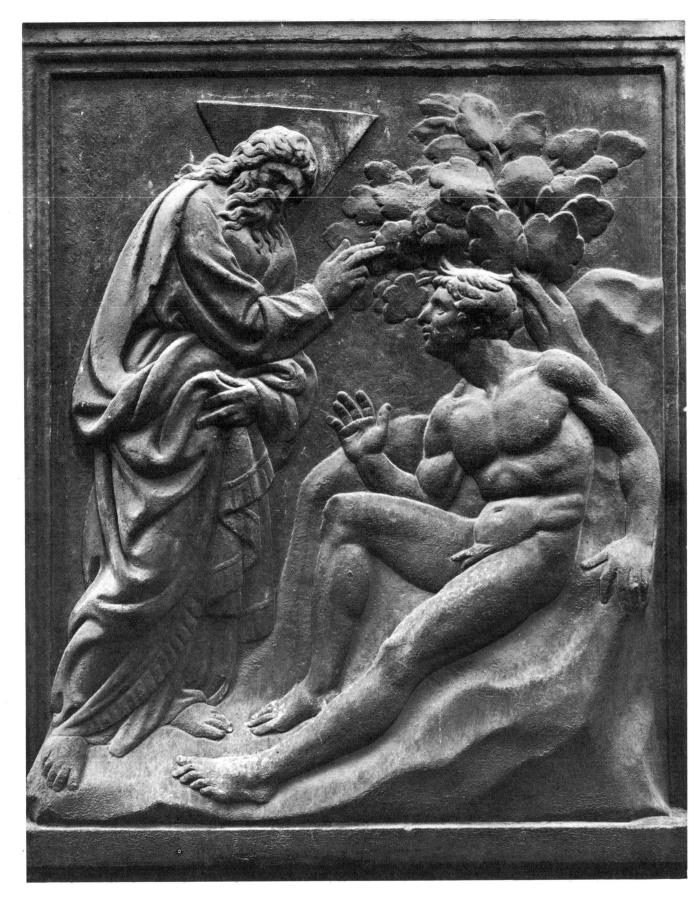

106. Porta Magna, Creation of Adam. Marble. H. (with frame) 99 cm. (39½ in.)

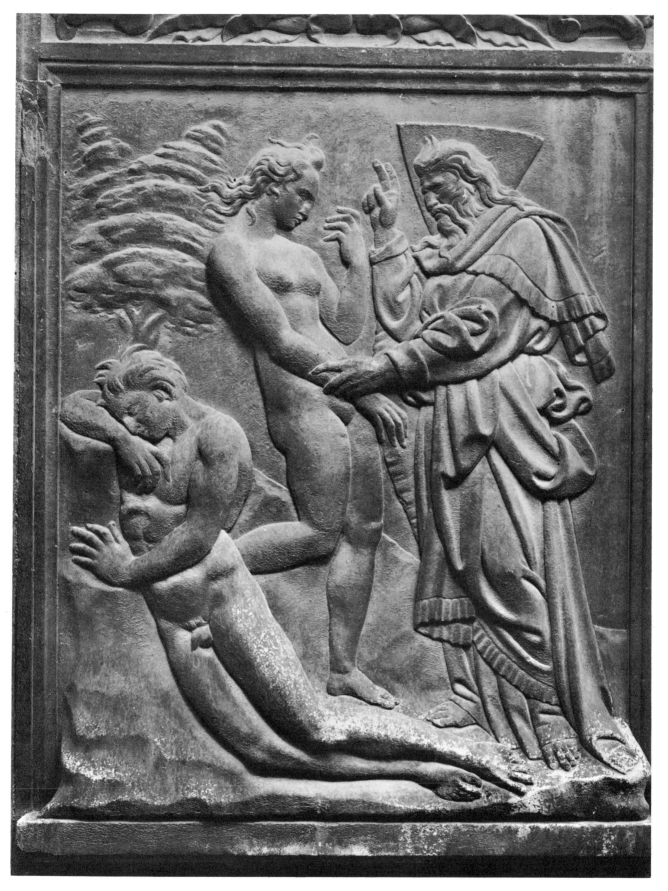

107. Porta Magna, Creation of Eve. Marble. H. (with frame) 99 cm. (39¹/₂ in.)

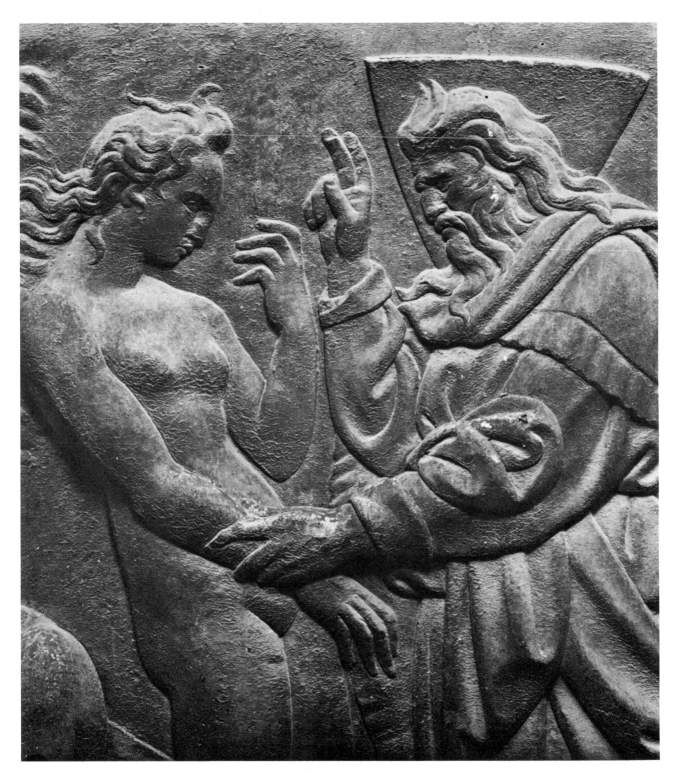

108. Porta Magna, Creation of Eve, detail

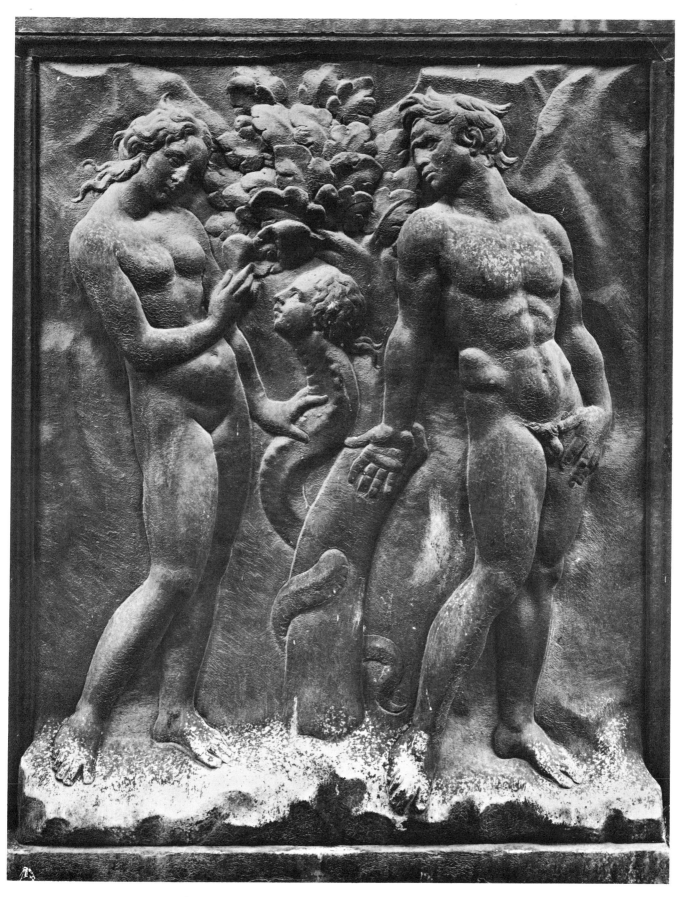

109. Porta Magna, Temptation. Marble. H. (with frame) 99 cm. (39½ in.)

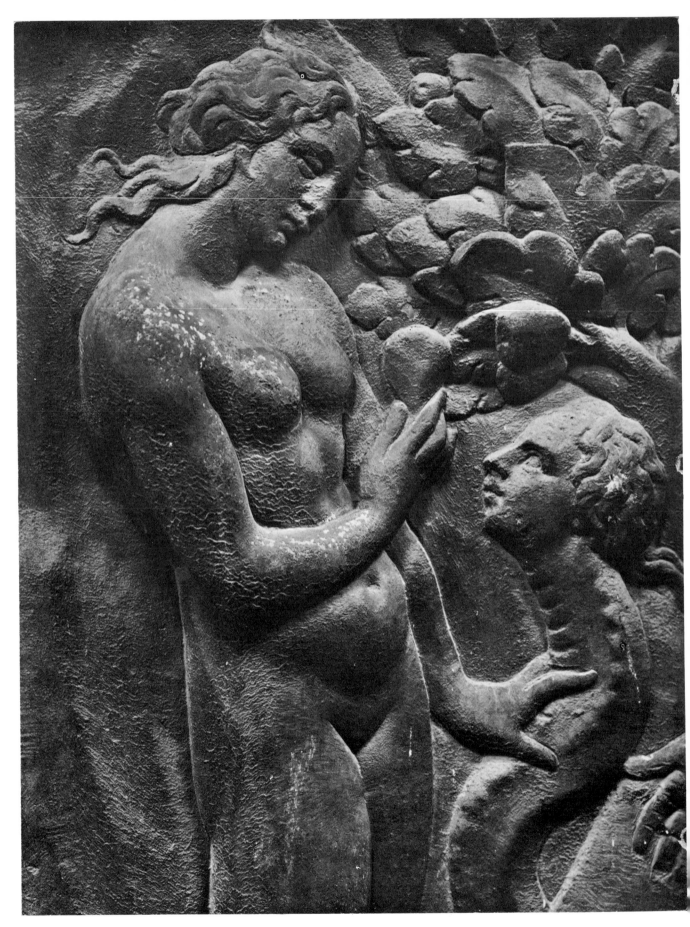

110. Porta Magna, Temptation, detail, Eve and the serpent

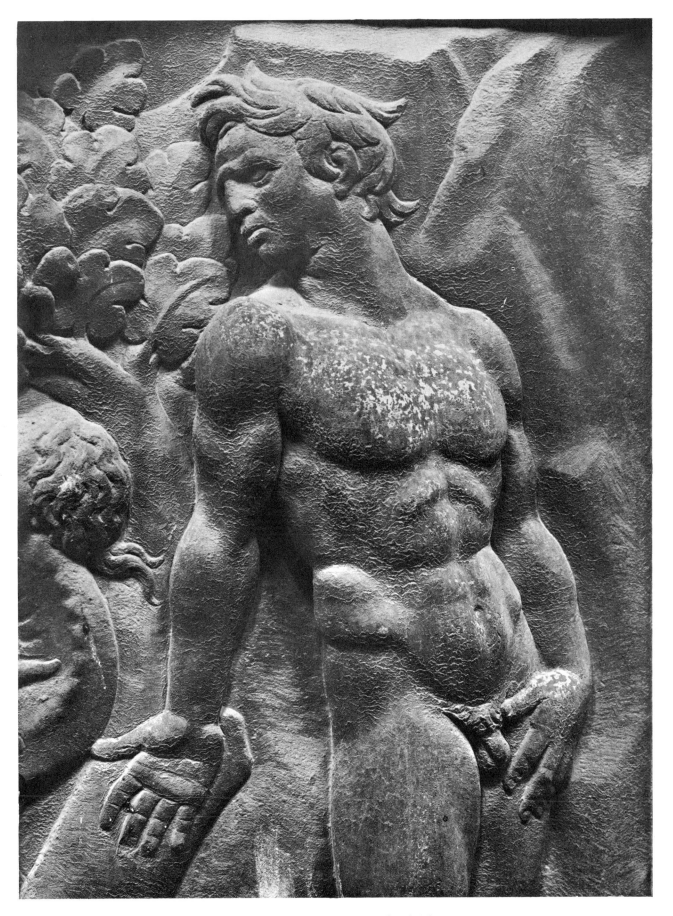

111. Porta Magna, Temptation, detail, Adam

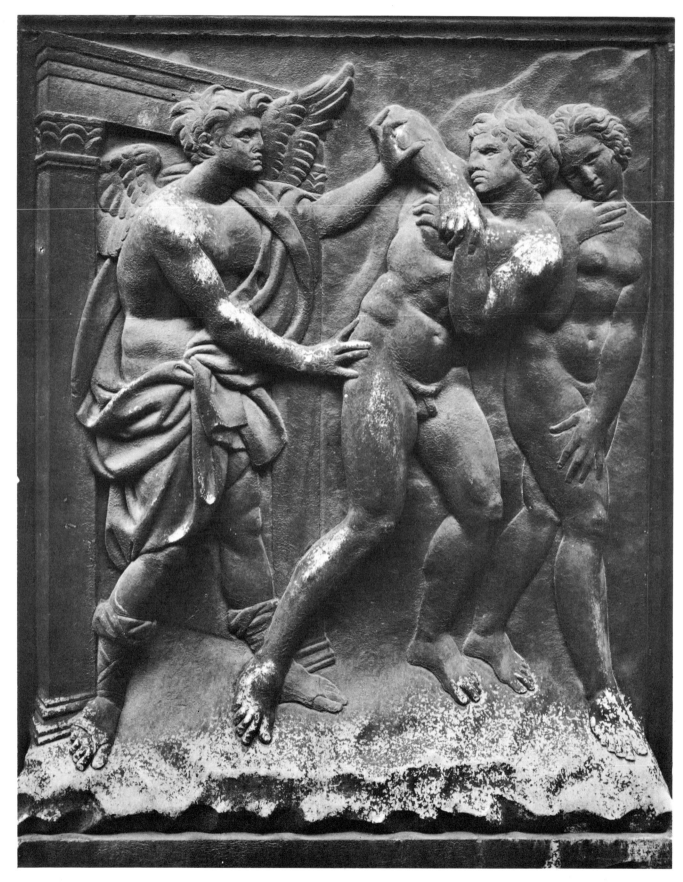

112. Porta Magna, Expulsion. Marble. H. (with frame) 99 cm. (39½ in.)

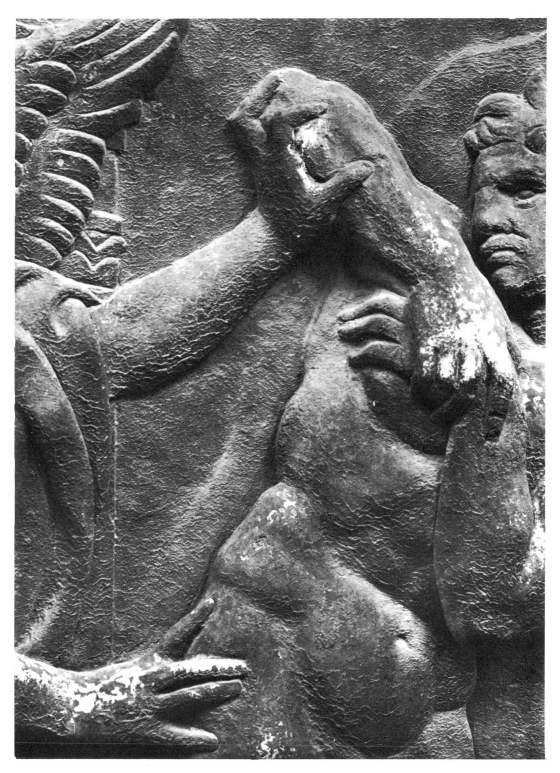

113. Porta Magna, Expulsion, detail,

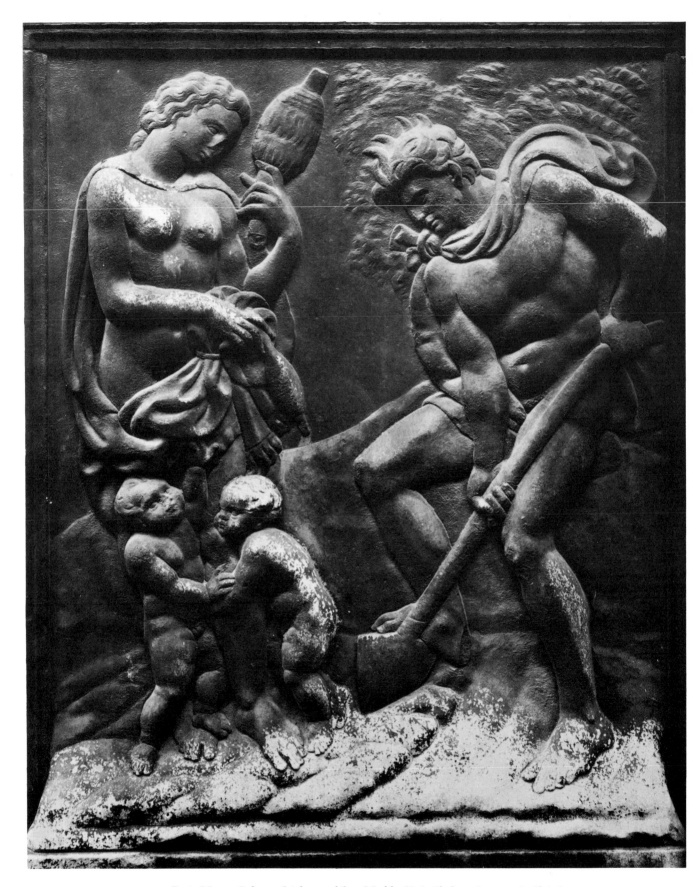

114. Porta Magna, Labors of Adam and Eve. Marble. H. (with frame) 99 cm. (39¹/₂ in.)

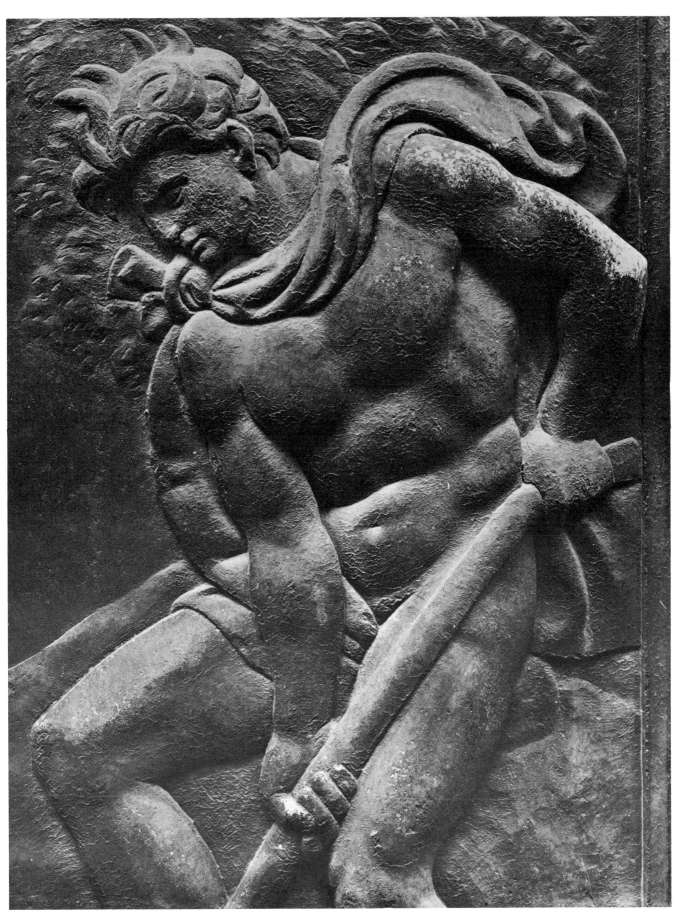

115. Porta Magna, Labors of Adam and Eve, detail, Adam

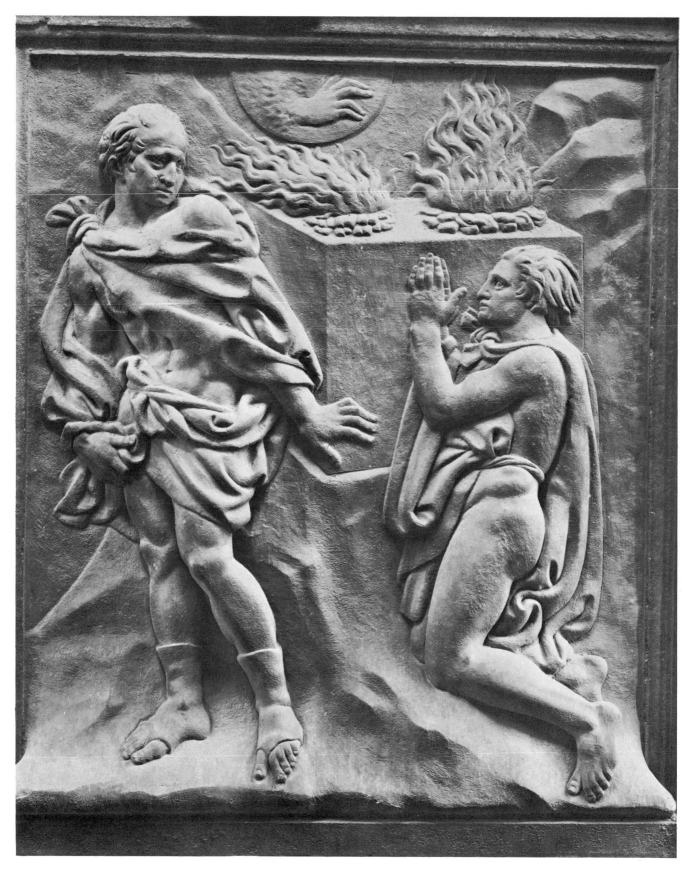

116. Porta Magna, The Sacrifices of Cain and Abel (with assistance?). Marble. H. (with frame) 99 cm. (39½ in.)

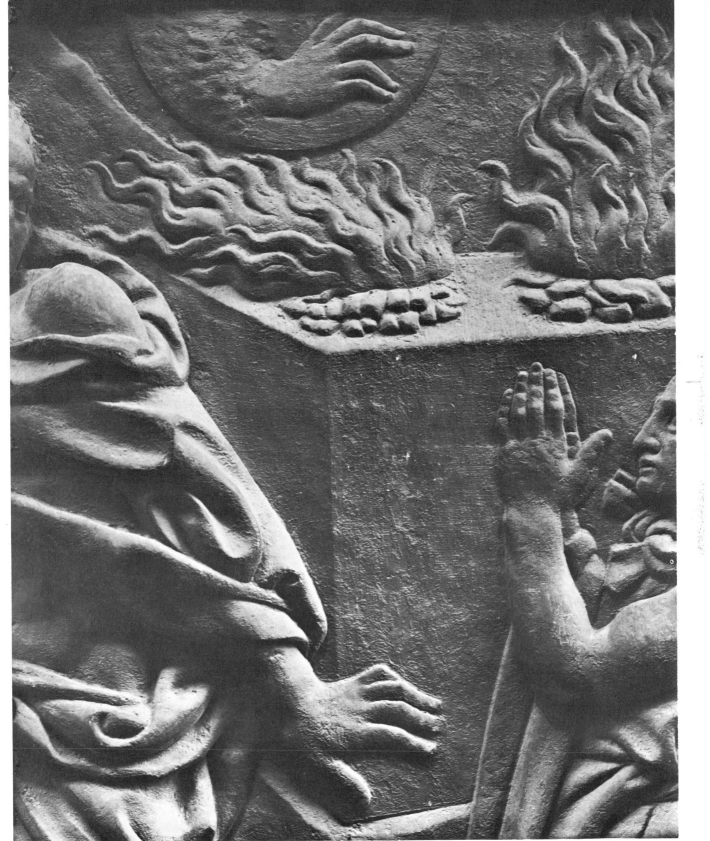

117. Porta Magna, The Sacrifices of Cain and Abel, detail, the altar

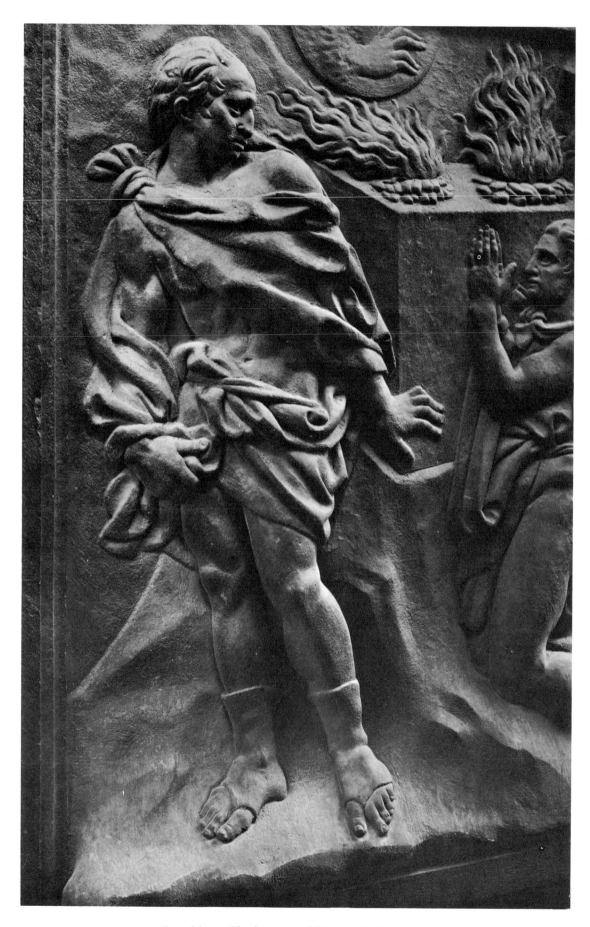

118. Porta Magna, The Sacrifices of Cain and Abel, detail, Cain

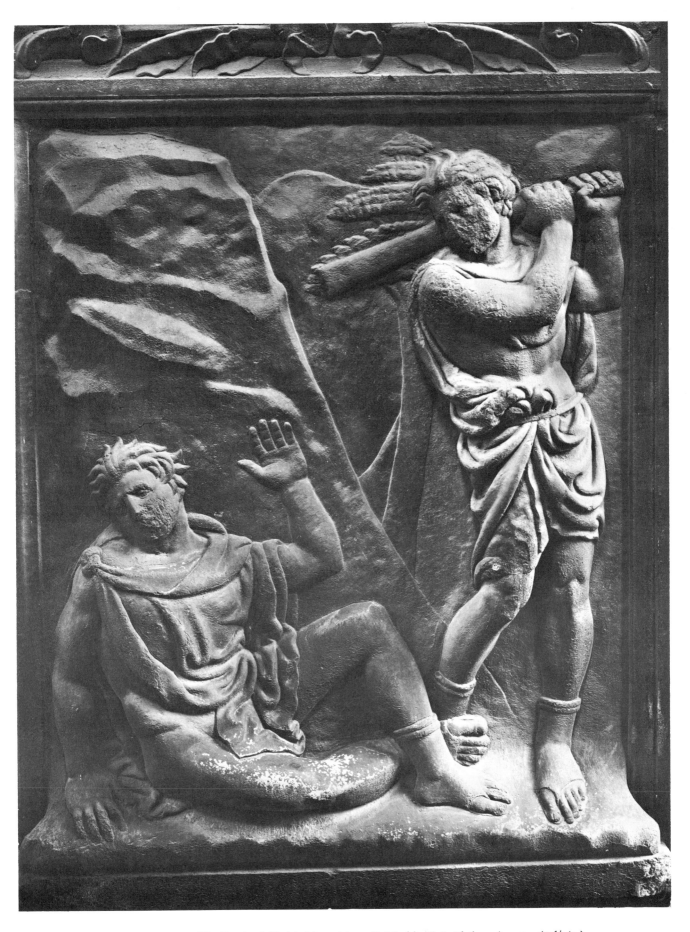

119. Porta Magna, The Death of Abel (with assistance?). Marble. H. (with frame) 99 cm. (39½ in.)

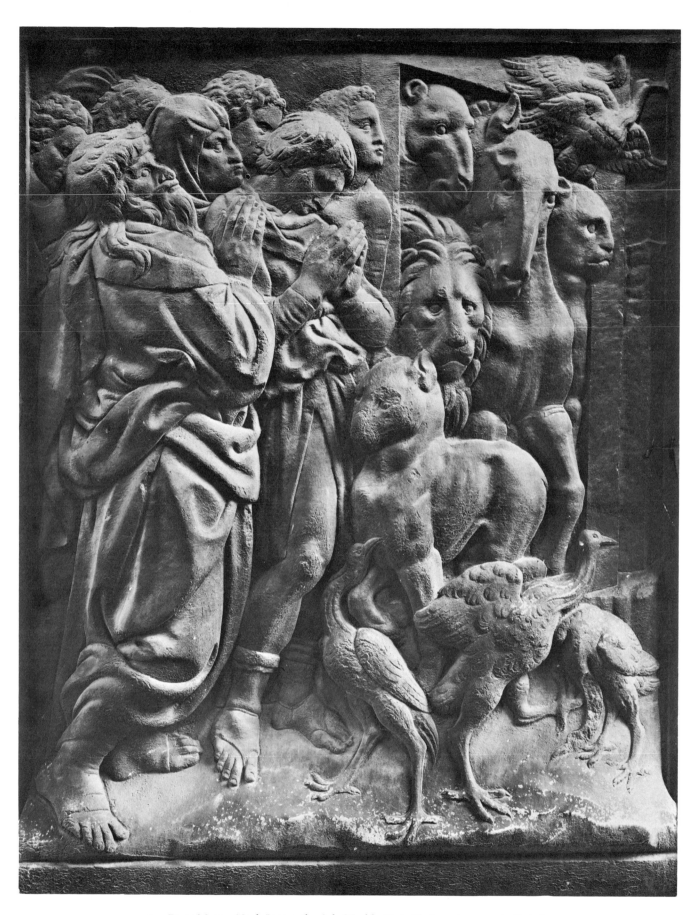

120. Porta Magna, Noah Leaves the Ark. Marble. H. (with frame) 99 cm. (39$^{1}/_{2}$ in.)

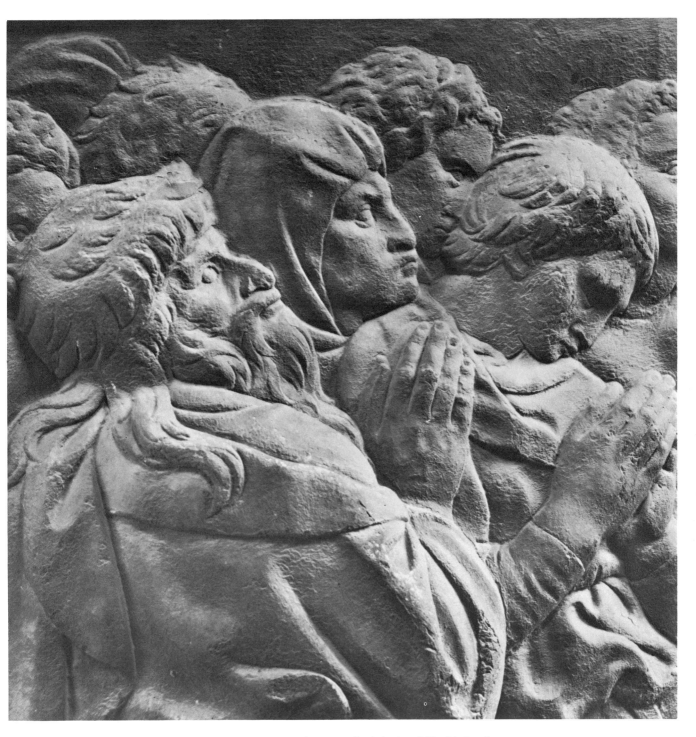

121. Porta Magna, Noah Leaves the Ark, detail, Noah's family

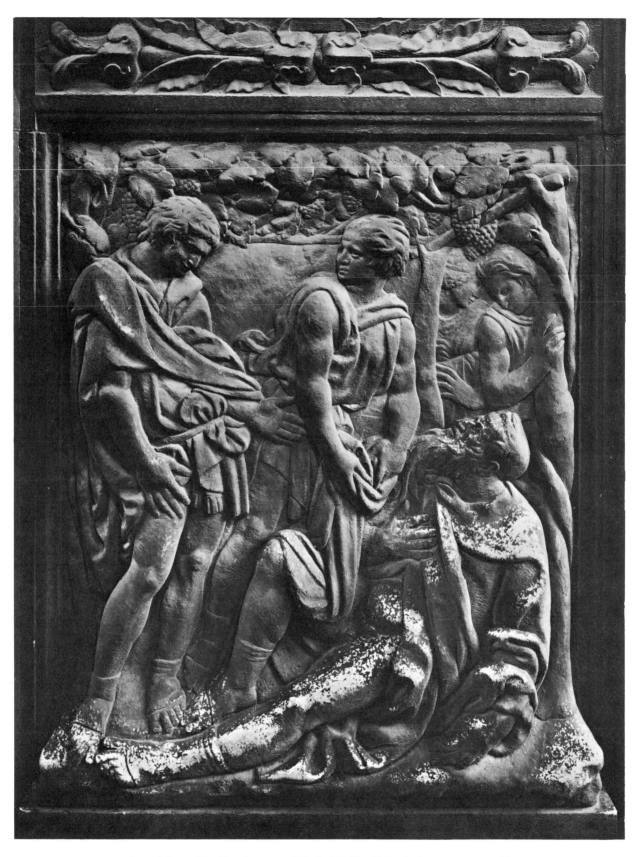

122. Porta Magna, The Drunkenness of Noah. Marble. H. (with frame) 99 cm. (39¹/₂ in.)

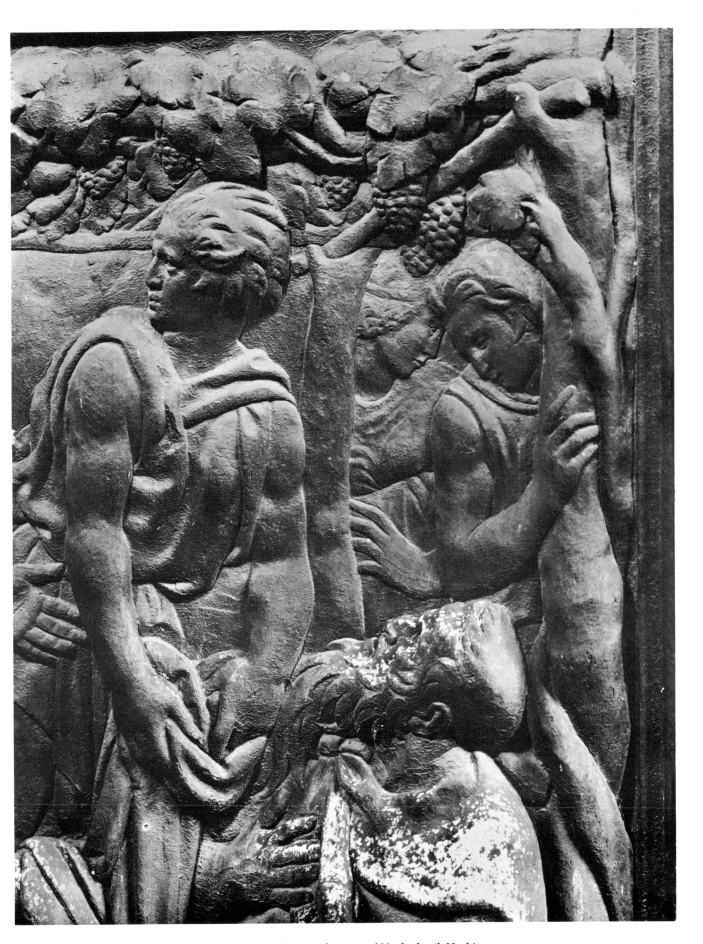

123. Porta Magna, The Drunkenness of Noah, detail, Noah's sons

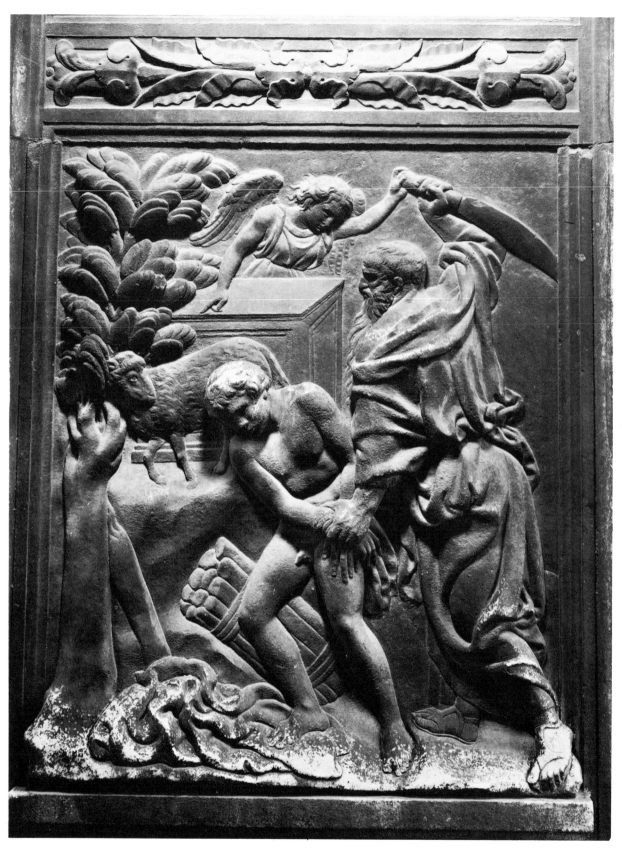

124. Porta Magna, The Sacrifice of Isaac. Marble. H. (with frame) 99 cm. (39½ in.)

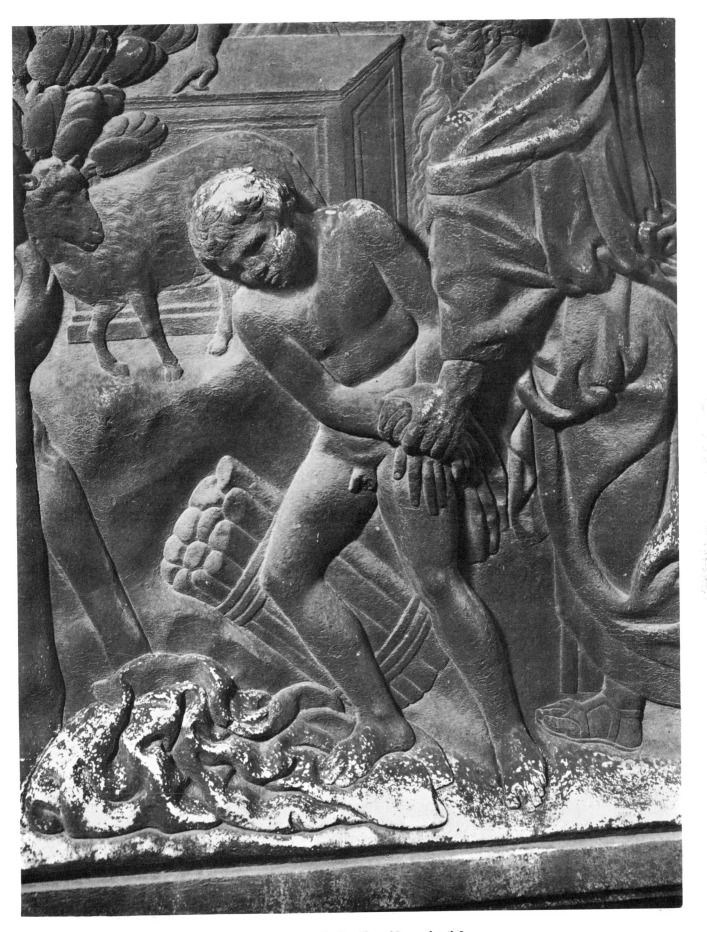

125. Porta Magna, The Sacrifice of Isaac, detail, Isaac

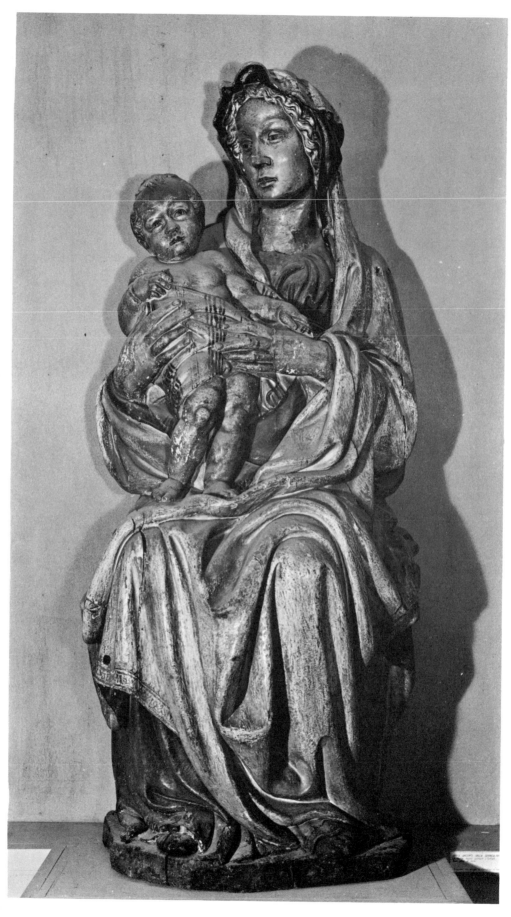

126. Madonna and Child. After(?) the modello for an unexecuted second statue of the Virgin for San Petronio, 1430–35(?). Wood. H. 180 cm. (62 in.). Louvre, Paris

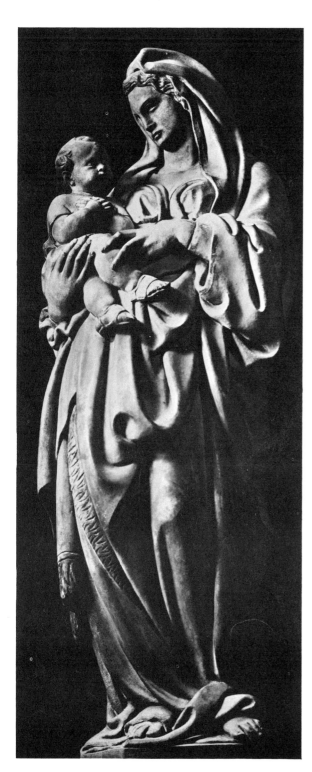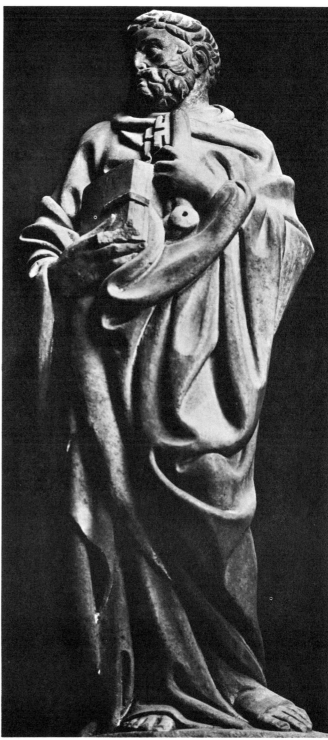

127a. Vari-Bentivoglio Monument. Design (after 1435?) but only partial completion by Jacopo della Quercia, Madonna and Child. Marble. H. (without base) 91 cm. (35³/₄ in.). San Giacomo maggiore, Bologna

b. Vari-Bentivoglio Monument, St. Peter. H. (without base) 74 cm. (29¹/₈ in.)

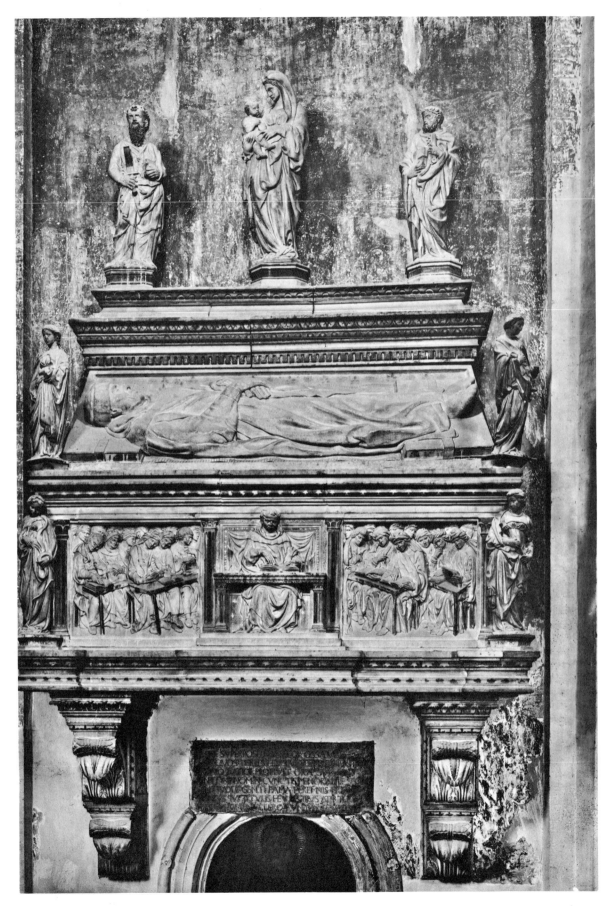

128. Vari-Bentivoglio Monument, view of the whole

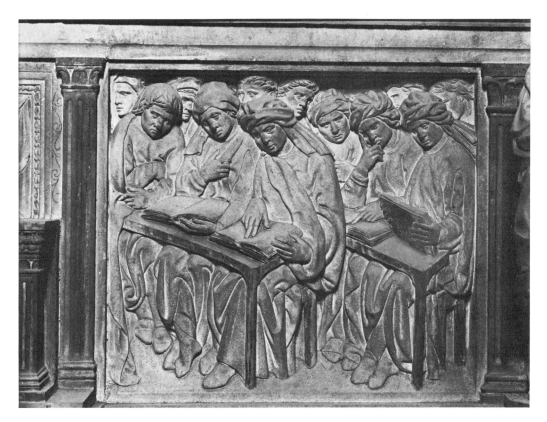

129a. Vari-Bentivoglio Monument, right panel, depicting students at a lecture (execution by Quercia).
H. 55 cm. (21³/₄ in.).

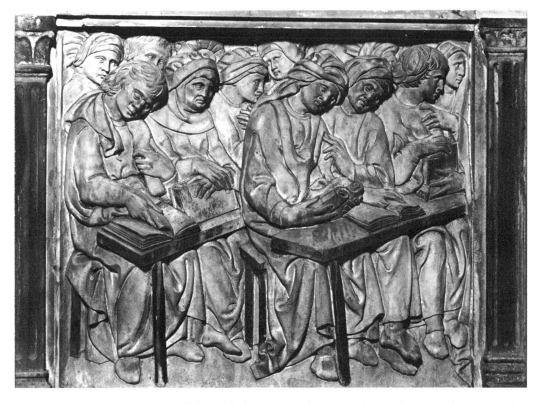

b. Vari-Bentivoglio Monument, left panel, depicting students at a lecture (execution by assistant).
H. 55 cm. (21³/₄ in.)

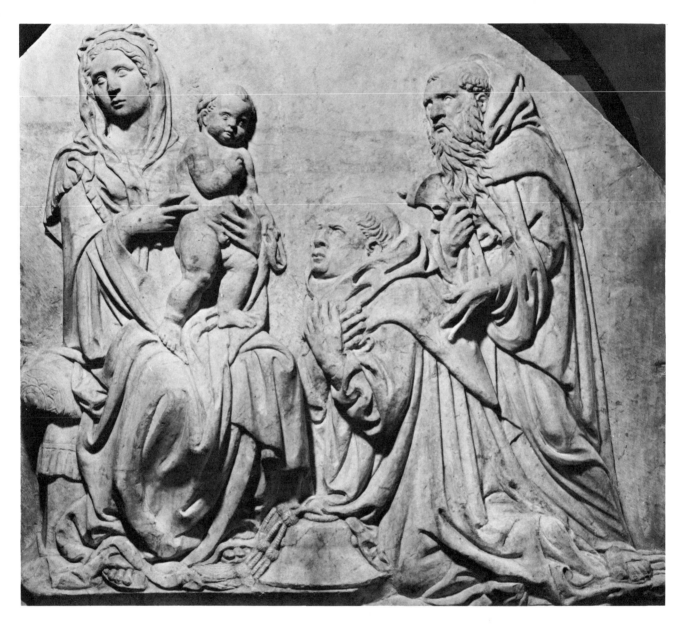

130. Fragment of lunette of Casini Altar for the Siena Duomo (with assistance?), ca. 1435. Marble. H. 120 cm. (48 in.). On loan from the Italian State to the Museo dell'Opera del Duomo, Siena.

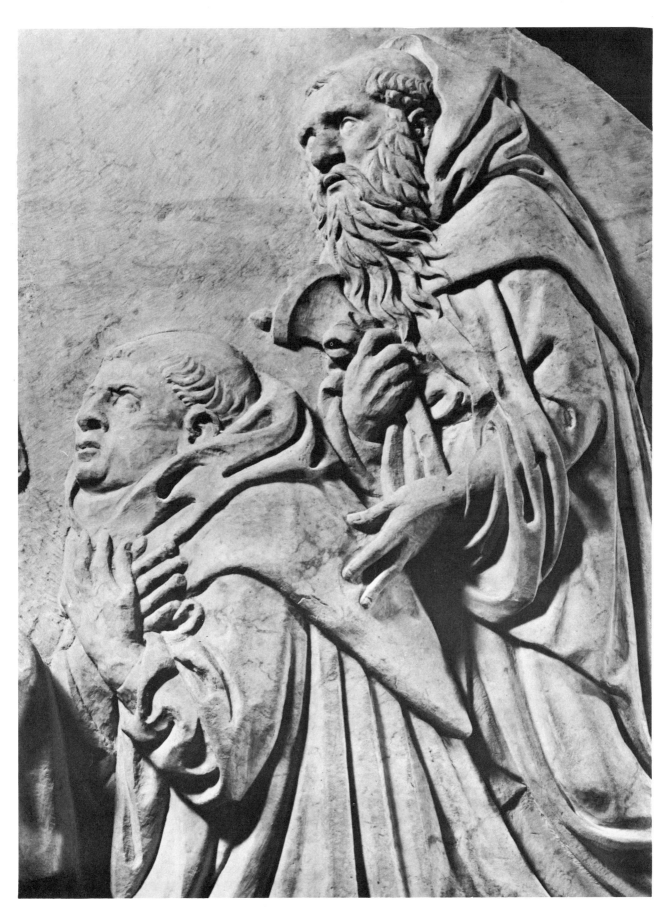

131. Casini Altar, detail, donor and patron

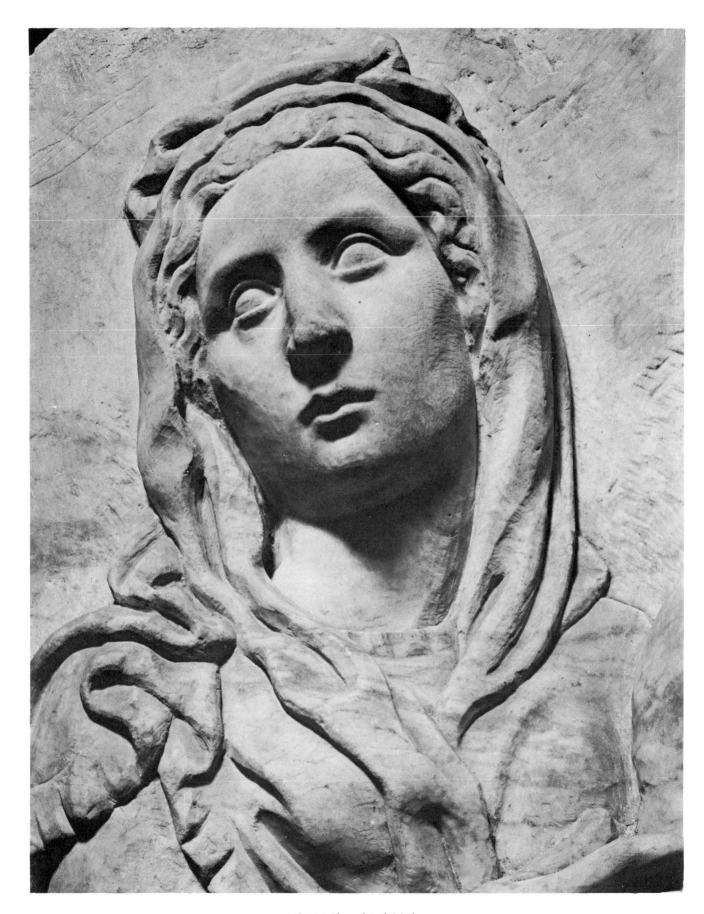

132. Casini Altar, detail, Madonna

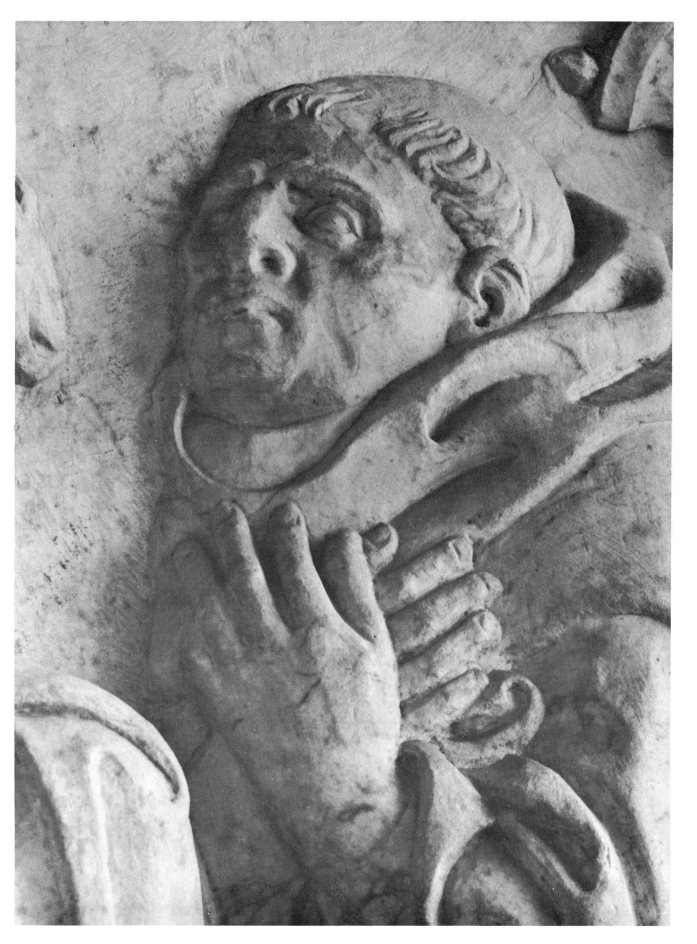

133. Casini Altar, detail, donor

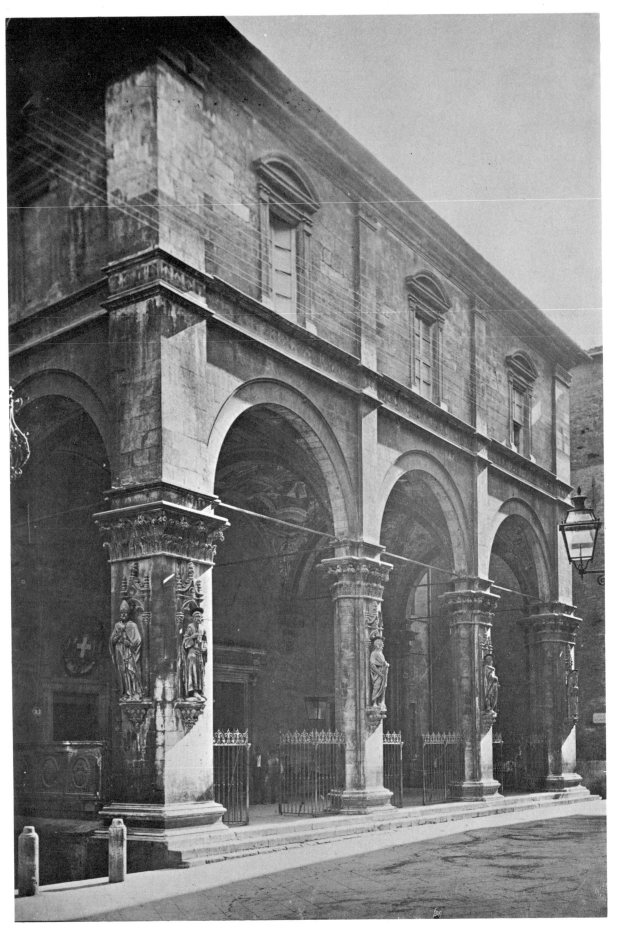

134. Design by Quercia, with partial execution by his bottega, 1433–38. Lower portion of the Loggia della Mercanzia, Siena

FIGURES

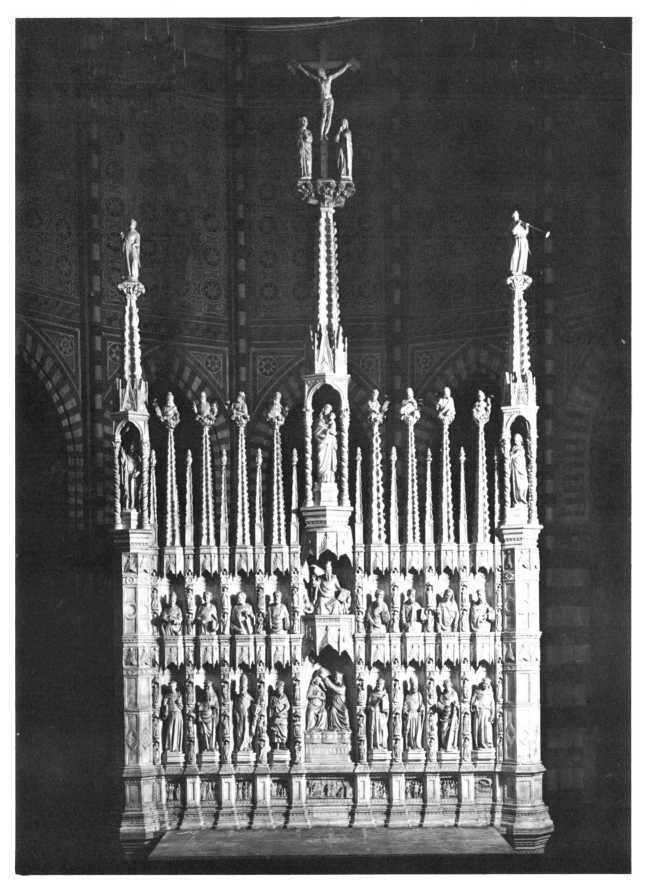

1 Pierpaolo and Jacobello dalle Masegne, with assistants, High Altar. Marble. San Francesco, Bologna

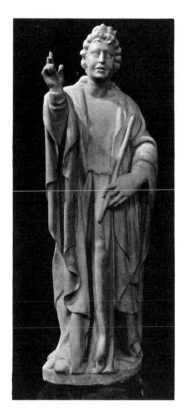

2. Dalle Masegne Assistant (hypothetical early style of Quercia), Angel of the Annunciation, right side, Marble. High Altar, San Francesco, Bologna

3. Dalle Masegne Assistant (hypothetical early style of Quercia), Angel Annunciate, from the front. High Altar, San Francesco, Bologna

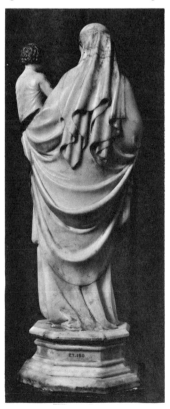

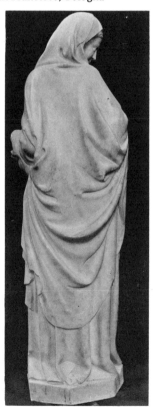

4. Nino Pisano, Madonna, rear view. Marble. The Detroit Institute of Arts

5. Dalle Masegne Assistant (hypothetical early style of Quercia), Virgin Annunciate, rear view. High Altar, San Francesco, Bologna

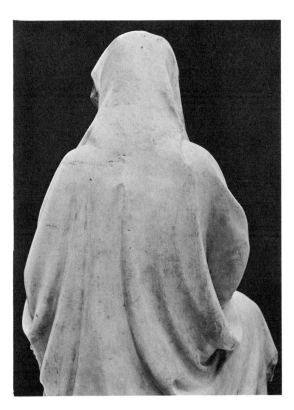

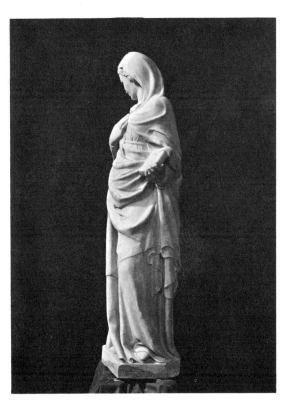

6. Jacopo della Quercia (?) or Domenico dei Cori (?), Madonna of Humility, rear view. National Gallery of Art (Kress Collection), Washington, D.C.

7. Dalle Masegne Assistant (hypothetical early style of Quercia), Virgin Annunciate, left side. High Altar, San Francesco Bologna

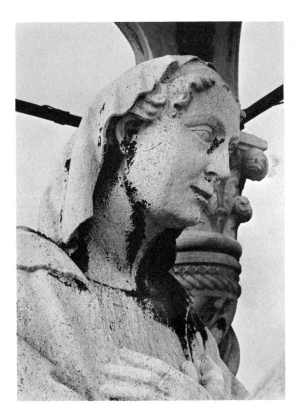

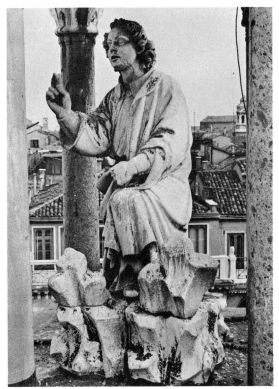

8. Sculptor uncertain (Jacopo della Quercia? Niccolò di Piero Lamberti? Lamberti School?), Virgin Annunciate, detail. San Marco, Venice.

9. Sculptor uncertain (Jacopo della Quercia? Niccolò di Piero Lamberti? Lamberti School?), Angel of the Annunciation. San Marco, Venice.

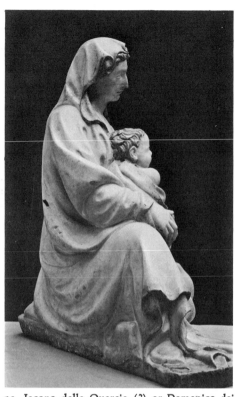

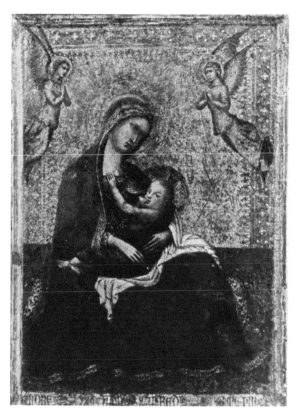

10. Jacopo della Quercia (?) or Domenico dei Cori (?), Madonna of Humility, from left. Marble. National Gallery of Art (Kress Collection), Washington, D.C.

11. Andrea di Bartolo, Madonna of Humility. Tempera on panel. Whereabouts unknown.

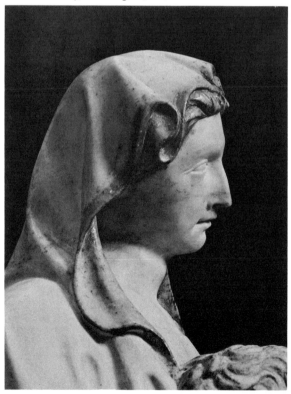

12. Jacopo della Quercia (?) or Domenico dei Cori (?), Madonna of Humility, detail of head. National Gallery of Art (Kress Collection), Washington D.C.

13. Domenico dei Cori (attributed to), Angel of the Annunciation, head. Wood. Museo d'Arte Sacra, Montalcino

 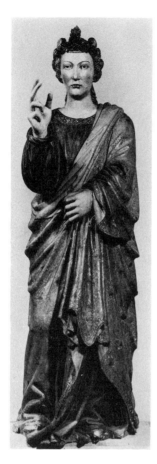

14a. Piero d'Angelo della Quercia (attributed to), Angel of the Annunciation. Wood. Santa Maria, Benabbio (near Lucca)

14b. Domenico dei Cori (attributed to), Angel of the Annunciation, from the front. Museo d'Arte Sacra, Montalcino

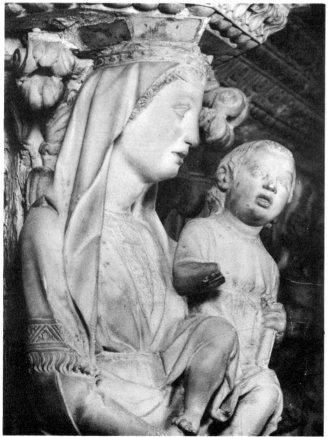

15. Nicola Pisano, Madonna and Child, detail. Marble. Pulpit, Duomo, Siena

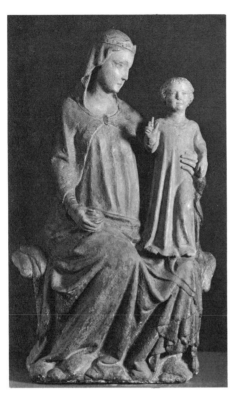

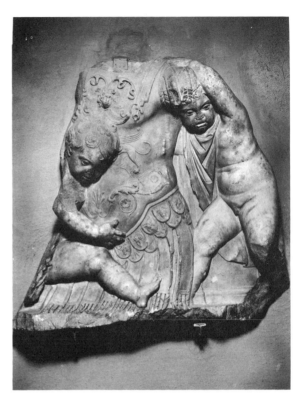

16. Sienese fourteenth-century (style of Giovanni di Balduccio), Madonna and Child. Polychromed wood. Walters Art Gallery, Baltimore

17. Fragment of "Throne of Mars," Roman Imperial Period. Marble. Uffizi, Florence

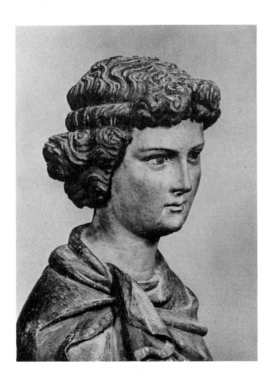

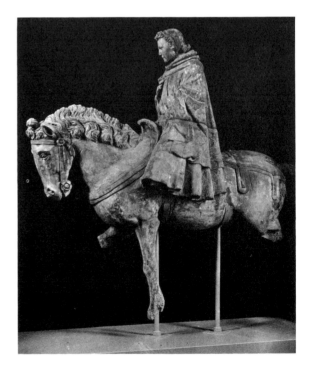

18. Francesco di Domenico Valdambrino, Sant'Ansano, detail. Wood. Santi Simeone e Giuda, Lucca

19. Francesco di Domenico Valdambrino, St. Cassianus, remains of an equestrian statue. Wood. Parish church, San Cassiano (near Lucca)

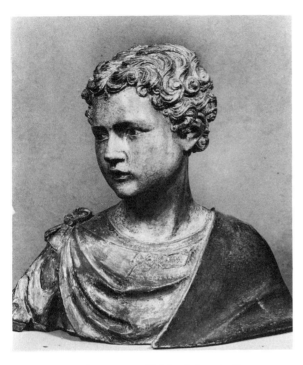

20. Francesco di Domenico Valdambrino, St. Crescentius,
fragment. Wood. Museo dell'Opera del Duomo, Siena

21. Artist unknown (Pisan?
Lucchese?), Virgin An-
nunciate. Wood. Louvre,

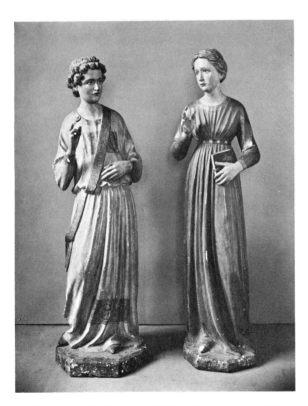

22. Francesco di Domenico Valdambrino, Annunciation
group. Wood. Rijksmuseum, Amsterdam

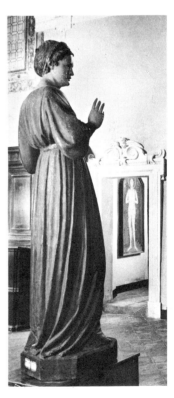

23. Francesco di Domenico
Valdambrino, Virgin An-
nunciate. Wood. San Fran-
cesco, Asciano

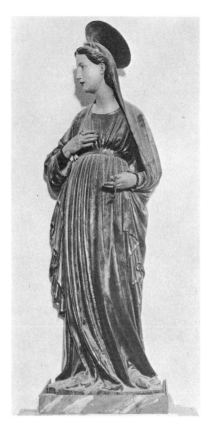

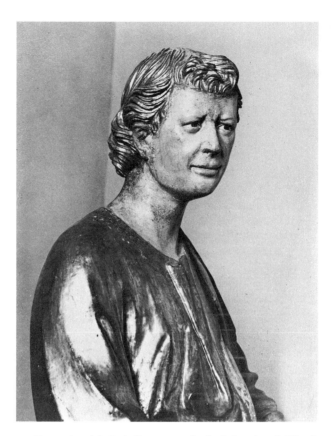

24. Francesco di Domenico Valdam-
brino (?), Virgin Annunciate.
Wood. Conservatorio di San Pietro
in Salci, Volterra

25. Domenico dei Cori (documented), St. John, detail. Wood.
San Pietro Ovile, Siena

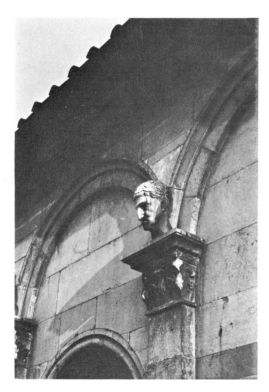

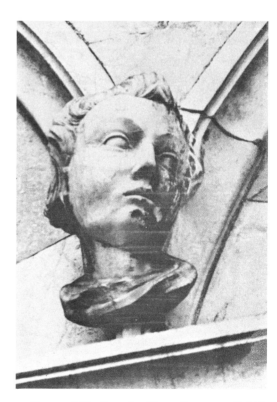

26. Jacopo della Quercia (?) or Francesco di Val-
dambrino (?) or bottega (?), ornamental mask.
Marble. Duomo, Lucca

27. Jacopo della Quercia (?) or Francesco di Val-
dambrino (?) or bottega (?), ornamental mask.
Marble. Duomo, Lucca

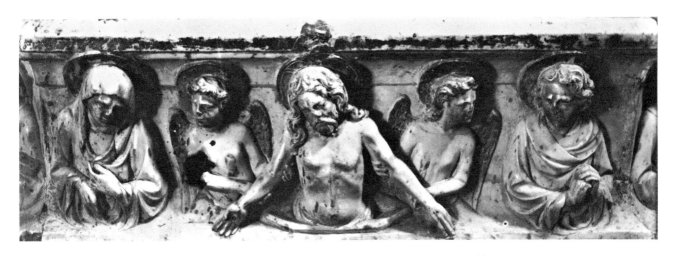

28. Dalle Masegne School (?), altar predella, Chapel of the Sacrament. Marble. Duomo, Lucca

29. Dalle Masegne School (?) holy water
stoup, with nineteenth-century base.
Marble. Duomo, Lucca

30. Masegnesque sculptor, Sant'Agnello relief. Marble. Duomo, Lucca

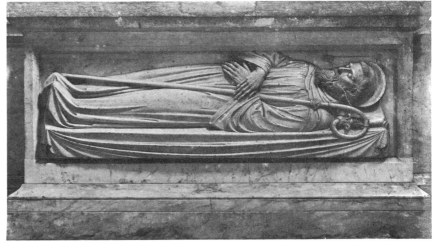

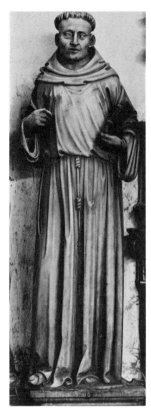

31. Dalle Masegne School, St. Anthony. Marble. Santo Stefano, Venice

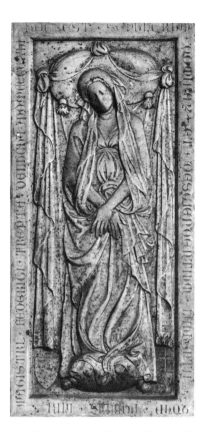

32. Giovanni da Imola (?), tomb-marker for Lorenzo Trenta's wife. San Frediano, Lucca

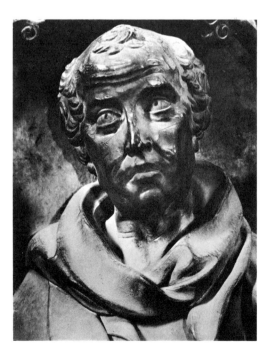

33. Giovanni da Imola (here attributed to), St Jerome, head. Trenta Altar, Trenta Chapel San Frediano, Lucca

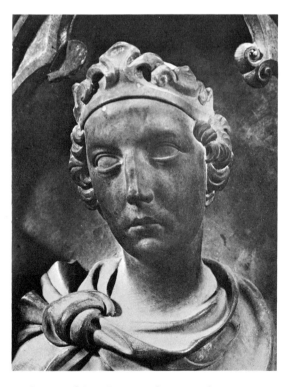

34. Jacopo della Quercia (here attributed to), St. Richard the King, head, Trenta Altar. Marble. San Frediano, Lucca

35. Dalle Masegne bottega, prophet. Marble. High Altar, San
 Francesco, Bologna

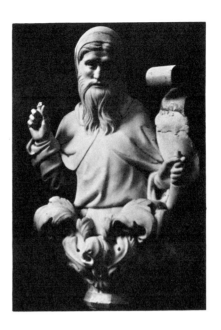

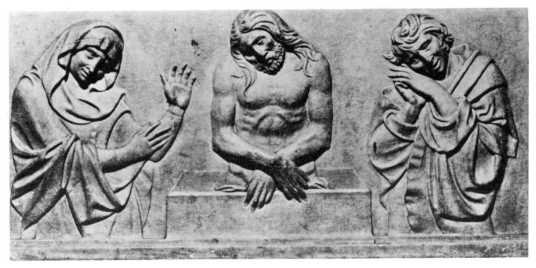

36. Giovanni da Imola (?), Christ between the Virgin and St. John, Trenta Altar. Marble

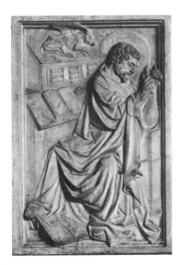

37a–c. Giovanni da Imola and Giovanni Turini, evangelists for pulpit panels. Duomo, Siena. a. Giovanni
 da Imola, St. Mark; b. Giovanni da Imola and Giovanni Turini, St. Luke; c. Giovanni Turini, St.
 Matthew

38. Predella, Trenta Altar, division between early and later work. San Frediano, Lucca

39. Predella, Trenta Altar. Later (seventeenth-century?) replacement of design by Jacopo della Quercia for Miracle of St. Richard the King. Trenta Chapel, San Frediano, Lucca

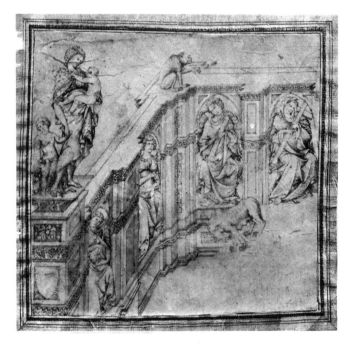

40. Design by Jacopo della Quercia; Martino di Bartolommeo, executant (?). Left-hand fragment of project for the Fonte Gaia. Ink on parchment. Metropolitan Museum of Art, New York

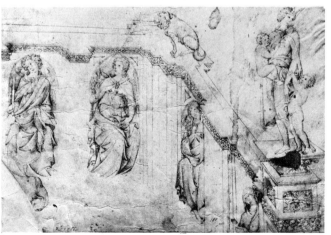

41. Design by Jacopo della Quercia; Martino di Bartolommeo, executant (?). Right-hand fragment of project for Fonte Gaia. Ink on parchment. Victoria and Albert Museum, London

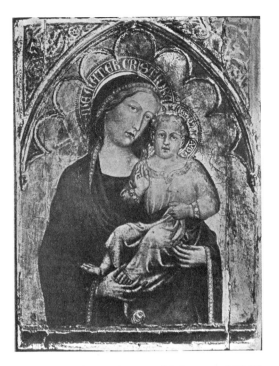

43. Sienese sculptor, fourteenth-century, relief figure of one of the Liberal Arts. Marble. From the Cappella di Piazza, Siena, now in Palazzo Pubblico, Siena

42. Martino di Bartolommeo, Madonna and Child. Tempera on panel. Signed and dated 1409. Whereabouts unknown.

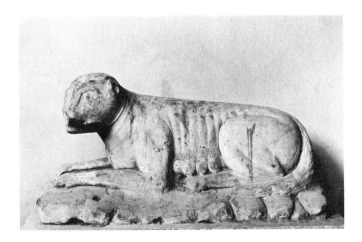

44. Assistant to Jacopo della Quercia (?), Reclining Wolf, at one time part of the Fonte Gaia. Marble. Palazzo Pubblico, Siena

45. Jacopo della Quercia and assistants, angel with original surrounding decorative elements, Fonte Gaia. Marble. Palazzo Pubblico, Siena

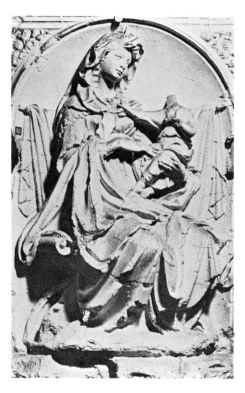

46. Madonna and Child (cast), Fonte Gaia, showing state as of 1858. Plaster. Palazzo Pubblico, Siena

47. Justice (cast), Fonte Gaia, showing state as of 1858. Plaster. Palazzo Pubblico, Siena

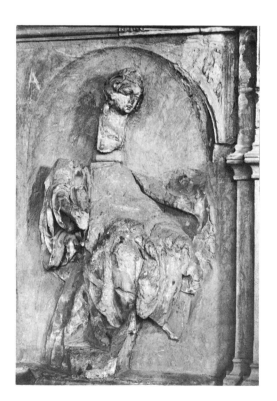

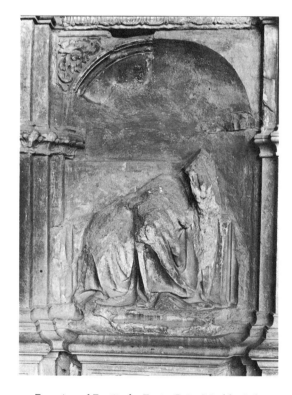

48. Prudence, Fonte Gaia. Marble. Palazzo Pubblico, Siena

49. Remains of Fortitude, Fonte Gaia. Marble. Palazzo Pubblico, Siena

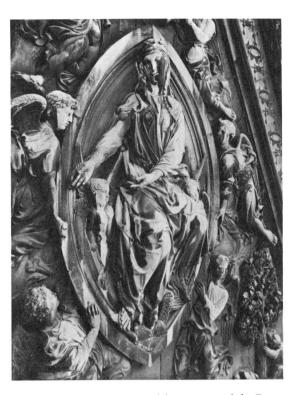

50. Remains of Charity, Fonte Gaia. Marble. Palazzo Pubblico, Siena

51. Nanni di Banco, Virgin of frontispiece of the Porta della Mandorla. Marble. Duomo, Florence

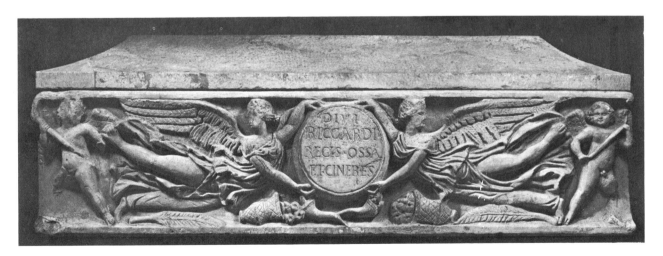

52. Cinerarium reused as reliquary for St. Richard the King, Roman Imperial Period. Marble. Now in original position under the altar, Trenta Chapel, San Frediano, Lucca

53. Hope (cast), Fonte Gaia, showing state as of
1858. Plaster. Palazzo Pubblico, Siena

54. Matteo Civitale, Faith. Marble. Bar-
gello, Florence

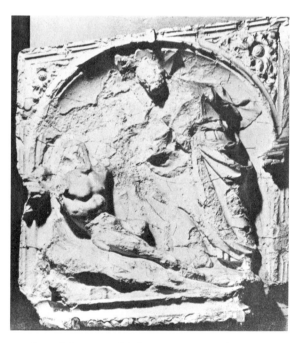

55. Jacopo della Quercia, Remains of Creation of
Adam, Fonte Gaia. Marble. Palazzo Pubblico,
Siena

56. Cast of Creation of Adam, Fonte Gaia, showing state
as of 1858. Plaster. Palazzo Pubblico, Siena

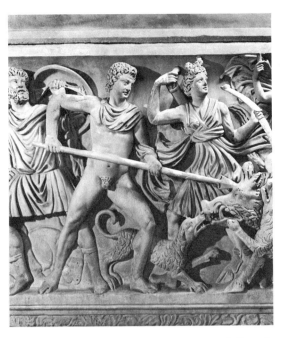

57. Meleager sarcophagus, Roman Imperial Period, detail. Marble. Palazzo dei Conservatori, Rome

58. Expulsion, Fonte Gaia, later version. Stucco. Piccolomini Chapel, Duomo, Siena

59. After Jacopo della Quercia, Expulsion, Fonte Gaia, another later version. Terracotta. Palazzo Chigi-Saracini, Siena

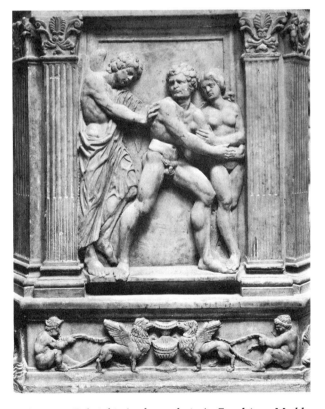

60. Antonio Federighi (perhaps design), Expulsion. Marble. Panel of Font, Duomo, Siena

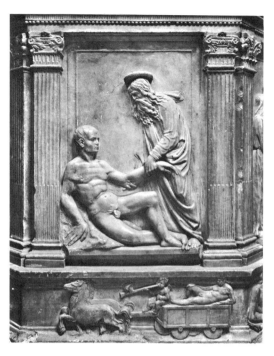

61. Antonio Federighi (perhaps design), Creation of Adam. Font, Duomo, Siena

62. Sixteenth-century artist (Sodoma?), drawing of standing figures, Fonte Gaia. Pen, ink, wash on paper. Gabinetto dei Disegni, Uffizi, Florence

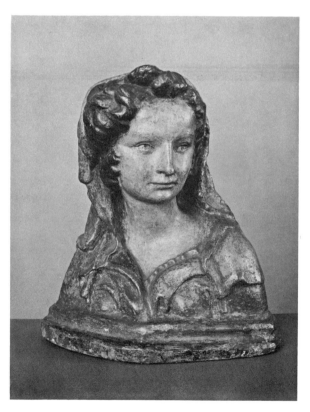

63. Bust after the Wisdom of the Fonte Gaia. Polychromed and gilded stucco. Rijksmuseum, Amsterdam

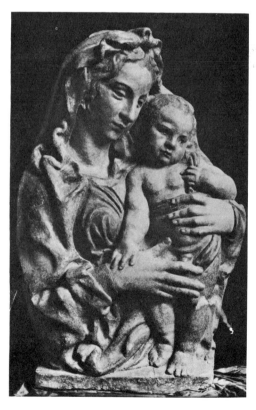

64. Madonna and Child. Polychromed terra-cotta (?). Cenacolo di Santo Spirito, Fondazione Salvatore Romano, Florence

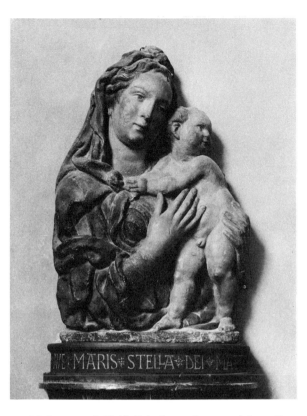

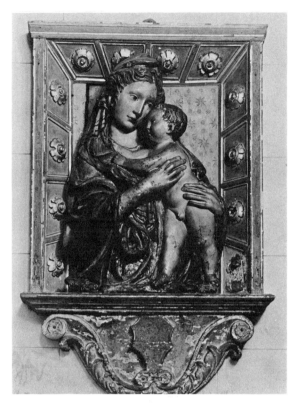

65. Madonna and Child. Polychromed stucco. Museo Bardini, Florence

66. Madonna and Child. Polychromed terra-cotta. Formerly Mortimer Collection and at one time on loan to the National Gallery of Art

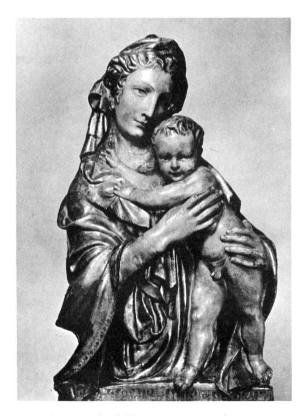

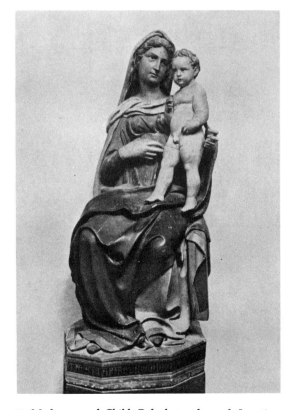

67. Madonna and Child, sometimes attributed to Lorenzo Ghiberti. Polychromed terra-cotta. National Gallery of Art (Kress Collection), Washington, D.C.

68. Madonna and Child. Polychromed wood. Location uncertain

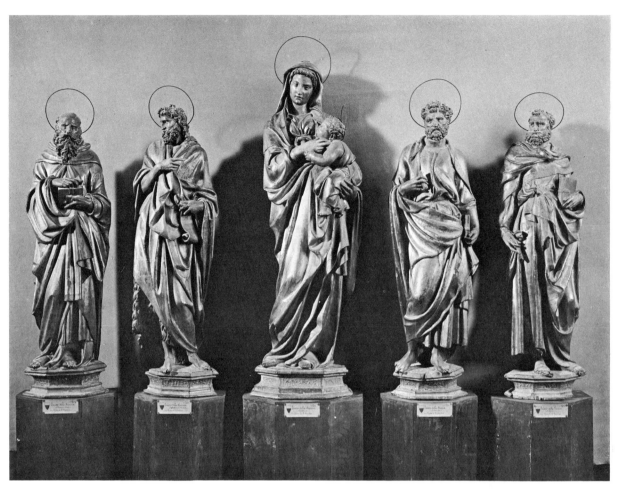

69. Jacopo della Quercia with assistants (probably Giovanni Turini and Giovanni da Imola). Madonna and Child with four saints. Wood. San Martino, Siena

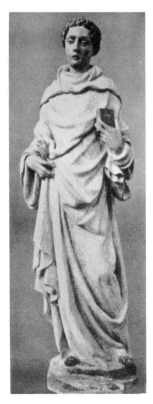

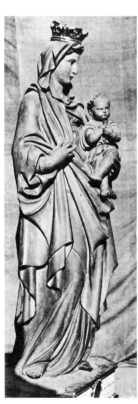

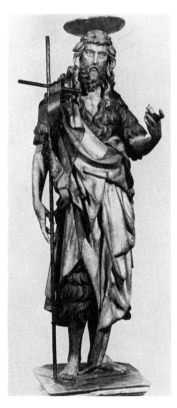

70. Follower of Jacopo della Quercia, St. Leonard. Wood. San Leonardo, Massa

71. Follower of Jacopo della Quercia, Madonna and Child. Wood. Parish church, Villa a Sesta (near Siena)

72. Follower of Jacopo della Quercia, St. John the Baptist. Wood. San Giovanni, Siena

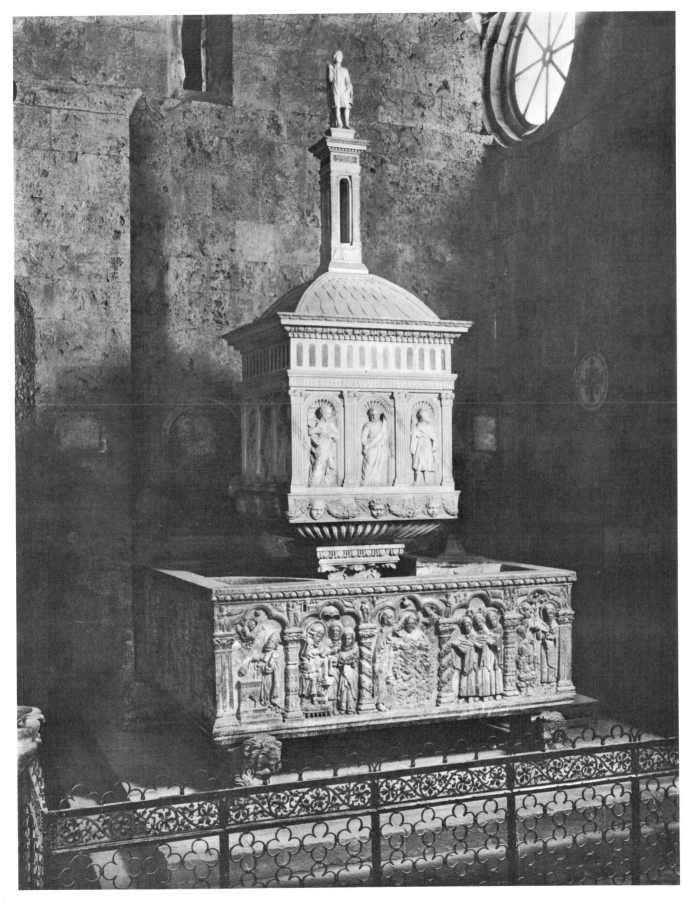

73. Font. Marble. Duomo, Massa-Marittima

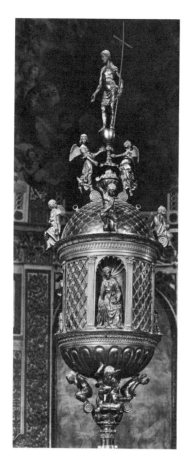

74. Vecchietta, Ciborium. Bronze. Duomo, Siena

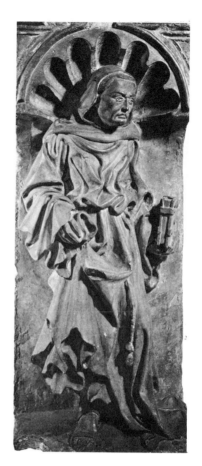

75. Prophet, possibly a modello by Quercia. Terra-cotta. Art market, Italy

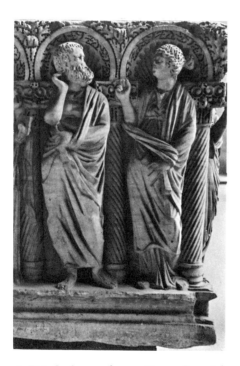

76. Detail of sarcophagus, Roman Imperial Period. Museo dei Conservatori, Rome

77. Donatello and Michelozzo, with assistants, lower part of Monument of Schismatic Pope John XXIII. Marble. San Giovanni, Florence

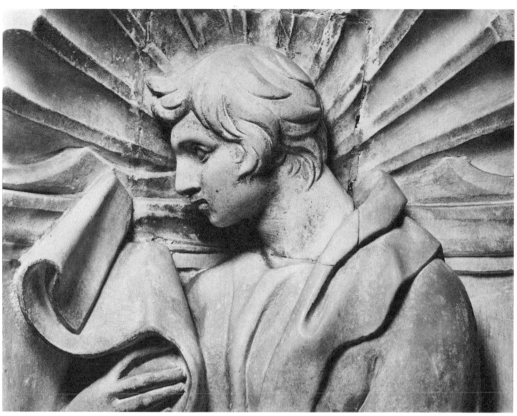

78. Prophet, detail. Marble. Font,
San Giovanni, Siena

79. St. John (cast of figure for
Font). Original in marble.
San Giovanni, Siena

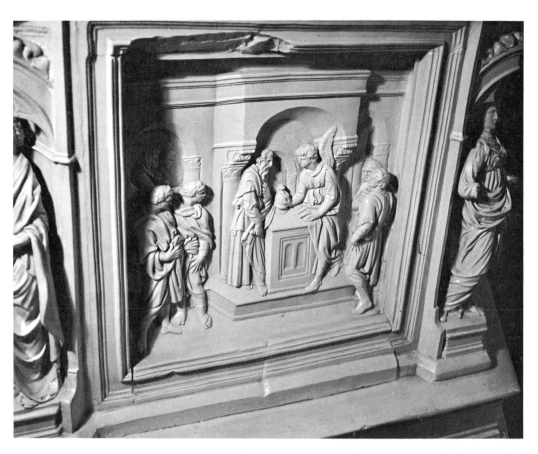

80. Annunciation to Zacharias relief
(cast). Original in bronze gilt. San
Giovanni, Siena

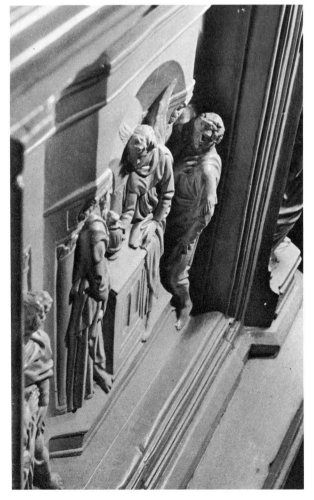

81. Annunciation to Zacharias relief
(cast), detail from above. Original
in bronze gilt. San Giovanni, Siena

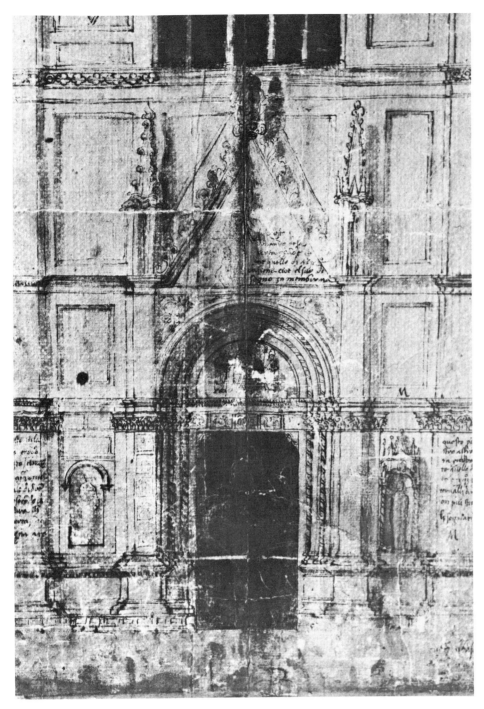

82. Baldassare Peruzzi (attributed to), copy of Jacopo della Quercia's design for the Porta Magna incorporated into new design for the facade of San Petronio. Ink on paper. San Petronio, Sacristy, Bologna

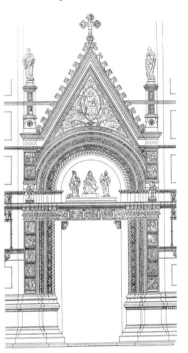

83. I. G. Supino, reconstruction of program of the Porta Magna. From Supino, *Sculture*

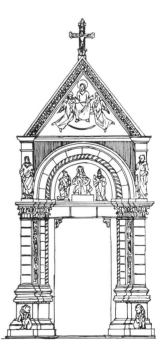

84. James H. Beck, reconstruction of program of the Porta Magna. From Beck, *Portal*

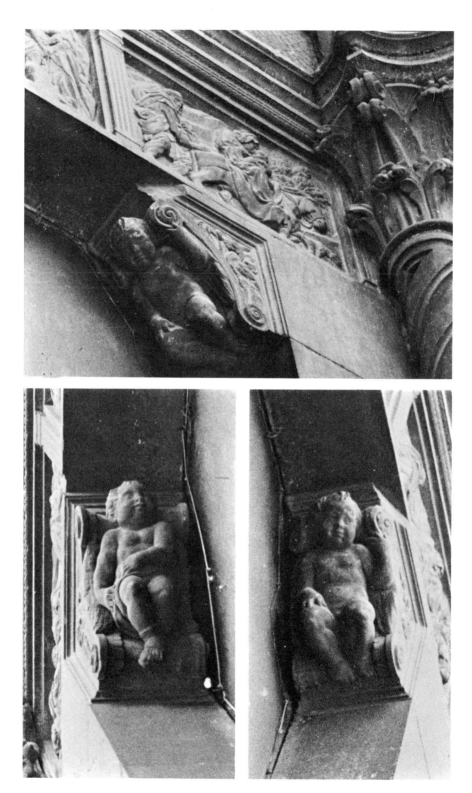

85a-c. Jacopo della Quercia, putti of consoles. Marble. San Petronio, Bologna

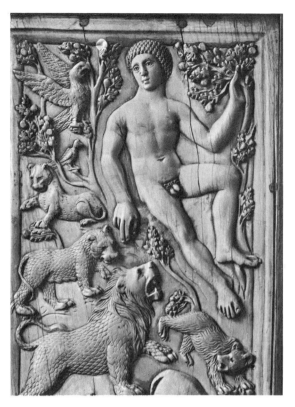

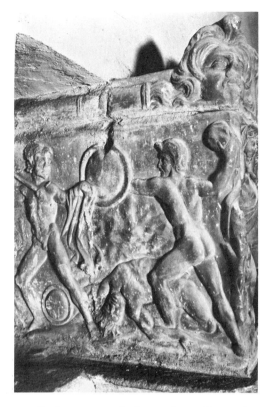

86. Early Christian diptych, detail, Adam. Ivory. Bargello, Florence.

87. Combat scene, end of sarcophagus, Roman Imperial Period. Marble. Uffizi, Florence

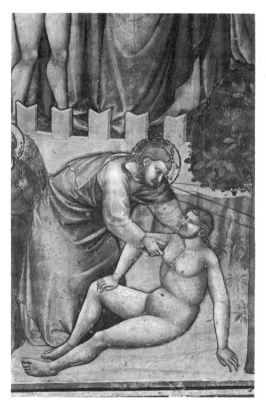

88. Pietro di Puccio d'Orvieto, Creation of Adam. Fresco. Campo Santo, Pisa

89. Pietro di Puccio d'Orvieto, Cain and Abel, detail. Fresco. Campo Santo, Pisa

90. Noah with Birds Entering Ark, detail. Mosaic. San Marco, Venice

91. Luca della Robbia, The Art of Music or Poetry, detail. Marble. Duomo (Campanile), Florence

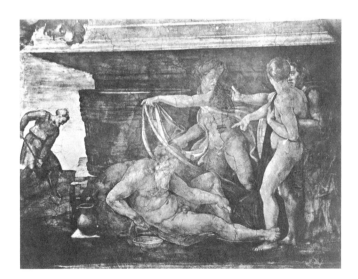

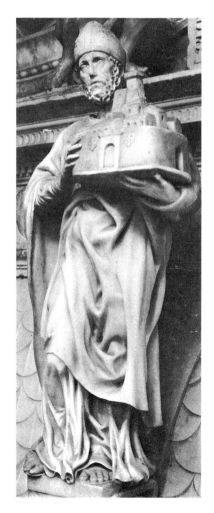

92. Michelangelo, Drunkenness of Noah. Fresco. Ceiling, Sistine Chapel, Vatican, Rome

93. Michelangelo, St. Petronius, Shrine of St. Dominic. Marble. San Domenico, Bologna

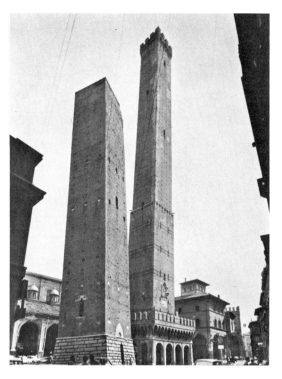

94. Medieval towers in center of the city of Bologna

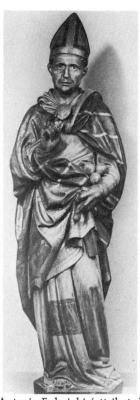

95. Antonio Federighi (attributed to), St. Nicholas of Bari. Wood (after cleaning). San Niccolò in Sasso, Siena

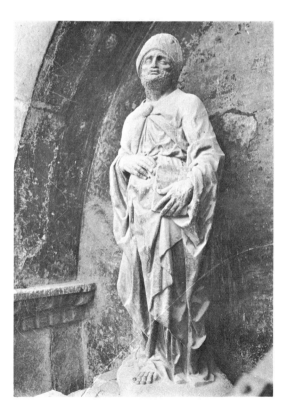

97. Domenico da Varignana, probably on basis of a design left by Jacopo della Quercia, St. Ambrose, Porta Magna. Marble. San Petronio, Bologna

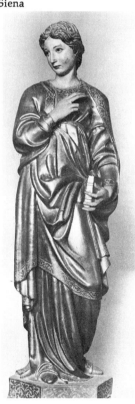

96. Antonio Federighi (here attributed to), Annunciation group, Virgin. Wood. Santa Maria degli Angioli "al Santuccio," Siena

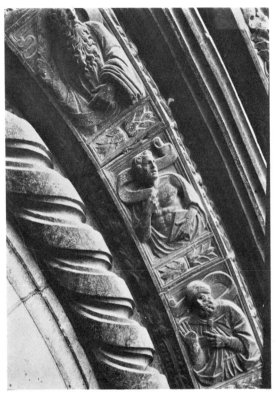

98. Sixteenth-century imitations of Jacopo della Quercia, great arch of Porta Magna. Marble. San Petronio, Florence

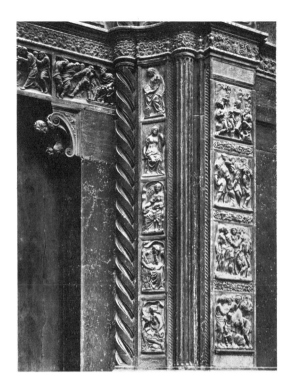

99. Girolamo da Treviso, Francesco da Milano, Tribolo, Silla, and Zaccaria da Volterra, reliefs on secondary portal to the right. Marble. San Petronio, Bologna

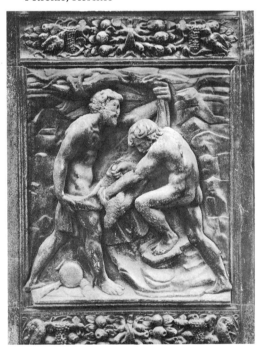

100. Girolamo da Treviso, Scene from the Story of Joseph, secondary portal to the right. Marble. San Petronio, Bologna

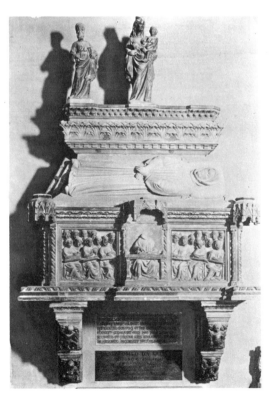

101. Andrea da Fiesole, Bartolommeo di Saliceto Monument, 1412. Museo Civico, Bologna

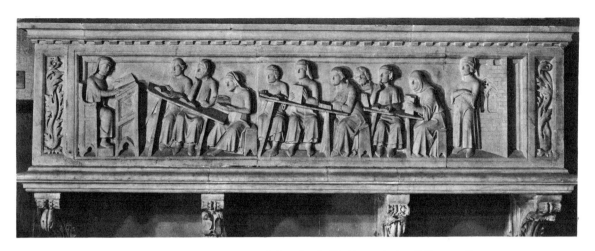

102. Sienese sculptor, Monument of Cino Sinibaldi (d. 1337), detail. Duomo, Pistoia

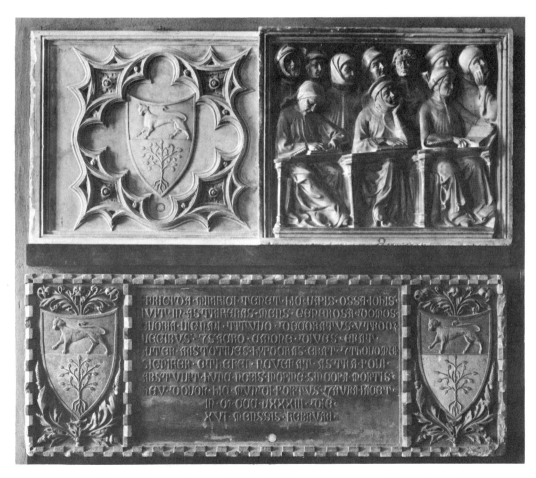

103. Bartolommeo di Saliceto Monument, 1412, detail. Marble. Museo Civico, Bologna

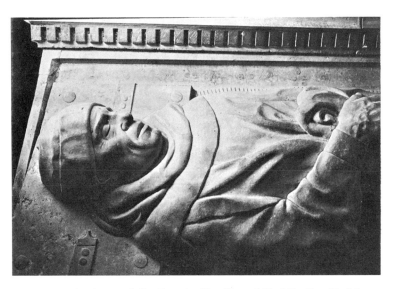

104. In part by Jacopo della Quercia (?), effigy of Vari-Bentivoglio Monument. Marble. San Giacomo Maggiore, Bologna

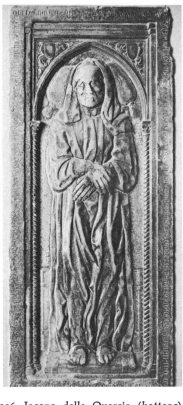

106. Jacopo della Quercia (*bottega*), Budrio tomb-marker. Marble. San Michele in Bosco (outside Bologna)

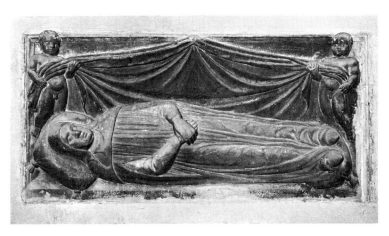

105. Influence of Jacopo della Quercia, tomb-marker of Cardinal Conti (d. 1437). Marble. Santa Maria dei Servi, Bologna

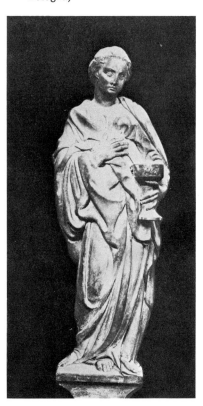

107. Begun by Jacopo della Quercia (?), Vari-Bentivoglio Monument, Faith. Marble. San Giacomo Maggiore, Bologna

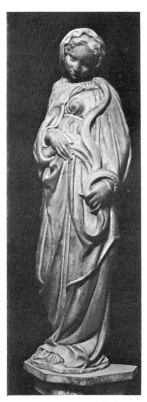

108. Design of Jacopo della Quercia
(attributed to), Vari-Bentivoglio
Monument, Prudence. Marble.
San Giacomo Maggiore, Bolo-
gna

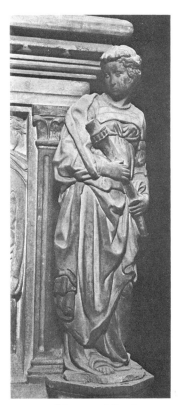

109. Design of Jacopo della Quercia
(?), Vari-Bentivoglio Monument,
Fortitude. Marble. San Giacomo
Maggiore, Bologna

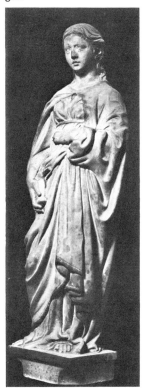

110. Influence of Jacopo della Quer-
cia, Vari-Bentivoglio Monument,
Justice. Marble. San Giacomo
Maggiore, Bologna

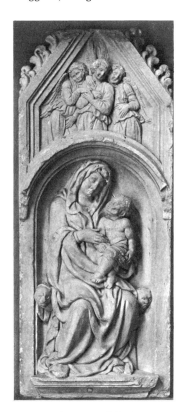

111. Design of Jacopo della Quercia,
central section of miniature trip-
tych. Marble. Museo Civico. Bo-
logna

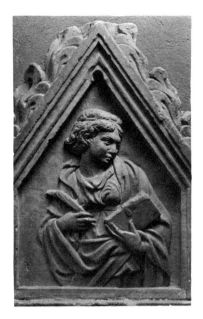

112. Design of Jacopo della Quercia, Madonna, St. Catherine, upper section of miniature triptych. Marble. Museo Civico, Bologna

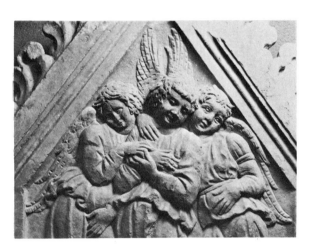

113. Design of Jacopo della Quercia, angels in gable of central panel of miniature triptych. Museo Civico, Bologna

114. Drawing related to design of lunette of Casini Altar. Ink on parchment. Albertina, Vienna

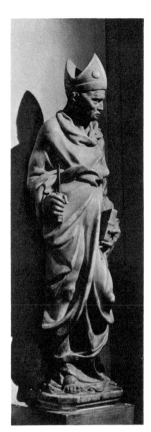

115. Influence of Jacopo della Quercia (possibly Niccolò dell'Arca?), St. Maurelius. Marble. Duomo, Ferrara

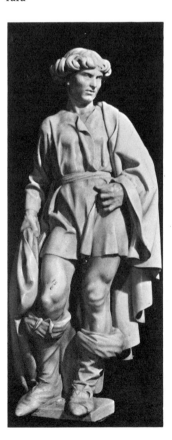

116. Niccolò dell'Arca, St. Vitalis. Marble. Shrine of St. Dominic, San Domenico, Bologna